CITY
OF LIGHT,
CITY OF
SHADOWS

Nationality and Citizenship in Revolutionary France:
The Treatment of Foreigners, 1789–1799

Nineteenth-Century Europe

1848: Year of Revolution

The Napoleonic Wars: A Very Short Introduction

The Unruly City: Paris, London, and New York
in the Age of Revolution

Understanding and Teaching the Age of Revolutions
(edited with Ben Marsh)

CITY OF LIGHT, CITY OF SHADOWS

PARIS IN THE BELLE ÉPOQUE

MIKE RAPPORT

BASIC BOOKS

New York

Basic Books
Hachette Book Group
1290 Avenue of the Americas, New York, NY 10104
www.basicbooks.com
Printed in the United States of America

First Edition: May 2024

Published by Basic Books, an imprint of Hachette Book Group, Inc. The Basic Books name and logo is a registered trademark of the Hachette Book Group.

The Hachette Speakers Bureau provides a wide range of authors for speaking events. To find out more, go to hachettespeakersbureau.com or email HachetteSpeakers@hbgusa.com.

Basic books may be purchased in bulk for business, educational, or promotional use. For more information, please contact your local bookseller or the Hachette Book Group Special Markets Department at special.markets@hbgusa.com.

The publisher is not responsible for websites (or their content) that are not owned by the publisher.

Maps from Auguste Logerot, *Le Nouveau guide de l'étranger dans les 20 arrondissements de Paris* (Paris: Logerot Éditeur, 1869), University of Glasgow Library: Maps, Official Publications and Statistics Unit, Case Maps C21: 50 PAR.

Print book interior design by Bart Dawson

Library of Congress Cataloging-in-Publication Data

Names: Rapport, Michael, author.
Title: City of light, city of shadows : Paris in the Belle Époque / Mike Rapport.
Other titles: Paris in the Belle Époque
Description: First edition. | New York : Basic Books, 2024. | Includes bibliographical references and index.
Identifiers: LCCN 2023039808 | ISBN 9781541647497 (hardcover) | ISBN 9781541674547 (ebook)
Subjects: LCSH: Paris (France)—History—1870–1940. | Paris (France)—Social life and customs—19th century. | Paris (France)—Social life and customs—20th century. | Paris (France)—Social conditions—19th century. | Paris (France)—Social Conditions—20th century. | Paris (France)—Buildings, structures, etc.
Classification: LCC DC735 .R27 2024 | DDC 944/.361081—dc23/eng/20231221
LC record available at https://lccn.loc.gov/2023039808

ISBNs: 9781541647497 (hardcover), 9781541674547 (ebook)

LSC-C

Printing 1, 2024

Pour Hélène, comme toujours.

And in memory of my mother,
Anita Esther Radford, 1943–2020

And of my father,
George Michael Rapport, 1943–2023

CONTENTS

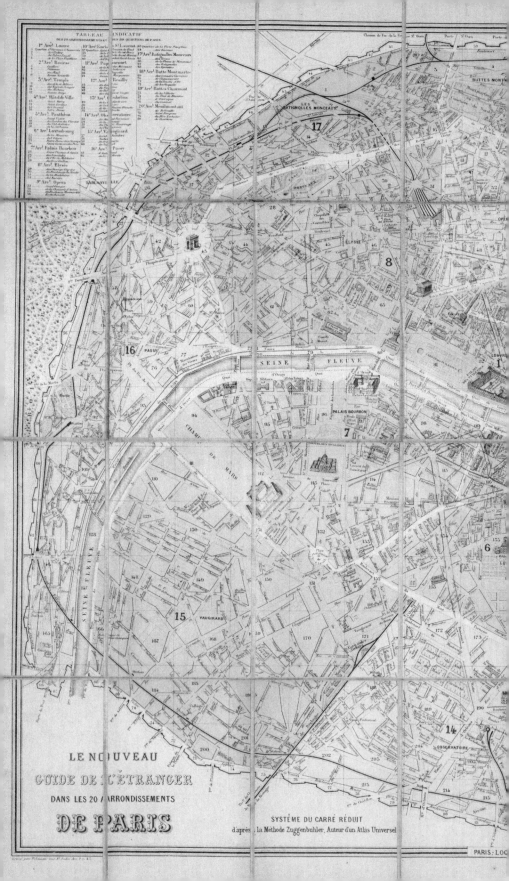

LE NOUVEAU
GUIDE DE L'ÉTRANGER
DANS LES 20 ARRONDISSEMENTS
DE PARIS

SYSTÈME DU CARRÉ RÉDUIT
d'après la Méthode Zuggenbuhler, Auteur d'un Atlas Universel

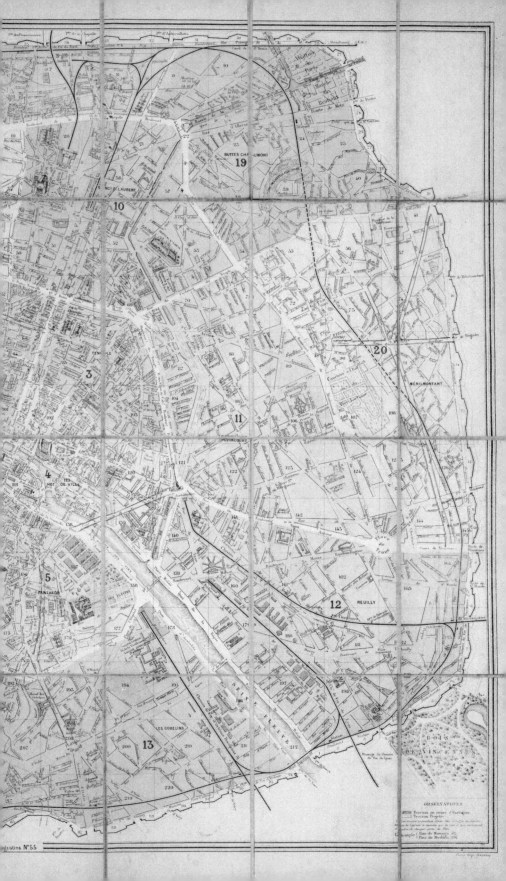

INTRODUCTION

On a bleak January morning, the abbé Pierre Froment stands on the steps of the Basilica of the Sacré-Coeur, still under construction on the Butte Montmartre, the steep-sided hill overlooking Paris. The good Catholic priest carries within him a heaviness. He has struggled with his faith for years, but continues to go through the motions, saying Mass for the faithful in one of the side-chapels of the gleaming white church. He pauses momentarily and, from his lofty vantage point, gazes across Paris. In the words of one of the greatest French novelists, 'Paris was shrouded beneath a mournful and trembling thaw,' from 'the east of the city, the quarters of misery and labour, where one could almost hear the puffing of workshops and factories . . . towards the west, towards the districts of wealth and labour, [where] the fog was breaking up and brightening.' What Froment beheld, as Émile Zola wrote, 'was a Paris of mystery, veiled with clouds, as if beneath the ashes of some disaster, already half-vanished in the suffering and shame of whatever its immensity was hiding'.[1]

Froment is the protagonist of Zola's *Three Cities* trilogy and is seeking ways of rekindling his faith, or of finding a new religion. While

1

wrestling with his conscience, he weaves from the slums of the poor to the Bohemian fringes of respectable society, and through the decadence and corruption of Paris's upper crust. He witnesses an execution by guillotine, dodges anarchist bombings, then finally finds redemption not in the Christian faith and charity that he had tried to practice for so long, but rather in the free play of human reason, science, and the pursuit of justice. Froment's story is ultimately resolved, but the malaise that Zola ascribes to his character bespeaks a deeper truth of this time and place in history.

Froment's view from the Butte Montmartre is very bleak: the fog hangs oppressively over Paris, the smoke evokes the din of the workshops and factories of the eastern working-class quarters, and the only promise of brightness hovers over the rich districts of the west. Yet as anyone who joins the crowds of visitors there today can see, the view from the Butte beneath the Sacré-Coeur is stunning in its panoramic scope. It is one reason that the hilltop was chosen as the site of the new basilica when construction began in the 1870s. From that spot in 1898—the year in which Zola completed the *Three Cities*—one could have also seen the Eiffel Tower pointing upwards into the sky, the dome of the Saint-Louis Church (beneath which lies Napoleon's tomb) at the Invalides, the unmistakable towers of Notre-Dame cathedral, and the dome of the Panthéon on its own hilltop on the Left Bank. One might also have been able to make out the rooftops of such secular buildings as Charles Garnier's famous opera house (its copper roof already turned green) and, nearby, of the department stores of the boulevard Haussmann.

From the Butte Montmartre, one could take in a cityscape riven by many changes—great and small—that were symptomatic of deeper transformations and divisions. This was the Paris of the 'Belle Époque', a term that was later retrospectively applied (broadly) to the decades from the 1870s or 1880s to the outbreak of the First World War in 1914.[2] This book explores the face of Belle Époque Paris, visiting some of the buildings, streets, and neighbourhoods of the era that endure to this day, touching its grit and glamour, and

taking measure of its grappling with modernity and of its conflicts over older enmities that had boiled and sometimes erupted over the previous decades.

Belle Époque Paris was roiled by conflicts both new and old. The city pulsated with pleasures, anxieties, and tensions stemming from technological advances, the expansion of mass culture and the mass media, 'Bohemian Paris' and the avant-garde, consumerism, social inequality and poverty, the role and status of women in society, and national identity and security. But besides the opportunities and troubles of 'modernity', Parisian buildings and spaces became the sites of political demonstrations and violence tied to bitter cultural and political schisms that had divided French society since the Revolution of 1789.

The two themes—the celebration and anxieties over modernity and the long-running political conflict—were, as we shall see, closely intertwined: collectively, they will form a kind of Parisian skyline that proclaims the ambiguities of the age, its triumphs and fears, its enlightenment and its darkness. The Parisian places visited over the pages that follow thus offer a view of the aspirations and worries arising from 'progress' and 'modernity' and of how political and social frictions and conflicts can simmer beneath life's surface calm but then explode in anger, hatred, and sometimes also in violence. In these ways, the Parisian cityscape of more than a century ago holds up a mirror to our own age.

THE VERY PHRASE *La Belle Époque* stirs memories of pleasure. It has been used nostalgically to recall the first cinemas, the music halls, and the exuberant dance floors of the *guinguettes*, the Moulin de la Galette in Montmartre and the can-can in the Moulin Rouge. It evokes sumptuous fashions, with women bustling in dresses and corsets that accentuated the 'S' shape of their figures (to put it bluntly: thrusting bust, slender midriff, rounded rear), their hats topped with teetering feathers, the ladies escorted by elegant men tightly bound in

close-fitting suits with black coats and tails. It is redolent of the glow of street lamps along the boulevards lined with linden, London plane, and chestnut trees. It is an era remembered for its parade of wealth and style, the vibrant cafés with their witty conversation bubbling across the round tables that populated the pavements outside—the Paris of Marcel Proust. 'Belle Époque' conveys a *frisson* of erotic promise, of discreet affairs between errant men and women (the myth arose in this period of the *cinq à sept*, whereby after work a man might call on his mistress between 5 and 7 p.m. before returning to the family home).[3] It conjures up the memory of courtesans and the over-glamourised high-class *maisons closes*, the brothels frequented famously by, among others, the Francophile Prince of Wales, the future King Edward VII. The Belle Époque also recalls an age of speed and new technologies ushering in the twentieth century, with the first motor cars jiggling down Parisian boulevards, the first Métro trains racing beneath (and sometimes just above) the city streets, the first aeroplane flights, and, with the democratisation of the bicycle, with ever larger numbers of Parisians weaving through the traffic on their *vélos*.

These glories of the Belle Époque were real enough—like many myths and clichés, they contain an element of truth—but they tell only one side of the story. The era was also riven by political conflict, crackling with social tension, and fraught with cultural friction. And, of course, it ended with the industrialised carnage of the First World War in 1914.

Today, we often use 'modern' casually to describe anything that is different from what went before, usually implying progress of some sort. As a nebulous, historical concept, 'modernity' has been subject to the work of legions of scholars and intellectuals heroically attempting to batter it into coherent shape.[4] Modernity is usually taken to mean the emergence of a new form of society from the profound economic, social, and political transformations in the Western world from the later eighteenth century. These processes included industrialisation, more rapid forms of communication, urbanisation, the secularisation of society and the decline of religion, the rise of a more scientific view

of looking at the world emphasising human reason over faith, and the growth of mass culture, democratisation, and the pursuit of individual freedom.[5] The Belle Époque experienced all of these, along with the considerable angst and frictions they aroused.

Parisians sometimes couched their anxieties about these changes and conflicts in terms of decadence, decay, and degeneration. Commentators at the time fretted about poverty and public health; disease, it was argued, hastened the 'degeneration' of the French as a people. They spoke in similar terms about the impact of technology on everyday life and how it made people lazy, caused infertility, or outstripped morality. They wrung their hands about the expansion of popular culture, thought by some to lower standards of good taste; the emergence of a mass media, whose polemics, slander, and prejudices risked taking the press's freedom too far; and the growth of consumerism, which sapped the civic fibre of virtuous, thrifty republican citizens. They worried, too, about the emancipation of women and their status and agency within French society: the challenges articulated by 'feminists'—the term dates to the 1890s—seemed to traditionalists to threaten the old family arrangements, and so, by extension, the social order itself (not least, it was sometimes claimed, by imposing a drag on the already flagging birth rate).

For the French sociologist Émile Durkheim, modernity was the outcome of industrialisation, which saw the evolution of ever more specialised forms of economic activity. This development gave modern society its flexibility and underscored the individual freedom of its members, but it also broke apart the moral consensus that had once given it cohesion. Durkheim saw the process of modernity as acultural—that is, as something that all human societies could undergo. Yet the Parisians among whom he lived after taking up his professorship at the University of Paris in 1902 (a position he kept until his death in 1917, living at No. 260 rue Saint-Jacques, in the Latin Quarter and a short stroll from the Sorbonne) inhabited a particular social and political world, a culture through which they inescapably understood the modern.

To state two truisms: the Belle Époque was a particular time and Paris was a particular place, especially a crucible of political division and conflict as well as a centre of taste, culture, and spectacle. 'Modernity' as lived by Parisians before 1914 was therefore, as the historian Eugen Weber has suggested, an experience that is both familiar and different to our own.[6]

Belle Époque modernity was the combination of social, cultural, and political developments that contemporaries remarked upon as characteristic of their age and that were either the consequence of or the motor of social or cultural change. These developments, namely technology, consumerism, the emergence of a mass public, and changes in the status of women, did not necessarily have to be new—and in fact few, if any, of them actually were—but together they have appeared both to contemporaries and to us to shape the Belle Époque itself. By 1870, Paris was already a city that bore the marks of a radical transformation, under the wrecking ball and renovations wielded by Baron Georges Haussmann, Napoleon III's prefect of the Seine between 1853 and 1870. Haussmann's brief was to turn Paris into a city worthy of being an imperial capital, a showpiece for the world, but also a place where the upheavals of the past would become unthinkable. In pursuit of these objectives, he drove broad avenues and boulevards through the cluttered labyrinth of the old city, aiming to encourage the faster circulation of traffic, fresh air, and light, connecting the great railway stations with each other so that people—and troops—could pass through quickly and unhindered, and opening up new vistas on Paris's many monuments. In all, he added two hundred kilometres of streets to the city.[7] He created green spaces to provide Parisians with places for recreation and escape, the landscaped gardens around the lake at the Bois de Boulogne, the Parc Monceau and the spectacular park at the Buttes Chaumont (landscaped on the site of one of the city's great quarries) being striking examples. He oversaw the expansion of the city from twelve arrondissements to the twenty that are still the main administrative districts today. Seeking to ensure social stability, Haussmann sought to combat disease and

hunger by promoting supplies of fresh water, by building the Paris sewers (which one can visit today), and by having capacious iron and glass pavilions (constructed by Victor Baltard) to house Paris's central food markets at Les Halles in the city centre (now sadly gone, demolished in the early 1970s, with one sole survivor reconstructed in the suburb of Nogent-sur-Marne). There may also have been an ulterior motive: it was no accident that some of the new avenues ran not too far from army barracks, that their width made them hard to barricade, and that their rigid, straight lines made it easier for troops to march and artillery to fire down them: Haussmann may have hoped that his renovations would give the advantage to the forces of order in any future revolutionary confrontation.[8]

His building regulations and practices are visible in the characteristic apartment buildings that remain one of the defining features of the Parisian cityscape: five to six storeys high, with smooth, stonework facades and a heavy, double carriage door at street entrance beneath a decorative archway, with windows ranging across the frontage behind wrought iron railings, all beneath curving zinc roofs. And no matter how many different architects were involved (their names can often be seen carved into a cornerstone just above street level), the rules ensured a broad continuity in design and look all along the street. He built no fewer than 34,000 new buildings with 215,000 apartments.[9] Moreover, the boost in rents in the renovated districts, and Haussmann's own conceptions of the city as a place of 'movement and exchange' between specialized areas, displaced thousands of poorer Parisians outwards to the north, the east, and the west—to slums and shantytowns on the fringes of Belleville and Ménilmontant, for example. Apartment buildings that once housed all strata of Parisian society (workshops and shops on the ground floor, nobles and bourgeois on the first, getting progressively poorer the higher up one climbed until one reached the upper garrets with servants, paupers, struggling Bohemians, and impoverished students) were replaced by Haussmann's grand designs, which were largely, or mostly, a middle-class and bourgeois affair, with only the upper rooms reserved for servants

(the *chambres de bonne*) and the ground floor still boasting shops. The segregation of neighbourhoods by social class and economic activity (workshops, shopping, education, finance, wholesale food selling, arts and music, and even prostitution) was accentuated.[10] It was against this backdrop—of a city already undergoing startling changes—that Belle Époque modernity made its mark.

The Belle Époque witnessed some stunning technological breakthroughs. These included new ways of communicating and of getting about: the incipient use of the telephone, the first radio messages, the first cinemas, the democratisation of the bicycle, the first aircraft flights—Louis Blériot flew his alarmingly light and flimsy monoplane on a thirty-six-minute crossing across a cloudy Channel on 25 July 1909—and the chugging of the first motorcars along Paris's already busy boulevards. The steady advance of electricity, which illuminated the Universal Exposition in 1889, was beginning to light up Parisian streets and powered the whirring Westinghouse engines that drove the Métro. Allied with technology, modernity meant an exaltation of science and human reason, a belief in 'progress' and an often militantly secular worldview as against the traditional values underpinned by religion: we have seen this with Zola's abbé Pierre Froment's personal, internal struggle. French republicanism, too, had been closely associated with secularism in public life (*laïcité*) and conflict with the Catholic Church ever since the Revolution of 1789. The elevation of science over faith was particularly acute in France because one of the ideological currents that quickened the Third French Republic was positivism, an approach to knowledge that sought to understand the world and society in a rational, scientific way and to order the sciences accordingly.

Belle Époque modernity also involved the consolidation and growth of consumerism. The later nineteenth century witnessed a general improvement in the quality of life, although this rise in prosperity was far, very far, from being equally shared. Even so, more people could enjoy the pickings of a rapidly evolving consumer society, especially a richer variety of clothing, food, drink, and new forms of leisure

and entertainment. This relative abundance encouraged a developing consumerism whose demands were met by large-scale production that enabled *prêt-à-porter*—a wide range of clothing made in standard sizes rather than individually tailored, sold at more affordable prices and ready to be worn off the rail. It was a consumerism that encouraged people's aspirations for a more comfortable lifestyle, a gospel of consumption on the high altar of the late nineteenth-century department store. Newspaper advertisements from this period, usually printed in columns on back pages, sometimes in the lower margins of the front page, can be entertaining to read to a twenty-first-century eye: 'Hogg's Cod Liver Oil: from fresh cod liver, the most active, the most nourishing, the tastiest [!]'; 'Asthma is not cured by powders, papers or cigarettes. . . . Only Gabon's Elixir rapidly and radically does so.'[11] And such advertising spilled across the city's walls in garish colours: Parisian streets were notoriously plastered and replastered with colourful *affiches*, posters selling a cornucopia of goods and events, competing with political notices calling for public meetings, political rallies, and strikes.

Technology and consumerism were interwoven with an ongoing expansion of a mass public. The era witnessed a striking growth in literacy fuelled by the introduction in the early 1880s of free, universal, and compulsory primary schooling for both boys and girls. By 1891, young Parisian army conscripts were almost universally able to read and write—an achievement almost certainly matched by women of the same age.[12] An explosion in the availability of printed matter of all kinds, from high literature and scholarly journals to the gutter press and pornography, occurred alongside the increase in literacy, which was also encouraged by the near-total abolition of censorship in 1881 and by the invention of machinery that made printing cheaper and more attractive (with the introduction of colour, for instance).

The growth of the mass public combined with the emergence of mass politics to produce a flurry of large-scale mobilisations in the pursuit of social justice and greater freedom (especially among and

for women). These movements jostled with the crystallisation of new, more extreme political movements, including anarchism and revolutionary communism on the left and populist, authoritarian nationalism on the right. Yet the mass public of the Belle Époque also coalesced around less overtly political displays of organised sport: the International Olympic Committee first met in the Sorbonne at the University of Paris in 1894, where it determined to hold the first modern Olympic Games in Athens in 1896 and the second games in Paris in 1900. The Tour de France first pedalled its way furiously around the country in 1903. Both contemporaries and subsequent historians have commented that 'spectacle'—a taste for display, colour, and entertainment—was one of the most visible features of Belle Époque modernity.[13]

Pervading all aspects of Belle Époque modernity was gender. Belle Époque women were unmistakably and irreversibly part of the public, of civil society, and of the spectacle of the age. They not only consumed, but also produced, much of the literature, journalism, art, and entertainment of the day. They were at the very heart of the consumption that was such a prominent feature of the Belle Époque. Working women produced and sold many of the goods now on offer, and middle-class women, in particular, were the targets for advertising and, above all, for the department stores. With women securing more agency in small but noticeable ways in an age when they were held to be biologically destined only for marriage, motherhood, and domesticity, and denied any formal rights to political participation, it is no surprise to find that some women also entered the political struggles of the day while also campaigning on their own behalf—to secure, for example, greater access to education (and to university degrees, in particular), entry into the professions, equality in the workplace, and legal reforms to women's status, including the right to vote. Women, in other words, were in the thick of the tumultuous debates that arose in France's democratic politics in these years.[14] Moreover, some fought to be actively engaged in shaping the very science that was a driver of modernity: this was the age, for example,

in which Marie Skłodowska-Curie twice won the Nobel Prize: first for physics, along with her husband, Pierre, in 1903, and then for chemistry in 1911.

INTERTWINED WITH THE energy and tensions associated with Belle Époque modernity was a longer-term conflict that infused these years. This was a cultural war and political struggle between contradictory visions of what type of society France should be, of what it meant to be French and what type of politics best represented the nation.

It was a clash of worldviews that dated to the Revolution of 1789. On one side were those who accepted, and indeed exulted in, its egalitarian ideals, its secularism, and its democratic promise. On the other were those who lamented the upheaval as a tragic, bloody separation from France's deeper past, a godless rupture from both religious faith and the monarchy, which were the 'true' pillars of Frenchness. The successive upheavals since 1789—revolutions in 1830, 1848, and 1871—were, on the surface, very different from each other, but some French historians have since looked back across the two centuries and seen common cultural and political threads binding them together into a long 'Franco-French war', *la guerre franco-française*, particularly as they sought to come to terms with the trauma of the Second World War.[15]

Though 'the Franco-French war' was often violent, it was not always so—it was waged in the cultural and political arenas as well as on the barricades and in the streets. Moreover, the polarisation can be exaggerated: much of French politics and culture tended to congregate on a broad centre ground, and French people from both sides could and did stand together in moments of crisis, such as the Prussian invasion in 1870–1871. And they worked together, if sometimes awkwardly, towards common imperialist goals overseas.

Yet deep-rooted currents can come tearing to the surface in times of political and social stress. The 'Franco-French' conflict had its origins in the bitter struggles between 'Left' and 'Right' (political

terms that actually date to 1789) in the French Revolution, which reformed (and for a period developed into an attack on) the Catholic Church, proclaimed the Republic (as it would turn out, the first of now five republics) in 1792, executed King Louis XVI in early 1793, and abolished titles of nobility and all personal and local privilege. These measures would ultimately combine in a vision of a republican order based on civil equality, the principle (if not always the practice) of equal rights, democracy, and secularism, but they were fought tooth and nail by those who cleaved to the old hierarchical order based on monarchy and religious faith, who were provoked by the attack on the Church, angered by measures such as the introduction of conscription, and faced hardship because of the economic dislocation caused by civil war and foreign invasion, and who in the long run would not be reconciled to the republican order because memories of the violence, including the legacy of the Terror of 1793–1794, would resonate across successive generations.

The long-term problem of political order in France was how to bring together the 'two Frances', that of the Revolution and that of Church and King. Despite the best efforts of some to build politics from the centre ground, the challenge proved to be intractable, which is why since 1789 France has had three monarchies, two Napoleonic empires, and five republics, not to mention the authoritarian, collaborationist Vichy regime in the 1940s, which was, in its own depressing way, a consequence of this longer history.

The Third Republic was the regime presiding over the Belle Époque, having emerged from the fall of Emperor Napoleon III in 1870. After Napoleon III had seized power in a coup d'état in 1851 (and so destroyed the short-lived Second Republic of 1848), he sought to straddle the political divide in France by offering something to everyone. He promised social order and stability to the propertied élites and land-owning peasantry, religious tolerance to Catholics and others, social reform to urban workers, and economic development and commercial opportunities for the middle classes. While initially dictatorial, he slowly released his iron grip, promising (and delivering)

a more constitutional government to his liberal monarchist and republican opponents. By 1869, in fact, Napoleon III's 'Second Empire' (the First Empire being, of course, that of his more famous uncle, Napoleon, who had fallen in 1815) was a fully functioning constitutional monarchy. Yet this political project fell apart in France's stunning military defeat in the Franco-Prussian War of 1870–1871.

The emperor's surrender to the Germans at the Battle of Sedan sparked the bloodless revolution of 4 September 1870, in which the Third Republic was proclaimed. The national humiliation of defeat by the Prussians and the subsequent loss to Germany in the peace treaty of 1871 of the north-eastern provinces of Alsace and a large chunk of Lorraine would rankle French people in the decades to come. Although the current of *revanchisme*—the desire for revenge against Germany—ebbed and flowed, it was present within French politics up to and including the First World War: as a mark of mourning, the statue representing Strasbourg on the north-eastern corner of the place de la Concorde was permanently wrapped in black crepe. The statue, chiselled by James Pradier and erected there in the first half of the nineteenth century, is one of eight representing the most important cities in France, their location on the square roughly corresponding to their actual place on the map. So the gathering around 'Strasbourg' every 14 July—Bastille Day—was especially poignant. This was a procession of men and women from Alsace in traditional costumes—the women particularly resplendent with their large black bows in their hair, their white blouses, and their billowing black taffeta skirts. They would parade to the place de la Concorde as a collective act of remembrance for their lost homes and as a protest against the German annexation. It was an expression of sadness, but it was also a ceremonial evocation of *revanchisme* and a plea for the reconquest of the two lost provinces. Even in stable times, *revanchisme*— easily exploited by hard-line nationalists—would sit like a coiled serpent at the feet of the French body politic.

Meanwhile, the terrible privations of the Prussian siege of Paris in 1870–1871 and the attempts by a conservative government to impose

its authority on the city provoked the socialist, working-class revolution remembered as the Paris Commune in 1871. The bloody repression of the Commune in May 1871, in 'Bloody Week', gave martyrs to both sides: twenty thousand insurgents were killed by government forces, mostly in summary, mass executions, and the Communards shot the archbishop of Paris along with a group of Dominican friars. The trauma of the Commune and the spectre of class war remained within living memory and weighed heavily in the decades of the Belle Époque. It crystallised another feature of the 'Franco-French' friction: a radical, socialist, or anarchist Left that, on the one hand, naturally rejected the conservative, clerical, monarchist tradition, but that, on the other hand, challenged the republican currents to embrace more than just the civil equality and democracy inherent in the principles of 1789, by pursuing social justice, workers' rights, and varying degrees of wealth redistribution.

The 'Franco-French war' received an injection of renewed urgency as universal male suffrage began to be well and truly felt. Introduced in the 1848 Revolution, it was now supported by a wider public engagement with politics through a noisy, often shrill popular press that enjoyed almost unprecedented freedom in this period. And although the Third Republic—painfully, fitfully—found a measure of stability by 1879, it, too, was beset by the friction between the 'two Frances', most notably in the Dreyfus Affair of the 1890s and by an upsurge of anarchist violence and working-class protest from the same decade onwards. The regime would last until 1940, when it collapsed under the crushing weight of the German invasion in the Second World War, but the internal 'Franco-French' struggle continued in the trauma of the Nazi Occupation, with, on the one hand, collaboration by the Vichy regime, and, on the other hand, the Resistance, while most French people sought the grim satisfaction of survival. The Liberation in 1944 was accompanied by the purges of collaborators in the *épuration*. Since then, there have been further crises, such as the impact of the wars of decolonisation in Indochina and Algeria as the French overseas empire contracted, the student and workers'

uprising in 1968, and later the rise of an anti-immigration, nationalist Far Right and debates over the Muslim hijab, niqab, burka, and burkini—all of which are overlaid by other issues of more recent vintage. As early as the Belle Époque, the old schism was being obscured by new political alignments—the wealthy and propertied of either tendency coming together in defence of social order, and segments of conservatism joining with elements on the left to create a new, sinister fusion of populism, nationalism, and authoritarianism. Yet the old 'Franco-French' conflict still resonates today, if rather more distantly, and much of its story lies behind the landscape of Belle Époque Paris.

THE BUILDINGS, PLACES, and people of this book belong to this story of social friction, cultural anxiety, and political conflict. Some of the key landmarks in the following pages were specifically designed not just for particular uses, but also to project a particular message, explicitly engaging with the cultural and political currents of the time. The Belle Époque was the age of Art Nouveau, with its sweeping, vegetal lines, stylised forms, and voluptuous bodies. It left us the Eiffel Tower, controversially pieced together for the 1889 Universal Exposition; the Grand and Petit Palais, both built for the 1900 Universal Exposition, the former striking for its capacious iron and glass dome; the Gare (now Musée) d'Orsay, constructed to bring visitors into the heart of Paris for the same event in 1900; the department stores, such as La Samaritaine (its stunning Art Nouveau staircase still worth a look), Au Printemps (with its striking corner towers and stained-glass dome), and the Galeries Lafayette (with its soaring Art Nouveau cupola); the (now) much-loved Métro entrances, with their green-washed enamel and gently organic curves designed by Hector Guimard; and the great statue of La République on the square of the same name, now a rallying point for demonstrations of all kinds.

Some of the old buildings and spaces took on new meaning as people appropriated them for their own purposes. Others became the location of particular events or developments that inscribed them

with the historical memories—sometimes now forgotten, overlaid by other associations—of the more dramatic moments of those years. The Grands Boulevards buzzed with human life as people strolled along their wide pavements and indulged in *flânerie*, taking in the sights and people-watching, with the promise of entertainment in their theatres and the clink of cups and glasses in their many cafés. The Bohemian streets of Montmartre came to life with the cabaret of the Chat Noir, the popular songs of Aristide Bruant, and the edgy artistic life on the Butte. Not far away, around the Goutte d'Or at the bottom of the eastern slopes of Montmartre, was one of the teeming, tubercular quarters of the working population. And along the rue Montmartre was the press district, packing politics and polemics densely into its relatively confined space. The usually peaceful, tree-shaded place Dauphine on the Île de la Cité and the streets around the hallowed grandeur of the neoclassical Panthéon in the Latin Quarter both at points became sites of noisy and even violent protest.

In using Parisian places to tell the story of the Belle Époque, this book does not aim to be a guidebook, although it might hopefully be enjoyed as a companion for anyone who wants to know more about these sites, many of which are iconic or at least well loved by visitors, if not always by Parisians. It shows how the anxieties and frictions, the opportunities and the dreams of the age, were projected by contemporaries onto the Parisian cityscape when they critiqued or used certain buildings, or appropriated certain spaces, for their own purposes as a means of giving expression to their hopes, fears, ideals, and prejudices.

The first chapter ('Conflict') traces the 'Franco-French war' from 1789 up to the construction of two of the Belle Époque's best-known landmarks, the Basilica of the Sacré-Coeur and the Eiffel Tower, describing the motivations behind them and the hostile and celebratory reactions they elicited.

The preoccupation with the changes wrought by new technologies and urbanisation are the subject of Chapter 2 ('Modernity'). The Belle Époque both celebrated and fretted over the rapid pace

of change, particularly when it came to the Métro and the Universal Exposition of 1900 (which saw the construction of the Grand and Petit Palais and the Gare d'Orsay). The Art Nouveau creations of Hector Guimard and the Pont de Passy (now Pont Bir-Hakeim) epitomise the changes in style that took place at this time.

Chapter 3 ('Spectacle') turns from the worries and conflicts of the Belle Époque to its lighter side, the Grands Boulevards, where Parisians displayed their sense of style and enjoyed the many pleasures of the modern city: the cafés, the theatres, and the first cinemas. This was the place for the *flâneur*, the urban wanderer who leisurely whiled away the hours taking in the sights and sounds of life around him.

While the very act of *flânerie* carried with it an assumption that the street was a space dominated by men, and organised to please the male gaze, the department store—the *grand magasin*—was designed primarily with women in mind. Chapter 4 ('Luxury') takes on the great emporia of the period and their promotion of goods and grandeur for an expanding consumer society.

Chapter 5 ('Bohemia') travels from there to the cultural frontiers of Belle Époque society, entering the world of Montmartre and visiting the cabarets and cafés along the boulevards—the Nouvelle-Athènes Café on the place Pigalle, the Chat Noir, the Mirliton, and the Moulin Rouge—and exploring the steep slopes of the old village on the Butte Montmartre. There, a mixed population of workers, squatters, crooks, artists, and anarchists sought to live outside the commercially driven, respectable world of middle-class Parisians—or to test its limits.

One did not have to probe very deeply beneath the elegance and glamour of Belle Époque Paris to find poverty. Chapter 6 ('Survival') delves into this reality by moving down the eastern slopes of the Butte Montmartre to the Goutte d'Or district, an impoverished, crowded area during the period. We will use some of its sites as a means of describing the conditions and living standards of the Parisian working poor as well as the responses of the city government to problems of overcrowding and public health.

Yet the widespread, grinding poverty still present in society and a burning sense of social injustice ensured that the authorities faced threats from both sides: not only from the reactionary Right, but also from the radical Left. These threats came in the shape first of anarchist bomb attacks, and then of revolutionary syndicalism, in a wave of strike actions aimed at bringing about the collapse of the bourgeois, capitalist Republic. Chapter 7 ('Struggle') explores how, in their different ways, anarchists and syndicalists both expressed frustration with the gross and persistent inequalities that were so evident in Belle Époque society, even as that society as a whole became more prosperous. Anarchists targeted cafés, the hubs of Parisian social life, and striking workers shut down, for example, the electricity grid that helped to give Paris its nickname as the 'City of Light'. One of the very organs of civil society, the Bourse du travail, or labour exchange, which the city government itself helped to establish, became the nerve centre of working-class, revolutionary syndicalism. The narrative thus takes in the Bourse du travail close to the place de la République, scene of a battle between strikers and police that spilled along the now idyllic Canal Saint-Martin in 1906.

The political and cultural—and at times violent—challenge from the Right was occasioned by the Dreyfus Affair of the 1890s, the focus of the two subsequent chapters. Chapter 8 ('Polemics') tours the press district on and around the rue Montmartre during the crisis, exploring how the mass media could fire up popular prejudices rather than challenging them, sometimes manipulating public opinion through a steady dose of half-truths and outright falsehoods. The media's pandering to prejudices ultimately created a set of 'facts' that were entirely at odds with the truth, or at least with a more nuanced understanding of the real situation—a process that today has been dubbed 'gaslighting'. Chapter 9 ('Hate') locates the action outside the lawcourts—the Palais de Justice—on the Île de la Cité, at the time of Émile Zola's trial and conviction for slander in 1898, after his dramatic intervention in the Dreyfus Affair with his thundering article 'J'Accuse . . . !'. The daily gatherings of hostile crowds outside the

18

courts on the place Dauphine—a traditional site of protest—linked long-standing schisms in French political culture and identity with a new set of anxieties surrounding populism, demagoguery, and crowd psychology.

In the wake of the Dreyfus Affair, French society's divisions grew more bitter, presaging the political conflicts ahead in the first half of the twentieth century. Chapter 10 ('Memory') portrays the growing polarisation by looking to the Panthéon on the Left Bank in 1908, when the remains of Émile Zola—who had died in suspicious circumstances in 1902—were entombed in this mausoleum for France's great and good. Zola's 'pantheonisation' exacerbated the seething political divisions of the day. By evoking a particular tradition—the appeal to 1789 and the principles of the Revolution—it stoked the long-running cultural conflict over what it meant to be French.

Accompanying the political friction was a moral crisis among philosophers, academics, and the interested public. The old scientific certainties in which the Belle Époque conception of modernity had been grounded were challenged by new ideas based on the latest understandings of human psychology, as well as by breakthroughs in physics, which suggested that matter was less stable than was once thought. Chapter 11 ('Crisis') explores this loss of confidence in the older worldview by visiting its intellectual epicentre: the Latin Quarter on the Left Bank, travelling the short distance from the unveiling of the statue of Auguste Comte at the place Sorbonne to the Collège de France, where the ideas of philosopher Henri Bergson set the stage for modernist abstraction and nationalistic subjectivity alike.

PLENTY OF PEOPLE appear in this book, but four in particular show up frequently in the pages that follow, bringing their own perspectives on the developments in the city and the events of the age: Émile Zola, Marguerite Durand, Nguyễn Trọng Hiệp, and Jean Jaurès.

Zola may have been born in Paris in 1840 (on the fourth floor of No. 10, rue Saint-Joseph, in the 2nd arrondissement), but he was

raised and schooled in Aix-en-Provence and was a school friend of the artist Paul Cézanne before he moved back to the capital to study. Then, falteringly at first, he became first a journalist and then a novelist. As a young man in Paris, Zola knew grinding poverty and struggle, but by the time the Third Republic had established itself securely in the 1870s he had become a well-established if controversial writer. In the 1880s he carried the portliness of respectable middle age, his waistcoat stretching over his paunch, with drooping eyes that peered out from under the pince-nez glasses that he had long worn for writing and reading, but that now, in his more advanced years, he needed to wear all the time.

As a writer, Zola investigated and depicted the world through a technique that he called 'naturalism'. It was a 'scientific' method that demanded meticulous research and that allowed Zola to depict things as they really were, as far as his characters and plotlines allowed. His preparatory notes included correspondence with experts and—very helpfully for the purposes of this book—descriptions of the topography and buildings for his Parisian settings, sometimes with maps sketched out in spidery lines across the page. Zola was also politically active in defence of his republican principles. As a 'naturalist' author, on the one hand he is a voice describing the very emergence of 'modernity' that was debated more broadly in the Belle Époque, while, on the other hand, his activism meant that he joined battle in the political controversies of the day, particularly the Dreyfus Affair.

The second character to weave her way through Paris in this book is the feminist journalist and activist Marguerite Durand. While Zola's childhood knew gnawing poverty, Durand was born into a well-to-do, if somewhat unconventional, family in January 1864, at home on rue du Colisée, which runs off the Champs-Élysées, no less, in the then aristocratic Faubourg Saint-Honoré. Durand was, at different times, an actress, a political activist, a journalist, and a feminist campaigner. As founder of the feminist newspaper *La Fronde* (The slingshot), which was run entirely by women from 1897,

she published articles about politics and women's rights as well as commentary on the social and cultural developments of the day. If Zola's work was grounded in the topography and physical face of the city, the reportage in *La Fronde* provided plenty of ongoing analysis of the implications and impact of the changes associated with Belle Époque modernity in this urban context. The feminist, republican writer Séverine (the pen name for Caroline Rémy) saw Durand on stage at the prestigious Comédie-Française in the early 1880s and described her as a 'fine creature, slender as a reed, with a complexion transparent as alabaster, with just a hint of rose, shrouded in hair so fine and of such a pale gold that one would think it the hair of a young child; eyes the colour of the sky, all grace and fragility'.[16] Durand herself would exploit her beauty in the cause of women's emancipation: 'Feminism', she would quip in one article in 1903, 'owes some success to my blond hair.'[17]

Belle Époque modernity and the internal French conflict were both interwoven with the European imperialism of the age, and it was imperial relations that in 1894 brought the Vietnamese diplomat and intellectual Nguyễn Trọng Hiệp, the book's third main character, to Paris. Sixty years old at the time of his visit to France, Nguyễn brought with him a wealth of experience, first in resisting and then in negotiating with the French invaders in the 1870s and 1880s. He signed the treaty in 1883 by which the Vietnamese accepted French imperial authority and 'protection'. Now, in 1894, a high-ranking official, he arrived in Paris as part of an official Vietnamese delegation to establish good relations with the new French president, Jean Casimir-Perier. Nguyễn was impressed by Paris and wrote thirty-six short poems on what he saw: they were published in a bilingual edition (Mandarin and French), *Paris, capitale de la France*, in Hanoi in 1897.[18] Although Nguyễn was an important figure in Vietnam who ultimately helped the French in their attempts to dominate Indochina (modern-day Vietnam, Laos, and Kampuchea), his pithy, descriptive verses also subvert, in subtle ways, the French claims to cultural and political superiority. Nguyễn provides a lyrical voice

from one of France's colonial subjects passing judgment on the impe-rial capital.

An age of empire, of bitter political division, of rapid social change, and—as we shall see—of gross inequalities of wealth and poverty, the Belle Époque inevitably produced figures with sophisti-cated views of the past, the present, and the future. One of the most likeable of these was Jean Jaurès. A southerner, born in 1859 in the south-western town of Castres in the department of the Tarn in the Languedoc, Jaurès was one of the greatest democratic and socialist politicians of his age, with a commitment that was displayed, above all, in his writings, his work as a parliamentarian, and his internation-alist commitment to peace. There was little in his background to sug-gest that Jaurès would take this path: if it was not fabulously wealthy, his family on both sides was made up of comfortable manufacturers. The modest, provincial, middle-class milieu from which he sprang was what one of the founders of the Third Republic, Léon Gambetta, called the *nouvelle couches sociales*—the middle-class professionals, small property-owners, and local businesspeople who would form the bed-rock of the republican regime.

Yet several other influences probably came into play. Jaurès's mother was a committed Catholic, but one who happily allowed the young Jean to roam freely in his spiritual and intellectual life. Educa-tion played a part as well, as he secured a scholarship, first to his local *lycée*, or high school, in 1869, and then to the Collège de Saint-Barbe in Paris; finally, he won a place at the teacher training École nor-male supérieure. It was in this formative period that Jaurès finally broke with his mother's Catholicism (finding, as he later recalled, 'a vast universe in which man had a wonderful but terrifying freedom'), although, always open-minded, he was no bigoted atheist: his wife, Louise Bois, whom he married in 1886, remained a practising Cath-olic throughout their life together. The École normale was (and is) a bastion of secular, republican values (what the French call *laïcité*) in education. 'It has', wrote one American observer on its students in 1907, 'made them free spirits roaming at will under wise and efficient

guidance.'[19] It was where Jaurès honed his commitment to education, knowledge, and reason and where his politics took shape.

One day, while Jaurès was teaching as a lecturer in philosophy at the University of Toulouse, a conversation with some of his students was interrupted by hullabaloo nearby: a right-wing politician was haranguing his audience against republicanism. Jaurès joined the crowd, plucked up his courage, and with a flourish gave a speech rebutting his opponent, earning a standing ovation. This was enough for others to encourage him to enter office, and in 1885 the die was cast when he was accepted as a republican candidate in the general elections. Waging an arduous campaign against the Right—a loose alliance of monarchists and Bonapartists—Jaurès was sent to Paris to represent the people of his department of the Tarn in the National Assembly.

It was the start of a career that would last until 1914, one that, early on, would witness his political migration from radical republicanism to socialism, although he never lost touch with the former. Through the coming years, Jaurès would produce a wealth of writing on politics, history, and ideas, both in books and in newspapers. He would reach out across political divisions in France and internationally, use his great oratory to mobilise popular support, and deploy his considerable intellect and eloquence in one of the greatest controversies of these years, the Dreyfus Affair. His political life was also, in this sense, a chronicle of the struggles of the Belle Époque, his writings a source for understanding one side of the political debate. A man who embraced life, who had a voracious appetite for food and an almost insatiable intellectual curiosity, and who, in his politically fallow periods, struggled financially, Jaurès cared little for fashion or for appearances. If Marguerite Durand was an intellect projecting elegance, Jean Jaurès projected generosity and earthiness. He was intellectual, yet never unbendingly doctrinaire. He pursued social justice, but he also believed that life was more than just about material well-being—culture and learning should also be accessible to all. At one and the same time a patriotic French republican who

was also critical of empire, he believed in international co-operation and worked tirelessly for peace in Europe. His tolerance makes him stand out in the political and cultural clashes of the Belle Époque, when politics could be broodingly dark and *in*tolerant, hovering ominously on the edge of violence. In an age when modernity seemed to foster not just progress and opportunity, but also excess, extremism, and fear, Jaurès appears to represent the more humane possibilities at work in the Belle Époque.

CONFLICT

When the Vietnamese diplomat Nguyễn Trọng Hiệp first encountered the Eiffel Tower in 1894, he was impressed by what he saw. Upon his return to his quarters, he penned a verse on the soaring structure, then a mere five years old:

> *A great tower of iron, whose metal parts interlace with each other like*
> *the threads of a spider's web,*
> *Rises into the air and offers a strange sight.*
> *I do not think that even the genie Truong-qua possessed within his guts*
> *a forge as skilful as the creator of this monument.*[1]

'TRUONG-QUA' IS A reference to a magical genie, also known as Zhang Guo or Zhang Guolao, from Chinese mythology, whose powers allowed him to make iron boats. Gustave Eiffel's achievement, Nguyễn suggests, surpasses that of one of the eight immortals of Taoism.

Nguyễn often used his poetry to compare Asia's achievements and virtues with those of the Europeans, and he does not dole out praise to the colonising powers lightly. Having once helped organise resistance against the French conquest of Indochina, he was well aware of French limitations. Yet he was willing to give credit where it was due: Eiffel's tower was indeed a great achievement of engineering. Over the course of his diplomatic mission to Paris, Nguyễn composed verses about other Parisian sites, but conspicuously, he says nothing about the Basilica of the Sacré-Coeur. By the time of his visit, the basilica was all but complete, visible from many points in the city on its perch at the summit of the Butte Montmartre. As a diplomat well versed in French culture, representing his monarch in the French Republic, he likely saw little to gain from lauding Paris's gleaming white church on a hill.

Where the Eiffel Tower was a confident, strident expression of the rationalist, secular values of the Republic, the dazzling Basilica of the Sacré-Coeur represented the other side of the divide, namely, France's longer-standing Catholic traditions. In almost all aspects of its design and construction, the Eiffel Tower was unashamedly modern. Its antithesis, the basilica, was religious, clerical, and potentially monarchist. Separated by just three miles, the Eiffel Tower and the Sacré-Coeur therefore symbolised very different visions of what France was meant to be.

During the Belle Époque, the two buildings, both featuring so prominently on the landscape, were locked in a kind of architectural duel, sometimes implicit, sometimes explicit, signifying the deeper cultural and political struggles over the direction of the country. The history of how the two structures came to be and how people responded to them exposes this conflict over what it was to be French.

THE GREAT BASILICA of the Sacré-Coeur arose on Butte Montmartre as a pious and patriotic reaction to two shattering events in 1870–1871: France's defeat at the hands of the Prussians, followed

swiftly by the revolution of the Commune. The Sacré-Coeur would be built on a key site of conflict, picking up on the Catholic tradition of turning to the Sacred Heart (Sacré Coeur) of Jesus in times of dire emergency.

These had been traumatic years for the people of Paris. Under siege by German forces, they had survived only by eating dogs, cats, and rats, and had even resorted to butchering the animals in the zoo (including the much-loved elephants, Castor and Pollux, their heart-broken keeper flinging himself weeping onto their lifeless bodies). Those able to escape did so: Marguerite Durand and her brother, then still children, were spirited to safety by their mother. Émile Zola and his wife, Alexandrine, moved to a village near Marseille, and the young Jaurès was still studying in Castres. A hundred Parisians were killed in shelling, especially from the south. The Parisians put up a strong resistance, with the citizens' militia, the National Guard (the *fédérés*), managing a sortie or two against the well-drilled Prussians. The charismatic republican leader Léon Gambetta sailed over Prussian lines in a balloon to drum up a new army in the Loire Valley to the south.

Yet if Parisians were willing to battle on through terrible suffering, much of the rest of the country was not. Elections to the new National Assembly propelled the monarchist Adolphe Thiers into the presidency. He promptly opened negotiations with Prussia's ruthless chancellor, Otto von Bismarck. The price of peace was stiff, including the loss of the north-eastern province of Alsace and a chunk of Lorraine and a hefty financial indemnity. When these terms were presented to the National Assembly, they were over-whelmingly accepted by the majority over the objections of the republican deputies—many of the latter, including Gambetta and the young Georges Clemenceau, stormed out in protest. The privations of the siege, the profound sense of betrayal felt by Parisians confronted with national humiliation, and, to compound it all, the very real possibility of a restoration of the monarchy were too much to bear for the predominantly republican workers and artisans, along

with some of the middle classes, many of them now in the *fédérés*, bristling with rifles and 600 artillery pieces.

In this tense situation, Thiers sent 20,000 troops to seize the cannon and disarm the 300,000-strong *fédérés*. The collision took place on none other than the Butte Montmartre on 18 March 1871: the government forces were driven back, and the Parisian radicals proclaimed elections to the city government, the Paris Commune, which took control of the city. For two months, Paris was for the first time controlled by a popularly elected socialist government. It could not last. Thiers marshalled his forces, beginning to bombard the city in early April. Once a peace agreement was signed with Germany, on 10 May, Thiers launched a final assault, breaking into the city from the west on 21 May.

This opened the terrible events of the 'Bloody Week'—*la semaine sanglante*—in which some 20,000 Communards were killed, mostly by summary execution. As they retreated eastwards, the Communards torched government buildings. The sky glowed red from the blazes as the Tuileries Palace and the city hall, the Hôtel de Ville, were burned to the ground. The final stand took place in the steep streets of the eastern working-class districts of Belleville and Ménilmontant. A bitter firefight amongst the gravestones and mausoleums of Père-Lachaise Cemetery finished with the mass execution of some 147 Communards against the south-eastern wall, their bloodied bodies hurled into a mass grave, where they were joined by a thousand more of their comrades who had been shot elsewhere. The wall would henceforth be remembered as the *mur des fédérés* and became a sacred site of memory for the Left.[2] Yet the Right also had its martyrs, even if its repression was far bloodier than anything the Communards did: the revolutionaries shot the archbishop of Paris, Georges Darboy, along with a group of Dominican friars.

Parisians, who had come to regard their city as a global centre of culture, taste, and enlightenment, were forced to digest the bitterness of defeat and the horrifying, fratricidal bloodshed of civil war. 'One half of the population wants to strangle the other, and the other has

the same desire. You can see it in the eyes of passers-by,' wrote Zola's friend Flaubert to his fellow writer, the feminist George Sand.[3] Zola himself, who had returned to Paris, witnessed the final days of the *semaine sanglante* and, on 27 May, filed a report for the *Sémaphore de Marseille*:

> I managed to take a walk through Paris. It's atrocious. All I want to tell you about are the corpses heaped high under the bridges. No, never will I forget the heartache I experienced at the sight of that frightful mound of bleeding human flesh, thrown haphazardly on the tow paths. Heads and limbs mingle in horrible dislocation. From the pile emerge convulsed faces . . . There are dead who appear cut in two while others seem to have four legs and four arms. What a lugubrious charnel house![4]

AND ZOLA HAD no doubt in his mind where the burden of responsibility lay. In an article on 23 March 1871—that is, even before the 'Bloody Week'—he had written, 'Between the dissidents [the Communards] . . . and the blind bigots of the Assembly, France lies bleeding, cut to the quick. If one day history tells us how the insurrection pushed her over the edge, it will add that the regular and legitimate power did everything to make her plunge fatal.'[5]

Not every bourgeois observer was so repulsed. The conservative Louis Veuillot, the editor of the Catholic journal *L'Univers*, positively rejoiced: 'God is victorious. He has taken martyrs, we will have miracles. We are saved!'[6] Through the more peaceful decades of the Belle Époque ahead, the fear of resurgent social conflict and the memory of chafing humiliation at the hands of the Germans were never far beneath the surface. Moreover, as Veuillot's exuberance suggested, the whole crisis had ultimately given momentum to the monarchist and clerical side in the 'Franco-French war'.

These chaotic years gave hope to the monarchists. Ultimately, their dream of bringing back the crown evaporated because they were split between the more liberal Orléanists (such as Thiers), who backed the claim of the comte de Paris, and the Legitimists, who supported the more conservative, indeed reactionary, Bourbon claimant, the duc de Chambord. Yet if they could not restore the monarchy, they would seek to bring the country back to its former stability and greatness through 'moral order', which meant reinforcing the old social hierarchies, entrenching the Catholic faith once again within society, and honouring tradition as the essence of what it meant to be French. In November 1873, Thiers was replaced as president by a conservative army general, Marshal Patrice MacMahon, who was given a seven-year term—the *septennat*. Even élite women's fashions seemed to turn back to bygone days, with voluminous dresses over expansive crinolines, busts decorated by flowering corsages, and the midriff forcibly narrowed by padding bound tightly around the waist.[7] The Catholic clergy reasserted some of its control over education. Morality was supposedly the order of the day—indeed, immorality was held to be the root cause of all of France's recent ills. It was in this environment that the campaign to build the Sacré-Coeur germinated.

The idea for a new church dedicated to the Sacred Heart in Paris came from a devout layman, Alexandre Legentil: 'France', he had written, 'is a guilty nation, harshly but justly punished.'[8] He was heard sympathetically by the new archbishop, Joseph-Hippolyte Guibert, who believed that if France was to be won back for Catholicism, then Christianity should be written on the landscape itself: the building of churches would be a metaphor for the reconstruction of France's Christian morality.[9] A Committee for the Work of the National Vow, with Legentil as secretary, was, by 'uniting our love for the Church and for our country', to oversee the construction of 'a sanctuary dedicated to the Sacred Heart of Jesus'.[10] Guibert agreed with their assessment of the ills that beset France, writing, 'They are the bitter fruit of all the infidelities that we have committed against God. . . . Having become rebels against heaven through our own

corruption, we have fallen into the abyss of anarchy during our troubles. France has traced the terrifying image of a place *where there is no order*, while the future offers the prospect of yet new terrors to come.'[11]

A new church consecrated to the Sacred Heart 'would be a monument of expiation' to which all the faithful in France would be called to donate, the nation's act of penance, its people supplicating God for an end to their sufferings, for redemption and 'for the spiritual and temporal regeneration' of the French as a truly Christian people. Mixing religious faith and patriotism, the project offered a path to renewal through reconnection with France's original Catholic essence: 'Nothing is more Christian or more patriotic than such a vow.'[12] When Guibert petitioned the National Assembly for permission to acquire the land on 5 May 1873, in the climate of 'moral order' he was pushing at an open door. The National Assembly's committee studying the question found that it was indeed necessary 'to efface by this work of expiation, the crimes which have crowned our sorrows'.[13] The decree sailed through comfortably on 24 July and an architectural competition was launched, attracting over seventy entries.

The commission was awarded to Paul Abadie, who had earned fame (indeed notoriety) for his restoration of the cathedral of Saint Front in Périgueux, where he added Byzantine features, an act which scandalised many who regretted the harm done to the original Romanesque features of the twelfth-century church. Undeterred by the criticisms, the incorrigible Abadie submitted a plan with the same promiscuous combination of Romanesque and Byzantine features: curved, Roman arches, windows, and doorways and five tall domes—one large central one guarded by four smaller ones, each accompanied by humbler cupolas surrounding them like pawns.

Criticisms came quickly and furiously. Some Catholics argued that a Gothic style—in line with the great Viollet-le-Duc's restoration of Notre-Dame cathedral—would be more in keeping with France's Christian heritage than Abadie's outlandish, 'foreign and pagan' design.[14] Others complained that the church did not fit easily with the rest of the cityscape. In the modernisations of the city

under Napoleon III, Parisian buildings had been constructed from the golden-hued limestone (*pierre de Paris*) that gives them their distinctively warm colour set against the grey-tinged plaster of Paris that distinguishes the frontage of older apartment blocks. Much of this material had been quarried from Montmartre itself and from Montfaucon (creating the rugged crags at what is now the park at the Buttes-Chaumont), but the resources were almost exhausted, so Abadie opted for stone from Château-Landon. This is striking for its gleaming whiteness, which becomes more intense as the building ages, sitting awkwardly alongside the gentler colours of the Parisian cityscape. To its critics the basilica looked both garish and alien when set against the surrounding city.[15] Even so, on 16 June 1875, Archbishop Guibert officiated over the laying of the first stone on the Butte Montmartre. By this point, President MacMahon was anxious that a grand ceremony would provoke republican demonstrations and urged discretion. The pope shrewdly came to the rescue by giving the stone-laying ceremony cover in dedicating the day to the Sacred Heart for Catholics everywhere in the world.[16]

For supporters, the Sacré-Coeur became iconic by virtue of its location, public appeal, and architecture. Together, these features made it a landmark in which Catholics could take pride. Its location on the Butte Montmartre was essential. Legentil originally suggested that Charles Garnier's opulent, unfinished opera house be razed as 'a monument to extravagance, indecency and bad taste', and the basilica be constructed on that site. Yet Legentil found inspiration while walking on a misty day in October 1872. As he climbed the Butte, the fog cleared to reveal the panorama of the great city, its sea of rooftops suddenly gleaming in the sunshine below.[17] Guibert himself highlighted the importance of the hill's location in the city. Should not such a temple calling for the relief of France's distress 'be placed on a site that dominates Paris, and that can be seen from all parts of the city? Would not a monument that would be like a new profession of faith be best placed on the sacred hill that was the cradle of the Christian religion in our old France?'[18] For Guibert, Montmartre's

elevation would ensure that the Sacré-Coeur would 'become, in the heart of the capital, a kind of sacred lightning conductor, preserving it from the strikes of divine justice'. Looking down on the rest of the city, it would be 'a protest against other monuments and works of art elevated to the glory of vice and impiety', a defiantly sacred monument rising above a secular cityscape bearing the imprint of revolution, republicanism, and worldly pleasures. It was a purpose implicit when the basilica came to be built not, as was customary, on an east-west axis, but along a north-south bearing, squaring up to the godless city below.[19] Guibert pointed to the Butte's long sacred history, its name meaning the 'Mount of Martyrs', where France's patron, Saint Denis, was decapitated by the Romans. According to legend, he had picked up his head and walked all the way to his burial spot, where later the Abbey of Saint-Denis would be built (which would become the burial place for French royalty). The story is commemorated by a modern sculpture in Montmartre's Square Suzanne Buisson: Saint Denis holds his head, gazing, somewhat disconcertingly, over the *pétanque* players below. Montmartre had once also boasted an abbey of its own, where (it is said) the Jesuit order was founded. The abbey was closed down during the Revolution, in 1790, and all that is left today is its church, Saint-Pierre de Montmartre. It remains almost unnoticed, a modest beauty sitting just west of the towering, attention-grabbing Sacré-Coeur.

The Sacré-Coeur was quite deliberately designed as a project that would be funded by voluntary contributions from the faithful. If *l'Oeuvre*, 'the Work', was to be an act of national redemption, then it needed to attract not only a few wealthy donors, but the great mass of the pious as well. To reach as wide a public as possible, the Committee for the Work of the National Vow published a monthly *Bulletin de l'Oeuvre du Voeu National* (Bulletin of the Work of the National Vow) to update supporters. It also sought to inspire people with stories of France's Catholic past (and occasionally to draw unflattering comparisons with triumphantly republic monuments, such as the Panthéon, resting place of the 'great men' of the Republic).

The incipient growth of mass tourism offered further benefits. Realising from the success of Lourdes (from 1858) as a pilgrimage site that railway travel brought tourists in ever larger numbers, the committee had a provisional chapel consecrated near the site to encourage pilgrims to come and, in the process, to make donations. As befitted an age of an expanding consumer society, pilgrims were encouraged to buy mass-produced religious tokens: medals, prayer-cards, rosaries, necklaces. They could pay to have one of the basilica's stones personalised with their name, as an *ex-voto*, an object left at a shrine by a pilgrim, signifying their fulfilment of a vow, their penitence and their gratitude to God. For a fee, a written prayer could be slipped into a glass tube, corked, and then inserted into one of the holes in the interior of each of the stones (there for the pulley system used to haul the masonry into place): it is intriguing to think that the hopes and prayers of hundreds of people more than a century ago lie rolled up within the walls of the basilica today. A special card covered by a grid of hundreds of squares was printed. Every time a donor set aside a humble ten centimes for the basilica, he or she filled in one of the boxes: once they were all covered, the donor had saved enough to pay for a stone. Donors could sponsor a whole pillar or column if they could afford it.[20]

The Sacré-Coeur was also distinguished by the triumph of its construction. Very early in the work, it was found that the rock below was a Swiss cheese of tunnels and shafts: for centuries, the hill had been mined for its gypsum, the ingredient for the plaster of Paris that gives the city's older houses that off-white tint. The church would collapse into a heap if constructed on such ground. The solution was found by digging deep, to some thirty metres beneath the bedrock. Eighty stone pilings were then built upwards to support the arches of the crypt, which in turn would bear the hulking mass of the basilica.[21] This work inflated costs, but it turned the Sacré-Coeur into a feat of engineering, even if it was not quite on the scale of the later achievement of the Eiffel Tower. It allowed the faithful to boast that the basilica rested on

deep foundations, as surely as, thanks to the fulfilment of the National Vow, the country itself soon would.

As the sparkling white basilica rose slowly from the ground atop Montmartre, its interior was consecrated in early June 1891, although its distinctive dome would not be finished until 1900, and the campanile (bell tower) not begun until 1905. The final consecration, postponed by the First World War, took place in 1919. The spacious side aisles within formed an ambulatory—a passage for the crowds of visitors. As pilgrims made their way up the steep hill to the basilica, they might sing the 'Canticle of the National Vow', or even the defiantly anti-republican 'Catholic Marseillaise', whose chorus called on God to 'Save Rome and France in the name of the Sacré-Coeur!'[22] For many, it provided an irresistible mix of the quest for spiritual redemption, the patriotic drive for national renewal, and the yearning for a return to France's older, Christian identity.

Based as it was on views that were diametrically opposed to France's revolutionary heritage, it is hardly surprising that the Sacré-Coeur had its detractors. When the National Assembly had approved the project on 24 July 1873, a republican deputy had defiantly raised his voice:

> When you think to establish on the commanding heights of Paris—the fount of free thought and revolution—a Catholic monument, what is in your thoughts? To make of it the triumph of the Church over revolution. . . . What you want to revive is the Catholic faith, for you are at war with the spirit of modern times. . . . Well . . . I tell you that the population will be more scandalized than edified by the ostentation of your faith. . . . Far from edifying us, you will push us towards free thought, towards revolution.[23]

The basilica's very position, perched high above the city, could not but put it in confrontation with Paris's more secular, republican

monuments—sometimes explicitly so in some of the polemics—such as the Panthéon and, from 1889, the Eiffel Tower itself.[24] It did not help, either, that some of the more prominent backers of the basilica were dedicated royalists. The pious devotees of the Sacred Heart included the Generals de Sonis and Charette, as well as the Duchesse d'Uzès, who used her considerable wealth in the later 1880s to back a general, Georges Boulanger, who looked likely at one point to overthrow the Republic. With friends like these, the belief system behind the National Vow and the historical symbolism of the Sacré-Coeur could not escape their political associations with royalism and counter-revolution.

From the perspective of the country's socialists and anarchists, the basilica was an attempt to erase the memory of the Paris Commune: it was being constructed at the centre of the very neighbourhood where the revolution had first erupted in 1871 and where a martyr of their own had perished horribly. Eugène Varlin was a bookbinder who had also organised a food co-operative under the Second Empire. In the National Guard during the Prussian siege, he had helped defend Paris and then, as a socialist, joined the Commune. On the last day of the 'Bloody Week' he was recognised, arrested, paraded around Montmartre, and beaten up so badly that his face was caved in, with one eye burst from its socket, before being stood in front of a wall and shot. 'The Left', remarked his biographer, 'can have its martyrs, too. And it is on that spot that the Sacré-Coeur is built.'[25]

Republicans, socialists, and anarchists loathed the Sacré-Coeur because to them it represented clericalism, superstition, and counter-revolution. It was not just that the decision to build the church was part of the aggressive cultural and political reaction of 'moral order'. It was also that its very name—the Sacred Heart—evoked the symbol of the Vendée, the Catholic and royalist uprising against the French Revolution in 1793. The Sacré-Coeur became a monument that the Left loved to hate.

At an emotionally charged city council debate that followed a protest at the site of Varlin's execution in 1891, a left-wing delegate

declared, 'The inauguration of the Sacré-Coeur is a declaration of war against the Republic and modern society . . . and yet citizens who gathered to form a rampart against Caesarism, reaction, clericalism, who fought for modern society and for the rights of the people, found themselves confronted by the police, ready to use violence and brutality.' Another rose to add that the church was built 'out of an idea hostile to free-thinking, to the Revolution and above all to the people of Paris. It was a work of expiation. They wanted Paris to fall to its knees and beg forgiveness.'[26] Yet if republicans and the Left bristled at the construction of the Sacré-Coeur, they would come to exult in an architectural symbol of their own: the Eiffel Tower.[27]

THE EIFFEL TOWER was the centrepiece of the Universal Exposition, which opened on 6 May 1889, a proclamation of the rationalist, scientific values that were held to have energized the Revolution and that were claimed by the Republic as its own. Tall and proud, it was an architectural riposte to the opposite side of the older political divide represented by the Sacré-Coeur.

The tower was also, as it turned out, a celebration of a Republic that had only just secured its footing. In the two decades since it was first proclaimed—perhaps more in hope than in confidence—the Republic had confronted two crises that threatened its existence. The first was in 1877, and the other had come to a head in 1889, just weeks before the Eiffel Tower and the Universal Exposition were opened. The importance of these two crises lay in the survival of the Republic itself and the values that, ultimately, were held to underpin it. In both, the regime fended off the threat of more authoritarian alternatives. Set against this context, the Eiffel Tower expressed all the more boldly the triumph of republicanism, science, and, ultimately, modernity over reaction and tradition.

The first of the crises arose from an attempt by the monarchists to impose their vision of the political future on an electorate that had resoundingly—and repeatedly—endorsed republicanism. The

Third Republic's central political institutions emerged from a series of compromises between the republicans and the monarchists, who all sought to ensure political and social stability, but who also saw these arrangements as a work in progress, something that could be reshaped more to their own liking as circumstances allowed. So over the course of the hard bargaining of 1874–1876, the monarchists said yes to universal male suffrage and no king, while the republicans agreed to having two houses in parliament (their preference being for a single-chamber legislature), with a Chamber of Deputies elected by universal male suffrage and a Senate appointed by electoral colleges of deputies and local politicians, including town and village mayors. There would also be seventy-five senators appointed for life, including some defiantly representing the lost provinces of Alsace and Lorraine. The Senate, entrenching as it did rural interests, gave the republican system a conservative weight. The republicans also conceded that a president would be the head of state, elected for a seven-year term by both houses of parliament: monarchists hoped that the office would be a bulwark against democracy and, potentially, a first step towards reintroducing the throne by stealth.

Yet the republicans ultimately triumphed. In February 1876, led by Gambetta, they swept in with a massive majority in the elections to the Chamber. President MacMahon, a monarchist, tried to ignore this fact by appointing as prime minister Jules Simon, who, though technically a republican, was, in his own words, 'resolutely conservative'.[28] Gambetta was relentless in his attacks on Simon, accusing him of uncomfortably close ties with Catholic monarchists, famously roaring, 'Clericalism—there is the enemy!' Simon could not cling on, but rather than appoint a premier who could secure the support of the republican majority, MacMahon unleashed the '16 May' crisis in 1877, when he appointed the monarchist nobleman Albert de Broglie instead, prorogued parliament, and called fresh elections. The republican candidates determinedly went to the country, energetically rallying support, denouncing the 'coup of 16 May' as a violation of the principle of rule by the majority and a counter-revolution

against the sovereignty of the people. They swept to victory in the elections of October 1877. This was followed by the 'town-hall' revolution in January 1878, when thousands of republican candidates won local elections. As mayors and councillors played a central role in the appointment of senators, republicans also took control of the upper house in early 1879. MacMahon, his position untenable, resigned, and in his place parliament chose a republican, Jules Grévy, as president.

The historical significance of this republican triumph was lost on no one. For the first time, the republicans had won power in elections rather than through revolution. The victory reverberated through French political culture: in July 1879, the government and parliament moved back to Paris from Versailles, where they had sat since the days of the Commune. In strongly symbolic decisions that connected the Third Republic with the inheritance of the French Revolution, the 'Marseillaise' was made the French national anthem in 1879. Bastille Day, 14 July, was decreed an annual national holiday in 1880, just as the surviving Communards who had been imprisoned or exiled were given a general amnesty. Émile Zola responded cautiously to the republican triumph: while 'the Republic exists in fact', he wrote, the true test of its survival would be how it adapted to modernity and whether it rested on respect for empirical, rational methods of understanding the world—in other words, Zola's kind of approach. Somewhat monomaniacally, the author concluded, 'The Republic will be naturalist, or it will not be at all.'[29]

It was the Impressionist painter Claude Monet who in 1878 most accurately captured the public mood by producing his unmistakably patriotic diptych of paintings of the rue Saint-Denis and the rue Montorgueil bedecked in tricolour flags, the bright, celebratory scenes made of splashes of colour dominated by the exuberant brushstrokes of red, white, and blue. Monet's two florid paintings represent the national festivities of 30 June 1878 commemorating 'peace and work'.[30] This was the first official public celebration since the war—and it exulted in the firmer grounding of the Republic: look closely at the painting of the rue Saint-Denis, and you see that

one of the larger flags is emblazoned with 'Vive la Rép[ublique]'. As Gabriel Hanotaux, historian and future foreign minister explained, 30 June was 'a festival of the people . . . a veritable baptism of the Republic'.[31]

Yet Monet's reaction was also a hopeful marker of France's emergence from the immediate shadows of war, civil strife, and humiliation, for the celebration also came as the 1878 Universal Exposition in Paris was already in full swing. It included displays of the most modern inventions, including Alexander Graham Bell's telephone, a prototype of an aeroplane, and—to the horror of some moralists— a sewing machine ('When will we ever stop denying women some of the work that nature seems to have reserved for her alone?' wondered one concerned commentator[32]). The massive copper head of the Statue of Liberty by Frédéric-Auguste Bartholdi—completed in 1886 (with its internal framework engineered by a certain Gustave Eiffel), and dedicated as a gift from the French people to America—was displayed in the Trocadéro gardens.

Yet there soon emerged a malaise, which would steadily build into the second crisis in the later 1880s. The republicans who took power were bourgeois and eminently respectable, top-hatted, bearded or mutton-chopped, but above all else they were moderates, still haunted by the red spectre of the Paris Commune and cautious about giving too much away to radical republicans and socialists (the latter were, in any case, still recovering from the shock of 1871). Another name given to the moderates, 'Opportunists', referred to their timidity in pursuing anything that might upset the balance: reform would come when the moment was 'opportune'. They were, above all, bound together by a web of social connection: business ties, marriage, and political alliances (often including, it should be said, a journalist on one's side to provide publicity, defend one's record, and advance one's career). This would give rise to the sarcastic description of the political élite as 'a republic of pals'—*une république des copains*.

It was not as if they were without landmark achievements: while prime minister on two separate occasions in the early 1880s, Jules

Ferry secured the passage of laws that laid down free, compulsory, secular primary schooling for boys and girls, established the principle and practices of press freedom, and legalised trade unions. For Ferry, however, the main task was, as he put it, 'to root the republic'.[33] The caution with which the moderate republicans, Jean Jaurès still among them, proceeded with reform frustrated radicals and socialists, while conservatives (Bonapartists and monarchists) were still very much a political force to be reckoned with. This, and the whiff of corruption occasionally emanating from republican politics, led to those disenchanted with the direction of the regime to find ways of reforming it, or getting rid of it altogether. The malaise was given a deeper dimension by an economic downturn in 1883–1886, which also led to a wave of strikes as workers sought to fight lay-offs and wage reductions. One of these stoppages was among the coal miners at Anzin in 1884, a strike that Zola witnessed as he researched his novel *Germinal*. These currents—which came from both ends of the political spectrum—eventually coalesced around a charismatic military figure.

General Georges Boulanger saw himself as a good, solid republican cut in the uncompromising Jacobin mould of the French Revolution, egalitarian and patriotic. His original political sponsor was Georges Clemenceau, a Radical, who appreciated these same qualities. When the elections of 1885 forced Jules Ferry to bring Radicals into his government, it was Clemenceau who secured Boulanger's appointment as minister of war. It proved to be a popular choice. Boulanger, a vocal proponent of a tough stance against Germany, faced off with Bismarck in 1887 when a French intelligence officer was hauled off by German agents on the frontier, and he took credit when the Frenchman was released. He reformed the army, dismissing Bonapartist and royalist officers, introducing a new rifle, patriotically having sentry boxes painted red, white, and blue, and allowing soldiers to sport 'republican' beards and to eat off plates rather than mess tins. He also prepared a law (which would eventually pass in 1889) to make national service in the army compulsory for all, without

exception—including the clergy, evoking the image of 'vicars with knapsacks'.[34]

Given the nickname 'General Revanche' (Revenge) for his undisguised hostility to Germany, Boulanger became immensely popular with the public. The accoutrements of modern consumer society were made to spread his name and his image: hundreds of songs (of predictably variable quality) were written and sold as sheet music or as lyrics to already well-known tunes in the news kiosks and by newspaper vendors. His face was used on food packaging, games, cards, scarves, hats, and medals, and there were even General Boulanger toy figures, as well as a strong spirit named after him: 'containing no German product, putting fire in the belly'.[35] Mass-produced images of Boulanger were disseminated across the country, and his activities were reported widely in the press.

The republicans—and indeed some monarchists who sought stability—took fright at the rise of an ultra-patriotic general who might provoke a war with Germany, ride the tide of popular adulation, overthrow the Republic, and establish a military dictatorship. The spectre of Bonaparte haunted them still. There were real similarities: 'Boulangism' had strong, authoritarian undercurrents. But Boulanger's adherents certainly included people from the radical Left. Among his close supporters was the parliamentary deputy Georges Laguerre, Marguerite Durand's radical republican husband, whom she married in 1888, leaving her career as an actress at the Comédie-Française. His talents as a politician had brought him to the editorship of the main Boulangist newspaper, *La Presse*, in June 1887. Durand quickly immersed herself in Laguerre's political world, and she steadily began taking on some of the work—organising the journalists, circulating around Parisian political circles for information, and then, eventually, assuming the editorship herself. She seemed to have found her new vocation.[36] Together, Marguerite and Georges frequented the cafés of the press district around the rue Montmartre, discussing Boulanger with the sympathetic writers from such newspapers as *L'Intransigeant* and the ultra-nationalist *Le Drapeau* (The flag).

42

Yet, unknown to Marguerite—and, for a while, Georges—Boulanger was also actively courting support from royalists and Bonapartists, who were attracted by the possibility of overthrowing the parliamentary republic and by Boulanger's hard-line nationalism. His close connections with them were kept secret until 1889, when Boulanger made an open bid for Catholic and monarchist votes in the elections that year.[37] What bound this unholy alliance of extreme Left and Right together was their common hatred of parliamentary politics and cautious policies of Opportunism. What his supporters wanted was strong government, armed with the 'will of the people', imposing reform on a potentially resistant society.

With hindsight, 'Boulangism' represented a new kind of political alignment that cut across the now century-old 'Franco-French conflict'. It was an authoritarianism based on nationalism, sometimes infused with antisemitism, that promised social reform, strong government, and a purging of the alleged weakness of parliamentary politics. The 'will of the people' would be embodied not in the unglamorous compromises of representative democracy, but in the figure of the strong, charismatic, and patriotic leader. It was a political evolution that would begin to crystallise in the last decades of the Belle Époque and bear its bitter, nationalist, and authoritarian fruit in the twentieth century.

In the summer of 1887, the government secured Boulanger's dismissal through a parliamentary vote and—after some of his more fanatical supporters had lain across the rail tracks at the Gare de Lyon to prevent his departure—he was safely removed from Paris to a posting at Clermont-Ferrand. His supporters formulated a strategy whereby Boulanger would use his popularity to contest every by-election, turning them all into a kind of referendum that would give him a mandate to demand the dissolution of parliament and the election of a new assembly that would revise the constitution.

On New Year's Eve 1888, Marguerite, always elegant, hosted a reception in her gloriously spacious apartment on the rue Saint-Honoré for some two hundred of the general's supporters. They were

mobilising for the most dramatic by-election of them all: Paris on 27 January 1889. The general won easily and was dining with his closest supporters, including Marguerite and Georges, in private rooms upstairs in the Restaurant Durand (no connection with Marguerite) on the place de la Madeleine.[38] His supporters teemed outside as the results came through, urging him to seize power then and there with cries of 'À l'Élysée!' ('to the Élysée Palace', the presidential residence). Boulanger, to his credit, held back—or rather, he was embarrassed and panicked, seeking a back exit from the restaurant to escape his fervent admirers. After he found the safety of his carriage, his coachman cracked his whip and cleared a way through the press of people. When Boulanger did speak out the following day, it was simply to announce that it would not be long before parliament faced dissolution: but he did not say when that would happen. It seems that he wanted to wait for the general election in the autumn of 1889, in which he would stand as a candidate in constituencies across the country, turning the vote into a referendum on Boulanger himself.

Boulanger's plans were stymied by the ruthless Opportunist interior minister, Ernest Constans, who pushed a law through parliament that altered the electoral system, including a rule that no candidate could stand simultaneously in more than one constituency. The Boulangist strategy was undone, but Constans was not finished yet. A government political campaign warned the public, 'If you want war, vote for Boulanger.'[39] Some of Boulanger's closest allies were charged with conspiracy, and, in April, Constans released the entirely false report that the general himself was to be arrested. Over the coming weeks, some of Boulanger's allies were indeed arrested, among them Paul Déroulède, whose nationalist Ligue des patriotes (League of Patriots) helped to organise Boulangism's mass following. Stories were leaked of attempted poisonings of the general's coterie. By 14 March, Boulanger, to the distress of his thousands of humiliated acolytes, took flight; slipped away to the Gare du Nord with his mistress, Marguerite de Bonnemains; and boarded the train to Brussels. 'What', sighed a deflated Laguerre, 'can you do with a coward?'[40] With Boulanger's

departure, the cause fell apart: Marguerite Durand, finally learning about the extent of royalist involvement, abandoned it altogether. In 1891, the general, his heart broken by the sudden death of Madame de Bonnemains, shot himself over her tombstone at Ixelles in Brussels. Constans, grimly satisfied at the outcome, later sneered, 'There were only two men in this history—Madame Laguerre [i.e., Marguerite Durand] and myself.'[41]

Émile Zola, who wrote relatively little on the whole affair, did draw one important lesson from it: one concerning the dangers of a populist press. If, he remarked, the people were to embrace a dictator, it would be from an ardent desire to sleep safely at night: 'to lie down, blow out the candle and sleep without care'. Their fears arose from the tendency of the press to make 'too much noise over too little substance', which in politics undermined faith in parliaments.[42] Jean Jaurès, then a mainstream republican deputy, after initially, like so many others, seeing in Boulanger 'a liberal and patriotic ardour for reform', soon perceived the dangers that a populist hardman posed to democracy. 'If our country, after eighteen years of freedom, wants slavery,' he warned, 'then everything is lost and no political expedient will save us.'[43]

The defeat of Boulangism came in the nick of time: the general fled in April 1889, just weeks before the opening of the next Universal Exposition, which was meant to celebrate the centenary of the French Revolution of 1789. Yet with the country still shuddering from the Boulangist challenge, some critics questioned whether it was wise to connect the Universal Exposition with 1789 while it still remained a controversial and seismic break in France's past. The Republic claimed the emancipating principles of '1789' as its own, but, as one trade journal wondered, would the success of the fair not be compromised by 'the commemoration of political events little made to please monarchical states, which today make up almost all of Europe'?[44]

Planning for the Universal Exposition had begun in March 1885, and in May 1886 a contest was announced for the design of 'an iron tower with a square base, of 125 metres squared and 300

metres in height', to be raised on the Champ de Mars.[45] The engineer Gustave Eiffel was among those who entered the competition. Born in Dijon in 1832 to prosperous coal merchants, Eiffel had a stoutly middle-class background. Since the coal business was in fact his mother's (and his father, an ex–army officer, helped her with it), Eiffel was raised by his grandmother for much of his childhood. Not especially driven academically, he was nonetheless fascinated by the work of his uncle, who ran a chemical factory and had instilled in Gustave a passion for science. After earning a *baccalauréat* from his local lycée, Gustave had secured a place first at the Collège de Sainte-Barbe (although too early to overlap with Jaurès) and then in the École centrale des arts et manufactures, one of the élite *grandes écoles*, specialising in science and engineering. He graduated in 1855 in chemistry and worked briefly (and auspiciously) in an iron foundry before securing a position with a railway engineering firm, where he learned much 'on the job'. He worked on various projects, many of them related to the expansion of France's railway network under Napoleon III. By 1864, he had garnered enough experience to secure a loan to set up his own metal construction business, specialising in engineering structures such as bridges, viaducts, and railway stations, with his workshops in the north-western Parisian suburb of Levallois-Perret. Among his successes was the Maria Pia Bridge across the River Douro in Portugal, the awe-inspiring Garabit viaduct in the Cantal in southern France, the Nyugati railway station in Budapest, and the metal framework for Bartholdi's Statue of Liberty (assembled first of all in Eiffel's works outside Paris before being dismantled and sent in pieces to New York).

Eiffel's successes also mingled with darkness. He was touched by tragedy when his wife, Marguerite Gaudelet, whom he had married in 1862, and with whom he had five children, died early in 1877. His eldest daughter, Claire, became a bedrock of support, first helping to raise her siblings and then working as his assistant. She accompanied him on his work and, when she got married, she and her engineer husband lived with Eiffel in his spacious and magnificent apartment

on the rue Rabelais, a short, quiet street not far from the Élysée Palace and the Champs-Élysées. The couple took over his firm—Eiffel et Compagnie—in 1893.

Though his daughter's support sustained him through losses, Eiffel was also driven, in part, by scandal. Along with the engineer Ferdinand de Lesseps, he had helped with the Panama Canal, constructing the locks beginning in 1887. The project ran into great difficulties, not least because of the pestilential conditions in which the work was carried out, and the company in charge of the construction folded, in February 1889, just as Eiffel's tower was nearing completion. Eiffel would later be convicted alongside Lesseps of fraud, although he would be exonerated on appeal. The experience, as his biographer David Harvie has put it, led him to reinvent himself—refocusing on the science and putting his business career behind him.[46]

Eiffel turned his attention to his great tower. He and two engineering colleagues, Émile Nouguier and Maurice Koechlin, along with the architect Stephen Sauvestre, had worked together on plans for a tall tower since 1884, so they were already primed for the contest to build the centrepiece for the 1889 Exposition. Eiffel's design emerged triumphant on 12 June 1886.[47] As the centrepiece of the fair, the tower's construction was funded by what today might be called a 'public-private partnership', with the state commissioning and then partially subsidising the work and Eiffel's firm taking on the tasks, most of the costs, and all the liability.[48] This agreement would make Eiffel wealthy for life, but it was the tower's precise engineering that actually impressed contemporaries.

Each of the tower's 18,000 iron components was individually designed. Eiffel, whose scientific passion was the study of wind resistance and gravity, calculated the effects of both on every single part. A team of draftsmen worked under Maurice Koechlin at Eiffel's workshop to produce no fewer than 5,500 drawings of different parts. The engineer later explained that the position of every single rivet hole in relation to its neighbouring component was calculated down to a tenth of a millimetre: 'Each part thus required a particular study and

an individual drawing usually drawn to half size for the small parts and one-fifth size for larger parts.[49]

The striking elegance of the curves and lattice-work of the iron was not just aesthetic, but eminently practical. Although Eiffel was proud of the beauty of his construction, his primary concern was that it stood up. He began with an innovative approach to the foundations. Since the axis of the Champ de Mars 'inclines almost precisely at 45° from the meridian,' he wrote, 'the Tower happens to be oriented so that its feet are positioned at the four points of the compass.'[50] These four feet rested on foundations sunk to a depth of 53 feet into the dense, clayey earth for the two piers farthest from the Seine, but at a 70-foot depth closer to the bank, where the clay (5 feet below the river's water level) was covered with silt, sand, mud, and gravel. Here the concrete foundations were laid by workers labouring in caissons lit by electricity and supplied with compressed air, the men entering and leaving through an airlock. Most remarkably of all, into each foundation were thrust 26-foot-long anchoring bolts, each attached to an iron cylinder which made the whole act as a piston. The genius of this mechanism was that, as the great iron legs were pieced together, the pistons could be adjusted to ensure that the tower's supporting ribs aligned precisely as they reached the all-important height of 189 feet, where the first platform was constructed.[51]

Eiffel chose to work with iron: steel may have been lighter, but it was more prone to bending and vibration from the wind. The challenge with iron was to balance the weight of the tower in comparison to its height with the force of wind resistance. In tackling the latter, Eiffel expended a lot of time, thought, and ink making calculations, drawing diagrams, modelling wind forces, and calibrating wind speeds. He understood that a light tower would be able to resist the high winds better than a heavy, solid one, hence its graceful curves and the striking lattice effect of its ironwork that Nguyễn Trọng Hiệp later lyricised.[52]

Following the precise design, each part was cast and every rivet hole drilled under Émile Nouguier's watchful supervision at the

Levallois-Perret workshop. Related parts were then numbered and loosely attached to each other with temporary bolts before being transported together by horse and wagon to the Champ de Mars, where Eiffel's master engineer, Jean Campagnon, oversaw their assembly. Since the parts had been made with such precision, there were no adjustments or boring of holes onsite. Instead, riveters removed the temporary bolts and hammered white-hot rivets into the holes, practically fusing the joints together. This was in contrast, Eiffel noted, to the construction of the 'beautiful Forth Bridge' in Scotland, completed in 1890 and designed by British engineers, where the parts may have been made in a factory, but the finer points, such as boring holes, were completed onsite.[53] The assembly of the Eiffel Tower, biographer Harvie noted, was like piecing together 'a giant Meccano set'.[54] The parts were hauled up ever higher on 'creeper cranes' mounted on tracks inside each of the four legs, so that they could ascend and descend the tower: the same tracks would later be used for the elevators.

When the writer Émile Goudeau visited the tower under construction, he witnessed the 250-odd workers wearing red caps and red sashes striking at the bolts in turn. He wrote of 'the din of metal screaming beneath the hammer', adding that 'with the shower of sparks, these black figures, appearing larger than life against the background of the open sky, looked as if they were reaping lightning bolts in the clouds'.[55] Eiffel was a stickler for safety: when assembling pieces high above the ground, workers were supported by wooden platforms forty-nine-feet wide. For their hour-long lunch break, there was a canteen on the first (and later the second) platform with subsidised prices—Eiffel calculated that the money he spent here would be recouped in time savings, as the workers would not have to descend to the ground for lunch and then reascend afterwards to resume their labour. The sale and drinking of alcohol were banned, but (in a nice Gallic concession) only 'outside mealtimes'.[56] There was not one work-related fatality during the construction: the sole tragic exception came after-hours, when a drunken worker showing

off to his girlfriend clambered up the ironwork, slipped, and plunged to his death.

Workers were well aware that this was a prestigious project and that time was of the essence if it were to be completed for the Universal Exposition. Eiffel's employees were not averse to the occasional strike to press for higher wages—demands that Eiffel met with small increments while reassigning ringleaders to tasks at the tower's lower levels, a loss of face that, if Eiffel himself is to be believed, led other workers sarcastically to label those 'demoted' as 'the Indispensables'. Eiffel also promised a bonus to all workers who stuck at their job until the *tricolore* flew from the very top.[57]

Unashamedly modern in almost all aspects of its design and construction, the Eiffel Tower was bound to draw bitter criticism. To some, the great iron structure was nothing short of an act of vandalism inflicted on the historic cityscape. On Monday, 14 February 1887, just after work had begun, the respectably moderate and high-brow Parisian newspaper *Le Temps* ('The Times', after which it was modelled) published an excoriating denunciation penned by forty-seven writers, artists, and architects. At this stage only the foundations had been dug, but the authors were in no doubt that it would be a hideous blight on the Parisian skyline:

> We . . . protest with all our strength, all our indignation, in the name of poorly understood French taste, in the name of art and French history under threat, against the erection in the very heart of our capital of the useless and monstrous Eiffel Tower. . . . Without falling into an exalted chauvinism, we have the right to proclaim loudly that Paris is the city that has no rival in the world. Above its streets, its broad boulevards, along its admirable quays, in the middle of its magnificent promenades, are ranged the most noble monuments born of human genius. The soul of France, creator of masterworks, is resplendent among this august flourishing of stone.[58]

Although *Le Temps* had a circulation of thirty thousand—a relatively modest record in this age of a burgeoning mass media—its dense though dry reportage ensured that it was read by the movers and shakers of metropolitan France. The protesters claimed that their concerns were driven by aesthetics, by a desire to preserve Paris's place as a great city of culture and taste and the heart of France's history. In this sense, the protest was just one side of the perennial friction between conservation and innovation:

> It is sufficient, moreover . . . to imagine for an instant a vertiginously ridiculous tower dominating Paris like a gigantic, black factory chimney, crushing beneath its barbaric mass Notre-Dame, the Sainte-Chapelle, the Tour Saint-Jacques, the Louvre, the Dome of the Invalides, the Arc de Triomphe, all our monuments humiliated, all our architecture diminished, which will disappear in this stupefying dream. And over twenty years, we will see spreading across the entire city, still pulsating with the genius of so many centuries, we will see spreading like an ink stain the odious shadow of the odious column of bolted sheet metal.

The signatories of the piece included some of the most influential names in Parisian cultural life, among them the artist Ernest Meissonier, well known for his deeply researched Napoleonic paintings; the composer Charles Gounod, perhaps most famous for his version of 'Ave Maria' and for his opera *Faust*; the architect Charles Garnier, designer of the exuberantly ornate opera house that bears his name; and the writers Alexandre Dumas, famed for *The Three Musketeers*, among other novels, and Guy de Maupassant, whose lively short stories evoked so well the travails, foibles, and sexual misadventures of contemporary life.

Zola's name is notably absent from the signatories. His whole approach as a novelist—his 'naturalism' and meticulous 'scientific'

mindset, his emphasis on the importance of inheritance and environment, and his own republicanism—made him something of a kindred spirit to Gustave Eiffel with his great project. In fact, critics hostile to both Zola's writing and Eiffel's tower made the connection between the two. Even as Zola's novel on peasant life, *La Terre* (*The Soil*, the fifteenth Rougon-Macquart volume), was being serialised in *Gil Blas*, the stolidly conservative *Gazette de France* scoffed that 'this book is a deliberately assembled collection of sweepings, a compost heap, a monument to contemporary progress rivalling Eiffel's iron syringe'.[59]

Yet the criticisms came from all directions. Maupassant, one of the signatories of the protest, castigated the tower as a 'high and skinny pyramid of iron ladders . . . which just peters out into a ridiculous thin shape like a factory chimney'.[60] Once the tower opened, he declared that he ate in its restaurant because it was 'the only spot in Paris in which one doesn't see *it*!'[61] A confidential memorandum submitted to the commission that selected Eiffel's design complained that the tower was contrary to artistic taste and to 'French genius'. With a certain Gallic *hauteur*, the memorandum concluded that the tower's brashness was redolent with philistinism in America, 'where good taste is not yet very developed'.[62] Some objected that its location would aesthetically 'crush' the city, while others, and certainly the Parisians living nearby, fretted that the Tower would *actually* crush their homes should it collapse. Residents living along the Champ de Mars—the main site of the Exposition—filed a lawsuit, fearing the consequences if the tower fell, and this delayed construction. Their anxieties were eased—and the court case failed—when Eiffel himself assumed personal liability for any damage or loss of life in that eventuality. He also answered the aesthetic concerns, replying to the artists' protests, in an interview in *Le Temps*, 'I myself think that my tower will be beautiful. Do not think that, just because we are engineers, we do not take account of beauty in our constructions and that because we build solidly and durably we do not also compel ourselves to construct elegantly.'[63]

As for the danger of the tower 'crushing' the other monuments of Paris beneath its enormous height, Eiffel remarked that to view Notre-Dame cathedral, one went to the *parvis*—the esplanade in front of it—from where one could not even see the tower. He denied that one building could 'crush' those around it, asking whether Charles Garnier's opera house was as much 'crushed' by the buildings around it as it crushed them. The houses around the Arc de Triomphe appear no less diminished by the forty-five-metre height of the great arch itself. Moreover, he said, the Eiffel Tower would be useful to scientists conducting experiments in astronomy, biochemistry, meteorology, and physics, and would have a military use in times of war as an observation point and signal tower. These were indeed considerations that Eiffel had included in his original submission—and for him the utility of his tower developed into a genuine passion: he would instal a laboratory at the top for experiments and observations in meteorology, aerodynamics, astronomy, wind resistance, and more. The tower did become a useful strategic vantage point as well as a giant mast for radio transmission: the first wireless radio message would be sent from the top of the Eiffel Tower to the dome of the Panthéon some three miles away in 1898, and a transmission was beamed across the Channel in the following year. A radio mast and antennae were installed and put at the disposal of the military (which proved invaluable in 1914). The scientific and strategic use of the tower, in fact, was what saved it from being dismantled twenty years after the Universal Exposition, as was originally intended. Not for nothing do the four side-panels of the tower bear the names of (mostly) French scientists who had preceded Eiffel.[64]

Ultimately, Eiffel concluded in his defence of his tower, it would be a source of national pride: France was not just 'a country of amusements, but also one of engineers and builders, whom one summons to all the regions of the world to construct bridges, viaducts, stations, and the great monuments to modern industry'. Elsewhere, Eiffel explained that the location chosen was important to its very existence. He admitted that, were it not for the Universal Exposition of 1889,

his tower would never have been contemplated: its primary purpose was to act as 'a triumphal entry to the Exposition and, from the Pont d'Iéna, one saw its great arches marvellously framing the outlines of the central Dome which led to the Gallery of Machines and, on either side, the domes of the galleries of Fine Arts and Liberal Arts'.[65] When approaching the Eiffel Tower today from the Trocadéro across the Pont de Iéna or from the École militaire at the far end of the Champ de Mars, the strength of its splayed legs and its tapering height are still impressive: it can well be imagined how startling it would have been as the entrance arch to the 1889 Exposition.

The *Temps* urged its readers to reserve judgment until the tower was finished, remarking that this was 'nothing other than an episode of the old quarrel between artists and engineers'. Yet beneath the practical and aesthetic concerns there lurked another, cultural and political, one: the tower also celebrated the cultural inheritance from the decisive—and divisive—rupture of the Revolution of 1789. Eiffel himself linked his great work with this revolutionary heritage and with the critical, scientific (and allegedly godless) culture of the 'Age of Reason' to which it was connected: 'Such a tall tower which goes far beyond anything achieved until now, may be worthy of personifying not only the art of modern engineering, but also the century of Industry and Science in which we live, the road to which was paved by the great scientific movement of the end of the eighteenth century and by the revolution of 1789, to all of which this monument would be erected as an expression of France's gratitude.'[66]

Émile Zola concurred. In his novel *L'Oeuvre* (*The Masterpiece*), published in 1888, his hero, the artist Claude Lantier, reflects that the nineteenth century needed its own kind of architecture. Modern society had no use for Greek temples, while there was no room for democracy in the Renaissance: 'What was wanted was an architectural formula to fit that democracy . . . something big and strong and simple, the sort of thing that was already asserting itself in railroad stations and market halls, the solid elegance of metal girders.'[67] Here, Zola has Lantier echoing Édouard Lockroy, the radical republican

who, as minister of commerce and industry, played an important role in organising the Exposition. Lockroy agreed that 'our industrial and democratic era must definitively discover its own [architecture]': 'Industry and science put new raw materials at our disposal. The more wrought iron and steel play a role in our construction, the more we will achieve our own distinctive efforts,' he wrote. 'This is the art of the nineteenth century, of the twentieth century. . . . The 1889 Exhibition has accelerated its birth.'[68] With the tower's celebration of republicanism and scientific modernity, it is perhaps fitting that it should have been at the restaurant reserved for journalists that Marguerite Durand and her husband, Georges Laguerre, should have had a very public, blazing row after he finally revealed the extent to which he had been involved in building monarchist support for General Boulanger. Durand's republican blood boiled: it would prove to be the beginning of the end of their marriage.[69]

Yet the Universal Exposition was not just a celebration of science, of ingenuity, and of '1789'. It also showcased the French overseas empire. By the First World War, the global territory controlled by the French was ten times the surface area of France itself. Yet, as contemporaries saw, France itself had become that most awkward of contradictions—a republican empire. On the one hand, the Republic claimed to be based on the sovereignty of all its citizens—but an empire implied domination over colonial subjects. The same French republicans who exulted in 1889 as a consummation of the universalist principles of 1789 therefore had to address this paradox.[70]

The answer was found in the concept of the *mission civilisatrice*—France's 'civilising mission'. If all human beings shared the same fundamental, immutable rights, not all peoples (it was argued) had reached a point of development where they were ready to see those natural rights translated into the legal rights of citizenship. France's mission in the world was, therefore, to bring the Republic's emancipating principles to its colonial subjects and, through 'modernising' projects—investment in education, railways, communication, hospitals—prepare them to be citizens of the universalising French

Republic.[71] With the emphasis on imperialism as an educational project, it comes as little surprise that just as Jules Ferry was the architect of the laws that brought free, universal, and compulsory primary education to France in the early 1880s, he was also one of the most enthusiastic drivers of French overseas imperialism based on (among other more material, economic motives) the 'civilising mission'. Education was the means by which republican values and citizenship would be rooted both in France and across its empire: this was how imperialism and republicanism were reconciled.[72]

This synthesis was underpinned by the very scientific, rationalist values celebrated at the 1889 fair and embodied by Eiffel's tower—or rather, a bastardised version of them, which held that racial differences were natural, and therefore unchangeable, and that, moreover, these differences divided humanity into 'superior' and 'inferior' races. This 'scientific' racism was used to justify further the *mission civilisatrice*: Jules Ferry proclaimed, 'We must say openly that the superior races have a right over the lower races . . . that the superior races have a right because they have a duty . . . the duty to civilise the inferior races.'[73] The explicit racism in Ferry's vision blunted France's republican universalism in practice: in 1870, for example, Jews in France's colony of Algeria were given the full rights of citizenship, but the vast majority—Arabs, Kabyles—were denied such a status.[74]

As if to emphasise the 'backwardness' of the colonial peoples and so justify the Republic's self-proclaimed imperial mission, during the six months in which the Universal Exposition ran, from May to November 1889, one of the most popular attractions was the colonial section on the Esplanade des Invalides. This consisted of richly ornamented pavilions from around the world—including the Algerian and Tunisian ones, inspired, in part, by the architecture of mosques, as well as the one representing Kampuchea, based on a tower at Angkor Wat. The whole, however, was centred on a wooden Palais Central des Colonies, its design primarily based on the colonial architecture of the French conquerors.[75] Yet the greatest draw for the more than thirty-two million visitors to the Exposition was

the *tableaux vivants*—reconstructions of 'native' villages populated by real people going about their daily activities. Visitors could gawp at Kabyle women at their looms, Arabs at prayer, Kanaks (from Nouvelle Calédonie) cooking their meals, and Senegalese and Vietnamese artisans at work: in all, there were some four hundred 'indigenous' people involved.[76] The guide to the Exposition rhapsodised about these presentations of the colonies 'in a delicious glow of colour, in an exquisitely disordered confusion of silhouettes . . . a suite of enchanting, animated sketches of African and Asian life'.[77]

For the people 'on display' in this way, the experience was a bitter one. Speaking in French, a Senegalese master-jeweller understandably complained, 'We are very humiliated to be exhibited in this way, in huts like savages; these straw and mud huts do not give an idea of Senegal. . . . [W]e have large buildings, railroad stations, railroads. We light them with electricity. The Bureau of Hygiene does not tolerate the construction of this type of hovel.' Some of the French visitors, at least, felt considerably ill at ease at the sight of these 'human zoos', one stating bluntly, 'We forget that these are people and not exotic animals that we are watching behind the fences.'[78]

This discomfort rarely translated into opposition to French imperialism itself. So deep-rooted was his attachment to the universalist values proclaimed by the French Revolution that had shaped his political identity that even Jaurès, though consistently expressing sympathy for France's colonial subjects, could not let go of the relationship between France's republican values and its self-assumed mission to carry them around the world. He nonetheless rejected the idea that the races were unequal: pointing to the cultural and scientific contributions of the Islamic, Chinese, and Indian civilisations to the world, he saw no reason that they could not flourish again. Indeed, he argued that it was by synthesising their own cultural inheritance with some of the changes brought by the Europeans that the colonised peoples of the world would inevitably arise and struggle for their independence. Meanwhile, he demanded that if France were to provide (for example) the Arabs and Kabyles of North Africa

with the security and conditions in which they could develop their societies, then it was essential that the French presence be peaceful, constructive, and unselfish. It was, of course, naïve, perhaps wilfully so, to believe that this was possible, but Jaurès at least denounced in parliament and in his journalism instances of abuse and rapacity by French colonisers.[79]

It was Nguyễn Trọng Hiệp who provided an eloquent if gentle rebuttal to French claims to have the universal blueprint for civilisation. The refined, scholarly, and now aged diplomat made the point in the thirty-sixth and final verse of his poems on Paris:

> *To govern a country there have at all times been certain immutable principles.*
> *In casting one's eye through history, one sees many differences between the ways of governing in Europe and Asia.*
> *However in the end there is but one type of reason in the world:*
> *This reason is the same for all countries.*[80]

FRANCE, IN OTHER words, never had a monopoly on reason and good governance.

Ironically, one of the few areas in which the two sides of the 'Franco-French war' could work together, albeit in an uneasy and often fractious partnership, was in the overseas empire. Catholicism, after all, was a universalist ideology no less than French republicanism. Catholic missionaries often preceded French officials and army officers in the process of colonisation, and, in practice, Catholic clergy and republican officials found themselves working together in running schools and hospitals and in spreading the French language. Both Catholics and republicans, moreover, when interacting with the indigenous people and facing European rivals, were forced to accept that they came from the same country and held—at least some of—their national identity in common.[81] It was for this

reason that even as Gambetta had thundered against 'clericalism' in France, he also declared that republican anti-clericalism was not to be exported.[82]

So if the Universal Exposition could express the uneasy, rather unstable, common ground between France's Catholics and republicans within the empire, it could barely paper over the deepest cultural and political challenge within France itself. The problem with connecting the triumph of the Eiffel Tower with that of the Republic and the principles of 1789 was that there was no consensus among the French people about whether the Revolution had been a good thing at all. If republicans and other progressives revelled in the tower's great iron frame as the fruit of the scientific rationality that was part of the inheritance of 1789, these were precisely the reasons for others to resent it. To those critics, just as the Revolution seemed to be a disastrous break with a past rooted in Catholic Christianity, tradition, and hierarchical order, so the Eiffel Tower was a rude, almost freakish break in the Parisian skyline hitherto dominated by the spires and towers of this older, ecclesiastical heritage.

IN HIS REMARKS on the Universal Exposition of 1889, the French diplomat and travel writer Eugène Melchior de Vogüé imagined a debate between the cathedral of Notre-Dame and the three-hundred-metre-tall iron tower, between the old and the new, between faith and reason. In the dialogue the Gothic towers of the great church mock Eiffel's creation as an 'impious parody of a Christian bell tower: in your arrogance, you rise above us in vain; we are built on foundations of indestructible stone. You are ugly and empty; we are beautiful and replete with God . . . You are proud of your science; you know very little, because you don't know how to pray. You can surprise people; you cannot offer them what we give them, consolation in their suffering. . . . Fantasy for a day, you will not last, because you have no soul.' The Eiffel Tower replies:

Old, abandoned towers, no one listens to you anymore. Do you not see that the world's poles have changed and that it now rotates around my iron axis? I represent the universal force disciplined by calculation. Human thought runs through my limbs. . . . You were ignorance; I am knowledge. You keep man enslaved; I free him. . . . I have no more need of your God, invented to explain a creation whose laws I know. Those laws are enough for me, they are enough for those minds that I conquered from you and which will not return.[83]

The dispute between science and faith found expression in the contrast between the Eiffel Tower and the Sacré-Coeur. When the Art Nouveau architect and staunch republican Frantz Jourdain glee-fully compared the light 'Gallic gaiety' of the Eiffel Tower with the 'sadness' of the basilica, the Catholic faithful retorted bitterly. A Cath-olic newspaper in Brittany spat that the Eiffel Tower was 'a Tower of Babel, a hideous, horrible, phallic skeleton that stands in stark con-trast to the white of Sacré Coeur'.[84] The implacable writer Joris Karl Huysmans, who was by then on a moral and intellectual migration towards Catholic piety, scoffed at the Eiffel Tower as a 'hollowed-out candlestick . . . a solitary suppository, riddled with holes'.[85] More gently, Émile Jonquet, a Catholic clergyman and author of an early history of the 'Vow' and the church, asked about the view from the basilica, 'In looking over that vast and dazzling panorama, what is it that most attracts the attention of the Christian observer? Is it the innumerable factory chimneys that hurl their garlands of smoke into the air? Is it the Louvre? Is it the Opera? Is it the Trocadéro? Is it even the Eiffel Tower? No, it is the truly incredible abundance of the reminders of faith and piety that come into view.'[86] Among the secu-lar monuments, the Christian eye, Jonquet opined, would be drawn to the spires and domes of religious buildings, such as Notre-Dame and many others. Thus the debates around the tower and the basilica reflected the deeper political and cultural divisions between secular republicanism and Catholicism.

The conflict can certainly be overstated. It is probably safe to assume that, in times of relative calm, most French people oscillated somewhere on a spectrum between them, leaning to widely varying degrees towards one side or the other. Speaking of the view from the dome of the basilica, the official pilgrims' guide from 1896 stated quite plainly that from there visitors could enjoy the view 'of the immense city stretched out beneath their feet', including churches but also 'the Louvre, the Opera, the Eiffel Tower, the Invalides and the Trocadéro'.[87] The guide probably judged its mostly lay, popular readership well, suggesting that many French Catholics could live with a landscape in which 'impious' republican buildings sat awkwardly with sacred, Christian edifices. Even in a society as politically polarised as Belle Époque France, outside periods of crisis, whichever way they leaned, most people other than radicals on either side could live peacefully and even amicably with people of different persuasions.

Though points of crisis drove people to take sides, polarising them around more radical positions, what all Belle Époque Parisians had in common was that they inhabited a city in which life itself was changing—and rapidly. They all shared in the excitement and delights as well as the fears and concerns that the evolving world around them brought. The resulting friction between anxiety and pleasure, between hope and fear, is a central feature of modernity itself, a tension that comes clearly to the surface at the Paris Métro in 1900.

MODERNITY

On 19 July 1900, during a summer heatwave—a *canicule*—a reporter for Marguerite Durand's newspaper, *La Fronde*, run by and for women, waited with some forty other people on the platform at the newly opened Palais-Royal Métro station. Her anonymous article is a vivid account of the passage of the first trains on the first underground railway line in Paris. When the station opened to let the first people in, 'it happened without the slightest of jostling,' she wrote, and observed 'the great satisfaction of the public happy to feel the noticeable coolness as they made their way underground'.[1]

Durand's correspondent described the stations in detail—their glistening white tiles, their trimmings of green, porcelain, and opal on the platform vaulting, along the corridors, and in the ticket foyer. She wrote in technical detail of the lighting—the spacing between the lamps that illuminated the tunnels, the signal systems, and the trains. She remarked that the whole journey from the Porte Maillot to the Cours de Vincennes took twenty-seven minutes, with thirty-second

stops at each station (which today, as it surely did back then, ratchets up the pressure for anyone dealing with an uncooperative small child). She noted that trains currently travelled ten minutes apart, but that as more rolling stock was introduced, this interval would be reduced to two minutes (as it usually is today). She noted, too, that this came at the price of fifteen centimes for second class and twenty-five for first class. This was factual, cool reporting: without ruminating on what the achievement signified, it reassured readers that the novelty was safe, efficient, and comfortable to use.[2]

On another train from the Cours de Vincennes, Georges Baumier, *La Presse*'s reporter, noted that the noise was minimal, the interior of the carriages bright, and the tunnels lit (which is still true), so there was no plunging into darkness. The train ran along twin rails within a cemented ditch driven by a five-thousand-volt current that ran along a third rail, which was generated by a power station on the quai de la Rapée by the Seine. As the train rolled at speed westwards towards the place de la Nation, sparks were occasionally thrown past the windows—Baumier patronisingly noting that despite her denials, the sole female passenger betrayed some anxiety in these moments. At the place de la Nation, more passengers climbed on board, including a small girl and her unconvinced grandmother ('It's the first Métro journey, isn't it, grandma?'). The rue de Reuilly station rolled past, a larger group of people mounted at the Gare de Lyon, and then, at the place de la Bastille, the train emerged briefly into daylight (as it still does).

On the platform, people had gathered to witness the first Métro train, some waving their hats in greeting as it trundled on, round a rather pleasing bend, downwards into the tunnel. Underground once again, the train rushed by stop after stop—Saint-Paul (for the Marais), Hôtel de Ville, where it crossed with the train thundering down from the Porte Maillot, and where two women up from the provinces boarded ('Wow! Isn't this machine funny!'), Châtelet, the Louvre, the Palais-Royal—where it was greeted stiffly by Prefect of Police Louis Lépine and where *La Fronde*'s reporter boarded.

The writer captured a moment of drama at rue Marbeuf (at the Rond-Point des Champs-Élysées, now the Franklin D. Roosevelt station) where a passenger absent-mindedly tried to descend on the wrong side of the train, but was saved from a long fall and a fatal electric jolt by the other passengers. Earlier, at the Porte Maillot, an employee had shouted at an overcurious voyager eager to see the rails, 'Mind you don't fall, *sapristi*! . . . Touch those and you die!'[3] These perils aside, the trains' maiden voyages passed without casualties.

The Métro's grand opening was a triumph, everyone who took the trains that day seemed to agree. A week after his exhilarating journey beneath Paris, Georges Baumier wrote that, for now, the Métro was a novelty—a plaything ('un joujou') for most Parisians, but 'the toy has to become a tool, the most beautiful working instrument for the capital,' and one upon which 'the great mass of workers' would depend.[4] And so it proved: in 1900 alone in a city of 2 million residents there were 48.4 million Métro journeys, a number that mushroomed to an impressive 251.7 million a year in 1910. And some 10 per cent of the roughly 1,000 employees on the Métro would be women, who were all ticket vendors, usually married to the men who checked and punched tickets at the barriers.[5]

Exciting as it was, Paris had been slow to build a metropolitan transport system. The long delay was the result of disagreements that turned into a veritable 'battle for the Métro'. It was a 'battle' that reflected deeper anxieties about the impact an urban transit network would have on the cityscape and on the health and safety of Parisians. Similar anxieties followed other technological developments, such as electrification or the adoption of the telephone. Exciting as modernity was, the rapidity of the technological changes transforming urban living was also unsettling.

Even as Belle Époque society became wealthier, more democratic, and more innovative, some observers detected a deeper malaise, not least because new technology, increased industry, and the social changes that followed on from them were breaking down old barriers

and traditions. Society seemed to be becoming less cohesive and more chaotic, people lazier, politics more corrupt, artistic taste and standards declining and even outlandish: a community in decline. The terms heard from concerned commentators were 'decadence' and 'degeneration'. The latter term was popularised by the German doctor Max Nordau in a book based on his observations of Parisian life and translated into French in 1894. For Nordau, another term, *fin de siècle*, encapsulated a state of mind of the era, one of being 'curiously confused' in 'a compound of feverish restlessness and blunted discouragement, of fearful presage and hang-dog renunciation'. 'The prevalent feeling', he added, was 'that of imminent perdition and extinction.'[6]

This chapter explores the friction between the enthusiastic embrace of technological and aesthetic change and the anxieties that it provoked. This friction lay at the heart of the culture of Belle Époque modernity—and was in evidence to varying degrees of intensity in the debate around the construction of the Paris Métro, the brief flourish of Art Nouveau (for which we will look at, among other constructions, Hector Guimard's Castel Béranger), and the architectural legacy of the Universal Exposition in 1900, including the Gare (now Musée) d'Orsay.

MOST OF THE world's great cities moved quickly to embrace the modernity afforded by a subway. London streaked ahead with the Underground, laying its first line in 1863. New York started with an elevated line in 1868, and its first subway track was opened in 1904. Many other cities, including Istanbul, Chicago, Berlin, Barcelona, Brussels, and Vienna, had railways operating around their city centres before 1900.[7] Paris was a late starter.

This delay was not for want of ideas. The first proposals were published under the July Monarchy in 1845, the first major study took place under the Second Empire in 1855, and the first law establishing a transit system passed in 1871.[8] A deeper debate continued to

simmer, raising searching questions about the nature of the modern city: How far would an integrated transport system erode the distinctiveness of old communities and neighbourhoods and between centre and suburbs, transforming their character? It would, at the very least, prompt people to rethink the ways in which they understood the geography and space of their city. It was also a statement about modernity itself: a public transit system of this kind was made possible by new technologies—in the case of the Métro, the whir of the electric motor and the glow of its lighting. By moving people and goods quickly, cleanly, and efficiently around, the Métro promised to relieve some of the long-standing frustrations that had bedevilled urban life for centuries, including the tangled congestion of people, horses, carts, and carriages and the accompanying issues of cleanliness on the streets above.[9]

These discussions revolved around whether the Métro should be underground, as in London, or elevated, as in Chicago (from 1892) and (at the time) New York. This debate became a flashpoint for all kinds of anxieties. There was a danger, some argued, that tunnelling beneath Paris would undermine the foundations of its tenements and monuments, or that the earth underground was a dark, noxious place—of sewers, of the buried dead, or of subterranean vapours—and then there would be the smoke from the trains themselves.

The debate also raised questions of national pride. Was it right to copy London, the capital of France's ancient rival, by having an underground system, or better for Paris to differentiate itself, with elevated lines? In 1881 the engineer Jean Chrétien claimed that it was all very well for Londoners to travel underground, because their country was fog-bound and there was rarely any sunshine; but for Parisians, only voyaging in the great, open brightness of their city would do.[10] On 16 March 1886, the *Figaro*, coming out in support of an elevated line, condemned 'the first "Métropolitain-at-all-cost" proponents whose subterranean plans . . . reflect their servile imitation of the London Underground'.[11]

Perhaps the greatest obstacle was the question of control, and whether it should be in the hands of the state or the city. Repeated proposals and studies were stymied by this conundrum, which led to political deadlock between the city and the central government. For the government, the Métro should be akin to a regional network. This vision was in tune with the interests of the great railway companies, which wanted no competition from a Métro system controlled by the municipality, and chimed with successive prefects of the Seine, who had to bear the strategic interests of the French state in mind and regarded the Métro as a vital link between the national railway lines—the *grandes lignes*—that bound the whole country together.[12] The city, in the shape of its elected municipal council, regularly made counterproposals for what Parisians began to call 'the real [*véritable*] Métro', meaning an autonomous municipal network run in the interests of the city's people.[13] By March 1886, the *Figaro* was frustrated enough to vent, 'Will we live long enough to see Paris endowed like Berlin, like London, like all colossal cities, with this invaluable means of fast and cheap transport?'[14]

The approach of the Universal Exposition in 1900 and of the Olympic Games (held in Vincennes, just east of the city, that same year) was the catalyst that broke the gridlock: with time slipping away as the great events approached, the government finally yielded, conceding to the Paris municipality the direction of the Métropolitain on 22 November 1895. A commission got to work early in the new year, the initial project was approved in April, and the plans drawn up by the city's engineers were accepted in July 1897. On 30 March 1898, the city council confirmed that the Métro would be an electrified, public transport system aimed at serving Parisians and connecting the different quarters of their city. Construction work on Line 1 began the following day and it was completed in 1900.[15] A further branch was built from Étoile (the Arc de Triomphe) to the Trocadéro to allow for easy access to the Universal Exposition. A little later, this extension became the first three stops on Line 6, which crosses the river, describing an arc through the Left Bank

before recrossing the Seine to finish at Nation at the eastern end of the city.

The distinctive character of the Paris Métro comes from this municipal victory, which ensured that it would serve Parisians who needed to circulate quickly and cheaply around their city. It was also rooted in a particular vision for the future of Paris. When the engineer Ernest Deligny made his proposals back in 1879, he had studied London, not without admiration, but noted that the Underground appeared to be designed for commuting—that is, to allow Londoners to travel into work from their distant neighbourhoods and to journey home again at day's end. It was a function that allowed for the growth of suburbs, so that each day witnessed mini-migrations into the city and back again. Deligny noted, too, that many of the London stations were deep underground, often demanding a long, time-consuming descent into the bowels of the earth. The distances between the stops were relatively long, so that some neighbourhoods were passed through rapidly and some were without a station at all. This served the longer-distance commuter well—and would also have suited the original visions of the French state and the great railway companies during the 'battle for the Métro'.

The designers of the Paris Métro took Deligny's reservations about London's system on board. Like Deligny, they rejected the idea of a transit system that would encourage workers to move out to the suburbs—rather, it should ensure fast, cheap, and convenient connections within the city centre itself, so that Parisians would still live within it, but find it easier to travel to work, using the trains frequently to go about their regular daily business. They also accepted Deligny's assertion that the Métro should allow workers to economise in terms of both time and money. If the costs involved in travelling on any form of public transport—omnibus, tram, or Métro—were not offset by consequent gains for Parisians in terms of the time they could be spending at home, at work, or at their various other destinations, compared with travelling on foot, then they simply would not use it. Trains had to be regular—at rush hours, virtually following one

69

behind the other—and stops had to be frequent. The Métro (unlike the modern commuter rail with which it is interconnected, the RER) would not be too deeply buried underground, for ease and rapidity of access. In a pleasantly French line of reasoning, it should not be much deeper than a Parisian wine cellar.[16]

The practical application of Deligny's analysis can still be experienced as one travels the Métro today: at rush hour, it is not unusual to have one train followed almost immediately by another to ease the flood of people who would otherwise crush on the platforms. Stand in a Métro station today, and a glance down the tunnel will sometimes reveal the not-too-distant sight of the next stop along the line—so Deligny's vision of regular, frequent stops came to fruition. This also means that a Métro station is almost always close at hand: visitors who feel irretrievably lost can simply ask a passer-by, 'Excusez-moi, Madame/Monsieur—le Métro, s'il vous plaît?': get to the nearest Métro station, and you'll be able to make your way to anywhere else in the city.

Yet there was a great deal of Parisian grumbling about the disruption caused by the works as one Métro line after another was constructed. Most, although not quite all, the lines were laid underground—the notable exceptions including the elevated sections of Lines 2 and 6 along the boulevards following the traces of the old city walls. The planners had hoped that the work itself would be carried out beneath the surface, unlike in London and New York, where the Underground and the subway tunnels were dug out beneath open skies before being reburied. In practice, much of the engineering and construction occurred in open trenches, and—since the Métro would follow the same route as the avenues and streets above, in order to avoid the foundations of the apartment buildings—this meant digging up broad sections of the road.

While initially the curious enjoyed the spectacle of the bowels of Paris being exposed to the light of day, this novelty soon wore off. The press was full of complaints about the *embarras de Paris* as its arteries were soon choked by the combined effects of the work and the

usual traffic. In September 1906, as further Métro lines were being constructed, the popular journal *L'Illustration* published a long article on the progress. It began with a map across a double-page spread showing where, at the time, the city's streets were being dug up, black squares and rectangles marking the irritating spots that were exciting the ire of Parisians. It opined that 'in waiting for the benefits of the Métro which will ensure that all will be forgotten, the patience of busy passers-by, of promenaders—and of businesspeople whose shops are inaccessible—is incontestably being sorely tested'.[17] An article in 1899 published in the *Revue illustrée* included photographs of the great gaping trenches on Paris's avenues and at its junctions, blocking them entirely to all traffic except pedestrians, and of worksites completely shielded from view by tall wooden palisades, an ugly blot on the landscape that gave rise to speculation as to what, exactly, was going on.[18]

There were accidents: in one incident near the Arc de Triomphe, close to the junction of the avenue de Friedland and the Champs-Élysées, the ground 'began to subside slowly, so slowly that a roadworker and a worker from the Omnibus Company, who were warming themselves by a brazier, did not even notice that they were falling bit by bit with the trees, benches, and streetlamps that surrounded them. But suddenly a crevasse opened and the two men, their fire, the streetlamps, and the benches were hurled pell-mell into a gallery of the Métropolitain six metres below: the unfinished vaulting had succumbed with the heavy rains.'[19] Fortunately, the workers escaped with minor injuries. Despite such difficulties, Line 1 opened to its first passengers in sections between July and December 1900, carrying—as was intended—visitors to the Paris Exhibition of 1900. The network grew between 1900 and 1914, when it counted 92 kilometres of track, carrying 470 million travellers each year, streaking effortlessly under the ground beneath its more expensive and slower competitors, the horse-drawn (by 1914 mechanised) omnibuses and electrified tramways.

While most working-class people still lived and worked in their immediate *quartiers*, or neighbourhoods, the Métro was a

key instrument in ensuring that they could move about their city cheaply, quickly, efficiently—and en masse. In fact, as Alain Cottereau has argued, the working-class character of Paris was actually accentuated by the Métro. This was because its very existence made domestic manufacturing more feasible: between 1872 and 1914, the proportion of workers who produced their wares at home workshops actually increased in precisely the period where elsewhere in Europe industrialisation became a striking feature of the economy. The tailoring of clothes, the cobbling of shoes, and the crafting of luxury goods (*articles de Paris*) on a small scale worked even better thanks to the Métro because it made it easier for workers to make deliveries, pick up raw materials, make sales, and take payment across the city. Often, different stages of the manufacturing process were carried out by different artisans in different workshops—the Métro reinforced this practice by allowing craftworkers to carry their half-finished goods to the next workers to complete the next stage. And this was why the Métro also became an important space for the working women of the city—because they predominated in these domestic industries, so had cause to use the Métro regularly.[20]

There were complaints. On his first voyage, Georges Baumier grumbled that smoking was not allowed on the trains: the response of one employee was that surely people could do without during the short duration of the trip. Baumier was unconvinced and repeated his grievance in an article a week later. The trains remained non-smoking—although smoking was allowed on the platforms until the 1990s. Clearly not satisfied, Baumier continued to register additional, more substantive complaints about the logistics, with which present-day users of public transport will be all too familiar: long queues for tickets, the services not running late enough into the evening (this would soon be remedied from 15 August 1900, when trains ran until 1.30 a.m.), the infrequency of services (ten minutes apart: the aim was for two-minute intervals, and this was to be met when there was sufficient rolling stock), and, perhaps worst of all, 'Parisians getting tired of being packed together like sardines'.[21] In this respect,

present-day travellers can commiserate with their Belle Époque predecessors. Far, far worse, however, was a disaster on 10 August 1903 at the Couronnes Métro station on Line 2 (fully opened that same year), when a short circuit caused a train to catch fire in the tunnel leading to the next stop, Ménilmontant. Passengers forced to disembark at Couronnes from the train behind were suddenly plunged into darkness as the electricity gave out—and as the station started to fill with smoke from the blaze ahead. Couronnes was—and is—one of only a few Métro stations that only has one exit, and the panicking, disorientated passengers jostled and tripped over each other as they struggled to find their way to safety in the obscurity and fumes. Eighty-four bodies were later carried out—and the awful accident remains the worst in the Métro's history.[22]

As the tragedy at Couronnes implied, much as Paris aspired to be a capital of modernity and experienced the excitement of novelty, it also wrestled with the pace and desirability of change, with its impact on morality and on physical health, and with the ways in which modernity pushed society to evolve. More than three decades after the Métro first opened, Walter Benjamin evoked the sense of alienation from the city that arose from travelling beneath it. 'Solférino, Italie and Rome, Concorde and Nation', he wrote, naming the Métro stops: 'Difficult to believe that up above they all run out into one another, that under the open sky it all draws together.' In the galleries beneath the city, the names no longer attached to street or square, but were 'transformed into misshapen sewer-gods, catacomb fairies'. As if it weren't enough to sever the urban fabric of the city above, Benjamin fretted that the mass transport of people beneath the streets added to the depersonalised experience of living in the metropolis: the trains swallowed up 'thousands of anaemic young dressmakers and drowsy clerks [who] every morning must hurl themselves [into the Métro]'.[23]

This detachment and isolation of the individual within the urban mass was just one aspect of the modern city's rupture of long-standing community and neighbourhood ties. Yet there were also aesthetic critiques, for the Métro was furnished with serpentine station entrances

that embodied Art Nouveau. The Guimard Métro entrances sported sweeping lines of lily stems and floral curves and were lit by burnt orange lamps at the tops of their floral gateposts. The fence panels evoked insect shells, and the whole was cast in iron and washed in a distinctive green enamel.

Though they would be classified in 1965 as national monuments, the style of these entrances was a direct challenge to the architectural traditions of classicism, with its straight lines and rectilinear designs, and represented a highly visible harbinger of modernity's incursion on the traditional Parisian cityscape.[24]

ART NOUVEAU FLASHED brilliantly for a short period in the last years of the nineteenth and the first years of the twentieth century before being overtaken by other, more abstract forms of modernism. It was a reaction against the more formal artistic, decorative, and architectural styles that had seemed to its practitioners to have been ossified in the past, rigidly immobilised in the strictures of academic art, much of which was commissioned by the state for its public buildings to convey its view of the French past and the values of the republican regime. Its creators were inspired by nature, but unlike the Impressionists, who tried to capture their momentary 'impression' of the play of light and colour at a moment in time, Art Nouveau stylised nature. Art Nouveau used forms such as leaves, stems, flowers, and insects along with a bright palette of colours within bold, flowing lines.[25]

It drew particular inspiration from Asian, and especially Japanese, art, an influence which can be traced to Western imperialism in Asia. The term 'Art Nouveau' itself was coined by an aficionado of Asian art, Samuel Bing, who opened his gallery at 22 rue de Provence (behind the great department stores of the boulevard Haussmann) in Paris's 9th arrondissement in 1896: his sign proclaimed *L'Art Nouveau Bing,* and it bore the same vegetal, whiplash lines that characterised the French form of the style. Ever since Japan had been forcibly

opened up to trade by Commodore Matthew Perry's 'Black Ships' in 1853–1854, Parisian collectors had been visiting Japan and keeping enthusiasm on the boil. Japanese prints by, among others, Hokusai and Hiroshige stunned European viewers for their striking use of colour; their bold lines; their landscapes of the sea, of rich greenery, and of mountains; and their decisive depictions of buildings and streets to frame their subjects.

Japan's Meiji Restoration that brought about the return of imperial authority in 1868 was accompanied by a programme of rapid economic and political development, and the nation exhibited at the universal expositions starting in 1867. Italian republican Henri Cernuschi became a leading Parisian collector, having taken French citizenship after the defeat of the 1848 Revolutions, and travelling to Asia in the early 1870s. His collection is now in the Musée Cernuschi, or Musée des arts de l'Asie de la Ville de Paris (Asian Arts Museum of the City of Paris) near the Parc Monceau. Émile Guimet was another key figure who, voyaging in Asia, assembled an impressive collection. It came to be housed in a remarkable building near the Trocadéro in the 16th arrondissement in time for the 1889 Universal Exposition. Now named the Musée national des arts asiatiques–Guimet, or National Museum of Asian Arts–Guimet, it is usually called simply the Musée Guimet in his honour. This fondness for Asian art spawned another decorative style, *Japonisme*. Paris still has a small number of buildings that were inspired by its adoption of Japanese motifs, the most striking being *La Pagode*—the pagoda—built in 1896 on rue de Babylone (7th arrondissement) by the architect Alexandre Marcel for the wife of François Émile Morin, the director of the Bon Marché department store and a lover of Japanese styles.[26]

Art Nouveau was a truly international movement, arising alongside many other artistic efforts to find new, fresher forms such as Jugendstil, Modern Style, Sezessionstil (Secession style), Liberty style, Tiffany style, Modernista, and Arte Joven. It was polycentric because it was spontaneous, the fruit of artists and designers striving

to find original expression in a late-industrial age where technology, the growth of popular culture, and the emergence of mass society seemed to be leaving older artistic and architectural forms trailing. In this sense, Art Nouveau in Paris was an aesthetic response to the very modernity that was shaping the city.[27] Yet today, it is easy to forget that it was a search for a modernity that most people—almost certainly—felt they could well live without.

Art Nouveau swam against the tide of a public that was comfortable with the established styles. Among the more derogatory terms for it was the 'noodle style', and, thanks to Guimard's controversial Métro entrances, 'le style Métro', or even 'le style Loubet', using the name of the French president Émile Loubet (1899–1906) to compare Art Nouveau unfavourably with the distant cultural glories of the 'Louis XIV', 'Louis XV', and 'Louis XVI' styles.[28] It also ran headlong into what had been officially proclaimed as 'art nouveau' back at the Universal Exposition of 1889, where the Eiffel Tower and the technological marvels on display encapsulated the kind of republican political culture that was underpinned by reason, scientific knowledge, and technology. For the vicomte de Vogüé, who had waxed so lyrically about the Eiffel Tower, the new style showed that the soaring ironwork of 1889 was not a great stride up the 'ever-ascending ladder of progress', but rather, by 1900, 'the culminating point on a descending curve'.[29]

Rather than rejecting modernity, Art Nouveau refocused artistic efforts on the domestic interior, a shift that connected also with contemporary understanding in human psychology. It was influenced by the discoveries of Jean-Martin Charcot, who discussed his work with Sigmund Freud, and whose treatment of the mentally ill at the Salpêtrière Hospital in Paris underscored the human mind as suggestible, sensitive to external stimuli, and prone not just to reason but also to visual thinking. Drawing from Charcot's findings, artists conceived of a design that could reflect one's own personal feelings rather than imitating any broader, historical moment or style. Art Nouveau's very modernity therefore flowed in part from the latest

understandings of human psychology and from the clear modern distinctions between the public arena of the street, work, and politics and the private space of the home. It did not in the end replace the monumental architecture of iron and steel: the two embellished the cityscape side by side, even if stylistically they directly contradicted each other.[30]

It was perhaps precisely for its focus on decorative work that Art Nouveau appealed to some influential patrons and sometimes the government itself. Hector Guimard could take much of the credit. One of his great projects was the Castel Béranger at 14 rue La Fontaine, commissioned by Madame Anne-Élisabeth Fournier, who had asked him to design a large building with twenty-six apartments. The building, still there to be admired in the 16th arrondissement, was part of a wider portfolio of work by Guimard in the area.[31]

To get to Castel Béranger, viewers may today approach from the station at Michel Ange Auteuil at the southern end of the rue La Fontaine. Getting there requires a long stroll along the full length of the street, but it's a pleasant walk, beginning with crossing the small square formed by the junction of a number of roads, at the centre of which is a Wallace Fountain (donated by the Englishman—and lover of Paris—Sir Richard Wallace throughout the city from 1872, to ensure that Parisians could have access to fresh drinking water). Rue La Fontaine is a fairly quiet street that kinks slightly left and right as it goes, which is a refreshing change from the uncompromising, rectilinear avenues of Haussmann's Paris and shows off the buildings to their best—and they include some gems, including (at No. 96) the birthplace of Marcel Proust and (at No. 17) an eight-storey apartment building Guimard built in 1911. This was part of an ambitious project, never entirely realised, to build eleven apartment buildings centred on rue Agar, a short street running off rue La Fontaine that Guimard was going to call rue Moderne. No. 17, with its discreetly flowing lines around bay windows, entrance doorways, and curved, ironwork balconies, was one of six apartment buildings to be completed; the others are nearby, on rue Gros and rue Agar.[32]

Castel Béranger, now just a little farther up, at No. 14 rue La Fontaine, was built more than a decade earlier and displays more confidence, or perhaps more youthful boldness, in its design. Interestingly, Guimard's original designs for Castel Béranger in 1894 (when he was just twenty-seven years old) were fairly ordinary. As he warmed to the task, he added more embellishments with what became his trademark style: curves, fluid lines, and motifs evoking lush greenery, not least in the remarkable, arching entryway with its vegetal pillars and a gate with swirling copper and ironwork. Look closely at the upper-storey balconies and you can see the large, scalloped leaves with their characteristic green enamel wash that evoke his later design for the fences around the entranceways to the Paris Métro. Completed in 1898, it was thanks to the faith that the widowed Madame Fournier placed in Guimard—indeed, her bold risk-taking—that Paris now had its first residences built in the Art Nouveau style. Moreover, Fournier charged relatively modest rents—and among her first tenants was the post-Impressionist painter Paul Signac. Guimard himself installed his office on the ground floor. Despite the discomfort of those who preferred the older 'academic' styles, Castel Béranger was accepted as an entry and commended in a competition of Paris façades sponsored by the city authorities in 1899, after which even the stolidly establishment *Figaro* hosted an exhibition of Guimard's drawings, models, and watercolours for the design of the building.[33]

In 1900, Guimard's designs—in a decision that came as a shock to many—were selected for the entrances to Line 1 of the Métro. It might not have happened, such was the general sense of unease that still greeted Guimard's innovative style. Guimard had not even entered the competition opened for the purpose, but it turned out that Adrien Bénard, president of the company running the Métro, was a devotee of Art Nouveau: blithely ignoring the contest, he gave a direct invitation to Guimard to take on the task.[34] Few other people actually liked Guimard's Métro entrances at the time. They seemed to be an affront to the Parisian architectural environment, entirely at odds

with the more solid, geometric design of the classic Haussmann style that surrounded them: 'Dragonfly wings' and 'hunch-backed lanterns with frog's eyes' were epithets hurled about Paris as the entrances sprang up across the city—this last remark coming in 1904 from the same newspaper, *Figaro*, that just a few years earlier had mounted the exhibition devoted to Guimard's work, a sign, perhaps, that the Art Nouveau wave was already breaking.[35]

To its credit, the Métro persisted. Guimard designed the entrances for all ten of the Métro lines that were opened before the First World War—167 stations in all. By then, Art Nouveau had already begun to run its short-lived course (at least in Paris) from 1905. The turning point came when the Paris municipality rejected Guimard's plans for a spectacular entrance to the station at the Opéra. Many of Guimard's entrances have now sadly disappeared after successive generations of 'modernisation'—only eighty-seven now survive across sixty-six stations, but these were classified as historic monuments in 1965, so are protected. Those that survive are now indelibly—and nostalgically—the ultimate trademark of the Paris Métro and have come to symbolise the city itself.

Guimard built three kinds of entrances: pavilions, canopies, and fences. Though no pavilions survive, two spectacular canopies still stand, one at Porte Dauphine (the terminus of Line 2 in the 16th arrondissement—take the exit for the boulevard de l'Amiral Bruix), and the other, saved from destruction at the Hôtel de Ville station and rebuilt at Abbesses (in Montmartre, 18th arrondissement, Line 12: if you can get close enough with the jam of tourists). A good reproduction was constructed at Châtelet (Line 1 and others) on the place Sainte-Opportune (1st arrondissement) to celebrate the Métro's centenary. The fences feature a distinctive lily-styled entrance post ending with curved stems bearing dark orange lanterns that hang over the heads of voyagers as they pass beneath. Fine examples can still be seen at the Palais-Royal–Musée du Louvre station (Lines 1 and 5, 1st arrondissement) and at Saint-Michel (Line 4, 5th arrondissement), at Réaumur-Sébastopol (with a rather bijou exit on the rue de Palestro,

at the corner with the rue Réaumur, Lines 3 and 4, 2nd arrondissement), and at Temple (Line 3), among many others.[36]

The Métro itself was rapidly enmeshed within the life of the city, where changes in its geographical and social fabric constituted further steps in Paris's march of modernity, making it more interconnected than even Haussmann's boulevards had and bringing about further integration of its economy. The result was to open up more opportunities for Parisians to move about their city in the performance of their work and in the pursuit of leisure.

Among the other city features propelled by the Métro's creation were new bridges. These were needed to carry the trains across the Seine where the lines were above ground, as with Line 6, as well as between Passy in the 16th arrondissement on the Right Bank and the boulevard de Grenelle in the 15th on the Left. Classic Belle Époque designers took full advantage of this opportunity when the Viaduc de Passy was built between 1903 and 1905. Devised by the engineer Louis-Joseph Biette, the viaduct runs across the river at two levels: at the stone-built bottom is the carriageway for road traffic, while the narrower ironwork above bears the train tracks. This metalwork was softened by the gentle architectural touch of Jean-Camille Formigé, who gave the iron its lanterns hanging from the railway bridge to illuminate the roadway below, and, befitting its elegant style, the almost organic lines of its ribbed pillars. Beneath the roadway, the four arches are decorated on either side by eight sculptures carved by Gustave Michel.

The real gem, however, is not the artistic embellishment of the bridge but the route that the viaduct created for the Métro. One can still appreciate it by taking Line 6 (direction: Nation) from the station at Passy, where the train emerges from the tunnel into daylight. It pulls away from the platform and trundles forward into what feels like a short canyon of neo-Haussmann apartment buildings on either side, rolling along a viaduct high above the rue Alboni. Seconds later, the train rumbles out from between the buildings and, like an amiably slow rocket, seems to take to the air above the river as it crosses

on Biette's bridge. In a spectacular view across water to the left, there is the Eiffel Tower standing guard over the Seine. Once across to the Left Bank, it's tempting to get off at the next station (called Bir-Hakeim after a Second World War battle that has also given its modern name to the viaduct: it's also the closest Métro station to the tower itself), descend into the streets below, and recross the river on foot, following the roadway at the lower level of Biette's bridge. Doing so allows you to take time to enjoy the view across the Seine towards the Eiffel Tower and to admire Formigé's slender pillars. With this backdrop, it is unusual not to see married couples, the bride's white dress rippling in the breeze, or even models with a full platoon of photographers and technicians, having a photo shoot beneath the elegant iron arches or along the parapet of the bridge—sometimes, rather disconcertingly, posing *on* the parapet. At the other end of the bridge, crossing the quayside avenue takes you up the short rue Alboni, with the viaduct high above your head. Then there is the long climb up the steep steps back to the Passy Métro station: alongside the flight on the right-hand (northern) side, there is at the time of writing an escalator, which takes those fortunate enough to have chosen to head in the direction of the Trocadéro and the Arc de Triomphe (direction: Charles de Gaulle Étoile) almost directly to their platform. Otherwise, those heading back over the river need to cross to the platform opposite via the station.

In their time, the Eiffel Tower, the Métro, and Biette's iron bridge, along with electricity, the telephone—and then the bicycle, the automobile, the cinema, and the first aeroplane flights, among other things—were heralded as larger or smaller triumphs of science over 'nature', steps in the human capacity towards controlling the natural world—gravity, wind, water, darkness, distance: the fruits of modernity. Life was changing for the better for many (if not most) of the residents of the city: people from an ever wider compass of Parisian society were experiencing all of this technological, political, and cultural 'progress' in myriad day-to-day ways. They read the newspaper while getting around the city on the Métro, went to the cinema, rode

bicycles, participated in sports, and tried new foods. Yet from these developments arose concerns—at least among those who thought, observed, and wrote about them—about the impact of change on the moral and cultural fabric of French society, shrilly fretting about 'decadence' or 'degeneration'.

'DECADENCE' IMPLIED THAT what some took to be decaying standards in culture, alongside the observable instances of political and financial corruption, crime, alcoholism, a falling birth rate and prostitution (and along with it, venereal disease), were caused by the very progress that others celebrated and enjoyed. The comforts of modern life were thought to weaken the resilience of individuals by making them softer and lazier.

Belle Époque anxieties about decadence and degeneration could take a number of forms and have different targets. In the bastardised Darwinism of the day, some believed that advances in medicine and social care (vaccines, pasteurisation, hospitals, welfare support for the poor) merely ensured the survival of the weak, which in turn sapped the strength of society as a whole—a concern often expressed in distinctly racial terms. As we shall see later on, for example, the royalist poet Charles Maurras argued that society could only be re-energised through action, which would reorder politics and society along nationalist (and explicitly antisemitic) lines that reconnected with France's prerevolutionary traditions. Some Catholic commentators were concerned that technological innovation had outstripped society's moral development, leaving a spiritual emptiness that was filled by any manner of practices, including Satanism, spiritualism, and belief in the occult. Meanwhile, as we shall also see, republicans fretted that the growth of a consumer society and the pursuit of luxury sapped the civic fibre of citizens, thus weakening the polity. Traditionalists across the political spectrum worried that the small, baby steps in expanding women's legal rights—alongside a burgeoning feminist movement—threatened to aggravate France's already flagging birth

rate, weaken the family, and, by extension, undermine the entire gendered order of society.[37]

Moreover, environmental forces could still expose the fragility of even (or perhaps especially) the sophistication of Parisian society. In 1910 the city experienced a trauma that showed that nature—even in the shape of the usually adored, picturesque Seine—had bite. Spectacular rainstorms in northern France swelled the rivers and streams that fed the Seine in the second half of January that year. The impact was devastating. A broad swath of the city on either bank of the Seine was inundated with river water. The tunnels being dug for new Métro lines were flooded, the equipment swept away: the northern (Right Bank) and southern (Left Bank) sections of Line 4 had only been joined by the tunnels passing beneath the river and the Île de la Cité for a couple of weeks when the water poured in. The Gare Saint-Lazare and the Gare d'Orsay took on the appearance of indoor swimming pools, and a great lake formed in front of the former. At its height, the flood reached a depth of 8.62 metres: ever since, Parisians have kept a watchful eye on the statue of the Zouave at the Pont de l'Alma, whose immersion in the rising waters of the Seine provided a gauge of how serious the accumulation was becoming. In 1910, the water reached the statue's shoulders, which of course spelled disaster. At exactly 10.53 p.m. on 21 January, all the public clocks in Paris suddenly stopped: the compressed air by which they were powered had been shut down by the floodwater. The modern machinery that kept the city moving, including the Métro and motorised taxis and buses, broke down, and Parisians resorted to the age-old, horse-drawn forms of transport and, like reluctant Venetians, to punting or rowing along the inundated streets. The waters would finally fall back to their normal levels on 15 March, but the cleanup operation—not least the removal of fetid silt and sewage-infested pools and the restoration of gas and electricity supplies—would take until the end of May. Faced with the elemental forces of the environment, the amenities and comforts of modernity had proven to be very delicate indeed.[38]

The emergence of a mass, democratic politics was not always celebrated. Hostile commentators and activists on the political right, such as Maurras and the nationalist writer Maurice Barrès, claimed that corruption, and indeed the very existence of the Third Republic's parliamentary democracy, sapped national strength by denying France the strong government it needed. On the left, socialists and anarchists saw the uneven prosperity of bourgeois-dominated society as self-centred and corrupt, while their propertied opponents saw their plans for social justice, be it through peaceful, democratic means or through revolution, as part of the problem of national decline. And there remained, as there always had been, fear of the crowd in the street, its potential for destruction and manipulation now overlaid by modern psychological explanations.

In the last years of the Belle Époque, even the old, scientific certainties—the measurement of time and space as objective, immutable facts—would come under attack. The popular lectures of the philosopher Henri Bergson would suggest that our understanding of the world around us, including time, was subjective and could be intuited. This argument alarmed republicans, who perceived it to be a direct assault on their rational understanding of the world, a world that they deemed to be measurable and understandable through stable, unchanging facts and scientific laws.

All these concerns were applied at different levels: to the nation (or 'race'), the family, and the individual. At the individual level, the anxieties were given form by interest in the psychological condition (first identified in the United States in 1880) held to be 'nervous exhaustion' ('neurasthenia'), characterised by moral weariness, a sense of emptiness, lethargy, and boredom. It did not take long for this idea to be applied to society as a whole, with one politician claiming in 1908 that he saw 'a kind of collective neurasthenia . . . [a] derangement of the collective consciousness'.[39] Even Émile Zola, whose faith in science and the capacity of humanity for progress was strong, wrote in 1896 that the freneticism of modern life had a psychological impact on people: 'Ours is a society', he wrote, 'wracked ceaselessly by a nervous

erethism. We are sickened by our industrial progress, by science; we live in a fever, and we like to dig deeper into our sores.'[40]

It is true that concerns about the unravelling of old certainties were primarily the preserve of those who had the space and time to reflect on these problems. But what is striking is how widely these concerns were expressed—either on specific issues, or about society in general—not just in the more rarefied circles of the 'chattering classes', but also in newspapers, magazines, and popular editions of books.[41] The illustrated journal *Fin de siècle* (which, as if to confirm the worst fears of those worried about the immorality of the age, always featured a picture of a woman on the front page, usually in some state of undress) first appeared on 17 January 1891, when the editor, François Mainguy, wrote that in society 'all is mixed, confused, blurred, and reshuffled in a kaleidoscopic vision'.[42] The literary historian, bibliophile, and fashion writer Octave Uzanne, introducing a series of pen-portraits of different types of modern Parisian women (he cleaved closely to the traditionalist view that women were not destined for public life), argued that the interest of 'this end of the nineteenth century' lay in its *transformisme*—its transformative character, but not necessarily in a good way:

> This society which is going to disappear and then renew itself is seeing itself disturbed by a thousand important visible and, so to speak, tangible symptoms of degeneration. This whole world of beings on the eve of undergoing the metamorphoses that politics, socialism and still more science, extraordinarily well-equipped, are preparing for it, is infinitely more complicated, more difficult, and . . . more curious and fascinating to fix in a series of portraits than the peaceful and sane citizens of 1840 ever were.[43]

UZANNE WAS EXPRESSING a view common to his age: it was somehow less stable, its people less secure (and less sane!), than those of

previous generations. He acknowledged the impact of scientific progress and political (particularly democratic) change, but he also saw the myriad ways in which they wrought an impact on society in terms of 'degeneration'.

The term 'degeneration' was popularised, although not coined by, Max Nordau, who in 1892 published *Entartung*, which was helpfully translated from its original German into French in 1894 as *Dégénérescence*. Following its appearance in French it was hotly debated in the Parisian press. Nordau clearly believed that the degeneration of society as they knew it was already taking place:

> Our epoch of history is unmistakably in its decline, and another is sounding its approach. There is a sound of rending in every tradition. . . . Things as they are totter and plunge, and they are suffered to reel and fall, because man is weary, and there is no faith that is worth an effort to uphold them. . . . Men look with longing for whatever new things are at hand. . . . They have hope that in the chaos of thought, art may yield revelations of the order that is to follow on this tangled web.[44]

FOR NORDAU, CONTEMPORARY art and literature were symptoms of the deeper problem, which was that both human beings and societies were degenerating. The broader signs of this condition included, at the social level, a deliberate rejection of morality and old habits, a listless weariness, and, in response, the nervous pursuit of ever greater sensations. At the level of the individual, it manifested itself both physiologically ('deformities, multiple and stunted growths . . . [and] unequal development of the two halves of the face and cranium', along with big, protruding ears—'like a handle'—'squint eyes, hare-lips, irregularities in the form and position of the teeth') and psychologically: degenerates were 'dwellers on the borderland between reason and pronounced madness. . . . For them there exists no law, no

decency, no morality. In order to satisfy any momentary impulse, or inclination, or caprice, they commit crimes and trespasses with the greatest calmness and self-complacency.'[45] Breaking this down, Nordau detected a toxic mix of egotism, impulsiveness, and emotionalism, but combined with 'mental weakness', manifesting as dejection, despondency, and pessimism.

The ultimate expression of this psychological breakdown was 'hysteria', which Nordau ranked alongside degeneration itself as the other main ailment of the *fin de siècle*.[46] The cause was the long-term exposure of humanity to narcotics—tobacco, alcohol, hashish; to disease, including syphilis and tuberculosis; and to pollution. And for all of these ills, the expanding cities were particularly blameworthy:

> The inhabitant of the large town, even the richest, who is surrounded by the greatest luxury, is continually exposed to unfavourable influences which diminish his vital powers far more than what is inevitable. He breathes an atmosphere charged with organic detritus; he eats stale, contaminated, adulterated food; he feels himself in a state of constant nervous excitement and one can compare him without exaggeration to the inhabitants of a marshy district.[47]

It was not just urban life that was a cause, it was the very impact of the modern world itself, with its rapid communications, its new modes of transport, and the rise of the mass media:

> Every line we read or write, every human face we see, every conversation we carry on, every scene we perceive through the window of the flying express, sets in activity our sensory nerves and our brain centres. Even the little shocks of railway travelling, not perceived by consciousness, the perpetual noises, and the various sights in the streets of a large town, our suspense pending the sequel of progressing events, the constant expectation of the newspaper, of the postman, of

visitors, cost our brains wear and tear. In the last fifty years, the population of Europe has not doubled, whereas the sum of our labours has increased tenfold, in part even fifty-fold. Every civilized man furnishes, at the present time, from five to twenty-five times as much work as was demanded of him half a century ago.[48]

THE VERY SPEED of change had not allowed 'civilized humanity' time to adapt, and it all had a mental and physical impact on the human brain and body and on society as a whole. Nordau worried about 'the vertigo and whirl of our frenzied life, the vastly increased number of sense impressions and organic reactions, and therefore of perceptions, judgments, and motor impulses'.[49]

Nordau was not alone in diagnosing the city as a cause of the nervous disorders that wracked modern human beings. In 1891, just a few years before his work was published, a French doctor, Fernand Levillain, published a widely circulated (and cheaply produced) tract, *La Neurasthénie*, arguing that the nervous condition was the natural result of urban living and that it cut across class and affected men as much as it did women: the relentless pace of life in the metropolis and the demands of the city punished the mental health of those who were caught up in its currents. The result was all too often an 'overtaxing neurosis'.[50] 'Degeneration' and 'hysteria', in other words, were blamed on precisely the same kinds of developments that would give the 'Belle Époque' its nostalgic allure to later generations.

It was against this cultural—and indeed medical—context that the Universal Exposition hosted by Paris in 1900 was judged, particularly in comparison with the roaring success of the previous event of 1889. While '1889' trumpeted the glories of 'hard' engineering and technology and connected them with the triumph of democracy and the values of the 1789 Revolution, '1900' was an almost orgiastic celebration of Paris as a centre of luxury and consumption. Although these were still very much features of modernity as it was understood

at the time, they also seemed to confirm the worst fears of those who fretted about the 'decadence' of French society. On one level, the flourish of the 1900 exhibition seemed, in retrospect, to be the 'apogee' of the Belle Époque, a fitting destination for the Métro that served it.[51] Whereas the 1889 Paris exhibition had celebrated science, engineering, and progress, that of 1900 luxuriated in more hedonistic pleasures, which some observers took to be a sign of the times.

One can get a sense of this shift by visiting one of the great architectural legacies of 1900: the Musée d'Orsay. This magnificent building, designed by Victor Laloux, was built in a style that paid tribute to the Haussmann tradition by reverting to the classical styles of the past. Like Art Nouveau, this retreat back to seventeenth- and eighteenth-century inspirations was part of an aesthetic reaction against the hard, metallic, and often utilitarian functionalism of the great iron-framed buildings associated with the 1889 Exposition. It was not necessarily a reaction against modernity itself. For Laloux's building was a railway station whose trains connected, via the Gare d'Austerlitz, with lines coming into the city from the south. The Gare d'Orsay was constructed in 1900 to ensure that visitors to the Exposition would be carried directly into the city centre, detraining within relatively easy walking distance of the Champ de Mars (which was lined by many of the pavilions in the shadow of the Eiffel Tower), but closer still to the other buildings specially constructed for the event, such as the Grand and Petit Palais and the central pavilion on the place de la Concorde. Laloux's design combined an elegant, classical stone frontage (most notably its long galleries overlooking the Seine, its two large clocks, and its mansard roof) with the metal-framed, vaulted interior of the station, into which trains approached through underground tunnels. Laloux, in other words, combined an unapologetically modern and utilitarian interior with a richly decorative exterior.[52] To catch a glimpse of the kind of opulence that would be associated with the 1900 Universal Exposition, it is worth visiting the old station's reception room overlooking the Seine, with its pillars, high mirrors, expansive parquet floor, gold leaf trimming, and

glittering chandeliers. This was far removed from the soaring, clean lines of the Eiffel Tower.

So, too, were the Grand and Petit Palais, built to house some of the showpieces of the Exposition—and which were served, conveniently enough, by the Champs-Élysées Métro station of Line 1. Also built for the Exposition was the highly ornate Pont Alexandre III across the Seine, connecting the Grand and Petit Palais with the Esplanade of the Invalides, where a commuter railway station was also constructed (and still serves as a station, 'Invalides', for the RER, the suburban transit system). The bridge, which, like the Gare d'Orsay, combined modern engineering with an older, more ornate style, is without question the most elaborately embellished bridge in Paris. Constructed for the Exposition, it had a practical purpose: easing the movement of the tens of thousands of visitors between its various attractions. Designed by the architects Joseph Cassien-Bernard and Gaston Cousin, its steel frame leaps across the river in one single arch. But it was its spectacular ornateness—rococo in its complexity—that struck contemporaries and that continues to strike visitors. Its parapets are illuminated by thirty-two candelabras designed by the Lacarrière company, which had won its spurs by designing the lighting for the Garnier opera house. The four corners of the bridge are each guarded by a column surmounted by gilded winged figures—three representing fame in arts, sciences, and combat, the fourth being Pegasus supported by fame in warfare. Yet it is the name of the bridge—after Tsar Alexander III—and the symbolism of the last two winged creatures that hint strongly at the explicitly political propaganda behind the bridge: besides its practical purpose, it was also a monument celebrating the military alliance between France and Russia in 1892. The visual clues are there if one looks closely enough: at the centre of the bridge's parapet looking upstream is a bronze depicting the 'nymphs' of the River Neva with the arms of tsarist Russia; looking downstream, those of the Seine with the arms of Paris, making a riverine connection of the French and Russian capitals. Moreover, the foundation stone was laid in 1896 by none other than Tsar Nicholas

II and his consort Alexandra, together with the then president of the French Republic, Félix Faure. For the French, the bridge was a celebration that their diplomatic isolation since the defeat of 1870–1871 had finally been broken. Yet the bridge's very flamboyance was no less a mark of two opposing themes: on the one hand, uneasiness with France's place in the world, the humiliation of defeat, and the lurking spirit of *revanchisme* that poisoned its politics, and, on the other hand, the exuberant—if, at the time, uncomfortable—marriage of engineering and the ostentatious display that characterised the 1900 Exposition itself.

The Grand and Petit Palais followed a model not dissimilar in principle to Laloux's approach to the Gare d'Orsay: they boasted soaring steel frames and so recalled the old Palace of Industry that had been constructed for the 1855 Exposition, and which they now replaced. Yet the two new palaces shielded their iron skeletons with high, Baroque-style façades hewn from masonry, so that, like the new station, they combined the spatial advantages of modern ironwork with the lush décor inspired by more classical Parisian buildings: 'A sort of railway station where masses of stone have been piled up to support what?' opined one ambiguous reviewer: 'A high, thin roof of glass. A bizarre contrast of materials!'[53]

Eschewing industry, the Grand and Petit Palais housed fine art displays, as if to show that art and taste were now supreme. Among the exhibitions in the Grand Palais, the Impressionists finally had their moment of acceptance into the mainstream, with a display of paintings by Monet, Pissarro, Renoir, Degas, and Berthe Morisot—but even this was controversial: when President Émile Loubet was being shown around, his guide, a member of the French Institute named Léon Gérôme, grabbed him by the arm and exclaimed, 'Stop, *Monsieur le Président*, it's the dishonour of France!' The Exposition's real tribute to modernity may have lain in the opening of the first Métro line, but the Gare d'Orsay and the new exhibition palaces doffed their cap to tradition in the more exuberantly decorative styles that were reemerging.

The almost hedonistic nature of the 1900 fair unleashed the familiar Belle Époque worries about decadence and modernity. The symbol of the Exposition was a great, five-metre-high statue of *La Parisienne* by René Binet on top of the gateway to the Exposition on the place de la Concorde, where visitors passed beneath a dome supported by three soaring, strangely rococo steel arches flanked by minarets and studded Byzantine-style ceramic decoration and sparkling crystals: 'Everything', a French illustrator and art historian later wrote, 'seems to have been chiselled by a megalomaniac jeweller.'[54] *La Parisienne*—her jawline set in an expression of (haughty?) determination—was enrobed in the latest and most luxurious of Parisian *haute couture*, her 'supple and vital' curves (as one critic put it) a contrast to the rigidly engineered centrepiece of the 1889 Exposition, the Eiffel Tower: some of the harsher comments growled that *La Parisienne* represented the triumph of prostitution. The most visited attractions among the pavilions that spread out across the Champ de Mars were the Palace of Woman, the Palace of Fashion, and the Palace of the Decorative Arts.

This did not mean that the fair was devoid of science, technology, engineering, or the pursuit of knowledge. The French entries made much of Pierre and Marie Curie and Louis Pasteur, but ended up exacerbating French worries about national decline when the Germans carried off all the prizes. Some Parisian observers worried that the fair was going too far in encouraging people to think of themselves as consumers, indulging in the pleasures of the senses, rather than as citizens motivated by the more Spartan virtues of reason, patriotism, and republicanism.

It was not that fashion, style, and luxury crowded out science and technology, but that the 1900 Exposition seemed to define Paris less in terms of its intellectual rigour and technological genius than in terms of its *style*. Consumption was taking precedence over scientific ingenuity. The displays foregrounded the cornucopia of goods now available in the city's *grands magasins*—the great department stores: luxuriant fabrics, high fashion, new styles of patterned wallpaper, bicycles,

portable cameras, sewing machines, telephones, electric lightbulbs, and a whole range of modern, domestic comforts that seemed to point to a softening of the moral and civic fibre of the French nation. As the French historian Patrice Higonnet has suggested, '1900' seemed to be 'an ideological retreat' from the scientific rationalism and optimism of '1889'.[55] Contemporaries appeared to have agreed—and this despite the undoubted achievement that was the construction of the first line of the Paris Métro—that, along with the great exhibition spaces of the Grand and Petit Palais, the Pont Alexandre III and what is now the Musée d'Orsay represented the lasting legacy of '1900', its great contribution to Belle Époque modernity.

The friction between what '1889' was supposed to have represented and what '1900' supposedly incarnated came from the much wider, longer-term cultural context, in which Belle Époque commentators fretted about 'decadence' and 'degeneration' arising from modernity. By 1900, the speed of technological and social change appeared to be leaving the old world behind the shrinking horizon—it was 'a society about to disappear', the signs being 'a thousand important symptoms of degeneration', as Octave Uzanne had written.[56] The gloomy assessments of people such as Uzanne and Max Nordau, sadly, seemed to be confirmed by the statistical evidence which was being produced in reams by the experts of the day, numbers which, when put together, looked indeed to be proof of a great social unravelling: a diminishing population and falling birth rate, the stunted height of army recruits, endemic crime, alcoholism of epidemic proportions, and a moral decline evidenced by an apparent explosion in pornography and prostitution. Society was changing, and for anxious traditionalists, not in a good way.

While these developments arose within a specific, Parisian context of a relatively brief point in time, they shared something in common with all societies that experience rapid change. All such ages provoke anxieties about the speed and consequences of that change, and particularly in the ways in which it affects morality and social behaviour. Yet, for all that commentators might express their mounting concern,

and are often right to do so, it is also true that most people are able to live with the anxiety, to navigate the contradictions and tensions that exist within modern life. Indeed, when Belle Époque Parisians worried about degeneration and decadence, what they were probably commenting on was the consequence of the friction that naturally arises between change and tradition, movement and resistance, innovation and custom. We still live daily with this kind of friction today: it is perhaps the defining characteristic of the modern condition. In Belle Époque France, however, when this friction connected with the deeper, highly charged currents of the political-cultural conflict, 'the Franco-French war'—it became dangerous.

SPECTACLE

O n the Grands Boulevards of Paris, the whole of human life was out and about, spontaneously staging the endless daily and nightly drama of the modern city. The poet and novelist Francis Carco, taking refuge in Nice in 1940 as the Germans occupied the French capital, reminisced about the bygone days in Paris: 'In the eyes of the crowd, everything is a spectacle. To the crowd, the street appears to be one immense theatre where the most unexpected events follow, each one from another and which it does not cost a single centime to see. Neighbours exchange comments with each other: one approves or disapproves, one applauds, one rails, one whistles at the scene that unfolds before your eyes and each time, like at the theatre, one rarely plays the part of the actors.'[1]

The Grands Boulevards are the great arc of older, wide avenues on the Right Bank connecting the Church of the Madeleine with the site of the Bastille, describing the limits of the old city centre. It was here that, more than anywhere else, one could witness the most vibrant face of Belle Époque life: the theatres and the cinema, the

music halls and the *café-concerts*, the cafés and restaurants, the street stalls and shops, and the Morris columns plastered with advertisements for various delights and diversions, along with kiosks selling newspapers and books produced by an ever-expanding popular press. These were all the accoutrements of the modern city, a centre of consumption feeding a growing public and entertaining an expanding, prosperous middle class.

Yet, it did not take much to see that there were other sides to this face of Paris. Life on the boulevards was evoked so richly in the many nostalgic impressions of the Belle Époque perhaps because the memories elided fleetingly over the more sinister currents: the long-flowing political and cultural divisions, the harsh realities of the gross inequalities of wealth, and just—as we have now seen—fears of decadence and degeneration. The historian Colin Jones's apt description of Paris in the period is 'the anxious spectacle'.[2]

The historical memories of this tension have of course been overlaid by decades of other associations, but a walk along this ultimate site for the Belle-Époque-as-spectacle allows us at the very least to reflect upon the now hidden histories of the glories and the anxieties of the era. If with hindsight the Belle Époque appeared to be an age in which prosperity and progress of all kinds promised so much, only to be cut short by the carnage and accelerated pace of change in the twentieth century, it seemed to be expressed by a spirited lightness that was perennially *on display* in the circus, the sports arena, the galleries, the theatres and cinemas, the department stores, the great international exhibitions, and the clubs and music halls—the Moulin Rouge and the can-can. The Belle Époque was, in other words, an age of *spectacle*: and this was true right down to the street life—and, in particular, what the French call the *haut lieu* (high altar) of that spectacle, the Grands Boulevards.

By the late nineteenth century, the boulevards had already enjoyed a long life as the spaces for Parisian pleasure, sociability, and gossip—so it is ironic that their origins lay in warfare, following the line of the city's old fortifications—or rather, those of Charles V and

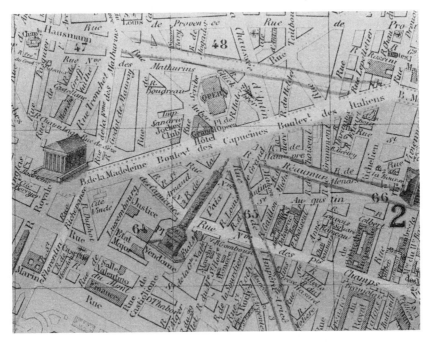

The Grands Boulevards start at the Madeleine in the west and cut diagonally through the city in front of Charles Garnier's opera house. In 1900, one writer described this stretch as the 'sanctuary of the spirit of Paris', and it was the ultimate site for the *flâneur*.

Louis XIII.[3] The original defensive purpose of this space lies in the very name 'boulevard', a Gallicisation of the Dutch *bolwerk*: bulwark, rampart, stronghold.

The boulevards were created in 1670, when Louis XIV, who had been traumatised by his childhood experience at the hands of his rebellious Parisian subjects during the Fronde rebellion (from which Durand's newspaper took its name—the word means 'slingshot'), ordered the walls to be levelled and replaced by a tree-lined avenue raised on dressed stones. While the fractious Parisians would be less able to resist his authority, they were compensated by a long, airy space for promenading.[4]

It was on the boulevards that Parisians mingled with the crowds and observed each other, and, in the fast-moving times of the Belle

Époque, where they experienced the rapidly changing life, land-scape, and spectacle of their city. Each section of the ring had its own character, as the Parisian historian Eric Hazan has put it, 'like the succession of rooms in an immense palace, each with its own décor, timetable, and habits'.[5] A guidebook issued in 1908 opened its chapter on the Grands Boulevards with this advice: 'The foreigner who wants to become familiar with Parisian life and get to grips with its phys-iognomy by mixing with Parisians and with pretty *Parisiennes*, will start with a promenade on the boulevards, with one or more stops at the terraces of the great cafés that have today almost all been trans-formed into luxurious *brasseries*.'[6]

For Belle Époque Parisians, the real glamour was in the western-most stretches from the Madeleine as far as the boulevard de la Bonne Nouvelle: 'Beyond that', opined one guidebook with, one hopes, con-siderable exaggeration, 'is unknown territory, the provinces, bar-bary.'[7] Parisians knew, however, that the true spectacle began at the colonnaded Church of the Madeleine (built in fits and starts between 1764 and 1842, with its glorious vista southwards down the rue Royale to the place de la Concorde). The square beneath the tower-ing columns of the church effloresced with a (still extant) flower mar-ket, where, among its vibrant spray of cut flowers, potted plants, and shrubs, 'the Parisienne can, according to her taste, decorate her cor-sage, her balcony, the window of her mansard room', the guidebook noted. 'This market is a meeting place. One flirts there. One chats there. It is the only market where one has a conversation,' it added. 'To wander among these two avenues is to walk in one of Love's back-stage areas in Paris.'[8] From here, a stroll north-eastwards, heading up the angle of the boulevard des Capucines, took Parisians past the glit-tering shops where the wealthy indulged their tastes in the offerings of the luxurious confectioners, jewellers, and florists—their windows aflame with rare orchids, azaleas, and lilies. At night, the electric lights blazed, and none more than those outside the entrance to the *montagnes russes*. These were roller-coaster rides run by the impresario Charles-Joseph Zidler (who became famous for creating the Moulin

Rouge with Joseph Oller), but they were first brought to Paris in the wake of the Russian occupying forces at the end of the Napoleonic Wars—hence their name.[9] Along the boulevard des Capucines on the left-hand side at the corner with the rue Scribe, the visitor might take time to admire the long, rather regimented façade of the opulent Grand Hôtel, where Zola's courtesan character, Nana, spends her last agonising days dying of smallpox—one wonders whether the author chose the spot because the hotel was opened under the Second Empire (in 1862) by Empress Eugénie herself. Opposite the hotel was one of the few stands in the city where one could hire a landau, one of the open-top carriages which were ideal for sight-seeing (and being seen).

Spectacular though the shopwindows and the entertainment may have been, it was the street life that was the real spectacle, and the Parisians and visitors who sought their pleasure there were acutely conscious of the fact. At the right time of evening, in front of Charles Garnier's exuberant opera house (according to Nguyễn Trọng Hiệp, 'Inside, the gold and the colour shine with a radiant brightness beneath the thousands of lights'[10]), the passer-by crossing the place de l'Opéra might have seen the 'avalanche of white ties, black suits, cloaks, furs, ball dresses or low-cut evening gowns, of jewels and feathered headdresses' pouring down the opera house's steps after a performance and heading to the Café de la Paix for one last glass of champagne to prolong the night's pleasures before heading home.[11]

The square itself, a bustling junction of streets heading in all directions, offered something of a respite from the human tide along the boulevards, with its cafés, its broad pavements, its streetlamps shaped like giant, bronze candelabra, and its views down the avenue de l'Opéra towards the Louvre and along the rue de la Paix towards Napoleon's column on the place Vendôme. Nearby, one could pass time spotting the writers and cartoonists of the *Gil Blas* satirical magazine at the Café Américain; or the journalists of the more serious *Presse* and the royalist *Gaulois* taking refreshment here, discussing the next issue or earnestly correcting proofs; and families enjoying an ice cream

at the Café Napolitain.[12] Here all forms of consumption—drink, food, print, and entertainment—jostled with each other.

After one crossed the place de l'Opéra and followed, first, the continuation of the boulevard des Capucines and then the boulevard des Italiens, one was on, according to the conventional wisdom at the time, the 'real' boulevard.[13] This, according to Edmond Deschaumes, author of a lavish guidebook for visitors to the Universal Exposition in 1889, was 'to the Parisian what Rome was to the ancient Romans': 'It is the country of enthusiasm and pleasure. It is sacred asphalt and three times holy. It is the sidewalk of fame.'[14] This was the stretch that A.-P. de Lannoy—the pseudonym of the political scientist Auguste Pawlowski—had in mind when he evoked the boulevards' many pleasures:

> It is on the Grands Boulevards that Paris converges: the club members have left the shaded avenues of the Bois and the seductive alleys of the Champs-Élysées; employees have fled the offices where they can barely breathe. The frosts chase the drinkers inside. In the overheated atmosphere, within the clouds of smoke, some play cards while others deal with business. . . . The greatest enterprises are born, developed and their fate decided between bitters and an absinthe . . . and the saucers pile up on the corners of tables. The Paris-Boulevard is a new, exuberant style of living, artistic to the end of its fingernails, hungry for spiritual ideas, greedily devouring the very latest news. . . . The boulevard is the sanctuary of the spirit of Paris. . . . From the Madeleine to the boulevard Sébastopol, it is the triumphal way, the crucible where the journalist and theatre critic can put themselves to the test.[15]

The boulevards des Capucines and Italiens were the territory of the *boulevardiers*—the wealthy men-about-town who met in the cafés, brasseries, and restaurants, which were a feast for the observer of Parisian life. This was the polished world of Marcel Proust. It was

in precisely these places that the refined socialite Charles Swann, Proust's character in the first volume of *À la recherche du temps perdu* (*In Search of Lost Time*), looks for Odette de Crécy, a onetime courtesan with whom he becomes infatuated. Swann has his coachman Rémi drive him from one restaurant to the next: 'He went all the way to the Maison Dorée, entered Chez Tortoni twice, and, still without seeing her, was just coming out of the Café Anglais, looking haggard and walking in great strides in order to regain his carriage . . . when he ran into someone who was coming in the opposite direction: it was Odette.'[16]

These were the haunts of agents and traders from stockbroking companies, journalists from the *Évènement* and the high-brow *Temps* that had their offices nearby. They were meeting places for politicians and civil servants (especially at the Riche), for army officers celebrating promotion (to the point that one waiter at the Café du Helder, known as Félix, became a 'flesh and blood directory' of the French army officer corps), and for theatregoers. Brokers streamed from the headquarters of the Crédit Lyonnais at the top of the avenue, sharing the latest information on the markets while bibliophiles browsed in the nearby Librairie Nouvelle. With the Havas press agency close by, in times of upheaval many Parisians would instinctively flock together on the boulevard des Italiens to hear the news and to share the latest rumours.[17]

Yet there was more: the boulevard des Capucines saw the first public showing of a new art form: cinema. The first film, a one-minute-long recording of workers leaving a factory in Lyon, had been privately demonstrated at scientific congresses in Paris, Lyon, and Brussels by the brothers Louis and Auguste Lumière, who used their patented 'apparatus to obtain and to show chronophotographic images' at a session of the Société d'encouragement à l'industrie nationale (Society for the Encouragement of National Industry) on the Left Bank, at the place Saint-Germain-des-Prés. The first public screening, however, took place on 28 December 1895 in the 'Indian Lounge' (*Salon indien*) in the basement of the Grand Café at No. 14 boulevard

des Capucines. Fewer than three dozen people paid the entry fee of one franc and entered the downstairs auditorium, perhaps with some trepidation. What they got was a series of ten short films that altogether lasted twenty minutes. They depicted brief scenes—of people fishing, a wall collapsing, a train arriving at a station, workers leaving their factory, a street scene complete with horse-drawn carriages and pedestrians, the sea at La Ciotat, a baby girl (actually Auguste Lumière's daughter) eating her soup, a gardener accidentally spraying himself with a hose. The small audience was astounded, and over the coming days queues would form down the boulevard as people massed to view the spectacle for themselves.

The technological marvel was turned into an art form by Georges Méliès, director of the nearby Théâtre Robert-Houdin of magic and illusion at No. 8 boulevard des Italiens. The Lumière brothers turned down his offer to buy their 'cinematograph' (*cinématographie* meaning 'writing in movement'), which he had initially sought as a tool simply to enhance his existing magic shows. Undeterred, Méliès designed his own camera; then he built a studio in the garden of his home in Montreuil, east of the city, where from 1897 he combined cinematography with his illusionist skills. His films included such recognisable classics as *Voyage to the Moon* in 1902, in which papier-mâché and backdrops helped produce the humorous sequence of a rocket landing in the unfortunate moon's eye socket.[18]

The Paris Exposition of 1900—true to its calling to give space to the pleasures of the senses—gave pride of place to the Lumière brothers' invention, setting up no fewer than eighteen projectors around the exhibition venues. Among the most spectacular was a cinema with a giant screen, twenty-one metres across and sixteen metres high. Even more so were the 360-degree 'Cinérama', which operated with the humming of ten projectors, and the 'Phono-Cinéma-Théatre', whereby one could watch, and—since this was the first, faltering attempt at talking movies—hear the stars of the stage and music hall perform, including Sarah Bernhardt. After 1900, cinema took off both as an art form and as a source of entertainment. At this

stage, there were no dedicated cinemas, so projectionists went from one improvised venue to another, such as fairgrounds, music halls, and cafés, to exhibit their films. Until 1905 many of these sites were along the Grands Boulevards, where theatres and cafés or restaurants with backrooms or basements could offer them space.[19]

Sometimes these improvisations had tragic consequences. Every year, society ladies organised a charity bazaar, the Bazar de la Charité, and laid on entertainment in marquees: in 1897, films shot through the Lumière brothers' invention were screened. At one showing, the projectionist struggled to keep his ether lamp lit and accidentally sent a flame shooting across the audience, setting fire to the marquee. Parents and children were trapped behind a turnstile as the whole tent went ablaze—later, the dandy Count Robert de Montesquiou, whose wife died in the fire, fought a duel with the poet Henri de Régnier for insinuating that the aristocrat had squeamishly used the tip of his cane to lift the blanket that covered his wife's charred body.[20]

Eventually, the inventor Léon Gaumont and entrepreneur Charles Pathé both established their own studios. Pathé opened factories for film and development in the suburbs, but in the process commercialised the venture of filmmaking, beginning to build dedicated cinemas from 1906. While they first appeared on the Grands Boulevards, filmhouses were also constructed in the outlying working-class districts. Far more affordable than the theatre, the movies were virtually tailor-made for the mass culture that was on the make in the Belle Époque.[21]

In the 'anxious spectacle' of the age, this democratisation of culture caused some concern. Along with the emergence of mass transport in the shape of the Métro, the expansion of such spaces for mingling as public parks, and the universal expositions, the cinema was one of those features of modernity that threatened to blur or break down social and gender distinctions. As the writer Charles d'Avenel opined enthusiastically, these were places where 'duchesses and millionaires rub shoulders with cooks and clerks'. But not everyone thought that this was a good thing.[22] It was fine for the well-to-do

bourgeois to enjoy 'slumming' in the night spots of Montmartre, but that was on their own terms. It was another for social hierarchies to be broken down spontaneously. Cinema addressed the crowd—it rapidly became a tool of mass culture and mass communication. Alongside universal male suffrage, the widespread availability of printed news, and the mobilisation of large-scale political movements, the cinema appeared to be a symptom of the democratisation of culture. As the philosopher Jean-Paul Sartre recalled of the cinema of his childhood, it 'had popular ways that shocked serious people. It was an amusement for women and children. My mother and I loved it.' Not everyone agreed. Sartre noted, for example, that his grandfather and father had preferred 'the social hierarchy of the theatre', and, 'accustomed to second balconies', had developed 'a taste for ceremonial'—the social rites that theatre affirmed. 'The movies proved the opposite,' wrote Sartre. 'I developed a dislike for ceremonies, I loved crowds.'[23]

Even early observers worried that, to capture the market, filmmakers were already yielding to the temptation to emphasise the sensational and the emotional. Would it ever be possible, cultural commentators fretted, to reconcile good taste and artistic beauty and style with the demands from the urban crowd for more 'vulgar' forms of entertainment? Moreover, both Pathé and Gaumont made not only movies, but also newsreels: the *Pathé-Journal* from 1909 and the *Éclair-Journal* (Flash-Journal) from 1912, respectively. They created another accessible source of news, information, and, potentially, propaganda or subversion—a point that was not lost on the authorities. When, in 1899, Méliès started making a film about the Dreyfus Affair, based on the press accounts that he read, the film was banned on grounds that it would provoke public disorder. As with so much else in the Belle Époque, the controversies over the cinema went to the very heart of the conflict between modernity and tradition and the anxieties about the corrosive effect of democratisation on culture and on civic virtue. Yet even without the technological novelty proclaimed by the cinema, the same anxieties were also in evidence in theatre.

At the top of the boulevard des Italiens, past the great, throbbing junction at the rue de Richelieu and rue Drouot, one passes successively the Théâtre des Variétés, the Théâtre des Nouveautés, the Gymnase, the Théâtre de la Renaissance, and the Théâtre de la Porte Saint-Martin. The long stretch almost all the way from here to the place de la République has an eclectic feel to its architecture and commerce, and in the Belle Époque was less well-heeled than the stretch around the Opéra. This, instead, was the playground of apprentices, shopworkers, and office clerks—yet all the more exuberant for that, skirting as it did the artisanal Sentier district to the south and the old working-class *faubourgs* of Montmartre, Poissonnière, and Saint-Denis to the north.

The theatre was (obviously!) part of the spectacle of Belle Époque life. Paris witnessed something of a boom in theatre-building in this period: in 1870, there were around thirty in the city, but by the early 1900s it could boast no fewer than forty.[24] In the last two decades of the nineteenth century, half a million Parisians went to the theatre at least once a week—and even more did so less frequently. The Parisian, wrote one journalist, 'lives in the theatre, for the theatre, by the theatre'.[25] The buildings themselves were meant to be spectacular. As one architect put it in 1893, 'The theatre is a place of luxury and its job is to reflect this. The public loves lavish displays.'[26] They were dotted around the capital, catering to all tastes, including the fringe and the avant-garde. Improvised venues sprang up for 'popular' theatre, often produced by intellectuals seeking to mobilise the masses in a political cause.[27] This diversity permitted productions to embrace the various anxieties and frictions that roiled the Belle Époque: the poet Francis Carco, later reminiscing about these years, opined that 'the theatre was the prolongation, the culmination, of the life of society'.[28]

Parisians still speak today of *le théâtre de boulevard* in the way a Londoner might talk of West End or a New Yorker of Broadway, meaning productions that by and large conformed to the prevailing tastes and values of their audiences—although in Paris, these were tinged

with a titillating hint of the risqué, as with the farces of Georges Fey-deau.[29] Émile Zola's 1879 novel *Nana*, set in the late 1860s, opens in the Théâtre des Variétés on the boulevard Montmartre. Here at the Variétés, Nana appears as the eponymous character in a play called the *Blonde Venus*. What Nana utterly lacks in talent she makes up for in her voluptuous figure and her brashly seductive, sexualised rela-tionship with the audience. Having grown up as the feral daughter of alcoholic parents in Zola's earlier novel, *L'Assommoir*, Nana now has a career that weaves between being an actress and a courtesan, with some street prostitution in between. Wrapped only in a gossamer-thin veil on the stage, she 'flaunt[s] her nakedness with a cool audacity, sure of the sovereign power of her flesh', Zola wrote. She is 'a disturb-ing woman with all the impulsive madness of her sex, opening the gates of the unknown world of desire'.[30] Zola's presentation of Nana played on the deep-seated sense that the catastrophic fall of 1870–1871 had come about because women like her—corrupt, independent—had emasculated male citizens, bringing about the country's moral collapse. The implication was that a return to morality, one that included a restoration of women to their 'proper' place, would ease France's recovery.

Yet French stage actresses gained respectability under the Third Republic. If, in the wake of the defeat and revolutionary incendiarism of 1871, actresses were seen (like Nana) as little better than prostitutes, their image was steadily made more reputable until they fit com-fortably in society, and indeed, until they served the purposes of the regime's republican values and society's morality.[31] As the historian Lenard Berlanstein has argued, it was not that the Republic's bour-geois leadership was entirely devoid of the libertinism in which their predecessors indulged. The politicians of the Third Republic were as likely to be found hovering around the stage door in reality as Zola's Second Empire characters were to fawn inside Nana's dressing room in fiction. But the theatre and its denizens, including actresses, were increasingly bound up in the wider evolution of a more sophisticated consumer society that, as we shall see, included the department store,

and that depended heavily on women as consumers outside the home. Actresses were increasingly seen as women primarily driven by their art and their career. The intertwining of theatre and theatre women within the wider evolution of middle-class society made it seem far less threatening for some women than it had been in previous eras to pursue a career providing commercial entertainment—even if this admission, inevitably, seemed to require a reaffirmation of the argument that the ultimate destiny of women was motherhood and the home.[32]

The most spectacular example of this kind of respectability could be found right by the old triumphal arch of the Porte Saint-Martin. Here, between 1893 and 1899, the greatest stage performer of the day, the 'Divine Sarah' Bernhardt, took over the lease of the Théâtre de la Renaissance, becoming at one and the same time manager, director, and lead actress.[33] Taking on strong but still recognisably traditional female roles, she interpreted them in the way that her public expected: sure enough, some of her most popular plays were those that demonstrated female heroism—including that of Cleopatra, Tosca, Gismonda, and Joan of Arc—while remaining resolutely 'feminine' as the Belle Époque understood it.[34] Bernhardt's memoirs are far from reliable—as one of her biographers writes, she was 'a complete realist when dealing with her life but a relentless fabulist when recounting it'.[35] Nevertheless, there was honesty in her own reflection upon the relationship between myth and truth in her professional career when she wrote, 'I have sometimes tried to compel the public to return to the truth and to destroy the legendary side of certain personages whom history, with all its documents, now represents to us as they were in reality, but the public never followed me. I soon realised that legend remains victorious in spite of history.'[36] In other words, she gave the Belle Époque the spectacle that it wanted to see.

Sarah Bernhardt became an early manifestation of that modern phenomenon: theatrical stardom, whereby not just what she did on stage, but also what she did off stage, became matters of public consumption. She worked with the great dramatists of the day,

including Victor Hugo, Victorien Sardou, and Edmond Rostand. In 1900, she had herself sewn into a figure-hugging male costume for the eponymous role of *L'Aiglon*—the youthful Napoleon II, the son and heir of Napoleon—who died in exile in 1832, but who (in Rostand's play) hears the stirring call of the distant bells of Paris, a patriotic calling that resonated with audiences still smarting from the humiliating defeat of 1870–1871. And an iconic moment in the stunning spectacle of Bernhardt's stardom arose at the Théâtre de la Renaissance in late 1894, when the Czech artist Alphonse Mucha produced the ground-breaking publicity for her production of *Gismonda* by Victorien Sardou in what would become his trademark Art Nouveau style.

Mucha had been producing illustrations for magazines and books while also working at the Lemercier printing company when Bernhardt telephoned his employer on 26 December asking for a poster advertising *Gismonda*. Mucha was given the task because all the other artists were off on their Christmas break. The result astounded even Bernhardt herself: it broke through the boundaries of theatre publicity by its long, vertical format, its portrayal of the actress, dignified, costumed in a heavy robe of pastels and gold, and surrounded with floral and cloisonné motifs. The actress was so pleased that she commissioned Mucha to produce posters for her future productions and to design the costumes. It was Mucha's breakthrough moment, one that is still sometimes taken to be a ground-breaker for the Art Nouveau movement.[37] It caused a sensation: it is not hard to imagine this poster drawing the attention of the promenaders, café patrons, and theatre-goers on the boulevards after it was pasted up on the Morris columns on New Year's Day 1895. People frequently paid the bill stickers to slip them a copy of the sought-after print.

Sarah Bernhardt not only provided spectacle for the Belle Époque—she was herself nourished by the spectacle of the Belle Époque and by the consumer society that sustained it. At the height of her popularity, she lent her name to soaps, boxes of sweets, and perfumes. Henry James remarked that if the 'trade of a celebrity' had

not already been invented, Bernhardt would have done so, writing, 'She is a child of her age—of her moment—and she has known how to profit by the idiosyncrasies of the time. . . . She has in a supreme degree what the French call the *génie de la réclame*—the advertising genius; she may, indeed, be called the muse of the newspaper.'[38] She was so successful that after surrendering the lease of the Théâtre de la Renaissance in 1899, she took over the Théâtre des Nations on the place du Châtelet, giving it her own name—and the theatre bears her name to this day.[39] Bernhardt and some of the other stars of the era showed that it was possible to be an actress while fulfilling Belle Époque fantasies of femininity and adhering to society's expectations for women. In the theatre, Bernhardt exhibited the virtues expected of bourgeois womanhood while asserting her strength and independence.[40] She reflected a wider, if gradual, change in broader perceptions of women in public life: that is to say, women who were busy and visible outside of the domestic sphere to which they were meant to be constrained. While the scope remained very limited, the boundaries of what were acceptable activities and behaviour for women were beginning to shift.

The south side of the boulevard beyond the Porte Saint-Martin and then the Porte Saint-Denis has a certain charm: the pavement is well removed from the traffic, elevated as it is on a terrace created under the July Monarchy, when the roadway was levelled but the sidewalk kept its original height. Walking, one passes by the Théâtre de la Porte Saint-Martin, which was originally built in the 1780s on commission from none other than Marie Antoinette. This theatre was burned down during the Communards' eastward retreat in the face of government forces in 1871, and a new building—the current one—rose in its place, reopening in 1874. It was here that Edmond Rostand's *Cyrano de Bergerac* premiered in 1897, to the salutations of traditionalists precisely because, although Cyrano defies convention, he is also honourable, brave, at one and the same time a poet and a soldier who uses his talents to help a friend win the very woman he loves. 'At last,' exclaimed the critic Jules Renard on seeing the

play, 'we shall be able to talk about a love other than the love of humanity!'[41]

From the theatre, one can press on to the place de la République, completing the whole ring of boulevards by crossing the square and continuing down the boulevard du Temple. This was once dubbed the 'Boulevard of Crime', not because it was a den of muggers, thieves, and murderers, but because the vaudeville theatres along this stretch specialised in melodramas that invariably involved their heinous acts. Much of the street life on this final stretch down to the Bastille is quieter: one passes by the winter circus—the Cirque d'Hiver, which during the Belle Époque also screened films. At the place de la Bastille end (which still has much to offer today), the boulevard jostled with *café-concerts* that attracted the working population of the eastern districts.

The boulevards served as a stage for the rich variety of human life on display. This brought out the *badauds*, or gawkers, who stopped to watch the life of the city—construction workers on their scaffolding, bill stickers pasting their posters on the Morris columns, or, most spectacularly, the *arracheurs de dents*—street dentists who, for a fee, could use their muscle and skill to pull out a tooth not only for the benefit (one hopes) of the patient but also for the entertainment of the crowd of onlookers who invariably gathered around to watch the spectacle.[42] Yet, this being Paris, life on the boulevard was always being more discreetly watched, contemplated, and weighed up by the leisurely, detached observer of urban life, the *flâneur*.

The *flâneur* was someone who idled away the hours in urban wandering, with little in the way of a clear purpose other than that of observing the life of the city and the people within it. *Flâneurs* appear earlier in the nineteenth century in the novels of both Honoré de Balzac and Gustave Flaubert, but perhaps the best description was published in 1863 in the *Figaro* in an essay by the poet Charles Baudelaire. This essay focuses attention on what Baudelaire calls 'the painter of modern life', and the painter in question was the suave watercolourist Constantin Guys, who specialised in street scenes:

The crowd is his element, as the air is that of birds and the water of fishes. His passion and his profession are to become one flesh with the crowd. For the perfect *flâneur*, for the passionate spectator, it is an immense joy to set up house in the heart of the multitude, amid the ebb and flow of movement, in the midst of the fugitive and the infinite . . . So out he goes and watches the river of life flow past him in all its splendour and majesty . . . He gazes upon the landscapes of the great city—landscapes of stone, caressed by the mist or buffeted by the sun. He delights in fine carriages and proud horses, the dazzling smartness of the grooms, the expertness of the footmen, the sinuous gait of the women, the beauty of the children, happy to be alive and nicely dressed—in a word, he delights in universal life.[43]

A *FLÂNEUR* WAS someone who observed the city's comings and goings, its changes and its vicissitudes, without necessarily fully understanding or engaging with them, but possibly learning from what he saw.

Yet even as the *flâneur* melted into the crowd, the better to observe it, *flânerie* involved some detachment from it. The passer-by was, by definition, a passer-by because one came into close physical proximity with others without actually noticing or acknowledging their existence. The republican historian Jules Michelet called such immersions into the masses 'populous solitudes': 'In order to judge movement, you have to be both in it and not in it,' he wrote. 'You have to see the crowd without being caught up in its whirl and made dizzy by it.'[44]

Critics suggested that the *flâneur* was in fact an outsider alienated from the modern life that he watched so dispassionately, and that, like others, he was unable to escape the atomisation that one felt within the modern metropolis. In 1903, the German sociologist Georg Simmel remarked that in the city, one was 'alone amidst everyone else'.[45] This sense of alienation flowed from the way in which modernity itself

had developed: traditional 'organic' relationships based on kinship, trade, occupation, and neighbourhood ties were broken down, and a more impersonal, individualist society, where relationships were fundamentally economic and transactional, had developed. Jean Jaurès's former classmate and friend, the sociologist Émile Durkheim, identified one consequence of this facet of modernity as *anomie*, a social condition in which norms and regulations were uprooted by the pace of change, leading isolated individuals to feel so unmoored from the rest of society that they slipped into crime and deviance. In 1911, Jaurès himself recalled the moment when he had first encountered a powerful sense of social atomisation within the city's faceless crowd: 'I remember that it was about thirty years ago when I arrived in Paris, just a youth. Alone in the immense city one winter night, I was overcome by a sort of fear for society. I thought I saw thousands upon thousands passing each other by without recognition, an uncountable crowd of lonely ghosts unmoored from all human connections.'[46]

While for Jaurès, this atomisation was closely bound with the gross inequalities of wealth of Belle Époque society, it was also positively encouraged by the pleasures of the modern metropolis, including mass entertainment and consumerism. For the interwar philosopher Walter Benjamin, its ultimate expression was the prostitute: she represented the commodification of relationships and, in her 'mythical communion with the masses', symbolised the mass production to which nineteenth-century capitalism ultimately pointed. She was 'saleswoman and wares in one'.[47]

Walter Benjamin's image of the prostitute exposes one of *flânerie*'s problems: it was a pastime primarily afforded to men. Yet the slowly evolving position of women in the public spaces of Parisian social life touched on some of the most sensitive anxieties that roiled the Belle Époque: those related to gender. Society as a whole was held to be ordered in terms of a natural, indeed biological, inequality between men and women. There were preordained areas of activity for both men and women: the public world of work, politics, and spaces of leisure for the former, the more confined domestic world

of marriage and motherhood for the latter.[48] At a time when women (at least 'respectable' women) had little or no independent, unescorted access to the sites of Belle Époque pleasure, such as the café, the theatre, the music hall, the club, and sporting events—there was an exception, as we shall see in the next chapter, in the department store—*flânerie* was broadly considered to be a masculine activity. Only men had the freedom to explore the city at will and unmolested—women were denied such liberties.[49]

Even the women Impressionists Berthe Morisot and Mary Cassatt tended to place their Parisian subjects in domestic environments, such as the drawing room, the bedroom, balconies, verandas, and private gardens—and the outdoor locations they depicted tended to show particularly bourgeois pastimes, such as promenading in the park, attending the theatre, or boating.[50] In 1879, the artist Marie Bashkirtseff protested to her diary, 'What I long for is the freedom of going about alone, of coming and going, of sitting in the seats of the Tuileries, and especially in the Luxembourg, of stopping and looking at the artistic shops, of entering churches and museums, of walking about old streets at night; that's what I long for; and that's the freedom without which one cannot become a real artist.'[51]

For a woman to be alone as she sat down at a café table, or entered a restaurant or *café-concert*, was for her to risk sullying her own virtue, disgracing herself and, at the very least, being subjected to the gaze of the male *flâneur*, to be objectified and appraised as an object of sexual desire. Baudelaire was unapologetic: 'No doubt Woman is sometimes a light, a glance, an invitation to happiness, sometimes just a word; but above all she is a general harmony, not only in her bearing and in the way in which she moves and walks, but also in the muslins, the gauzes, the vast, iridescent clouds of fabrics in which she envelops herself . . . in the metal and mineral which twist and turn around her arms and her neck, adding their sparks to the fire of her glance, or gently whispering at her ears.'[52]

For most critics, the very idea of the *flâneuse*—the *flâneur*'s feminine counterpart—was horrifying: If a woman could hide among

the crowd, then she might be able to free herself from the bonds of social control and break out from the strictures that sought to shape her behaviour and constrained her freedom to act. If the object of the *flâneur*'s observation became herself the critical observer, then this was an act of reversal in the gender roles that were supposed to order the family and society alike. Such anxieties may also have reflected broader concerns that, in the expanding economy of the Belle Époque, newer forms of employment, particularly in financial services, retail, and communications, were drawing thousands of young, unmarried women to Paris and other great cities—unattached, potentially uncontrolled, and so quite possibly dangerous to the hierarchies of gender and class on which society was supposedly based.

In reality, the freedom these young women enjoyed, in their choice of job, accommodation, and even partners, was hemmed in severely by rules, convention, and the male dominance of most public spaces. *Any such* freedom on the urban terrain was feared as potentially corrosive of the rigid gender divisions upon which the social order was thought to depend. In fact, *because* unescorted women were barred from most of the indoor venues of pleasure and leisure, the boulevard was one of the places where they *could* go unescorted, at least if they were in groups, which young, working-class women often were.[53]

Among those who descended on the boulevards were the *grisettes*, or, more usually, the *midinettes*. Since the seventeenth century, the term *grisette* had referred to young working women, particularly the seamstresses in the garment trades, the nickname coming from the cheap grey fabric of the dresses they wore. The term also carried connotations of flirtatiousness, frivolity, and gaiety, particularly in song and popular literature, a fantasy that was a far cry from the lives of hard graft that they mostly led. In her poverty, the *grisette* could gravitate into prostitution, so she also came to be associated with sexual licence. She was at one and the same time believed to be an essential wheel crushed in the machinery of the Parisian economy and an obliging, fun-loving, sexually available figure—an object

of affection by writers and songsters.[54] The *grisette* had her ultimate incarnation in Mimi Pinson, the eponymous character in Alfred de Musset's 1845 short story who became the prototype for *La Bohème* in Giacomo Puccini's 1896 opera. After the mid-nineteenth century, although people still spoke of the *grisette*, she began to recede into the past as a stock character, a figure of nostalgia for the 'old Paris' that was rapidly disappearing. Symptomatic of this Belle Époque nostalgia is the statue by Jean-Bernard Descomps from 1911, *La Grisette de 1830*, who today still gazes across the traffic from her pedestal on the Square Jules Ferry, appropriately enough on the border between the then working-class 10th and 11th arrondissements.[55]

By the time of the Belle Époque, the *grisette* was being replaced in Parisian lore by the *midinette*, a Parisienne who worked (ideally) in one of the *haute couture* houses, although the name was applied to any young woman working in the garment trade. The word's origins lay in the fact that she often appeared outside at midday—*midi*—for her *dinette*, or lunch break. Like the *grisette*, she was meant to be hardworking and earnest, oblivious to or wearing lightly the grinding hours and working conditions while also being fun-loving, pretty, and romantic, an object of male desire and, their admirers fantasised, available. As one writer opined in 1908, 'Her physiognomy is alert, at times cheeky, her eyes sparkle with spirit. She is bright, lively, and impulsive; she is always joking, and seems indifferent to even the most painful events. At heart, she is very sensitive, sentimental even, and goes from laughter to tears like a child.'[56]

Yet the *midinette* diverged from the *grisette* in some essential ways. Firstly, she was a little more liberated—in the *haute couture* shops, at least, she was better paid, which gave her a little more freedom to indulge in the pleasures of the city. Secondly, she was stylish, which, in the lore, at least, made her both desirable and an embodiment of modern French womanhood. Thirdly, she moved in groups with her workmates, particularly at the fabled lunch hour, which allowed them to take control of the public space of the boulevards for themselves. An article in *Gil Blas* in 1888 wistfully described how such women

would burst forth 'in large numbers': 'They imagine themselves *chez elles. . . .* Between 11 and noon, the street belongs to the midinette.' The author went on to imagine their return to work, and, at the end of the day, a further, exuberant invasion of the streets and boulevards as they walked arm in arm with each other, admiring the displays in shopwindows and maybe heading for assignations with their lovers before heading home.[57]

And indeed, in 1908, a worker from one of the great *haute couturiers* on the boulevard des Italiens wrote to the journal for working women, called (what else?) the *Journal de Mimi Pinson*, echoing this description: 'We leave the workshop, jovial, noisy, prattling on with energy about the little twists and turns of the day, making a remark in passing about the *première* [supervisor] who is too authoritarian or who sticks too much to the old routines. Then we talk *métier* [talk shop] and we admire some new design, then . . . I don't know, maybe we hatch a surprise for the saint's day of one of our own or contemplate a nice trip to the country on Sunday, whose arrival, consequently, seems to us slow to come.'[58] The same worker described how 'amused, the passers-by watch us and make . . . their remarks'—some flattering, others 'insulting propositions'. The women developed strategies to deal with the harassment: a smile to the kinder and politer comments, but a shrug and severe look 'to keep the louts in line'.[59]

The boulevard was becoming less of a male-dominated site than it once might have been. The working woman of Paris, though finding safety when accompanied by her colleagues, could claim for herself at least some space, some of the time, on the boulevards. It might not have been *flânerie*, and the *flâneuse* might have remained invisible in the literature and painting of the day, if she existed at all.[60] But the economic development and cultural and social growth of Belle Époque Paris, the importance of women to an increasingly diverse range of forms of work, and the emergence of new kinds and places of leisure all converged to make the boulevards one of those rare spaces where male dominance was not absolute. They were becoming, instead, places where relations between men and women were

more fluid.[61] And in yielding some space to women, unescorted, free, exuberant, on the pavements and on the café terraces of these avenues of pleasure, the teeming, complex environment of the city also surrendered some of the ground in which the male-dominated public world could, however momentarily, be breached.

A full range of Belle Époque pleasures was on display on the Parisian boulevard. So, too, was the diversity of Parisians from all social backgrounds, from top-hatted, white-scarved dandies straight out of Proust, lounging at the tables of the pavement terraces of the boulevard des Italiens, to opera-goers having a post-theatre drink and an *amuse-gueule*; from the middle-class couple out to the theatre to enjoy some of Rostand's rambunctious fare to the hardworking artisanal family going to see their first-ever cinematograph; and from the journalists clustering around a café table, unwinding after making the next day's deadline, to the satin-sheathed streetwalkers sashaying along the pavement. The street—with its newspaper kiosks; its Morris columns advertising theatre, opera, and music; its electric streetlamps; and its serpentine Guimard Métro entrances—proclaimed its modernity. This spectacle—for that is what it was—was real enough.

But the spectacle was in itself an escape from the hard realities of life in Belle Époque Paris, realities that we will soon encounter. We ourselves live in an age where we sometimes speak of certain types of entertainment as 'pure escapism', a sense of the stresses of modern life momentarily ebbing away. Unless you were one of the élite who did not need to work, like Proust's characters, then spending some time admiring—while also being *part of*—the spectacle of the Grands Boulevards, and indulging in the many pleasures that these streets had to offer, was a welcome diversion from the daily struggle for survival. And if the *haut lieu* of the era's spectacle was the Grands Boulevards, the high altar of Belle Époque consumerism was the department store.

CHAPTER 4

LUXURY

Émile Zola did not lack for ambition when making notes for his 1883 novel: 'I want *Au Bonheur des Dames* to be the poem of modern-day activity,' he wrote.[1] What he ultimately crafted was a battle of the sexes, represented, respectively, by the spirited Denise Baudu, a store assistant, and the smooth, thrustingly ambitious Octave Mouret, the store's owner. Mouret is a widower who has taken over his wife's haberdashers, a *magasin de nouveautés*, and expanded it into a massive emporium. His aim nothing less than the exploitation of women, he sets out to inspire their acquisitive impulses—and through shrewd marketing, sales techniques, and display in the vast building the store occupies, he ultimately proves devilishly successful at doing so. It is a rich story chronicling the working life of one of the great commercial establishments of Zola's age: the *grand magasin*. Zola's novel, in other words, describes the operation of the modern department store.

In Belle Époque Paris, these commercial institutions—now part of the fabric of cities around the world—aroused both enthusiasms

and concerns about the direction of modern society. Spectacular to look at architecturally, modern but (usually) not too daring in their design, they were situated short distances from railway stations and the boulevards and avenues, so they could draw customers from across Paris and beyond. Their internal organisation was aimed at connecting customers with a cornucopia of luxuries from around the country and the wider world. In other words, they responded to the gradual democratisation of consumption that was in evidence during the period, making merchandise more available that had previously been enjoyed only by the privileged few.

Yet, as expressions of consumerism, Belle Époque department stores excited some of the same concerns about modernity that are still raised today. French commentators of the time worried that deliberately tickling people's acquisitive impulses would sap the moral and political (especially republican) fibre of the populace. If department stores, along with advertising and the media, both then and now, do much to shape and to promote standards of beauty, so feminists both then and now have debated the issue. While Belle Époque feminists debated whether conformity with prevailing expectations of feminine style and looks helped or hindered their cause, modern-day feminists discuss whether conformity to imposed standards of beauty underpins the persistence of male power. In the Belle Époque, male power was entrenched institutionally in the department store, as elsewhere. As we shall see, these establishments certainly gave the women who worked within them conditions that other forms of labour did not (becoming part of the wider shifting landscape of the changing nature of women's work). Still, their earnings and opportunities were restricted compared with those enjoyed by their male colleagues, and in their daily routine, their comportment was closely monitored and controlled, often (though not always) by male supervision. Finally, the department store, as a large-scale enterprise, put considerable, indeed sometimes terminal, pressure on their more traditional, smaller competitors, who could not cast their

net as widely for customers and who could match neither the diversity nor the price of the luxuries on offer.

THE PARISIAN DEPARTMENT store first emerged during the Second Empire, made possible by the relative political stability and prosperity under Napoleon III. When Aristide Boucicaut, in what would become a familiar trajectory (and indeed one followed by Zola's character Octave Mouret), opened a *magasin de nouveautés*—a store selling fabrics, millinery, drapes, and household linens—in 1852, it met with such success that the entrepreneur diversified his stock. He witnessed the first stone of his purpose-built department store being laid on the rue de Sèvres in the 7th arrondissement in a quiet ceremony in 1869—although the building was not entirely finished until 1878, a year after Aristide himself had died.[2] Boucicaut's Au Bon Marché was the ground-breaker for the *grands magasins*, which enjoyed a particularly rich flourishing during the Belle Époque. It was in this period that several important department stores were founded, including Au Printemps (1881), Établissements Dufayel (1887), the Bazar de l'Hôtel de Ville (1902), La Samaritaine (1905), the Grand Bazar de la rue de Rennes (1906), and the Galeries Lafayette (1906–1907).[3]

The department store became a distinctive feature of the Belle Époque city, both architecturally and socially. In his 'poem of modern activity', Émile Zola wrote a lavish account of the 'cathedral of modern commerce'.[4] The store where the fortunes of Denise Baudu, the decent, upright, determined assistant, and owner Octave Mouret, loosely based on Aristide Boucicaut himself, become intertwined, Au Bonheur des Dames (usually translated in English editions as The Ladies' Paradise or The Ladies' Delight), happens to be located on what was at the time of action called the rue du Dix Décembre (now the rue du Quatre Septembre). One of Haussmann's creations in the 1860s during his renovations of Paris, it is not that far from two of the

actual department stores on boulevard Haussmann, Au Printemps and the Galeries Lafayette.[5]

Zola's research was meticulous—his notes run to eight hundred pages. He spent long hours exploring the real department stores of the area, especially Au Bon Marché and the Grands Magasins du Louvre (founded in 1855), speaking to people involved with every level of the operation. Because he was already a famous novelist, the stores welcomed his presence. In March 1882, the chief managing officer of Au Bon Marché wrote to Marguerite Boucicaut, who effectively had been running the company since her husband Aristide's death in 1877, saying, 'The famous *naturalist* writer—that is what people call him—wished to tour Le Bon Marché because he plans a novel in which a *magasin de nouveautés* will figure prominently. I showed him the whole establishment and he was wonderstruck. I hope, if he portrays a department store, that he will do so with some other pen than the one he used to write *Nana*—or *L'Assommoir!*'[6] And so it would prove.

Among those whom Zola consulted was a young, up-and-coming Belgian Art Nouveau architect, Frantz Jourdain, who would himself go on to design La Samaritaine. The fictional Au Bonheur des Dames building plays its part in the story, as the narrative is interwoven with lavish descriptions of its architecture: 'Space had opened up every-where, air and light flooded in, the public circulated freely beneath the bold, flowing branches of the roof beams. It was the cathedral of modern commerce, light and solid, made for a congregation of customers.'[7]

Zola's notes include a description of how a department store should look—the author of the unsigned document may have been Jourdain.[8] The architecture of any self-respecting department store building, Zola's informant explained, served a dual purpose. On the one hand, it was to make a statement, advertising the shop itself and drawing in the crowds. On the other hand, it was to be practical enough to fulfil its fundamental role, which was to sell the luxurious goods inside.[9] So at street level, around the great window displays, the

building should be 'sober and mute, so as not to vie with the merchandise'.[10] Zola's character Denise and her two brothers, newly arrived in Paris, are stunned at their first sight of the shopwindows of Au Bonheur des Dames: 'A display of silks, satins and velvets blossomed there, a supple and vibrant range in the most delicate floral tones: at the top, the deep black and milky white velvets; beneath them satins, pinks, blues . . . fading into infinitely tender shades of infinite tenderness; lower still, the silks in the whole span of the rainbow, pieces rolled up into shells, or pleated as if around an arching waist.'[11] Higher up the façade, 'the decoration gradually gains in intensity and importance, to finish at the eaves in frankly striking and brilliant style'.[12] It was in the upper reaches of the frontage that the designer could really indulge in the fantasies of grandeur, spectacle, luxury, and modernity necessary to meet the establishment's commercial function. Its scale, and, inside, its exposed and ornamented iron pillars, beams, stairways, and balustrades, the glow of electric lamps, and the whir of hydraulic elevators, reinforced the department store's image as a cathedral for modern consumption.[13]

The buildings were justifiably regarded as being at the cutting edge of commercial architecture. Their scale and purpose demanded space and light, a need that was served by an iron frame which could bear heavy loads yet convey a sense of lightness, with natural light flooding in from outside—especially from above. Light, Zola's correspondent insisted, was 'primordial' in a building of this kind.[14] When Nguyễn Trọng Hiệp visited Au Bon Marché, the first line of his verse described it as 'an immense house open on all sides'.[15]

The airiness of the interior would be reinforced by the centrepiece: 'All the galleries would fan out from an immense polygonal or circular room rising, in one leap, to a dome made of stained glass and set in a gilded framework,' Zola's correspondent wrote. 'The buffet could be in this space, bathed in the light and colour and luxuriantly decorated and arranged with the richest fabrics and most sumptuous furnishings that the store offered.'[16] Thus the customers would be assailed by displays of the finest merchandise and—if only for a short

time—experience the luxury for themselves. The inspiration came partly from the shopping arcades of an earlier era—passages with glazed roofs protecting the clientele from the elements and sheltering them from the clamour, dirt, and 'riff-raff' of the street: these arcades had their heyday in the July Monarchy of the 1830s and 1840s. Then there were the great halls of the universal expositions, which strove for the same elements of light and space, although department store buildings were more sophisticated, because they required several floors, along with galleries, stairways, and bridges.[17]

Laying out the various departments to ensure that shoppers were happy circulating through the store was something of a science. It had to be done 'in a rational and methodical way', so that customers would not have 'to make tiring searches' and engage in 'useless backtracking', noted Zola's informant.[18] Internal decoration had to 'identify with the building, respond to its aims, [and] complete the general character of the structure'. But the Parisian climate would play a part, too: 'To combat the fog, grey skies, rain and snow to which Paris is susceptible for seven months in the year, the decoration should in general be bright and luminous. It should not be drowned in detail.'[19] Boldness, at least at eye level, should be left to the real 'brilliance and richness of the fabrics, dyed cloths, furnishings, clothing, and the thousands of objects that such a store contains'. It was only at the upper reaches of the interior that the architect could enjoy more splashes of design and colour in the features of the building itself.[20]

While the general form was similar from one store to the next, the actual aesthetics varied considerably. The department store certainly had to be, as *Le Monde illustré* put it in 1889, a 'Palace of Marvels' that seduced the passer-by and astounded the customer.[21] But it also had to be as attractive as possible to as much of the public as possible—that is, modern, but not so avant-garde that it was off-putting for a clientele with largely conventional tastes.

By and large, the architects succeeded in achieving this fine balance. A look today at the different surviving Parisian stores suggests that they reflected the predominant taste of the era in which they

were constructed rather than helping to shape it.[22] The Bon Marché, built on the rue de Sèvres between 1869 and 1878 by a father-and-son team of architects, Louis-Auguste and Louis-Charles Boileau (with the iron framework by none other than Gustave Eiffel)—the first Parisian purpose-built department store—is relatively sober and classical in style, cautiously reflecting its pioneering role.

Frantz Jourdain was in fact an innovator in department store design—and sometimes this could go too far for contemporary tastes. In 1882, if he was indeed author of the note to Zola, he had written that the style of a department store should be inspired by 'new needs': 'A newborn society should have . . . architecture that is unique to itself', he insisted, rather than being held in thrall to 'a past that has forever been extinguished'.[23] The husband-and-wife partnership Ernest Cognacq and Marie-Louise Jaÿ engaged him to remodel the interior of their original store, the first Samaritaine, in 1891, and then, as business expanded, to create the purpose-built second Samaritaine on the banks of the river Seine. The second store was completed in 1910.[24] Jourdain, an enthusiast for iron and an Art Nouveau zealot, sought to imprint the 'new architectural grammar' on his creation.[25] In 1902, he had become the first president of the Société du Nouveau Paris—a group of Art Nouveau enthusiasts whose very name was a gauntlet thrown at the Commission du Vieux Paris, the city's conservation body formed in 1897. Theirs was a radical effort to drive the city towards embracing new forms rather than preserving the old.[26] So Jourdain's Samaritaine store incorporated a visible metal frame with an extravagantly sinuous ironwork façade of tendrils, leaves, and flowers weaving across a frontage designed by his son, Francis. Two domes peered out over the Seine, their cupolas gripped by iron trellises laced with copper flowers and surmounted by lanterns and spires emerging from a veritable bouquet of iron vegetation.[27] The most striking feature of Jourdain's original design, now renovated (the store was closed for many years until its reopening in the summer of 2021), is his stairs in the building on the rue de la Monnaie (Magasin 2): The iron beams and bolts are barely hidden—quite the opposite!—but

they are softened with a light grey paint and balanced by the floral curlicues that decorate the bannisters as the steps race symmetrically up the light well. The stairs finish beneath a vast glass canopy supported by walls decorated with painted murals depicting stylised flowers, trees, and peacocks, fanning their feathers in soft, golden hues.

At the time the public mostly hated it. The defenders of *le vieux Paris* loathed the way in which the unabashedly Art Nouveau building overlooked the oldest bridge in the city, the Pont-Neuf, and intruded upon the skyline along the river. In 1910, the mainstream *Gazette des Beaux-Arts* remarked that Jourdain was using the building to write his 'manifesto for iron . . . conceived in the lyricism of his spirit of revolt'. Others were far less polite. The writer and critic Rémy de Gourmont seethed in 1911 that he wanted to see 'whoever [had] so dishonoured the banks of the Seine' strung up from the domes that he had created. The hostility continued unabated after the First World War: in 1924, the *Revue de l'art ancien et moderne* called down 'the winter rains' in order to obscure 'the all-too-modern décor of La Samaritaine'.[28] In fact, when the Cognacq-Jaÿs' company applied for permission for an extension in 1922, the city authorities agreed on condition that Jourdain's domes were razed. From 1926, Jourdain and his colleague Henri Sauvage covered the elaborate ironwork with new cladding and windows: the exterior of the Samaritaine visible today is more Art Deco than Art Nouveau, although in some places one can still see some of Jourdain's original work coyly peeking out.[29]

Few places better capture the kind of exuberance in luxury and extravagance that the department store—and Zola's character Octave Mouret—actively promoted than the Galeries Lafayette. Like Au Bon Marché and Zola's fictional Au Bonheur des Dames, the Galeries Lafayette had humble beginnings. It first opened as a little shop run by Alphonse Kahn and Théophile Bader in 1895 on rue Lafayette (from which the store drew its name), on the corner with what was then the upmarket rue de la Chaussée d'Antin. Kahn and Bader gradually bought up the entire building, and in 1906 they purchased the adjacent strip of real estate running westwards along

the boulevard Haussmann. It was here that the store designed by Georges Chedanne was completed in 1908. When, in 1910, Kahn and Bader acquired the rest of the block, formed by rues Mogador and Provence, the extension was confided to Ferdinand Chanut, who included its stunning centrepiece, an iconic glazed cupola, over the soaring central space.[30] With its bright, elegant span and spray of colour reminiscent of a fan, the dome, high above the shopfloor, is breathtakingly opulent and worth admiring from amidst the human currents of shoppers. The coloured panes were created in 1912 by the Art Nouveau glass artist Jacques Gruber. Today, the best view of his work can be had by stepping out onto the 'glass walk' of the top storey, which juts out vertiginously from the third-floor gallery, directly beneath the dome and over the central shopping hall in what is now the main building (La Coupole). Between the perfume counter below and the glass dome immediately above, the galleries of the intermediate levels circle the central space—indeed, just as Zola's informant said they ideally should. The elegantly curving balustrades of the grand central stairway are said to have been designed by none other than Louis Majorelle, the master of French Art Nouveau best known for his furniture featuring the familiar whiplash curves and graceful inlays. The stairway, sadly, was removed in 1974, on the grounds that it was no longer being used by the public. But the dome still draws much attention today.[31]

Next door, along the boulevard Haussmann to the west of the Galeries Lafayette, is Au Printemps (At Springtime). Like its neighbour and rival, the first Au Printemps building was built in ways that evoked its purpose but did not offend public tastes. Constructed in the 1880s by Paul Sédille, it picks up the theme of spring—the store's name was intended to evoke freshness and renewal—by including motifs such as garlands, florets, palmettes, and acanthus leaves. But these are relatively subtle, confined to the window frames, to reliefs running along the upper levels, and to the domes that rise from the store's corners.[32] A second, neighbouring building, on a plot westwards along the boulevard Haussmann, was taken on by René Binet

in 1906. In the bustle and traffic of the street today, it is not always easy to pause and inspect the architecture, but one can see that Binet was comparatively restrained in his design. He had triumphed in 1900 with his Art Nouveau–style entrance to the Universal Exposition, topped with the *haute-couture*-clad 'Parisienne', but with Au Printemps he was careful not to break with Sédille's original style.[33] As Sédille remarked when he designed the first Au Printemps building, the features had to 'command attention' and leave a positive impression 'that would be carried home as a souvenir by the foreign or provincial visitor'.[34] A visit to the rooftop terrace (which on the way takes you directly beneath another colourful glass dome) provides a good close-up view of a couple of Sédille's towers, as well as a spectacular sight of the back of the Opéra Garnier. From here, too, one can look down boulevard Haussmann, which (not accidentally) was associated with the wealthier classes who benefitted from the prefect's renovations. From 1909, Marcel Proust wrote *À la recherche du temps perdu* in an apartment at No. 102, entombed inside a cork-lined room for soundproofing. The Impressionist painter Gustave Caillebotte drew inspiration here, his paintings including *L'homme au balcon, boulevard Haussmann* (1880), depicting a man with top hat and frock coat studying the tree-lined boulevard below from a balcony shielded with a red-and-white-striped awning. He also painted, in 1878, the rue Halévy, towards the Opéra Garnier, from what appears to be a servant's room in the eaves—a *chambre de bonne*—on the corner of the boulevard and the rue de la Chaussée d'Antin.

The view from the rooftop of Au Printemps also reveals how carefully the department stores were integrated into the wider fabric of the modern city. The boulevard Haussmann, driven through the area by Napoleon III's prefect, connected at one end with the bottom of the rue Lafayette (and from there to the Gares du Nord and de l'Est) and, at the other end, with the avenue de Friedland, and thence to the Arc de Triomphe at Étoile (and the prosperous west of the city).[35] Yet the two stores also cast their appeal much wider, for they are both

within easy walking distance of the Gare Saint-Lazare, the station serving connections to the north-west and the coast.

If Au Printemps and the Galeries Lafayette appealed to an unapologetically bourgeois clientele, Au Bon Marché, on the Left Bank, sought to attract the more middling classes of the southern parts of the city, while the Bazar de la rue de Rennes sought to capture provincial visitors arriving by train from the south and west into the Gare Montparnasse (its original built in 1840). The Bazar de l'Hôtel de Ville and Samaritaine, with their central locations, could seek to draw in a socially more modest customer base—and even more so could the Grand Magasin Dufayel, located in the 18th arrondissement, at the bottom of Montmartre's eastward slope on the edge of the working-class district of the Goutte d'Or.[36] The owner and founder, Georges Dufayel, made purchases more affordable by selling coupons to customers for down payments, the rest payable in monthly instalments. By 1904, he could boast no fewer than 3.5 million people on his credit system—a number so enormous that it would have extended far beyond the geographical limits of Paris and included lower-middle-class and working-class subscribers.[37] It also showed that, despite the grinding poverty that was much in evidence in the outer arrondissements of the city, mixing with the elegant *bourgeois* and *bourgeoises* around the counters of Au Bon Marché, La Samaritaine, and, especially, Dufayel, was not off-limits to the better-paid Parisian workers.[38] One might expect that Jean Jaurès's socialist newspaper, *L'Humanité*, would seek to discourage such working-class aspirations to middle-class consumerism, but in 1904 it published a short notice on Dufayel, explaining that one could subscribe to its coupon scheme (through which one could repay purchases from a free catalogue at fixed monthly payments) at no fewer than seven hundred shops around the country, 'which makes it much easier to offer goods without straining budgets'.[39]

So the department stores were carefully woven into the material and social fabric of the modern city that had made their existence possible. Haussmann's often brutal reshaping of Paris—with its

emphasis on facilitating communications, establishing broad street connections between railway stations, and easing traffic through the construction of boulevards and avenues—alongside the introduction of public transport, broke down the sense of distance within the dense urban labyrinth and enabled the department stores to have a wide geographical 'reach' across the metropolis. It became easier for Parisians, suburbanites, and provincials to consider shopping far beyond their own neighbourhoods. Shopping by catalogue and home delivery services would not have been feasible without the 'Haussmannisation' of Paris and the modern amenities that succeeded it. The department store was the ultimate expression of the emergence of a mass consumer society, of the evolving place of women in Belle Époque society, and of the brutal realities of economic competition.

The department store both drove and responded to what Zola called 'democratising luxury': the expansion of a consumer society in which the acquisition of material comforts and luxuries were markers of fulfilment and status.[40] That so many of the stores founded in the nineteenth century are still in business today is a testimony to one of their essential qualities: their ability not only to meet the demands of a mass clientele, but also to *create* the demand by turning their wares into objects of desire. This was achieved through a variety of strategies, including the promise of a rich, diverse range of goods, aggressive advertising, fixed prices, cut-price sales in the slow seasons, prompt and efficient service, the guarantee of quality through a policy of 'returns', sumptuous window displays, and the careful layout of the shopfloors to encourage browsing and impulse buying.[41]

All of this marked a break with older ways of shopping. Most retailers before the mid-nineteenth century were specialised, neighbourhood storeowners: drapers, haberdashers, milliners, linen-sellers, pewterers, stationers, tailors, umbrella-sellers, glovers, perfumers, jewellers, and so on. It was expected that the customer who had entered a particular shop did so to fulfil a specific need and that the visit would end with a purchase. The customer dealt directly with the shopkeeper or one of the assistants, who alone had access to all the

wares on sale—behind the counter, in drawers, or in storage. Before the exchange was complete, there would be a process of negotiation over price, haggling that could be time consuming and stressful.

Department stores, by contrast, emphasised *entrée libre*—a term still seen on shopwindows today—meaning that customers were allowed to wander freely among the displays without the pressure to buy. Goods had fixed prices, so there was no bartering: the emphasis was on low profit margins but with a larger number of sales and a rapid turnover of stock. Nguyễn Trọng Hiệp captured the atmosphere in these lines:

> *The resonance of the murmur of the tides of buyers and the thousands*
> *of goods whose incomparable splendour deceives the eyes.*
> *One would think that one was seeing the 'Market of the Sea' trans-*
> *ported to the centre of the Capital.*[42]

The 'Market of the Sea', according to Chinese legend, was the market of the immortals: when the light refracted on the water, creating the impression of colour, that was because the immortals had gathered for their market. On one level, the passage from Nguyễn was a poetic description of the wash of colours the emporium presented. Yet, at another level, the very comparison—and indeed the presence of Nguyễn himself at Au Bon Marché—are also reminders that, interconnected as the department stores were by rail and steam with the wider world, some of the merchandise would have come from the French overseas empire. It is true that most French imports from its colonies were raw materials and agricultural produce (bananas became a feature of French marketplaces in this period, and coconut was used for, among other things, the making of margarine, a far cheaper alternative to butter, which was a real luxury for Parisian working families). But it is also true that French consumerism was fed by more sumptuous colonial products—furnishings, fabrics, ornaments—and by advertising that used colonial (often racist) imagery, including on teas, chocolate, coffee, and soaps.[43]

Once the shopper had made her choices, the shop assistant would lead the client with the goods to a cashier, who recorded the details and price in a ledger before money was exchanged. The customer could then go home carrying her purchases—boxed up or bagged—or, in another innovation, could use the delivery service.[44] Au Bon Marché boasted stables and vehicles for precisely this purpose—and it was a source of publicity: postcards produced by the department store in this period and now in the archives of the Musée d'Orsay include one depicting the fleet of horses, carriages, and deliverymen proudly lined up on the street outside as if on parade.[45] The sheer scale of a single one of these enterprises was captured by the sociologist Georges Avenel in 1896, when his research on Au Bon Marché showed that the *glissoir*, the conveyor belt in the delivery room at the lowest level of the building, handled eighty-seven thousand parcels a year from the provinces and from abroad, and that was before those taken in from Paris were counted.[46] The *glissoir*—a not-too-distant forerunner of the machinery used by present-day online retailers—also featured on Au Bon Marché's postcards.[47]

The department store sought to make the experience of shopping more enjoyable than it had been previously and, crucially, more likely to be repeated.[48] Shopping itself was being turned into a leisure activity: the store became a social as well as a commercial space, with places for people to linger. There were rooms dedicated to relaxation, to reading, to letter-writing, and to exhibitions of paintings, sculptures, and photography, as well as cabinets where customers could use telephones and send telegrams.[49] The ultimate example of these kinds of facilities was in the Grand Magasin Dufayel in the northern 18th arrondissement. Georges Dufayel, anticipating modern shopping malls, effectively turned the enormous hulk of his store at No. 22 rue de Clignancourt into a leisure space with shopping. The vast floor area of his building included a reading room, a concert hall, a garden of palm trees, an ice cream buffet, and hugely popular winter gardens, where families strolled and picnicked to the strings of the Harmonie Dufayel, the store's own orchestra. For a period, customers

were invited to experience for themselves the 'human opera glasses'—Wilhelm Röntgen's new medical discovery, the X-ray—at work. There was also a cinema, in which the young Jean Renoir, the future film director, recalled seeing his first-ever movie in 1897.[50]

This new way of shopping explicitly targeted women. Octave Mouret, Zola's smoothly cynical owner of Au Bonheur des Dames, felt no compunction about his success resting on 'the exploitation of woman': 'It was woman for whom the stores competed, woman whom they continually trapped with their bargains, after making them dizzy with their displays. . . . [H]e was building a temple to her . . . [and] he thought only of her, relentlessly trying to find ever greater forms of seduction, while behind her, when he had emptied her purse and frayed her nerves, he was full of the same secret contempt held by a man for a mistress who had made the mistake of giving herself to him.'[51] The suggestion was that women abandoned their senses and became insatiably acquisitive. It is just as well, for his own sake, that Mouret is a fictional character: Marguerite Durand, embracing luxury and style for feminist purposes, would surely have given him a run for his money.

'FEMINISM OWES SOME success to my blond hair: I know it thinks the contrary but it is wrong'—these controversial words were penned by Marguerite Durand in an article in *La Fronde* on 1 October 1903.[52] And Durand, everyone agreed, was beautiful: in her obituary in 1936, the feminist Georges Lhermitte wrote that in order to understand her remark, one had to have known 'how resplendent with beauty she was during this era. The phrase was true. Marguerite Durand appeared to be a beacon towards which all other efforts converged.'[53] Blue-eyed, blonde, fair-skinned, she was often compared with Marie Antoinette. Durand argued that flaunting her beauty at least made it more likely that she would be listened to: writing in 1902 in *Le Temps*, she urged Frenchwomen 'not to renounce their privileges, elegance of manners and dress, charm, [and] beauty', but to use them to advance

women's rights.[54] To a very great extent, playing to male fantasies of womanhood for political purposes stemmed from Durand's own experience as an actress. As the historian Mary Louise Roberts has decisively shown, acting and feminism were interwoven for Durand, with the former enlisted in the service of the latter. The very theatricality of Durand's political appearances—lecturing to audiences; wooing voters while resplendent in feather boa, plumed headdress, and an evening dress shimmering in velvet and lace; and, most spectacularly, campaigning with her pet lioness, whom she called (in a deliberate paradox) 'Tiger'—was a means of drawing attention to feminist causes.[55] It was also a way of trying to explode the stereotypes, common at the time, firstly of feminists as 'unwomanly'—as *hommesses*: women-men made ugly by their choices—and secondly as hostile to men (one cartoon depicted a bicycle-riding feminist bumping over Cupid's testicles).

Durand and her colleagues on the *Fronde* were 'New Women': *femmes nouvelles*, who had broken out of the domestic ideology supposedly imprinted on all women by biology.[56] Yet, while her office staff all wore smart green dresses, Durand's particular brand of feminism to some extent rested on precisely the kind of consumerism that was oxygen to the *grands magasins*. As her friend and colleague on *La Fronde*, Séverine, noted, the very glamour of Durand's political appearances was a means of drawing attention to feminist causes.[57] Durand argued that 'taking good care of oneself and the pursuit of elegance are not always, for the feminist, a dereliction, a pleasure. It is often extra work, a duty that she must take on, if only to deprive superficial men of that argument that feminism is the enemy of beauty and of the feminine aesthetic.'[58] This aesthetic could have an impact, because, as Mary Louise Roberts has suggested, it both addressed and used the mass culture of the Belle Époque. Durand was tapping into the consumerism on which both mass culture and the department store were (and are) based. She drew on the mystique of beauty widely promoted by the full arsenal of an expanding consumer society—cosmetics, fashion, couture, and the *prêt-à-porter*

goods aimed at a mass market—as well as on portrayals of women by women (first in the theatre, then in the cinema), by advertising, and by the women's press.

Modern-day critiques of 'the beauty myth' (to use Naomi Wolf's term from her 1991 book on the issue) argue that, even as women and men have begun to stand on more equal terms, so women have been subjected to mounting pressures to conform to standards imposed by the media and by consumerism.[59] Durand, for better or for worse, played their game in the cause of feminism by conforming to such standards.

Beauty guides suggested that cosmetics were not just good for a woman's looks, but carried health benefits, too. What the historian Mary Lynn Stewart calls 'the swell of beauty consciousness' in the Belle Époque coincided with the evolution of feminism in this period and also engaged with it. Some beauty writers reinforced Marguerite Durand's position: in 1907, one beauty expert, the Baroness d'Orchamps, in a book on 'women's secrets', baldly stated that feminism, after all, was nothing less than 'a revolt of the feminine soul against some abuses of masculine power'. Others, such as the comtesse Tramar, suggested that feminism would turn women into hermaphrodites.[60] The point is that Durand was tapping into what were effectively politically neutral (though not gender-neutral) phenomena—the cult of beauty and the consumerism of the Belle Époque—but trying to inject them with feminist significance. The department store, in fact, encapsulated the intersection of the aesthetics of femininity with consumption, of women's agency and the anxieties that these things unleashed. As the art historian Ruth E. Iskin has suggested in her study of advertising in the Belle Époque, the images of women enjoying the range of goods on sale suggested that they had agency as consumers—and in fact this was reflected in the social reality that slowly, gradually, changes in the law were giving women more control over their own earnings. This was no small matter considering that, in 1891, just over a quarter of all Frenchwomen were in waged employment.[61]

At the same time, during an era when 'respectable' women had little easy, individual access to the places of leisure unless they were chaperoned, the department store provided a (fairly) safe space where they could act with relative freedom. Women were able to move about the space of the department store without escorts and finally become *flâneuses*. Their identities as wanderers and observers of human life were facilitated by the mirrors that were affixed to department store walls throughout, which allowed for discreet study of other shoppers.[62] Zola noted that in the department store there was a veritable 'cult of woman, the woman as queen': women reigned over the store en masse as if it were 'a conquered country'.[63] Although the prevailing ideas of gender roles at the time still consigned women to the home, women could also be consumers in the marketplace of the Belle Époque city. This activity was regarded as an extension of their domestic role—purchasing goods for the household was part of managing the home—but with the department store it entailed entering a massive public space offering the possibility of independence and agency. Women's journals at the time grasped this: as historian and literary scholar Rachel Mesch has shown in her engaging study of *Femina* and *La Vie Heureuse*—referring to the titles of two illustrated magazines that first hit the kiosks in 1901 and 1902, respectively—the journals promoted an image of femininity that at one and the same time celebrated women as consumers of cosmetics, soaps, corsets, petticoats, and so on and advocated greater freedoms and opportunities for women in daily life. These magazines made it clear that they did not see participation in this kind of consumerism as breaking from women's traditional, domestic roles, but rather as expanding their traditional spheres of activity. Women as consumers, women with more agency than before, yet who remained essentially bound to the hearth, were not 'New Women', feminists of Marguerite Durand's stripe—they were something more cautious: *femmes modernes*. The modern woman may not have carried the banner for women's rights, but her intellectual independence, her embrace of new activities while never eschewing her traditional role as wife, mother, and daughter,

made new opportunities imaginable.[64] In this sense, the department store—perhaps even despite itself—may have encouraged the gradual emergence of aspirations for greater equality between women and men.

As one might expect, conservative critics loathed the department store. The right-wing nationalist Maurice Barrès railed against the unbridled consumption, the apparent licence it gave to women, and the republican regime that enabled both.[65] Yet department stores also worried republicans. Women yielding to their desires within these female-dominated spaces were in their view abandoning the modesty and self-restraint with which they were supposed to manage their households, a shift that would eventually corrode the republican fibre of the family as a whole.[66] 'It is in vain that revolutions have transformed political values,' opined the fashion critic Octave Uzanne. 'Nothing has changed. Fashion dominates the eternal feminine more than ever.'[67] Doctors diagnosed kleptomania in a small minority of women: one expert studied 120 cases of shoplifting, of which 111, he argued, stemmed from various conditions, including delirium, hysteria, menstruation, pregnancy, nervous disorders, or 'moral or physical exhaustion'.[68]

The department store was also an important workplace for women. It was not until after 1914—when many of the men went off to war—that women would make up the majority of workers. Even so, Belle Époque women worked in large numbers in these places: in 1910, there were 4,500 employees at the Bon Marché, of whom 1,350 were women; at the Galeries Lafayette and Au Printemps, women made up 1,000 of, respectively, 2,700 and 1,350 employees, making the latter the only Parisian department store where the majority of sales assistants and office staff were women.[69] They were not wide-eyed peasants from the countryside or working-class girls on the make, but rather young women from lower-middle-class families (like Zola's Denise Baudu), often with Parisian backgrounds and usually with working experience in smaller stores—sometimes (again like Denise) their own family businesses.

Working at a department store *was* an improvement on the alternatives. With the expansion in the economy, the appearance of new forms of leisure, and improvements in women's education, traditional jobs became less attractive to young working women: seamstresses and domestic servants might have envied the leisure time—brief though it was—and money that department store workers had. There were the higher rates of pay than in most other jobs open to them: an experienced sales assistant could earn seventy-five francs a week, compared with seventy-five francs a month for a woman working in manufacturing. Moreover, department stores awarded 0.5–3 per cent commission to employees for sales, so the salesclerk who could persuade customers to part with their money could earn more—although this also meant, as Zola noted, there was no camaraderie among the staff, but only 'jealousy . . . rivalry, moroseness, hatred: the struggle for survival', competition that of course suited the department store.[70]

The job had perks, of a sort. Half of the unmarried women who worked in Parisian department stores were given lodging, although it was in rather austere, spartan rooms at the top levels of the buildings, as with Au Bon Marché. There was also the possibility of promotion through the hierarchies of assistants and the various benefits, which—if a woman was kept on long enough—might offer security in retirement. Most store owners, like the Boucicauts and the Cognacq-Jaÿs, provided pensions, retirement savings funds, and medical care, as well as occasional outings to the countryside. This can be contrasted with the hundreds of low-paid seamstresses who laboured to produce the store's 'own brand'—ready-to-wear clothes—either in basement workshops or in external sweatshops. Called *ouvrières* (workers), rather than *employées*, they did not share in the benefits enjoyed by the floor staff.[71]

Even so, the hours for sales assistants were very long. They were expected to be at their posts at 8 a.m. every morning, with the stores open until 8 p.m. in winter and 9 p.m. in summer. Fines were levied on late arrivals. A law in 1892 limited the working day for women to ten hours (and there was almost always a day off on Sundays from the

1890s), but the department stores found ways around this, especially in the evenings—*veillées*—before big sales events. Salesclerks were expected to be polite, charming, and well groomed at all times, no matter how tired they were deep into their shift, where the pace could be frenetic. The hour break for lunch undoubtedly came as a welcome relief, but it was strictly regimented: the women were not allowed to wander outside the store (in the Galeries Lafayette they were actually locked into their dining hall), but had to march, en masse, from their posts to the lunchroom under the watchful eyes of one of the store's 'inspectors'.[72] Those who lived in the rooms on the top floor were guarded by a concierge (no male visitors allowed!) and subjected to a curfew of 10 or 11 p.m.

The relentless activity in often stuffy conditions and in close contact with the public may explain why the incidence of tuberculosis among store employees was no lower than it was among other Parisian workers. A damning medical report in 1903 found that 'most of the department stores record a terrifying level of morbidity and mortality among their employees, to the point that those who remain for several years and avoid tuberculosis are the exception'.[73] Until 1900, when the *loi des chaises* forced department stores to provide women employees with chairs, they had to stand non-stop. Even after the legislation, the salesclerks were not allowed to sit while there were customers in the vicinity, and when the customers were gone, they had to reorder the displays, meaning that opportunities to rest were actually few and far between.[74]

There was no job security, particularly for those just starting out. Many of the positions were temporary, to bolster the full-time staff in peak seasons, after which the extra employees would be laid off. In quiet seasons, there was always the fear that even regular staff might face the axe. Marguerite Durand's *La Fronde* reported on this lack of security for women workers, in particular, in December 1897 noting that some of the *grands magasins* had over a number of years been steadily suppressing women's positions on their workforce. Soon, the newspaper claimed, all the jobs would be held exclusively by men.

This ignored the fact that women's moral and intellectual qualities equalled those of the men, said *La Fronde*: 'How can woman escape the state of inferiority in which she is held, despite herself, if she is systematically prevented from earning a large enough salary to uphold her dignity?' The directors of the *grands magasins*, in fact, were all too aware that it was the women's knowledge of certain types of goods—linens, lingerie, haberdashery, for example—that ensured their success. *La Fronde* proposed a boycott of the *grands magasins* that were engaged in these shady employment practices.[75]

Workplace discipline remained severe and inflexible. The women wore uniforms (usually a black silk dress) and were watched closely. Each department had a head—a *premier*—whose power over the sales assistants included hiring and firing—and they were usually men (and indeed *La Fronde* also raked its fire on the exclusion of women from these more senior positions), which meant that some were not above sexually abusing their charges. In one case at Au Printemps, a mother wrote to the owner on behalf of her daughter, an employee, who had been threatened with dismissal by her *premier* unless she slept with him. Also intrusive were 'inspectors', often former policemen or soldiers, who were charged with preventing theft and keeping watch over the salesclerks. The clerks could be fined or dismissed for infractions such as poor appearance, a bad hair day, talking back to superiors, actual or perceived rudeness to customers, or failure to satisfy a customer's demands (or allowing them to leave before they had made a purchase and spoken to the department *premier*). Even romantic liaisons were policed: relationships between employees were strongly discouraged. If the management got wind of one, then for the sake of the store's 'respectable' image, the couple were told to get married or face dismissal. Au Printemps fired an employee when it was discovered that she had a child and was of 'light morals', another because she had left her husband and was now living under an assumed name.[76]

Most women employees were unmarried, but there does not appear to have been any pressure to resign when they did tie the knot. Once a marriage had taken place, store owners gave the couple

a gift—customarily 100 francs—and a married employee who gave birth might receive a bonus of perhaps 200 francs. The Samaritaine even provided a day nursery for the children.[77] All this seems to contradict the fantasy—common amongst commentators and writers at the time—that women department store workers had particularly loose sexual morals and engaged in prostitution to satisfy their desire for luxuries.

Even so, the precarious nature of their position shows that the women operated within the same narrow social constraints affecting all Belle Époque women. Occasionally—very occasionally in this period—they rebelled: in October 1907, when the male employees at the Galeries Lafayette went on strike, they secured the women's support by demanding an end to the policy of locking women into their lunchrooms at mealtimes; instead, the strikers said, they should be allowed to go outside the store during their break if they wished. Eventually, during a massive walkout at the Bazar de l'Hôtel de Ville in November 1909, some fifty women joined strike meetings and urged the men to greater action—many of them were fired. In the following year, a 'Feminine Section' of the department store workers' trade union claimed two hundred members, a small proportion of the employees but a number that would grow from the First World War onwards.[78]

And for all the ambiguity of their status, department store employees became distinctive figures on the Parisian cityscape. Usually unattached and with a little leisure time and relatively decent earnings, the women could be seen at concerts, cafés, and the more affordable restaurants (including the famous Belle Époque *bouillons* catering to the burgeoning population of white-collar workers). Zola noted that some cafés were practically monopolised by department store clerks and shop assistants. Women salesclerks were particularly fond of the *café-concerts* found in the outer *quartiers* of the city. Zola commented that, as a group, they could make or break a singer's career through their applause or whistling. They frequented the public dance venues, such as those on the place du Château Rouge (not far from Dufayel)

and in the Elysée-Montmartre (in 1880 the Belle Époque painter Jean Beraud captured this venue, with the pleasures of the dance, the glow of the lanterns, the trees strung with pearls of lights, and the quiet flirtations off the dance floor). The women took to the bicycle joyfully, as it gave them mobility that allowed them to make full use of their leisure time. Others promenaded together, aiming to enjoy the spectacle and experience of mingling with other people—domestic servants, office workers, bourgeois families out for a stroll—and to be admired themselves: with their black silk dresses, their well-polished boots, and their gloved arms and their hats, it was often easy to spot the groups out on the town. There was a perfume of glamour about them that belied their long hours and their strict and somewhat monastic existence in the store itself.[79]

As the experience of women employees suggests, the department store was both a symptom and a driver of deeper social and economic changes. Yet the mass consumption of which it was part came at a cost: it drove many of the independent retailers to the wall. Indeed, the brutal economic realities that the department stores presented to their smaller, more vulnerable competitors are one of the currents in Zola's novel. The hard-boiled Mouret has little sympathy for the smaller store owners, who included Denise's own uncle. With his 'Provençal verve', Mouret at one point explains how the large-scale accumulation of stock, sold at very low profit margins, but at fixed prices and with rapid turnover, was part of 'the great revolution' in retailing. In the narrator's words, Mouret adjudged that 'if the old shops, the small shops, were in torment, then it was because they could not sustain the battle over low prices. . . . Competition was taking place beneath the very eyes of the public.' Although this was happening only 'with the slimmest possible profits', the effect was devastating: 'It was overturning the market, it was transforming Paris, because it was made from the flesh and blood of woman.'[80]

Mouret sees himself simply as the instrument of a greater, impersonal power, the power of economic progress, rather than as someone who has any real agency in determining the fate of his competitors. In

his later book *Germinal* (1885), Zola would return to the dilemma that economic change presented: competition was the driver of progress, but this amounted to the ability of the stronger to consume the weaker competitor. When he applied this insight to the harsh existence of the coal-mining communities of northern France in *Germinal*, Zola's sympathies were with the weaker, the innocents who got crushed beneath the wheels of economic progress. Yet when he had addressed the same phenomenon among the Parisian commercial classes in *Au Bonheur des Dames*, he seems to have been rather more ambiguous.[81]

It is perhaps small wonder that, watching events from Toulouse, Jean Jaurès's socialist awakening began in 1889 as a result of the very process of economic change that Zola had addressed in *Au Bonheur des Dames* and in *Germinal*. 'The small and middle-sized manufacturers, the small and middle-sized shopkeepers bend under the weight of large-scale capital,' Jaurès wrote. 'The latter alone has the means to establish large mechanised factories; they alone have the credit to purchase goods very cheaply. That is how, little by little, the smaller shops are absorbed by the bigger, and how the small employers are devoured by the big companies.' For Jaurès, big capital did not just exploit the workers: it also devoured the middle class of producers and traders—and the *grands magasins* were very much part of the process. The example he cited was none other than Au Bon Marché: 'The house of the Bon Marché, in Paris, has scarcely appeared within the last twenty years. And yet on her death last year Mme Boucicaut left a fortune of 120 million francs. How many businesses had to disappear, how many independent concerns were swallowed up in order to make that fortune?'[82] This is a cry that is repeated today from in-person retailers (now including department stores themselves) faced with the challenge of global online retailers. Yet, interestingly, the selling points that made the department stores (in particular) so successful in the Belle Époque may be the key to the survival of (some of) them today: the promise of personal service; the direct browsing through the range of the actual, physical objects on sale; and the wider experience that shopping in-person might offer—refreshment,

entertainment, sociability—as Dufayel, in particular, had understood so well.

If Jaurès had felt himself being drawn towards a strongly democratic form of socialism, the Parisian shopkeepers lent their support to the nationalist Right, helping in 1900 to break the long-standing Radical Republican dominance of the Paris municipality. They did so for a complex jumble of reasons—the picture, in fact, is rather more nuanced than one of a knee-jerk embrace of reactionary politics, as Philip Nord has shown. On the one hand, they feared socialism and anarchism: as small property owners dependent on economic stability and loyal customers, they loathed the collectivism and egalitarianism represented by the Left, and by the Radicals who were willing to countenance social reform. On the other hand, they were hard-pressed by big business and big capital, embodied perhaps above all in the department store, but more broadly by the impact of Haussmann's reconstruction of Paris, which broke down old connections between the local shops and their local customers: the street was transformed into a 'commercial corridor' rather than a space for socialising and for savouring the traditional shop sign, its specialist services, and its bartering. Haussmann's Paris created a faster pace, amplified by modern advertising which shouted out its slogans in bold letters and garish colours. For Parisian shopkeepers who claimed to know about such things, the Parisian department store was the French equivalent of the great 'trusts' in the United States—big business embodied by the Rockefellers and Vanderbilts, backed by immense reserves of capital, stifling fair competition and the honest small producers and sellers.[83]

In Anatole France's fictionalised account of the 1900 municipal elections, *M. Bergeret à Paris*, the defeated Radical candidate, admits that he lost because of 'the discontent of petty *boutiquiers* crushed between department stores and cooperatives'.[84] There was a lot of truth in this statement, not least because one of the reasons for their revolt was that, in 1899, the prefect of the Seine, Justin de Selves, had ordered that all external displays of merchandise be removed from the pavements after 8 p.m. on weekdays. The motivation was

benign—it was intended to ensure that shopworkers would not labour for overly long hours—but for the small shopowners, the new rule gave a natural advantage to the department stores, whose expansive plate-glass windows ensured that their displays remained untouched by the law. While Parisian shopkeepers had by and large already, in the 1890s, committed to right-wing nationalism, because it claimed to speak for the small, honest Frenchman against the allegedly cosmopolitan and collectivist republicans, this specific, material issue was one around which shopkeeper resentment was successfully mobilised.[85] And with the populist, nationalist association of both capitalism and socialism with Jews, organised protest among Parisian shopkeepers tended to be antisemitic. It is not for nothing that the 'lower middle class' would be regarded as the bedrock of support for the more virulent strains of authoritarian nationalism in the first decades of the twentieth century.

The department store was fully immersed in the frictions and aspirations of the Belle Époque. On the one hand, it aimed to meet the growing aspirations of an expanding consumer society with its goods, its polite commercialism, and its ambitious but 'safe' architectural style. Yet, on the other hand, with its unbridled spending, its emphasis on satisfying material desires, and its attachment of status and identity to the act of consumption, the 'democratisation of luxury' also challenged the values of thrift, self-control, and self-reliance and the stable relations of family and community.[86] Modernity, with all its physical accoutrements and amenities, was underpinned and in some ways defined by such consumption and by the expansion of a consumer society that, in itself, unleashed a wave of anxieties about decadence and social unravelling, not least because of the role women played in this development.

Women as producers, sellers, and consumers of goods opened up questions about their legal and social status in the Belle Époque—and also about how much agency they actually had to carve out independent lives for themselves: this was how Marguerite Durand just about managed to combine her emphasis on style and beauty with

her freedom as a *nouvelle femme*, but few Frenchwomen had the opportunities to achieve such a fine balance. Durand was a successful actress, moved in political circles, and was wealthy. So, while, on the one hand, the department store became part of the Belle Époque's 'democratisation of luxury'—the broader culture of leisure and consumption, part of the wider world of spectacle, glamour, and sensation that included the cinema, the expansion of the popular press, popular concerts, the music hall, museums, advertising, sporting events, festivals, and the great universal expositions[87]—it also, on the other hand, represented a culture that was struggling with some of the very frictions of modernity that can still chafe today.

CHAPTER 5

BOHEMIA

Ten days after the opening of the 1900 Universal Exposition in
Paris, *La Fronde* published a short article that addressed the
concerns of a French senator who, anonymously, had expressed
his outrage at the range of licentious, scurrilous, and frankly por-
nographic entertainment available to visitors in Paris. As Marguerite
Durand's reporter put it, with some mirthful irony, the 'honourable
senator' had manfully chosen to 'see for himself the spectacles that
we are going to be offering foreigners' by 'methodically devoting a
fortnight climbing what he calls the "Montmartre hill [*colline*]"' and
seeing what its narrow, crooked, and vertiginous streets and passages
had to offer.[1] The senator had published his findings in the high-brow
Revue des revues. He had in fact visited a range of venues between the
Grands Boulevards and the Butte Montmartre. 'I can summarise in
two words the feelings that overcame me after this exploration', he
had complained: 'profound disgust'.[2]

On the Butte Montmartre, the intrepid investigator found
cabarets every hundred metres, encountering 'erotomania, base

chauvinism and scatology!' He was shocked by a cabaret presided over by the 'Devil', whose hair, he noted, was plastered onto the collar of his frock-coat by his pomade—and whose jokes seemed to consist of scarcely veiled references to venereal disease. The senator was particularly upset by the Anglophobia of some of the acts—this was still before the Entente Cordiale between France and Britain: the acts mocked Queen Victoria and came close to demanding war against the old enemy. But where, demanded the senator (and here, one can truly sympathise!), would these ultra-patriots actually be should such a conflict break out? He was shocked, too, by the near nudity of some of the dancers in these acts, including a woman who claimed to be from Australia, but who, he suspected, was more likely to be from the working-class Parisian district of Batignolles, an assessment that was remarkably specific. Her chaotic routine climaxed with her stripping off down to her waist, exposing her breasts.

The senator finished by proposing censorship, which the Republic had virtually abolished in its entirety in 1881. He admitted that political censorship was dangerous, but he based his demand on three grounds: first, in cases where national security was threatened; second, where free expression actually broke the law, such as in cases relating to public morality; and third, where there was an incitement to violence. He pleaded with Paris to attend to its reputation on the world stage: 'It's up to us to cleanse the City of Light to show its true face!' he wrote. He felt it was 'essential' that what attracted people to Paris should be 'its good taste, its beauty, and its elegance'. The city should not seem like a 'city of loose morals'.[3]

Durand's contributor in *La Fronde*—a writer named Andrée Téry—was rather more sanguine. Paris must simply not try so hard to 'beat the record for lubricity'. She accepted that censors might even turn their attention to the kiosks on the boulevards that sold 'libidinous volumes, obscene engravings, and suggestive photographs'— although here she could not resist impishly adding, 'But what is left for them to "suggest"?' One can almost see Téry's raised eyebrow as she answered the senator's concern that visitors seeking to admire the

technological and artistic achievements on display in the city would also encounter the seamier side of the city: 'Could not one object that the cabarets of Montmartre, and other places of ill-repute, attract the peoples of the Universe far more perhaps than the marvels of the Arts, of Science and of Industry?'[4]

Téry's ironic remark hit upon the contradiction that was essential to the flourishing of the more marginal, raffish aspects of spectacle in Belle Époque Paris. On the one hand, the raunchy, the scatological, and the crudely satirical appeared to be the reversal of the morality and taste in which 'respectable' culture was supposedly rooted. On the other hand, the very existence of that underbelly was to a great extent dependent upon the patronage of the same bourgeois clientele whose values were being mocked, and whose tastes were being challenged.

This contradiction was at the very heart of the survival of 'Bohemian Paris'. On the one hand, to be a 'Bohemian' meant being free from social convention, youthful, impoverished, and creative—the term, coined in the 1830s, drew on the then French word for gypsies, free spirits who, it was wrongly believed, had originally come from Bohemia in the modern-day Czech Republic.[5] Bohemian life claimed to reject bourgeois society and its conventions—meaning conformity to rules of behaviour, the pursuit of social and political stability, the individualist drive for personal enrichment and the rewards and pleasures of an expanding consumer society. Yet in reality, 'Bohemian Paris' was interwoven with this same society. This Paris of avant-garde artists, cabaret performers, dancers, political radicals, intellectuals, rebellious students, eccentrics, *strip-teaseuses*, prostitutes, and other refusers of their 'place' within 'respectable' society was dependent upon the very bourgeois Paris from which it distinguished itself.

This paradox arose because Bohemia defined itself with reference to 'respectable' Paris, while the latter was ineluctably drawn to Bohemia. As the historian of Bohemian Paris Jerrold Seigel puts it, they were like 'positive and negative magnetic poles'—apparently

opposites, but in fact 'parts of a single field', needing and indeed attracting each other.

Bohemian Paris grew out of the challenge arising from modernity of reconciling individual freedom with social cohesion and political order—a conundrum that produced a fluid, porous frontier between bourgeois respectability and outcast status. 'Bohemia' consisted of people seeking to explore and to test these boundaries of what bourgeois society deemed to be tasteful, acceptable, and conducive to social stability. While artists and other creatives could once seek out royal, aristocratic, or clerical patrons for support, in the modern world they were increasingly thrust onto the open market, which meant that their art had to appeal to the public for customers. While Bohemians naturally fretted about commodifying and degrading their art (just as today committed fans might complain about their favourite band or artist having 'gone commercial'), the Belle Époque also presented opportunities to artists. The expansion of literacy, the growth of the press, and the publication of cheaper, more affordable books, newspapers, and prints, along with the emergence of new forms of entertainment and leisure, all gave artists, writers, musicians, dancers, and performers the chance to make a living from their work, gain wide recognition, and secure a level of independence that had been absent beneath the demands of a patron.[6] So Bohemians chose to live socially and morally outside bourgeois society while also having to work with commercial forms of entertainment and of promotion, publicity, and advertising that flourished in the consumer society of the era.

The relationship went the other way, too: good mutton-chopped and bustled bourgeois Parisians periodically sought an escape from the confines of what was 'respectable' by seeking out the *frisson* of Bohemia for themselves—provided that they could safely return to their own world once they had had their fill.[7] And, as Téry ironically noted in *La Fronde*, this was one of the city's attractions.

To understand how respectable society connected with the Bohemian world, we can visit the very place where the anonymous senator found himself so outraged: Montmartre. What follows is not a guided

tour as such—if it were, it would be a fairly decent cardiovascular workout, because part of Montmartre's beauty lies in its steep, indeed vertiginous, staircases and passages. But a mental map of the village during the Belle Époque can reveal how bourgeois, Bohemian, and revolutionary Paris lived in proximity to, and in an awkward dependence upon, each other.

MONTMARTRE IN THE later nineteenth century included the village on the Butte in the 18th arrondissement—where today's tourists visit the Sacré-Coeur and seek out traces of the artistic and Bohemian life that flourished here. But there was also a 'lower' Montmartre,

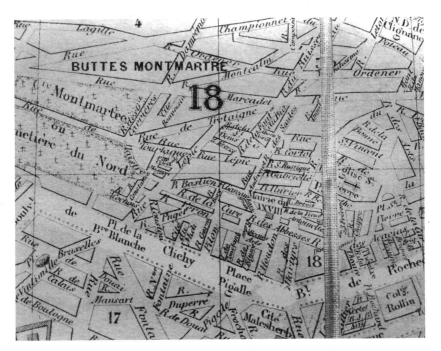

Montmartre in the years just before the construction of the Sacré-Coeur (Chapter 1), whose site would be on the steep hill just above the place Saint-Pierre (*right*). In the centre, the rue Lepic winds up the Butte Montmartre, while the rues Cortot, de l'Abreuvoir, des Saules, and Ravignan, among others, crisscross the upper slopes. Along the boulevards (*bottom*) lie the place Pigalle and the place Blanche—sites of the Nouvelle-Athènes and the Moulin Rouge, respectively.

along the boulevards de Clichy and de Rochechouart, around the places Blanche and Pigalle, and spilling a little way south into the 9th arrondissement.

We start on the Butte. Many Parisians today seem to avoid it because of its tourists, but—as Eric Hazan points out—'they do not know what they are missing, above all the joy of the hilltop'.[8] He is absolutely right: it is not just the famous panorama that unfolds to the south from beneath the steps of the Sacré-Coeur (where Zola's tortured priest, the abbé Pierre Froment, pauses to ruminate at the start of his novel, *Paris*). The streets of the Butte often suddenly reveal surprises in other directions—visit the statue of the much-loved singer Dalida, who lived and died in Montmartre, on the square that now bears her name, and you are treated to a northwards and rather spectacular view over the steep steps of the rue Girardon. Even the topography of the hill itself, with its slopes, its drops, its climbs, its winding roads, and its dizzying staircases, makes it a pleasure to explore.

Visitors who today wander the steep weave of streets and steps might take in the artistic Bohemian Montmartre of the avant-garde—the Lapin Agile, the Bateau-Lavoir, and the house once inhabited at different times by Auguste Renoir and his onetime model-turned-artist Suzanne Valadon and her son, Maurice Utrillo, a slender and rather tragic figure. Yet in searching out this Paris of artists, poets, writers, musicians, intellectuals, rebellious students, eccentrics, and refusers of convention, visitors also pass by sites that carry the memories of other, grittier aspects of the old village's life—its crime, violence, and grinding poverty. 'Bohemian Paris', in fact, was both entangled with these dimensions of urban life and drew inspiration from them. The urge to explore life at its limits, to search out and experiment with the frontiers of experience, naturally drew Bohemians to the political extremists, the crooks and the lowlifes who haunted these same streets.[9]

The Butte Montmartre projected an anarchic, even discordant, array of meanings, of which the Bohemia of artists and writers was only a part. Appropriately for a quarter whose landscape still bears

signs of rupture by ancient watercourses and gorges, of centuries of quarrying, it contained a diversity of human life. Because of the hill's location outside the old boundaries of Paris—until its relatively late incorporation into the city in 1860—and its steep and challenging topography, which spared it from Haussmann's renovations, it held on to its village character. The novelist Roland Dorgelès later recalled, 'In my youth, the Butte was still a village. There you heard the sounds of the farm: the barking of dogs, the clucking of hens, the mooing of cows, and, if the windmills stopped their clacketing, you heard the birds singing.'[10] Its semirural character, in turn, ensured that rents remained cheap, even if the rundown fabric and insalubrity of its buildings made it much less picturesque than today's gentrified streets.

Besides cheap rents, the Butte also offered more affordable entertainment, with cheap cafés, cabarets, and *guinguettes*. The Moulin de la Galette dance hall at No. 83 rue Lepic was the haunt of the hard-pressed working people of the area. With its admission price in 1898 at twenty-five centimes for women and fifty for men, it was considerably less pricey than other places of entertainment—the Moulin Rouge, still raffish but catering to a clientele consisting more of middle-class people and tourists sampling the delights of Montmartre, cost two to three francs.[11] The Moulin de la Galette took its name from the windmill whose space it occupied and where the owners had produced a sweet, flat pastry, a *galette*. Over the course of the nineteenth century, the business expanded to include a wineshop—*guinguette*—and a dance floor popular with the inhabitants of the Butte. The interior was austere—little more than a dance floor separated by a long balustrade from the seating around long, heavy wooden tables. The working men and women of the neighbourhood were the mainstay of its clientele—and among the dances they performed to the brass chords of the orchestra was the *chahut*, an explosion of energy involving a high-kicking display of legs, a whirling lift of petticoats, and the stamping of feet, making it the forerunner to the can-can.

Artists were captivated by the exuberance of the place. The great Impressionist Pierre-Auguste Renoir's 1876 painting of the *Bal du Moulin de la Galette*, produced while he was living on the nearby rue Cortot, captured its revellers (apparently from a range of social backgrounds, so it probably depicts a weekend) dancing and chatting in the garden, speckled by light from a canopy of trees and lights above.[12] Henri de Toulouse-Lautrec drew a pastel of the dancing in 1889, and in 1900, on his earlier visit to Paris, Pablo Picasso painted the *Moulin de la Galette*—where the women, with lips painted red, brightly dressed in the colours that had drawn his attention upon his first arrival in the city, are foregrounded against the dance, turning on the floor with a largely bourgeois male clientele, gleaming top hats and white shirts, the necklaces of fairy lights glowing in the background.[13] Kees van Dongen's 1904 painting *Le Moulin de la Galette* captured the young men and women enjoying a break from the weekly grind of work in a swirl of movement: the male white-collar workers with their bowler hats and dark suits; one couple seemingly poised for a kiss while in mid-flight; and the sprawling (and alarmingly enormous) hand of another male dancer unmistakably reaching for his female partner's bottom.[14]

Artists who found places to live and studio space in these streets included Vincent van Gogh, who lived at 54 rue Lepic in 1886–1888 with his brother, Théo: the building today is a pretty, five-storey apartment with light grey shutters. Toulouse-Lautrec, who drew a pastel portrait of Vincent in those years, had his studio nearby for a decade (1887–1897) at No. 7 rue Tourlaque, at its corner with the rue Caulaincourt. From 1892, Renoir lived and worked in a house off the rue Girardon in the secluded and beautiful allée des Brouillards—which was until recently gated to keep riff-raff (like historians) out but which (at the time of writing) is now open again. It can be accessed via the park that rests up a short flight of steps leading from the impasse Girardon (which runs off from the rue Girardon, almost parallel with the rue Junot). Walk through the park and exit down the steps at the other side onto the place Casadesus, which marks the end of the

rue Dereure. The allée des Brouillards can be reached via the balus-traded steps to the right after leaving the park. Families picnic in the park on weekends, and there is a pitch where *boule* players are watched by a modern statue of Saint Denis, who is almost nonchalantly carrying his severed head under his arm. At the end of the allée des Brouillards one emerges onto the place Dalida, with its statue (it is, some say, good luck to rub the poor singer's breasts, which are showing clear signs of wear) and its northward view over the steep steps of the rue Girardon. In 1906, the Italian painter Amedeo Modigliani would set up in a workshop at the upper end of the rue Lepic before joining the growing exodus of artists to the Left Bank, to Montparnasse, in 1909. Other artists who inhabited the Butte for a time included Raoul Dufy (who had studios near the Lapin Agile cabaret), Georges Braque (on the rue d'Orsel), Kees van Dongen (in the impasse Girardon, 1897–1907), and Pablo Picasso, along with others, in a small artists' colony at the Bateau-Lavoir, on what is now place Émile Goudeau.

Picasso moved permanently to Paris from Barcelona in the spring of 1904, at the age of twenty-four. He had previously stayed in Paris between the spring and Christmas of 1900, in part to see the Universal Exposition, but he now took up a cheap, dilapidating studio and rooms at No. 13 rue Ravignan in Montmartre, on the present-day place Émile Goudeau. The ramshackle, three-storey wooden building was a squat, parcelled up into smaller rooms. It shook in high winds, as if it were a laundry boat on the Seine—from which came its nickname ('Bateau-Lavoir' literally means 'wash-house boat'). The artists who lived in the building at some point during these years included Kees van Dongen, Modigliani, and Braque, among many others. It was here, at the water tap in the basement—the only source of running water in the building—that Picasso met Fernande Olivier, and they became lovers, a relationship which, it is said, brightened his colour palette.

Picasso drew much inspiration from Montmartre itself, including the Moulin de la Galette and the Lapin Agile. He enjoyed the range of styles and experimentation that he encountered among the

artists of the quarter as he found his own artistic voice. He also found Frenchwomen a source of fascination and inspiration, moving with the colourful swish of their dresses, seemingly so at ease in the cafés and as they went about their business on the streets and danced in the *guinguettes*. More widely, the city offered an endless parade of spectacle and cultural expression that led him in a new direction. In 1906, a visit to the Musée d'Ethnographie (now the Musée de l'Homme) at the Trocadéro saw him admiring the African face masks and wooden figures, whose features he then used in the Bateau-Lavoir in 1907 when he painted five naked women whom he would jocularly call *Les Demoiselles d'Avignon*. The Avignon in the painting is actually the Carrer d'Avinyó, a red-light district in the Gothic Quarter of Barcelona; the setting is a brothel at No. 44, the naked women prostitutes, painted from the memory of his own visits to them in his youth.[15] The crucial breakthrough about the painting was the way in which Picasso drew from African art a style that would become known as Cubism—breaking figures down into separate components and then reassembling them irregularly, bringing some features into relief, leaving others at a different plane, which also allows the artist to play with light and shading.[16] One might say that Cubism arose from the intersection of Picasso's youth in Catalonia, the creative milieu of Montmartre, and France's imperial reach into Africa.

The artists of Montmartre lived among the urban poor who were drawn to the Butte for some of the same reasons: the squats, the low rents, even the opportunities for grazing and gleaning. For the steep, meandering web of streets between the rue Lepic, the rue Caulaincourt, and the rue Girardon was known as the *maquis* of Montmartre, a shanty town—*bidonville*—where families driven from the city centre by the high rents that followed Haussmann's urban renewals constructed their shacks and huts among the trees and scrub on the steep slopes, keeping hens and their dogs and cats wandering at will. Though the black-and-white photographs of the *maquis* look quaintly rustic, this was an area of grinding poverty. Such an island of rurality could not escape the attention of developers forever, and in 1902,

they moved in, slowly but determinedly driving out the inhabitants before 1910, when the sharp curve of the avenue Junot was driven through, slicing through the heart of the *maquis* like a fishhook. In the 1920s, Art Deco townhouses and villas began to line this new street, making a walk beneath its tree-lined shade a pleasure (and, along with it, the Villa Léandre that runs off it), but from then on development consumed the *maquis* in large bites: by the 1930s, it was receding into memory.[17]

The Butte also attracted revolutionaries who were variously lying low to escape the authorities, caballing for the next revolution, meeting to discuss electoral strategy, or haranguing the impoverished residents at public meetings. The anarchist bomber Émile Henry (whom we will encounter later) was living quietly, first on the north slope of the hill in a third-floor room at 101 rue Marcadet (from November 1891 until October 1892), then on the south side in a room on the top floor of 31 rue Véron. His fellow anarchists, the literary critic Félix Fénéon and the Mexican-born burglar Léon Ortiz (who argued, like some other anarchists, that theft was a political act), lived nearby on the rue Lepic. After Henry threw a bomb inside the Café Terminus near the Gare Saint-Lazare in February 1894, with murderous consequences, Fénéon and Ortiz were among the thirty anarchists caught in the police trawl that followed. Fénéon and the other 'intellectual' anarchists were acquitted, but Ortiz and two other anarchist thieves were convicted and suffered harsh sentences—Ortiz to fifteen years of hard labour.

Living in Montmartre, these revolutionaries encountered—and they themselves experienced personally—the hunger, deprivation, and daily struggle inflicted by poverty. Victor Serge (whose real name was Victor Kibalchich), then a young Russian anarchist, who arrived in Paris in 1908, would later recall the view from the Basilica of the Sacré-Coeur: 'An ocean of grey roofs, over which there arose at night only a few dim lights, and a great red glow from the tumultuous squares. We would pause there to take stock of our ideas. At the other end of the street [rue du Chevalier de la Barre] a lopsided square

stretched at the crossing of two roads, one a steep incline, the other rising in flights of dull grey steps. In front of a tall and ancient shut-tered house, the . . . *Causeries Populaires* and the offices of *L'Anarchie* . . . occupied a shabby building, filled with the noise of printing-presses, singing, and passionate discussion.'[18] Both of the newspapers Serge mentions had been founded by the flamboyant, spirited anarchist Albert Libertad, who had been taken in by the anarchist journal-ist Sébastien Faure when he discovered him homeless, living on a bench on the boulevard Rochechouart. Libertad had served a couple of months in jail in 1897 after disrupting Mass in the Sacré-Coeur and soon became a regular sight around Montmartre, harangu-ing passers-by on street corners or addressing people sitting at café terraces. In 1902, Libertad started up a series of public meetings to debate anarchist ideas, calling them *causeries populaires* (popular dis-cussions); in 1905, he found a permanent venue for them in No. 22 rue du Chevalier de la Barre. The ticket sales quickly helped him to establish the newspaper *L'Anarchie* in the basement of the same build-ing (which is still there), and which also had rooms that could provide a bed for up to ten anarchists who needed refuge.[19] Among those he recruited to write for the journal was Serge, who left the following description of Libertad:

No one knew his real name, or anything of him before he started preaching. Crippled in both legs, walking on crutches which he plied vigorously in fights (he was a great one for fighting, despite his handicap), he bore, on a powerful body, a bearded head whose face was finely proportioned. Destitute, having come as a tramp from the south, he began his preach-ing in Montmartre among libertarian circles and the queues of poor devils waiting for their dole of soup not far from the Sacré Coeur. Violent, magnetically attractive, he became the heart and soul of a movement of such exceptional dynamism that it is not entirely dead even to this day. Libertad loved streets, crowds, fights, ideas, and women.[20]

It is somewhat staggering to learn that no fewer than twenty-five different anarchist organisations were already embedded in Montmartre between 1889 and 1896, just before both Libertad's and Serge's arrival. And these were not entirely in isolation from the artists who also lived here. It is certainly true that the radicals eschewed the places where the Parisian bourgeois went 'slumming it' among Montmartre's Bohemians: 'Our Montmartre', Serge recalled, 'adjoined, but never met, the Montmartre of artists' taverns, bars haunted by women in feathered hats and hobble-skirts, the *Moulin Rouge*, etc.'[21] But many of the artists themselves connected with the anarchists. Toulouse-Lautrec, aristocrat though he was by birth, knew Montmartrois anarchists, who met and drank in the same cafés and cabarets as the avant-garde.

Art and anarchy, in fact, were held to march hand-in-hand. Although not denizens of Montmartre, Camille Pissarro and Paul Signac were both committed anarchists—Signac producing a portrait of Fénéon, no less. Such artists stopped short of condoning revolutionary violence, but for them art *was* revolutionary. Bohemia, whether Impressionist, post-Impressionist, Symbolist, Fauvist, or Cubist, had already determined to challenge convention. From there, it was a short distance to arguing that such conventions were 'bourgeois'. So shocking the public and expressing the individual vision of the artist, regardless of what was expected by the established art world, was in itself a political act. As Kees van Dongen, who lived on the Butte, explained, 'We were all anarchists without throwing bombs.'[22] Moreover, on the hilltop, anarchists had a daily reminder of the society that they hoped to overthrow and make anew: the Sacré-Coeur. The drawings of Théophile Steinlen—an anarchist—included one showing revolutionaries assaulting the basilica. Anarchist meetings on the Butte protested the presence of the clergy, and in 1893, one meeting heard a proposal to dynamite the church (something that Guillaume Froment, in Zola's novel *Paris*, comes close to doing).[23]

Yet the place that perhaps best illustrates the edgy mix of Bohemian life is the house and grounds at 12 rue Cortot. Today the

premises of the Musée Renoir-Valadon, and, behind it, the Musée de Montmartre, the gardens are bucolically peaceful. But a leap of imagination can take us back more than a century, offering a sense of how the Bohemian world of Montmartre rubbed shoulders with life on the social margins of poverty, crime, and political radicalism. The seventeenth-century building on the street now houses a reconstruction of the studio and apartment of the artists Suzanne Valadon and her son Maurice Utrillo.

Suzanne Valadon's life followed the twists, encounters, and accidents that one might expect from a creative world that lay outside the boundaries of bourgeois respectability but that also regularly crossed streams with it. Born in poverty in 1865 and originally named Marie-Clémentine, Valadon was raised in Montmartre by her mother, a laundress. Though she refused to submit to the long-suffering nuns who tried to teach her at school on the rue de Caulaincourt, the tearaway Marie-Clémentine developed a love of drawing. She honed her skills on the pavements, on the walls of the family's cramped lodgings on the boulevard de Rochechouart, and on random sheets of paper, with charcoal that she was given by a coal deliveryman. After a career as a trapeze artist at the nearby Cirque Fernando was cut short in 1880 by a fall that nearly broke her back, Suzanne became an artist's model.

Every Sunday, the fountain on the place Pigalle became a model market. Aspiring models paraded in their finery, hoping to be chosen by the artists who gravitated here to find the figures who would best suit their compositions. Valadon loved the work, even though the hours were long and the pay far from regular: after her first sitting, she recalled, she kept saying to herself, 'This is it! This is it!'[24] She befriended Edgar Degas, who did much to promote her career; posed for Puvis de Chavannes, a well-established artist famed for his murals, including some in the Panthéon; and worked with Pierre-Auguste Renoir, who had himself lived at 12 rue Cortot, where he completed *La Balançoire* (The Swing) and *Bal du Moulin de la Galette* (Dance at the Moulin de la Galette). From 1882, Renoir hired

Marie-Clémentine as a model for a trio of paintings he was planning: *Danse à la ville* (Dance in the City), *La Danse à Bougival* (Dance at Bougival), and *Danse à la campagne* (Dance in the Country). Valadon was the flame-haired model for the first two, but the rosy-faced dancer in the third painting was Renoir's mistress, Aline Charigot. A few years later, Marie-Clémentine posed for Toulouse-Lautrec, who jokingly called her 'Suzanne', a reference to the Old Testament story of 'Susanna and the Elders', a jibe on her apparent preference for older painters. Valadon took it as a badge of honour and henceforth signed her own work 'Suzanne Valadon', or sometimes simply 'S. Valadon', leaving viewers guessing as to the gender of the artist.[25]

The world that Suzanne inhabited was on the fringes of what was deemed to be 'respectable' society—and sometimes it lay far beyond that. After the long working hours, she mixed with the other models and the artists and writers, drinking absinthe in the cafés. In her spare time she shaped her style as a draughtswoman, charting her own creative path. The art world—whether of the mainstream, 'academic' kind represented by Puvis de Chavannes, or the avant-garde inhabited by Renoir, Toulouse-Lautrec, and others—was dominated by men, although it was not their exclusive reserve. Valadon's own drawings were exhibited at the Paris Salon in 1894, through the good offices of Degas, but she was something of an exception. Some other women painters had successfully submitted work to the annual Salon—the official exhibition of the Académie des Beaux-Arts, the school for establishment art—among them Impressionists Mary Cassatt (an American), Berthe Morisot, and Marie Bracquemond. These women artists were supported by comfortable backgrounds (although Cassatt's father insisted that she fund her work through the sale of her paintings) and drew upon the networks of contacts that had enabled them to enter the art world in the first place. They also gained wider acceptance by strategic choices of subject matter that conformed to expectations of women, such as mothers and their children, promenades, and theatre visits. Most male artists were wary of encouraging such talent: it was all very well for middle-class

women to dabble in painting as a hobby, but dangerously subversive for them to become professional artists. When Morisot and her sister were learning how to paint, her teacher warned their mother about the risks they were taking: 'Do you really understand what that means? In the world of the *grande bourgeoisie* in which you move, it would be a revolution, I would say even a catastrophe.'[26]

Unencumbered by such bourgeois constraints, Valadon opted for radical subject matter for a female artist in the Belle Époque. In 1909, for instance, she depicted *Adam and Eve*, in which the young artist André Utter appears nude as Adam, with Suzanne herself posing alongside him naked as Eve. It was unheard of for a woman artist to dare present a male and a female nude alongside each other in the same painting. Although André's genitals are strategically covered by the branch of a vine, it was perhaps all the more piquant that the couple would quickly become lovers. *Adam and Eve* would be shown at the Salon d'Automne, an annual exhibition created in 1903, by, among others, the Art Nouveau designers and architects Frantz Jourdain and Hector Guimard, as a place where the avant-garde, including the Fauvists and the Cubists, could display their work as against the establishment Paris Salon.

Suzanne also inhabited a Bohemia that was sexually liberated. Her lovers included Puvis de Chavannes, Renoir (which explains the intense jealousy that Aline Charigot was known to harbour towards Suzanne), and Toulouse-Lautrec. In 1883, Suzanne fell pregnant, possibly by her close friend Miguel Utrillo, then a dashing Spanish engineering student and a talented artist who loved the scene in Montmartre. Utrillo would later accept paternity of the sickly boy, whom Suzanne named Maurice, and the boy was given Utrillo's surname.[27] Among her other lovers was the composer Erik Satie, with whom she had a brief affair in the mid-1890s, when he was living at No. 6 rue Cortot. This was just a few steps away from her studio at No. 12, which she acquired thanks to another lover: the banker Paul Mousis, whom she married in August 1896.

Up to this point, Suzanne's *montmartrois* life was unmistakably Bohemian. After the hard poverty of childhood, the rejection of conventional schooling, the modelling and mixing with the avant-garde in the cafés, freely loving whom she pleased, she defiantly, on the certificate of her marriage to Mousis, stated that her profession was 'artist'. This was just a year after an official wrote 'no profession' on the death certificate of Morisot, who had died in the undeniably bourgeois Passy in the 16th arrondissement. Valadon presented a somewhat eccentric sight as, wrapped in a cloak, she clattered around the Butte in her distinctive trap, her comings and goings from the rue Cortot announced by the clopping of her mule's hooves, the tinkling of bells in its harness, and the rumbling of wheels across the cobbles. She also kept wolfhounds and a parrot perched in a cage.[28]

Yet, like the world of Bohemia itself, her life touched and indeed was made possible by its connections with the bourgeois world. She had one foot in the well-heeled, plutocratic world of French finance through her marriage to Mousis. She may have been able to support herself by her own talent, but that also meant engaging with the commercial world of the bourgeoisie. In a kind of topographical illustration of the point, Suzanne flitted between her apartment and studio at 12 rue Cortot and the solidly bourgeois country house her husband built near Pierrefitte-sur-Seine north of the city, the payback being that she could now afford to give up modelling and concentrate fully on her art. Yet one world could erupt on the other: Suzanne discovered that Maurice, who had been left in the care of her now elderly mother, had been fed alcohol to keep him quiet, and was now addicted. It was a demon that pursued Maurice Utrillo for the rest of his life. Mousis found ways of helping—finding the young man work in a bank and paying for treatment in a sanitorium, but Suzanne was also haunted by the fate of her friend Toulouse-Lautrec, who, wracked by the syphilis that he contracted in one of the brothels he depicted with such brutal honesty in his drawings, also succumbed to

the ravages of alcoholism. It sent him to a premature death at the age of thirty-seven in 1901. Moreover, Suzanne's own free-spiritedness eventually led to the dissolution of her relationship with Mousis, who discovered her affair from 1909 with André Utter. He would divorce her, and Suzanne would marry Utter just as he was about to march off to war in 1914. Valadon, her son, Maurice, and Utter would, together, be spoken of as the 'cursed trinity'—*la Trinité maudite*—for the stormy, unconventional nature of their relationship.[29]

Suzanne's life straddled the Bohemian world of Montmartre and Paul Mousis's bourgeois world of respectability for almost two decades. At the same time, it ran alongside, even if (as Victor Serge might have suggested) it never really connected with, the more marginal world of criminality and revolutionary politics that also abounded on the Butte. That this proximity was not just social, but was true in a literal, geographical sense, can be seen from the grounds of No. 12 rue Cortot. Today, behind the seventeenth-century building, at the end of a gravelled path overarched with delicate climbing plants, is a stunning country house built in the later 1790s (which is now home to the Musée de Montmartre). Beyond that the grounds drop steeply northwards towards Montmartre's famous vineyard: the Butte had been home to several in earlier centuries, but these had gradually disappeared. The present vineyard, the only one in Paris, was re-created in 1932. Quite beside the stunning beauty of this spot, it conveys—with the help of a little imagination—something of the character of Montmartre as a place where Suzanne Valadon's Bohemia touched the more dangerous world of the Butte.

From the back of the garden, look north-west across the vines perching on the steep slope and you will see a wall and building painted burnt orange on the corner of the rues des Saules and Saint-Vincent: the Lapin Agile cabaret. Today part of the picturesque tourist itinerary in the village, the small building has also known darker days, underscoring the porosity of the boundaries between Bohemian Paris, the desperate struggle for survival of many other Parisians, and radical politics. Its original name in the 1860s, when it

was a bar, was 'Au Rendez-Vous des Voleurs'—the Thieves' Meeting Place. The name was primarily intended to thrill the mixed clientele who came here, but it also reflected the site's somewhat unsavoury reputation, not undeserved, as a place where the petty crooks and pimps of the hill could discreetly gather. In the 1880s, the bar was taken over by the poet and caricaturist André Gill, who was heavily influenced by his association with Émile Goudeau, founder of the 'Hydropathes' and the Chat Noir cabaret, of which we shall learn more further on. It was Gill who converted the bar—a single room and terrace—into a cabaret, which, trading in on its reputation, he called the 'Cabaret des Assassins'. He recited his own politically radical poetry and painted his own sign, a rabbit bearing a wine bottle and sporting a red sash and worker's cap bounding from a copper pan. The rabbit was Gill's tribute to the legend that the old building was originally a hunting lodge for King Henri IV in the early seventeenth century, but people called it 'Gill's Rabbit'—the 'Lapin à Gill'—which quickly morphed into the 'Lapin Agile'. In 1903 it was taken over by the popular singer Aristide Bruant, who left the management of the place to Frédéric Gérard. It was on Gérard's watch that the Lapin Agile became a gathering place not only for the usual cast from Montmartre's lowlife crowd, but also for artists, poets and other writers, students, and the occasional bourgeois seeking the thrill of 'slumming it' in Bohemia. Frédé, as he was affectionately known, brought with him two main groups of clients—a small community of Spanish artists, including Picasso, and a circle of local anarchists. Both had frequented his first cabaret, the Zut on the place Ravignan (now place Émile Goudeau), near the Bateau-Lavoir.[30]

With the anarchists, small-time crooks, and impoverished artists and writers rubbing shoulders, the Lapin Agile encapsulated the interconnection between Bohemia and Parisian society's shadowy margins. Frédé was especially indulgent towards hard-up artists and poets, offering them free drinks and food in return for a painting or recital. He did this for Picasso when he asked the Spanish artist to produce a picture that he could hang inside the cabaret. Picasso's

painting depicts a slender young man in a harlequin costume, look-ing stony-faced and reflective while nursing his drink. He is seated alongside a pale young woman who is similarly lost in her thoughts. In the background, a performer strums a guitar. The harlequin is in fact Picasso himself, and the woman is Germaine Pichot, a seam-stress and a painter's model. Picasso's friend, the highly strung art-ist and poet Carlos Casagemas, with whom he had first travelled to Paris in 1900, fell madly, obsessively, in love with Germaine. When the young woman spurned Carlos after a stormy affair in 1901, Casagemas pulled a pistol on her in the Lapin Agile and fired. The bullet grazed Germaine in the neck and, though she survived, the artist-poet believed he had killed her. He turned the gun on himself and shot himself dead. Picasso was deeply affected by his friend's death—although he himself had had a fling with Germaine. Casage-mas was no crook, but his fascination with violence and with Parisian prostitutes (whom he described in lurid detail in his letters) suggests that one of the attractions of Bohemia for him was its proximity to the criminal underworld and the sexual demimonde. Picasso him-self carried a Browning pistol for his own safety. The second part of the tragedy relates to the guitar player in the background of Picasso's painting: this is Frédé himself, whose son would be shot dead in the Lapin Agile in 1911.[31]

So paupers, artists and writers, Bohemians, crooks, squatters, and anarchists brought almost all human life to the 'lively, crowded, bright streets on the great hill of Paris', as a contemporary account put it: 'Here are hot-chestnut vendors at the corners; fried-potato women, serving crisp brown chips; street hawkers, with their heavy push-carts; song-sellers, singing the songs that they sell, to make purchasers familiar with their airs; flower-girls; gaudy shops; bright restaurants and noisy *cafés*,—all constituting that distinctive quarter of Paris, Montmartre.'[32] All this life was clustered on the Butte Mont-martre. Its more idyllic reputation was later reinforced by the mem-oirs of poets and artists who looked back on their Belle Époque youth with nostalgia.[33]

Yet it is all too easy to look on knowingly as crowds of tourists seek out the 'artistic' flavour of a Montmartre that the passage of time has safely disentangled from the more dangerous aspects of its past. It is even unfair to do so because the present-day relationship between tourism and Montmartre's artistic heritage is not far removed in practice from the way in which 'respectable' bourgeois Paris related to 'Bohemian Paris' in the Belle Époque.

This dynamic relationship is exemplified further by the cultural life of 'lower' Montmartre—that is, the part of the village which had historically spilled southwards, onto the gentler but still noticeable incline into the 9th arrondissement. It was here that much of Montmartre's avant-garde and risqué nightlife provocatively entertained its socially diverse clientele in cafés like the Nouvelle-Athènes, in *café-concerts* like the Chat Noir and the Mirliton, and in dance halls like the Moulin Rouge and the Elysée-Montmartre. The ribbon of Montmartre along the boulevards de Rochechouart and Clichy had long-standing associations with pleasures of all kinds because these broad thoroughfares were built on the line of the late eighteenth-century customs wall: today's place Pigalle is the site of the *barrière* de Montmartre, the customs gate where dues, the *octroi*, were levied on goods entering Paris. So just outside the wall (which was demolished in the 1840s) Parisians would gather in the taprooms to drink alcohol cheaper for not having the duty levied on it, buy goods from traders who gathered here, and enjoy all kinds of entertainment, and maybe to find the prostitutes who hung out here, a little safer from the reach of the police. This part of Montmartre, with its cabarets, cafés, dance halls, and not undeserved reputation for the sex trade, developed from its location astride the old customs wall.

By the Belle Époque, the 'lower' Montmartre of the 9th arrondissement was also home to a great many artists, who either lived within this neighbourhood or not too far away. These included Edgar Degas, Mary Cassatt, Claude Monet, Toulouse-Lautrec, Gustave Caillebotte, Paul Gauguin, Georges Seurat, and Paul Signac.

The clustering of artists' studios and apartments stemmed from the area's decades-long association with artists and writers: this quarter was the northernmost part of the genteel and rather pretty district of 'Nouvelle-Athènes', which extended southwards all the way to the Gare Saint-Lazare, and which evokes the Paris of the Romantics of the 1820s and 1830s. The association with this earlier creative generation was made explicit on the place Pigalle, at No. 9, where one could find the Café de la Nouvelle-Athènes (at the junction of the rues Frochot and Jean-Baptiste Pigalle).

In the 1870s, the Nouvelle-Athènes café had become the haunt of a new wave of painters who had gathered around Édouard Manet: the Impressionists, including Renoir, Degas, Paul Cézanne, Alfred Sisley, Camille Pissarro, and Claude Monet. Impressionism was characterised by its emphasis on capturing the moment in light and colour instead of the more formalised depiction of life. It wanted to convey how colours and shade constantly shifted with the ever-changing conditions of nature, so that the scene viewed by the artist was changeable and unstable. Catching the moment demanded quick brushstrokes, not the meticulous, accurate work of the more established 'academic' artists. In the Nouvelle-Athènes they found solidarity against the attacks of mostly hostile critics who did not understand—or who did not want to understand—what they were trying to achieve. The Irish writer George Moore, in Paris in the early 1870s studying art, later famously wrote about the experience in his memoirs:

> I did not go to either Oxford or Cambridge, but I went to the 'Nouvelle Athènes'. What is the 'Nouvelle Athènes'? He who would know anything of my life must know something of the academy of the fine arts. Not the official stupidity you read of in the daily papers, but the real French academy, the café. . . . Ah! the morning idlenesses and the long evenings when life was but a summer illusion, the grey moonlights on the Place where we used to stand on the pavements, the shutters

clanging up behind us, loath to separate, thinking of what we had left [un]said, and how much better we might have enforced our arguments.

HE THEN RECALLED 'the white face of that café, the white nose of that block of houses, stretching up to the place, between two streets', writing that he could remember 'the smell of every hour': 'In the morning that of eggs frizzling in butter, the pungent cigarette, coffee and bad cognac; at five o'clock the fragrant odour of absinthe; and soon after the steaming soup ascends from the kitchen; and as the evening advances, the mingled smells of cigarettes, coffee, and weak beer'.[34]

An impromptu sketch of Moore by Manet captures him in the Nouvelle-Athènes, leaning on his elbow, looking relaxed but attentive beneath his large bowler hat and behind his striking ginger beard. Moore came to know Émile Zola, too: as a critic as well as a novelist, the writer had been one of the few voices to defend the Impressionists in the 1860s. Zola saw only futility in attempts to establish any measure of what was ideal or true in art. To lay down hard-and-fast rules about what was aesthetic or not was too dogmatic, for art was the expression of the human spirit, whose creativity was boundless and forever producing new and radically different kinds of work.[35] Zola understood, as Théophile Gautier did for the Romantic generation before, that a new artistic style battling to break free from tradition was a struggle that would be repeated with each emerging generation of artists and writers. This was part of the modern condition, which could not be expressed in any one style: modernity was instead characterised by the ongoing process of one new aesthetic following on from the old. To be an Impressionist was not necessarily to be a Bohemian, since some of the former, among them Manet, Renoir, and Degas, were refined in their dress and respectable in their conduct. They felt that to be successful they would have to exhibit at the regular Salon, which would win them recognition and exposure to

the wider public. For them, the independent exhibitions and salons were merely a means of getting to that position. By the 1880s, some members of this group were making decent earnings from their work, explicitly acknowledging what many Bohemians did not: that while their creative freedom may have shocked and outraged most bourgeois tastes, the path to success and financial security also lay ultimately in appealing to those same tastes or winning them over.[36]

Not far from the Nouvelle-Athènes, the symbiotic relationship between Bohemian and bourgeois Paris worked in an outrageously irreverent way in the Chat Noir cabaret. The self-proclaimed Bohemian Rodolphe Salis established the Chat Noir at 84 boulevard de Rochechouart in December 1881 and moved it in 1885 to 12 rue Victor Massé (then rue Laval, 9th arrondissement). Salis, inspired by the gatherings of artists and writers in the area, was convinced—rightly, as it transpired—that it was an ideal spot for a dedicated venue that would allow artists and musicians to experiment and present their work to a limited but interested public. He had the building—which formerly had belonged to the post office—decorated in a rather incongruous, rustic seventeenth-century style (the Chat Noir advertised itself as a 'Cabaret Louis XIII', after the king who ruled in the age of Richelieu), with heavy oaken chairs and tables, tapestries and copper pots hanging from the walls, pewter crockery, antique weapons, and a massive fireplace, which was never lit because of all the bric-a-brac stored inside of it.[37] It was a country-inn style that sought to emphasise the cabaret's connections with older traditions of French entertainment and festivity. While these renovations were going on, a black cat sauntered in off the street and, as cats are wont to do, made itself comfortable. The cat became a permanent resident and inspired the cabaret's name.

Just before opening, Salis joined forces with Émile Goudeau, who led an avant-garde group of poets, musicians, and artists on the rue Cujas near the Panthéon on the Left Bank called the *Hydropathes*—because they (allegedly) only drank alcohol, never water. Salis persuaded Goudeau and his circle to take up artistic residence at

the Chat Noir, and the cabaret got off to a roaring start, with reserves of talent that attracted other performers, writers, and painters. More remarkably still, it proved to be immensely popular, especially on the weekends, for Goudeau brought with him the spirit of *fumisme*, which, in his own words, 'was a sort of disdain for everything, of contempt on the inside for beings and things, which translated on the outside into innumerable insults, pranks and practical jokes [*fumisteries*]'.[38]

Fumisme was targeted at all and sundry, but especially at the élites: the rich, the respectable bourgeois, and politicians. Goudeau's *fumisme* had its origins among the students of the Latin Quarter—the original 'Bohemia' from the 1830s—on the Left Bank, who adopted an irreverent attitude towards authority and established cultural norms. The Chat Noir's brass-necked publicity claimed it to be 'founded, in 1114, by a *fumiste*'. It was one of the attractions that drew much of its middle-class Parisian clientele on the weekends. Revellers arriving at the Chat Noir were greeted with deliberately overblown deference by staff dressed in mock-ups of the uniforms of members ('the Immortals') of the Académie française, the official guardian of French language and culture. Yet this kind of mockery was precisely what the customers had come to experience. While supporting the avant-garde by giving artists, musicians, and writers a thriving stage for their work—one of the regular pianists at the Chat Noir was Erik Satie—the cabaret also brought them the audience and publicity on which they depended to earn a living. As Jerrold Seigel has argued, *fumisme*'s appeal was that it spoke to the expanding middle class that constituted the bedrock of support for the Republic. The members of this group enjoyed the lampooning of the social élites—the old aristocracy and the established, wealthy bourgeoisie who had dominated politics for most of the nineteenth century.[39] The Chat Noir allowed these wider layers of the middle classes to experience 'Bohemia' for entertainment while also providing a paying audience for the creatives who performed there.

Goudeau brought an aptitude for publicity, grasping the value of advertising to artists and writers in an expanding consumer society.[40]

He and Salis lost no time in exploiting one of the flourishing media of the Belle Époque—the advertising poster—and in this they recruited some great talents: Henri de Toulouse-Lautrec began his career as an artist by producing publicity for the Chat Noir, and the anarchist and skilled draughtsman Théophile Steinlen created the now iconic *Tournée du Chat Noir* poster, featuring the eponymous scruffy black cat fixing the viewer with its intense, yellow-eyed stare, in 1896. The feline also appeared on the banner of the cabaret's weekly newspaper in the 1880s and 1890s, *Le Chat Noir*. Appearing every Saturday, the journal served a dual purpose: on the one hand, it gave writers, poets, artists, and songwriters a space to publish their work; on the other, it promoted the cabaret itself, reaching out towards the wider, interested market that provided much of the Chat Noir's clientele.

The paper stamped itself irreverently with the identity of Montmartre. With the subtitle *Organe des intérêts de Montmartre* (Organ of the interests of Montmartre), its distinctive banner featured a scrawny black cat, its back arched as if on high alert, in front of the famous windmills of the Butte. The very first article in its first number on 14 January 1882, written by Jacques Lehardy, titled simply 'Montmartre', claimed that the 'Mount Ararat' on which Noah's ark came to rest should in fact be read as 'Montmartre': 'So, Montmartre is the cradle of humanity,' Lehardy wrote. 'Montmartre is the centre of the world. . . . It was at Montmartre that humanity's first city was built.' He then goes on to speak of Montmartre as a place separate from Paris:

The *Chat Noir*, chronicler of Montmartre, was established with the sole goal of telling the entire inhabited universe how this town, although the oldest in the world . . . is still the most beautiful, the richest and the most flourishing in our epoch. . . . And to avoid seeming to express contempt for those small cities that were built a long time after Montmartre, the *Chat Noir* . . . has already organised a legion of bold explorers who will not hesitate to risk their lives. . . . [D]evoted men capable

of every sacrifice will press on as far as Paris, and their corre-
spondence effervescent with interest will allow the *Chat Noir* to
teach the *Montmartrois* about the morals, customs and civilisa-
tion of the most distant peoples.[41]

In a similar vein, the alleged 'correspondence' from a roving
Montmartrois travel writer, 'À Kempis', who 'visits' and 'discov-
ers' Paris for the first time, describes his experiences with all the
open-mouthed naïveté and candour of someone discovering a strange
kingdom with unfamiliar customs—and, in mock innocence, heav-
ily implies the superiority of the village over the rather chaotic city.[42]
The front page of the 12th issue (1 April 1882—so April Fool's Day)
carried in bold type the 'sensational' news of an assault on the inde-
pendent statelet by Parisian forces, detailing the 'order of mobilisa-
tion' and the 'latest news'. The piece ends with the line 'A pretty hard
day, this 1 April'.[43]

Yet this joking insistence on Montmartre's distinctiveness was,
of course, aimed at the *Chat Noir*'s Parisian readership, which by
1884 had reached twenty thousand. The attraction of stressing that
Montmartre was separate was a way of reinforcing the area's claim
to being a centre of entertainment and of Bohemia, 'the French tra-
dition of festivity and creativity' that cast back to a more bucolic,
pre-industrial age.[44] In other words, it was a way of attracting the
mostly middle-class clientele of the very city from which the journal
satirically claimed Montmartre's separation. So the journal was part
of the wider landscape of the growing consumer society of the Belle
Époque.

Yet the Montmartre of the cabarets had its share of thugs,
pimps, and petty crooks lurking in its alleyways and drinking in its
watering holes. When the Chat Noir moved out of its original haunt
on the boulevard de Rochechouart in 1885, one of its regular per-
formers traded in on this tougher side of Parisian life by taking over
the premises and making his songs the centrepiece of his own night-
club. This singer was Aristide Bruant. Born outside Paris (in Sens) in

1851 to a solid middle-class family that fell on hard times when he was still a boy, Bruant took up an apprenticeship in Paris and then fought in the Franco-Prussian War before working as a clerk at the railways. In that time, he explored the outer reaches of the city, coming to know the poorest districts, particularly the shanty towns of the north-eastern edges and the desolate, grindingly poor *zone*, the bleak landscape beyond the city proper and the line of fortifications that ringed the city. Mingling with the working poor, drinking in cheap cafés, and listening to the conversations of tramps, labourers, street-cleaners, concierges, washerwomen, pimps, prostitutes, thieves, and the street thugs known as *Apaches*, he gradually absorbed the Parisian *argot*, or slang. He became familiar with the popular songs of the cafés and the streets. In time, he wrote his own songs that spoke directly to his working-class audiences in the *café-concerts* of Belleville and Montmartre. He then tested himself at the Chat Noir.

Before this more middle-class audience, Bruant developed a style that aimed to thrust before them the Paris of the poor, of struggle, and of crime. When the Chat Noir moved out of the boulevard de Rochechouart premises, Bruant acquired a loan; had the mock seventeenth-century décor ripped out, replacing it with simple wooden chairs, tables, and benches—reproducing the austerity of a working-class cabaret; and called his new venue the Mirliton, evoking the kazoo-like street instrument. He also gave *fumisme* a more aggressive twist.

Dressed in the style that expressed his tough man-of-the-street persona, Bruant glared fiercely from beneath a broad-rimmed black hat and thrust out his square jaw, his powerful frame filling his flannel shirt, with thick black trousers, a swirling red scarf, a black cape, and heavy boots completing the look. Brandishing a walking stick that could equally have been a cudgel, Bruant presented himself in a way that would be deliberately intimidating to his audiences—and this was how Toulouse-Lautrec would depict him in the publicity.[45] That blunt coarseness was precisely the attraction of Bruant's cabaret.

Visitors to the Mirliton had to gain access from the boulevard by requesting entry from a surly doorman behind the front entrance who would growl at those who knocked through a small grille. Wielding a heavy stick, he would let the customers in, who would then be subjected to a chorus from Bruant, who also expected the audience to join in, which was a tirade of abuse: 'Oh, là, là! C'te gueule—c'te binette! Oh, là, là! C'te gueule qu'il a!' (Oh, my, look at that gob, that mug! Oh, my, what a mug he has!). Bruant, often springing onto one of the long tables, would recite his poems or sing one of his songs, which, as one English-speaking visitor wrote, 'does not bear reproduction here': 'For that matter, being written in the argot of Montmartre, it could hardly be understood even by French scholars familiar with Montmartre.'[46] This was—partly—the point. Bruant's middle-class audience expected to be treated to gruff insults; they wanted to listen to the voice of the streets through Bruant's mouth, to experience through popular song the 'other' Paris. His lyrics evoked the outer districts of the city, Montmartre, Belleville, Ménilmontant, Batignolles, Montrouge, La Glacière, presenting the daily struggles, the brutality, the poverty, and the humanity of the Parisian working poor.

Yet although it pretended not to be, the Mirliton was part of the wider landscape of commercial entertainment. While Bruant's performances could claim to be exposing his audience to harsh social realities, he also understood that his songs and the language he used in them had to address middle-class expectations and prejudices as much as they gave voice to the very real daily struggles of the Parisian working poor. Significantly, when Bruant stood in the working-class 20th arrondissement in the elections to the National Assembly in 1898 as a protest candidate, the socialists refused to back him—not least because, while railing against capitalism, he also claimed to be standing against 'cosmopolitan Jewry'. This combination of populism and antisemitism (in the context of the Dreyfus Affair) marked him out as a man of the Right, not of the Left. He was hammered in his electoral contest as the working-class voters turned to the socialists to represent them.[47] Even so, Bruant's songs were gritty but almost

unsurprising fare for those who had been exposed already to recent trends in literature—including the 'naturalism' of Zola—that had drawn inspiration from the harsh existence of workers, peasants, and the poor. But, like the novels of Zola, it was most certainly not for everyone.

Montmartre famously had its dance halls as well: the Elysée-Montmartre at 72 boulevard de Rochechouart dated to 1807 and outlived the customs wall that had helped to give it life (it still exists as a concert venue). During the Belle Époque, the expansive dance floor beneath its cavernous roof, supported by great iron beams and pillars, hosted the dancer 'La Goulue' (meaning 'the glutton', after her ravenous, energetic dancing style), who was immortalised by Toulouse-Lautrec. La Goulue, whose real name was Louise Weber, excelled at a dance popular amongst young Parisian working women, the *chahut*, which involved much spinning, high kicking, and lifting of skirts and petticoats, ending in the splits. She gave this stamped-ing, energetic, and demanding dance an erotic twist, flashing the bare flesh between her garters and petticoats and finishing by bending over and showing her behind—as one observer put it, 'She dialogues with desire whose progression she reads among the flaming glances darted at her.'[48] La Goulue turned the *chahut* into that 'unshakeable cliché of tourist Paris', the can-can, with the help of her dance partners, who included a lanky amateur named Renaudin whose double-jointed style of dancing earned him the nickname 'Le Desossé', 'the bone-less'.[49] He, too, features in some of Toulouse-Lautrec's dance-hall paintings.

La Goulue, Le Desossé, and other Elysée-Montmartre dancers, including Jane Avril, another Toulouse-Lautrec subject, but more ele-gant and demure than La Goulue, were lured by the director Charles Zidler to the Moulin Rouge on the place Blanche when it opened in October 1889. The iconic red windmill was the idea of the artist Adolphe Willette (who had also produced a mural for the Chat Noir).[50] The Moulin Rouge's dancers performed the can-can on dance floors surrounded by galleries where the clientele could drink and enjoy the

spectacle. Among the other star attractions was the 'Pétomane'—a performer who could fart at will, including (apparently) for a rendition of the folksong 'Au Clair de la lune' (By the Light of the Moon) that had audiences roaring with laughter. Behind the building, there was an open-air garden strung with fairy lights and featuring a massive effigy of an elephant (acquired from a fun fair held during the 1889 Universal Exposition). The elephant towered over everything else—and inside of it there was a small stage for belly-dancing performances. The Moulin Rouge quickly became a world-renowned, if rather clichéd, icon of Paris and of the Belle Époque itself.[51]

The can-can attracted spectators expecting (and hoping) to be shocked. One amused writer wrote in the 1890s of 'the old English ladies and the young misses . . . who always sit in the front row in order better to ascertain the immorality of the French dancers'. They would 'then utter their properly indignant "Shockings!" '[52] What shocked the authorities as well was the impromptu invention of the striptease, which took place in the Moulin Rouge when it hosted the Bal des Quat'z'Arts (Four Arts Ball) in 1893. This event, first organised by the students at the university in 1892, became an annual fixture in Montmartre. The student revellers attended in costume, travelling to Montmartre from the Left Bank throughout the 1890s on decorated floats with artists' models posing on them. One of these models was Marie-Florentine Roger, better known as Sarah Brown (a nickname evoking her pale, 'Celtic', red-headed beauty), who provocatively stripped off her Cleopatra costume to wild applause and cheers as the Saturnalia reached its height. The press published scandalous accounts of the exuberant nudity. When charges and fines were levied against some of the participants, including Roger, it provoked a student riot in the Latin Quarter, which of course gave the 'strip tease' the oxygen of publicity that ensured that it would continue.[53]

Just as the lives of Bohemian artists, writers, and musicians were interwoven with those of the more respectable bourgeoisie, Montmartre was entangled with the consumerism and commercialism of the Belle Époque city as a whole. Montmartre's attraction as a centre

for pleasure was dependent on its accessibility from the rest of the city, made all the more feasible by Haussmann's renovations and by the development of transport connections, especially the Métro after 1900. So the Chat Noir's jocular boosterism about the superiority of Montmartre over Paris was a backhanded acknowledgement that it needed Paris if it was to thrive as a distinctive area of pleasure and entertainment.

The Chat Noir, the Mirliton, and the Moulin Rouge emerged from and engaged with the expanding middle class, with the consumer and commercial society underpinning it, and with the urban space it inhabited. It is for this reason that, along with their habitués—Toulouse-Lautrec, La Goulue, Théophile Steinlen, Jane Avril, Erik Satie, Aristide Bruant, and others—these places would become indelibly associated with the Belle Époque, a memory redolent with a pungent combination of *joie de vivre*, creativity, experimentation, elegance, decadence, style, and eroticism.[54] Yet Montmartre's Bohemianism was bound up within the complexities of Belle Époque modernity: it, too, was part of the transformation in the life of the modern city that made the Belle Époque both an exhilarating time of change and an unsettling period of deep-seated anxiety.[55] As shown by the weave between 'Bohemian' and bourgeois life; by the dangerous mixing of art, radical politics, poverty, and crime on the Butte; and by Aristide Bruant's songs of the streets and slums, Montmartre flourished as a Bohemia precisely because it was shaped by the harsh realities of the modern city.

CHAPTER 6

SURVIVAL

In the autumn of 1875, a portly *bourgeois*, with pince-nez glasses covering alert if somewhat drooping eyes above a trademark black goatee, visited the impoverished neighbourhood of the Goutte d'Or. The out-of-place stranger was Émile Zola, the neighbourhood a slum district in the 18th arrondissement lying between the eastern slopes of the Butte Montmartre and the expanse of railway tracks approaching the Gare du Nord—although its name, meaning 'drop of gold', evokes the white wine that was produced here when it was still covered with vineyards: it was a favourite of King Henri IV in the early seventeenth century.[1] Zola, then thirty-five years old, may only have been little more than half an hour's walk from his home, but he was a world away from the comfortable three-storey house that he was then renting with his wife, Alexandrine, at No. 21, rue Saint-Georges, in the 9th arrondissement.[2] Zola was focussed on one task: research. He was observing the buildings, the topography, the people, the sights, and the sounds for the novel that would not only bring him fame, indeed notoriety, but also wealth: *L'Assommoir*, which was serialised in the journal *Le Bien Public* from 13 April 1876.[3]

Today's Goutte d'Or district still conveys a strong sense of the social geography underlying Zola's narrative from 150 years ago. The character of the area has long changed in some senses. Some older buildings were smashed down in the 1980s and replaced by modern edifices. The area now has a long-standing association with immigration from the Maghreb and from West Africa. For that very reason it has lost none of its vibrancy, its industriousness, its sense of independence, or, for that matter, the poverty that is never far away.

The story of this area—and those of many others, like La Villette, Belleville, and Ménilmontant farther east, or some of the crammed slum districts of the centre, like Saint-Merri, the Beaubourg, and the Marais on the Right Bank and Saint-Sévérin on the Left—tells us that Belle Époque modernity was not experienced evenly, let alone equally, among Parisians. The social differences were captured in an observation by Nguyễn Trọng Hiệp: 'The great ladies walk together, followed by the humble ladies,' which is a blunt observation of class difference.[4] All classes in society experienced the Belle Époque as an era of technological and economic flux and of cultural change, but while for some, protected by their wealth, the changes were felt with a rush of exhilaration and the promise of possibility, for many others—much of France's working population—they dimly illuminated what was, in essence, a daily struggle for survival.

L'ASSOMMOIR, WHICH TRANSLATES roughly as 'the drinking den' or 'boozer', charts the struggles of Gervaise Macquart as she fights to make a life for herself in these sloping streets. Gervaise has recently moved to Paris from the small Provençal town of Plassans with her lover, Auguste Lantier, and their two illegitimate sons, Claude and Étienne. A selfish ne'er-do-well, Lantier abandons Gervaise and the boys in a miserable, grimy room in the sordid Hôtel Boncoeur. With two children to support, she determinedly finds work at Madame Fauconnier's wash-house on rue Neuve de la Goutte d'Or (now rue des Islettes, where the name of the place de l'Assommoir is a tribute to

Zola's gritty immortalisation of this area).[5] While thrashing out a living by wringing and beating clothes in the laundry's steaming humidity, Gervaise meets the sober, clean-living roofer Coupeau, who is persistent enough in trying to persuade her to marry him that she eventually succumbs, against her better judgment. Gervaise's ambition is to run her own laundry—and she sees an opportunity when a shop on the rue de la Goutte d'Or falls vacant. And when Coupeau falls from a roof, his severe injuries mean that he can no longer work.

Undeterred, Gervaise finds the money she needs by accepting the offer of a loan from a steady and friendly neighbour, Goujet, a blacksmith who works in a factory making nuts and bolts. After signing the

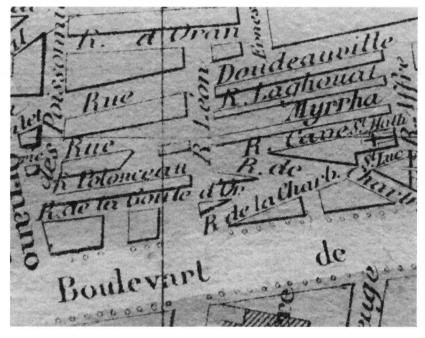

The Goutte d'Or district, the setting for Zola's depiction of the struggles of the urban working poor and the impact of alcoholism in *L'Assommoir*. In the novel, the rue des Poissonnières is the site of old Colombe's bar, and the rue Neuve de la Goutte d'Or (the westernmost of the short streets linking the rue de la Goutte d'Or with the boulevard de la Chapelle, *bottom*) is the site of the laundry where Gervaise works at the novel's opening. The Villa Poissonnière (not marked) runs between the rue de la Goutte d'Or and the rue Polonceau.

lease on the shop premises, Gervaise spruces the place up brightly and proudly decorates the frontage in a striking blue, complete with signage. Yet her chances of breaking free from the squalor are hamstrung by the unemployed Coupeau, who takes to drink. The financial pressure becomes too much, and Gervaise is forced to give up her lease on the shop, later reflecting that on 'that day she must have buried a bit of her own life, her shop, her pride as an employer, and all kinds of other feelings. . . . [I]t was a complete moving out, a descent into the gutter.'[6]

The family moves into the massive rabbit-warren of the Villa Poissonnière, which in the novel is a labyrinthine tenement building centring on a damp, fetid courtyard off the rue de la Goutte d'Or, but which today is an almost bucolic alleyway accessible through a gated archway on the north side of the street. It is here, amidst the tightly packed warren of dark corridors, rancid with the smell of cooking and resounding with the noise of human life, that the Coupeaus begin their final decline into alcoholism, abject poverty, prostitution, and death. Gervaise herself gives in to the temptations of drink, not least the hard spirits distilled by the beast of a still in the back courtyard of old Colombe's bar—the eponymous 'assommoir'—on the corner of the rue des Poissonnières and the boulevard de Rochechouart. Coupeau dies agonisingly in an asylum, delirious from the long-term impact of alcohol. Gervaise, her body and spirit shattered by poverty and drink, scrimps whatever existence she can, tries to prostitute herself, and ends up dying of starvation—and, as Zola puts it, weariness with life—in an obscure pauper's hole beneath a staircase in the Villa Poissonnière.

With each instalment of the novel, public anger mounted. Radical republicans disapproved of Zola's depiction of working people in a less than edifying light, especially by putting into their mouths the slang from the Parisian gutter. No matter that Zola had, in fact, researched this language deeply, and had used it to lend greater realism to his characters: all good middle-class republicans knew that, obviously, solid working-class republicans spoke proper French. For

the Left in general, the 'People' was essentially noble and its vices arose from their oppression by the propertied and by capital.[7] Yet Zola's working-class Parisians had a heavy hand in their own misery, much of it the consequence, as the novelist put it brutally, of 'drunkenness and indolence'.[8] As one of Zola's supporters explained, 'If the good democrats expected sycophantic drivel about the noble slums . . . they soon discovered their mistake.'[9] For critics on the right, it was the shock to morality that rankled. *L'Assommoir* 'isn't realism, it is grubbiness; it isn't crudity, it is pornography', wrote one critic in *Le Figaro*, concluding that the novelist deserved to face criminal proceedings.[10]

The literary journal *La République des lettres* took up the serialisation, but it was when the story was published in book form in January 1877—when President Patrice MacMahon's government of 'moral order' was still just in the ascendant—that it was threatened with an official ban. A government report, claiming that 'the crude and relentless obscenity of the details and terms aggravates the immorality of situations and characters', recommended that authorisation for sale be withheld.[11] Conservative newspapers echoed this demand, and the government did indeed manage to ban the sale of the novel at railway station kiosks.

Yet Zola did have his supporters. Among them was the literary giant Anatole France, who admitted that *L'Assommoir* was far from 'likable', but observed that it was not meant to be: it was instead 'a powerful book' that depicted the lives of its characters 'with immediacy and directness' and in their own authentic language.[12] Zola was depicting in truly gut-wrenching detail the daily struggles of the poor in Paris: as Zola put it, 'the inevitable downfall of a working-class family in the polluted atmosphere of our urban areas'.[13] While his novels were set in the Second Empire, his Belle Époque readers would have recognised that he was in effect also writing about their present.

Belle Époque Parisians, like their counterparts across Europe, inhabited a society with glaring discrepancies of wealth. As a whole,

France grew wealthier during this period, thanks to the growth in manufacturing, consumerism, and the exploitation of the overseas empire, but the distribution of that wealth was becoming more unequal. The share of peasants and workers in the nation's wealth slipped between 1870 and 1914, while the wealthiest 10 per cent englobed even more than they already had. The nadir of this inequality was reached in 1910, when the wealthiest 10 per cent had amassed a dazzling 90 per cent of the nation's riches.[14] Indeed, the world of the leisured socialites who inhabited Proust's pages was made possible by these gross inequalities. A staggering 82 per cent of the Parisian population was defined as poor, measured by the possessions they left to their children, with the vast majority of them (72 per cent) classified as indigent, meaning so poor that they left absolutely nothing material to their families. When one bears in mind that, by the same measures, in 1820, 83 per cent of Parisians were defined as poor and 68 per cent as indigent, it's clear that little had changed over the course of the nineteenth century.[15]

It is true that there was a *general* increase in earnings, along with improvements in living standards. As national income as a whole expanded, working people—here defined as the 70 per cent of the Parisian population who, whether manual or white-collar workers, owned no property and depended on their wages to survive—ended up better off by the start of the First World War than the working population had been at the end of the Second Empire in 1870.[16] Although increases in the cost of living outstripped the increase in wages between 1905 and 1913, the purchasing power of French workers had risen by 25 per cent between 1840 and 1900.[17] Yet these global figures hide some crucial inequalities.

Terrible, crushing poverty persisted on a wide scale, an impression confirmed at the time by a wealth of social studies and political commentaries. There were disparities between men and women: in some industries, women took home half the earnings of men for doing the same job. Quite apart from the glaring injustice, this vast difference took a terrible toll on families where the husband or father had

died, was incapacitated, or had left: these were considerably poorer than those led by a working male.[18]

Besides the discrepancies between men and women, there were also differences between Paris and the provinces, where wages were lower, and between different types of work, especially between skilled, semi-skilled, and unskilled labour, with the unskilled workers hovering perpetually on the brink of indigence. These factors nuance the general picture of rising real wages, showing how uneven they really were. In many types of work, employment itself was precarious. Parisian crafts and manufacturing were always susceptible to fluctuations in demand. To protect their businesses, employers and master-artisans hired a 'core' of skilled, well-paid workers on a long-term basis, supplementing this workforce with short-term labourers who could be readily laid off when times were slow. Even among the skilled workers, quiet periods of trade saw them underemployed, performing tasks that were beneath their skill and pay levels.[19]

For the unemployed and the underemployed, the expansion in purchasing power was virtually meaningless—unemployment was almost literally a daily possibility for many workers. In 1907, René Martial, an expert in public health, studied 2,800 Parisian hatters and found that, depending upon their speciality and level of skill, unemployment in any given year could range from four to eight months, with the 'quiet' seasons being May through July and the dark winter months of November to January. Only 2 to 3 per cent of these workers avoided unemployment altogether.[20]

What Martial witnessed in one Parisian trade was replicated in others. There was no protection against unemployment, and the persistence of seasonal work meant that some types of work had 'dead seasons', or, as the socialist Jules Guesde put it, 'the season when one dies', especially in construction and textiles. Martial found that carpenters typically worked only 250 days a year, a stage dancer 270 days, and enamellists and upholsterers only 200 days annually. As the French economic historian Jean Lhomme has remarked, 'the nineteenth century, which has laid claim to the beginnings of

improvements in the lives of workers, was also the period when the misery of workers had probably reached its most lamentable level'.[21] Economic precariousness was one of the harsh facts of Belle Époque life that distinguished much of the working population from the middle classes and the über-rich.

It is true that most workers in 1914 were better fed and clothed than their grandparents had been in the 1870s. Clothing habits, at least for the better-off, more skilled workers and their families, also changed between 1870 and 1914. This was in part because of the very organisation of mass production that threatened to undercut the livelihoods and independence of the master-tailors and mistress-dressmakers. Although the quality was lower, more clothing was being produced, and it was being sold at cheaper prices. It was also thanks to the new practices of credit (payments in instalments and the use of vouchers) introduced by the department stores, especially Dufayel in the 18th arrondissement, not far from the Goutte d'Or district. So while in 1870 many Parisian workers had clothed their families from visits to the city's flourishing secondhand clothes shops and the many stalls in Paris's famous markets, by 1914 skilled workers could expect to buy firsthand.

For men, these clothes might have included a suit and a hat that were expected to last and would be worn on special occasions, as well as a modest collection of less durable workaday clothing, supplemented by a few fashionable items that were not necessarily made to last. The heavy, formless worker's blouse—almost a trademark of the barricade-manning Parisian workers of the revolutions of 1871, 1848, and 1830—was being seen less and less. Skilled women workers (or the wives of the male counterpart) might have a good cotton dress for social events and Sundays but could also expect to have a small wardrobe of cheaper cotton and wool dresses for everyday and work wear, accompanied by a small number of accessories for a touch of glamour. The more regular appearance of suits, along with bowler hats, for working-class men, and the grey or black dress, for working women, also reflects the changing nature of work in the Belle Époque

city as services grew, the state expanded, and the consumer city lengthened its reach.[22] The better-paid workers, at least, had become fashion-conscious—or rather, could afford to be so.

Food, especially meat and dairy, had become more varied and more readily available. While the staff of life for working families remained bread, it at least took up only 9 per cent of the household income in 1900, as opposed to 20 per cent fifty years previously. Overall, the amount of staples eaten and drunk in France—bread, potatoes, and wine—increased by 50 per cent between 1850 and 1900; that of meat, beer, and cider doubled, and that of sugar and coffee increased fourfold.[23] The children of the workers were spared the worst ravages of hunger with the introduction of free school meals from the 1880s. This was reflected, in fact, in the fitter condition of military recruits on the eve of the First World War as compared with those from the Second Empire just before the Franco-Prussian War in 1870.[24]

This global picture is reinforced by the lunchtime habits of Parisian workers—as is the evidence that the benefits of a more substantial diet were unevenly shared. A skilled cabinet maker could afford a 'proper' lunch in true French fashion at a popular restaurant, a *bouillon*. The menu would include a starter (usually soup), a main course of meat with vegetables, a salad, and a piece of cheese, all accompanied, naturally, with wine (a pint of it!) and a coffee. Here, uniformed waitresses and waiters took orders by putting ticks alongside a preprinted menu on cards left on each table; the price of each item was specified, allowing customers to calibrate their meal to their wallets. Some of these *bouillons* still exist in Paris.[25]

Lower-paid craftworkers or labourers might have tried to stretch their earnings to the *ordinaire*. This meant dining on a chunk of beef swimming in a thin vegetable broth, saving some of the meat for a sandwich later. Women workers, paid far less than their male counterparts, also relied on the *ordinaire*, or on even cheaper versions, such as those at the *crèmeries*, aimed specifically at women by providing cheaper if smaller meals and, it was hoped, a safe haven from the male

harassment they all too often experienced. There were also restaurants with fixed prices and, strikingly, cafés that offered take-away sandwiches and dishes, with signs advertising *vente à emporter* (sales to go).

Vendors selling street food—*friandises parisiennes*—such as soup, fried potatoes, black puddings, and sausages, were a regular feature of Parisian life at lunchtime. In the Tuileries one could see workers leaning up against the north wall (which catches the sun shining from the south) and lunching on their small bag of fries: the park had to employ three attendants to make sure the gravelled grounds were not littered with oily paper wrappers. Modern nostalgia for the 'proper' French lunch taken at a restaurant or café, entirely understandable though it is, overlooks the fact that 'fast food' taken on the run and bolted during a quick break was already an established feature of working life in Belle Époque Paris. The *Journal du dimanche* (Sunday newspaper) remarked that 'in our era of so many hurried, busy and rushed people, it is possible to eat a lunch worthy of Lucullus, while walking, without losing time and cheaply, to boot'. That was in 1913.[26]

Failing all this, there was always the packed lunch. It was not uncommon to see women sitting on park benches at lunchtime nibbling cold food from their lunchboxes. Women workers' earnings were in fact so small that René Martial was astonished that they could afford to eat at all. Speaking of the *midinettes* whose exuberant presence on the boulevards became the stuff of Parisian lore, he told his listeners that they sustained themselves on dinners of cheap fries and some bread: 'You can verify this for yourselves by going to watch the exit from the workshops in the faubourgs and walking between midday and one o'clock in the popular districts, where you will see them sitting on benches, near a Wallace fountain.' For the *midinettes*, he added, typically '[gave] 2/3 of their earning to their families': 'They support their parents, often ill or infirm; they live in perpetual misery.'[27] A Catholic reformer, Lucien de Vissec, observed the 'hubbub on the streets, the lines in front of the *crèmeries*, the bakeries, the charcutiers, and the stalls sporting signs such as "cuisine à emporter—portions à

30, 40 et 50 centimes" and the bars where working-class girls "gulp down" their pittance with a glass of white wine and a coffee'.[28] Staples, however, were more affordable than they had been for previous generations. The poorer workers may not have been able to enjoy the rich range of fresh produce and meat that their more skilled counterparts did, but they were able to avoid hunger by bulking up on bread, rice, lentils, potatoes, and some cheese—the *strict nécessaire* (the bare essentials). It kept them going through the day, even if their budgets were often severely stretched.

Depending upon the price of vegetables and the season, a meal eaten by René Martial's hatters and their families might have included 'a ragout in which there are some of the cheapest pieces of beef, potatoes and flour, or even a vast plate of sauerkraut (*choucroute*), or even a mixed plate of cabbage, potatoes and lard, or of potatoes and turnips, or of artichokes, or carrots, or green beans or seasonal salad'. Eggs were pricy, so were used as a rare condiment rather than as part of a dish in their own right: an omelette for the family was an expensive luxury. Butter was used only in small quantities, substituted by the much cheaper margarine. Combining the cost of food with rent, transportation, clothes for the children, and other minor expenses of daily life, Martial showed that a hatter and his family would have to struggle to make ends meet, 'especially in the winter, when daily expenses are increased as the prices of food rise, [and] fuel and shoes have to be bought'. In the 'quiet' seasons of unemployment, there was little elasticity in the family's outgoings, so 'What can that worker do when he obviously is in no condition to save anything? He and his family have to live. He goes into debt, which he repays little by little when work picks up again.' This naturally reduced the family's disposable income in busy times, threatening a long-term spiral of indebtedness. 'And now I'm envisaging the possibility of a sudden illness! If that happens, it means ruin and misery, pure and simple.'[29] In such circumstances, families would send children to be cared for by elderly relatives, if they were able to do so. If not, they went through the wrenching experience of committing them to the 'Service for

Morally Abandoned Children', created in 1880 by the Prefecture of the Seine. As its name suggested, the service was intended to take care of children who had fallen into delinquency because their parents were deemed, for 'moral' reasons, such as alcoholism or mental incapacity, to be incapable of looking after them. In practice, about half of the children committed—some seven hundred to nine hundred of them each year—were voluntarily though reluctantly given up by desperate parents who felt they had no other choice because the only alternative was a precipitous slide into the most abject poverty.[30]

Yet not all such children were taken in hand in this way. Gangs of young people stalked the streets of the poorer districts of the eastern arrondissements and the old slums of the city centre engaging in crime, violence, and prostitution. Called *Apaches*, they arose in the poorer districts of Paris in the 19th and 20th arrondissements in the east, and in the (then) crammed and pestilential district of the Beaubourg and Saint-Merri not far from the Halles, the central food market. They were usually between fifteen and twenty years old, and they were typically the children of first-generation migrants who had fled rural poverty in the economic crisis of the 1880s to seek work in the factories of the Parisian suburbs. What they had found was misery: penniless, they gravitated towards the fringes of the city, seeking unskilled work in the factories on the outer rim of Paris, often settling in the shanty towns of the *zone* that ringed the city, in the slums of Belleville and Ménilmontant, or in the city centre. Their children, having grown up in squalor, were coming of age at a time when legislation was seeking to improve the lives of France's young people, with compulsory and free schooling and a reduction in the number of hours that a minor could legally work. The inadvertent result was that the children of impoverished migrants, who had now left school and were emerging into their mid-to-late teens around 1895, were caught between schooling and full-time employment.

With their parents struggling to survive in the desolate outskirts of the metropolis, too stretched to take care of their growing children, sometimes succumbing to alcoholism and its effects—including, all

too often, the brutal hand of domestic violence—these traumatised, rootless teenagers broke away. They found miserable accommodation in the dark, dank *chambres garnies*, rooms that were rented out cheaply by the night. When they formed gangs, they were dubbed 'Apaches' for their 'savage' ferocity. They survived by means of theft, especially muggings, prostitution, and violence. They caused a sensation, indeed a panic, in the press, with their fearsome weapons (knuckle-dusters, garrots, cut-throat razors, revolvers), their ferocious attacks, and their strong sense of identity that placed them outside law-abiding society.[31]

The gangs were sometimes named for the areas they haunted (such as the 'bande du Sébasto', or 'la Beaubourg'); others gave themselves more sensational names, such as 'Les Vampires'. They wore different coloured sashes and spoke an *argot*, slang, of their own. Gangs fought running battles with the police and fought each other in turf wars over the control of the sex workers: In one notorious case in 1902, a sex worker dubbed 'Casque d'Or'—golden helmet, for her towering blond hair—provoked a war among rival Apache gangs when she left the 'protection' of one pimp for another. When the police intervened to stop the murderous battle along the city's old fortifications, the two Apache groups joined forces to fight them. It did not end well: the leaders of the gangs were arrested and deported for life to the gruelling, living hell of the penal colony in French Guiana.[32] The Apaches remained a very real, if somewhat overblown, nightmare for police and public alike until 1914, when the call to arms drew Paris's young men off to violence that was far worse in scale and trauma. In one sense, the (understandable) panic that surrounded them anticipated a feature of modern life: fear, anger, and anxiety about the potential for 'antisocial behaviour' among feckless adolescents and left-behind youth.

The marginal world of the Apaches coexisted with and indeed exploited desperate women teetering on the brink of absolute poverty who felt driven into prostitution. Pimping and the violent control of the women in their grip appears to have been the primary source of the Apaches' income. Yet prostitution went far beyond the activities

of a few violent gangs of what today the media would call 'youths' or 'juveniles'. Estimates as to the numbers of women engaged in the sex trade during the Belle Époque varied wildly, from 14,000 to a staggering 120,000: the prefect of police Louis Lépine told one researcher that there were 40,000.[33] Whatever the scale, it reflected the desperation of many women confronted with poverty, abandonment, and the need to look after elderly relatives or children single-handedly. Their dire situation had already been well-established by Dr. Alexandre-Jean-Baptiste Parent-Duchâtelet, whose two-volume study *De la prostitution*, published in 1836, became the standard account.

On the one hand, his research contradicted his own original assumption that women became prostitutes because of their own immoral proclivities. He was honest enough to accept that, in fact, they were driven by their desperate economic circumstances: despite himself, he humanised the women who had turned to sex work. He accepted that 'of all the causes of prostitution . . . there is none more active than the lack of work and misery, the inevitable result of insufficient salaries. What are the earnings of our dressmakers, our seamstresses, our menders, and in general all those who occupy themselves with the needle? . . . [O]ne will cease to be surprised to see such a great number fall into a disorder that is, so to speak, inevitable.'[34] Parent-Duchâtelet's was the most influential study on the topic in the nineteenth century: when 'Dr' Jean Fauconney, who did not in fact have a doctor's qualification and who made a living by popularising—and sensationalising—medical research, turned his pen to the same questions about prostitution in 1902, he appears to have relied heavily on the (real) doctor's work. Admitting that 'it is evident that for almost all prostitutes, misery in its different forms is the predominant cause of the depths to which they have fallen', he went on to explain that 'the *couture* trade supplies the largest contingent', because a woman's 'earnings from work are not enough to balance her expenses'. This rings true, given what we know about women's wages during the era and how women on their own, or those abandoned by their husbands or with incapacitated partners, did indeed struggle

to make ends meet. Yet Fauconney, perhaps telling his readers what they wanted to hear, then added that the couturiers' own extravagant tastes for luxury and beauty signally augmented those expenses: there was a moral sting in his analysis.[35] More importantly, that Parent-Duchâtelet—a doctor writing in the 1830s—should remain the primary authority on prostitution right up to 1914 suggests that Belle Époque modernity barely touched one group of impoverished women, namely sex workers. In fact, that the system within which they lived was virtually the same as that which had ruled sex workers' lives for most of the nineteenth century suggests that it had passed them by altogether.

The reason that police and social researchers could only guess at the number of sex workers in the city arose from the fact that the former only had records of those who were registered with the Prefecture of Police. France had a 'regulated' system of prostitution, justified on the basis of what would later be spoken of as the 'sexual double standard'. Again, it was Parent-Duchâtelet's work in the 1830s that carried the most authority—'Prostitutes', he argued, 'were as inevitable in an agglomeration of men as sewers, gutters and cesspits.' In drawing off the natural sexual urges of men, 'they contribute to the maintenance of social order and tranquility'. Without the prostitute—the term Parent-Duchâtelet uses here is the *fille publique*—man, 'who has his desires, will pervert your daughters and your domestic servants.... [H]e will cause trouble in your households.'[36] Men, therefore, had natural urges that could not be contained, but women were expected to be virtuous, saving themselves for marriage and family. So the virtue and lives of a minority of women—prostitutes—were sacrificed to service male desires in order to preserve the moral integrity and social prospects of the rest. Moreover, when a young woman did marry, it was expected that her new husband would be able to instruct her in the ways of the marital bed—and it has been assumed by modern historians that the vast majority of young Frenchmen garnered the necessary experience in the first instance from a visit to a sex worker. Thus prostitutes—drawn largely from struggling

families of workers and artisans and seeking just to survive—turned their bodies into 'instruments of work', as the historian of French brothels Laure Adler puts it, and, in the process, were supposed to have safeguarded the families of others from moral contagion.[37]

As such, sex workers were given a special legal status. Those who registered with the police, called *filles soumises*, were not criminals, but they were subjected to a rigorous regime of surveillance and control that left them with no legal rights. To avoid arrest, a would-be sex worker had to register at the Prefecture of Police in Paris, where she was questioned and subjected to an invasive medical examination; if she was married, her husband would be contacted. She was then given either a number (thus becoming a *fille à numéro*), if she was going to work in one of the formally recognised brothels (*maisons de tolérance*), or, if she was striking out independently on the streets, she was given a special identity card (becoming a *fille en carte*).[38] There were 6,196 *soumises* in Paris in 1907, so even if we take the lowest estimates of the number of women involved in sex work, it means that the vast majority refused to register and so remained *insoumises*.[39] There was good reason for this: as the French historian Alain Corbin has pointed out, to be registered was not to declare a profession, but rather a legal status, to submit to a realm of regulation that was without the normal protections of the law. As such, one did not just 'leave' prostitution at will: to register was to be legally marked for a long time, quite possibly for life, since the process of getting one's name stricken from the records was laborious and not always successful.[40] Since most women who felt driven to sex work did so on a temporary basis—to see themselves and their families through particularly hard times—it was best to avoid such a permanent, or near-permanent, legal mark against their name. Moreover, to be registered meant submitting to regular, humiliating, and painful medical checks, either at the dispensary at the prefecture or by a police-appointed doctor who visited the *maisons de tolérance*. Toulouse-Lautrec, who spent some time living in a brothel at 24 rue des Moulins close to the Palais-Royal and the old Bibliothèque national, depicts in one of his brutally frank

paintings the women queueing resignedly for just such an inspection in 1894, already scrunching up their chemises, ready for the doctor's speculum.[41]

The *maisons de tolérance* have, it is probably safe to say, been over-glamourised. The luxurious 'houses', shimmering with satin, silk, velvet, and gossamer, bedecked with gilded mirrors, suggestive paintings, and magnificent furnishings designed for their erotic appeal, certainly existed. These upmarket *grandes tolérances* were clustered in a central area roughly plotted by the Madeleine, the Palais-Royal, the Opéra, and the Bourse (the stock exchange): those on the rue Chabanais were especially famous (one was frequented by the Prince of Wales, the pleasure-loving future King Edward VII). The brothel on the rue des Moulins, depicted in the colourful if frank work by Toulouse-Lautrec, was one of these.[42] Yet of the 123 *maisons de tolérance* in the city in 1903, the majority were not of this kind.[43] Most had sprung up in the outer arrondissements, displaced under the impact of Haussmannisation, often clustered close to the old fortifications. These were the *maisons d'abattage* (literally, 'knocking shops'), cheap brothels used by the working poor and soldiers, and *estaminets*— drinking dens in which the women, plastered with make-up and rouge, dressed in short shifts or just aprons that left little to the imagination. They drank with the clients before taking them upstairs, all in a fug of smoke, alcohol, cheap perfume, and din.

The reformer Armand Villette visited one such place on the outer limits of the 17th arrondissement. He found a dive accessible down a narrow, damp, and dirty corridor stinking with mould: on the ground floor the women and their clients sat on benches around large wooden tables encrusted with filth, adjacent to a stove on which the sex workers cooked their own food. The corpulent madam sat in an armchair with a ledger in front of her: each time a girl took a man upstairs, her name was marked with a notch, which indicated a *passe*—a session with a client. The sex worker took the payment from her client, but gave half to the madam, who totted up the totals at the end of the night's work, usually at three or four in the morning. According to Villette, he saw

one woman notch up a gruelling ten *passes* in one evening. These took place in four rooms on the upper floor of the three-storey building:

> These four rooms are repugnant, each with a low bed with-out a box spring, dirty sheets, scuffed upholstery revealing the cracked plaster of the wall; the chest of drawers broken in several places; the chamberpot and bowl and water-jug chipped, curtains tattered and never washed; the bedside rug seemingly made of a discarded potato sack, and the armchair which, at the slightest touch, lurches to the sinister groans of old scrap metal. These four rooms are assigned to the *passes*.[44]

These squalid realities help explain why so many sex workers refused to register with the prefecture. They also explain why the *insoumises* who sashayed around the boulevards at night looked down on the *soumises*, scoffing, 'Elle est en carte!' at their 'legal' co-workers. Most of the street prostitution—which Zola described in vivid detail in *Nana*—in fact would have been carried out by the *insoumises*, since they could try to move on if the police appeared. So Armand Villette, an activist who campaigned against the 'regulated' system, reported bluntly, 'One only has to cross the rue du Faubourg Montmartre at 10 o'clock in the evening to see this deplorable state of affairs. There, groups of three or four, sometimes more, openly solicit, women young and old parading, calling out to passers-by, making the filthiest of proposals.'[45] It was on this same street that Zola's character Nana and her friend Satin, desperate for custom, finish up in the small hours after trailing the boulevards: 'There, till two o'clock in the morning, restaurants, brasseries and butchers' shops blazed with light, while crowds of women clustered round the doors of the cafés, in this last living, lighted part of Paris, this last market open to nocturnal bargaining, where deals were being struck quite openly, group after group, from one end of the street to the other, as in the main corridor of a brothel.'[46] Dumbfounded by the kind of open solicitation that Zola described in fiction, during his

research Villette approached a tall, blonde sex worker on the rue du Faubourg Montmartre and asked her about registration and the police. "'The regulations?" she replied, laughing, "We don't give a f— about them!'"[47]

This was risky, however, since, as Zola's character Nana discovers, the *insoumises* were regularly targeted by police who swept through the streets known for prostitution in raids, or *razzias*. Nana gets swept along in such a raid, carried along by 'a wild stampede through the crowd': 'Skirts streamed out behind, and dresses were torn. There were blows and shrieks. A woman fell to the ground. The crowd stood laughing and watching the brutal tactics of the police as they rapidly closed in.[48] To be caught unregistered was to be imprisoned in the Saint-Lazare 'hospital', checked for venereal disease, and then locked up for a spell—anywhere between 10 and 250 days—without trial, under the supervision of guards and nuns, who ran the place with a rigid discipline. When the liberal reformer Yves Guyot visited, he found a 'sombre and sad' institution. Its waxed corridors, he reported, were pervaded by the smell of the greasy soup that passed as food. The inmates, in poorly fitting grey dresses, grey shawls, and white bonnets, laboured at sewing machines in a workshop or cleaned floors; like penitents, they kept their heads down to avoid making eye contact, moving mechanically at the imperious orders of the superior. They slept in dormitories or were locked up in cells at night, sleeping on simple mattresses without covers.[49]

Some commentators raised their voices against the iniquities of the regulated system. The British reformer Josephine Butler, who had conducted a successful battle against a similar system in her own country, launched a campaign in 1874. She inspired others, including Guyot, who dedicated his 1882 book on prostitution to Butler. In it, he castigated, among other things, the dehumanising effects of the system: 'The result of the inscription leads people to consider prostitutes as separate beings, having a different organism, other nerves, other brains, to our own.'[50] Others, such as Louis Fiaux, pointed to the highly exploitative nature of prostitution. In one passage, he

described how things ended for the aging sex worker from the *maisons de tolérance*: 'Maddened, ragged, dying of hunger, young at least, they entered; now, worn out, dishonoured, offering only the outline of precocious, repugnant old age, incapable of attracting trade to the lowest house, rotted with all the putrefaction amassed . . . they are thrown into the street and the doors shut against them.'[51] Others still were angered by the obvious infringements of civil liberties that came with enforcing the system: in 1879, the city council was concerned enough to grill the prefect of police on the practice whereby officers would sweep down streets and arrest all unescorted women indiscriminately, many of whom might simply have been going about their daily business.[52] Yet no reform came, and the regulated system continued to consume desperate, impoverished women from the Parisian working poor until it was abolished in 1946.

If prostitution arose from desperation, and if the 'Apaches' sprang from a deep sense of exclusion among some of the young, second-generation members of migrant families, then it is hardly surprising that many working-class families were determined to find an escape of some kind. Although the working day was long—often eleven to thirteen hours until the 1890s—some escapism could be had at the many cheap dance halls. The industrial suburb of Saint-Denis boasted no fewer than four cabarets and twenty dance halls. Working-class cafés put on concerts on Sunday afternoons. For workers and their families, too, the long weekend walk and picnic in the surrounding countryside, though increasingly hard to reach as the industrial outskirts expanded, remained an important break from the routine of the working week.[53] Despite the poverty—and perhaps because of it—workers were determined to share in the consumer culture of mass, commercialised entertainment that was a feature of Belle Époque modernity, patronising theatres and cinemas when they could.

Yet some found the pressure too much to bear, as is testified by the rise in alcoholism. The Belle Époque, in fact, was the period in which French people drank more than in any other period before or since:

In 1900, the average French person consumed four times as much distilled spirits as they had in 1830—and Paris was a particular hot spot of heavy drinking. Wine consumption grew more erratically, but it, too, climbed. Most notorious of all, the amount of absinthe drunk in France expanded from a modest 6,713 hectolitres (about 177,000 gallons) of pure alcohol in 1873 to a mind-addling 238,467 (about 6.3 million gallons) in 1900. Originally designed in Switzerland for its alleged medicinal properties, absinthe (from the Greek *absinthion*, meaning 'impossible to drink') was distilled from wormwood essence, giving it its bitter taste and its distinctive green colour, from which it earned the nickname the 'green fairy'. It was also poisonous, but it would not be banned until 1915, during the First World War. Alcoholism and its attendant social impacts were nonetheless symptomatic of the hard-pressed workers' search for an escape from the daily struggle for survival.[54]

Though better fed and clothed than their forebears had been a generation or two previously, most Parisian workers were little better off in their housing. In a vicious circle, French workers often had trouble paying their rent, so landlords were not too keen to invest in repairs or improvements, which in turn made tenants less inclined to sacrifice food, clothing, and heating to line the owners' pockets.[55] And, owing to a shortage of accommodation, rents rose rapidly—by a fifth—in the years just before the First World War. When rents fell due, as they usually did every quarter, there was a palpable atmosphere of anxiety in working-class tenements: when working families could not pay their rent, they often resorted to the midnight 'flit': the French expression was to move *à la cloche de bois* (at the wooden bell), a term that came from the habit of ringing a bell on moving day to warn others that there would be heavy lifting going on in the stairwell. To leave in the dead of night meant making as little noise as possible: no more than that made by a wooden bell.[56]

Families were crammed into small, filthy, downright unsanitary apartments. This is what Émile Zola discovered when he investigated the Goutte d'Or district. His notes describe the Villa Poissonnière,

which is now No. 42 rue la Goutte d'Or: today an enamel sign attached to the entrance gate helpfully admonishes passers-by not to drive vehicles into the alleyway, not to walk dogs, not to feed the cats, and not to urinate. On the façade overlooking the rue de la Goutte d'Or, the top two of the six hulking storeys have been cleanly faced with brick, but in Zola's day this was a dark, teeming warren with rows of blackened windows, many with shutters with missing slats. The building was entered through an archway between a wine merchant and a coal seller—today, there are shops selling all kinds of wares, from the accoutrements of modern life, such as mobile phone covers, to exotic goods such as jellabiyas (loose robes associated with the Nile region in Africa), shawls, decorated cooking pots, and more, reflecting the vibrant, ethnic mix of this neighbourhood. Inside the 'Villa', there was a courtyard in Zola's day with rows upon rows of windows beneath a roof from which the tiles and lead flashings were loosened and slipping.

Today the Villa Poissonnière is surprisingly bucolic, for as it leads up the gentle slope, it runs along a parade of small villas with front gardens, sprouting with shrubs and hedges. One passes beneath a copper beech tree standing guard in front of one of the villa entrances before one reaches the gate at the far end. In Zola's time, one entered the complex via an archway from the rue de la Goutte d'Or, passing across a courtyard that had workshops, including a joiner, a locksmith, and a dyer, whose inks spilled across the cobbles in coloured rivulets. The rooms and apartments on the four sides of the building were accessed by four staircases (A, B, C, D) and 'inside long corridors on each floor, with uniform doors painted yellow', noted Zola. 'At the front, in the lodgings with shutters, live people, all workers who pass for wealthy, overlooking the courtyard; laundry hanging out to dry.' There was a sunny side, and a side that the sun did not reach, which was darker, damper, the walls streaked green with algae from years of rain. Within all this, there was a paved courtyard, perpetually sodden from the water pump.[57] These details found their way into Zola's novel, and the novelist's pen adeptly added the sounds and

smells that he no doubt also encountered in person: the fetid drains, the pungent smell of cooking, pipe smoke, the clatter of dishes, the crying of a baby, the running of water from a tap, the footsteps on wooden floors, and, terrifyingly, the shouts and blows of a man beating up his wife—the simmering threat of domestic abuse never far from the surface.[58]

Even allowing for his own authorial voice, Zola's realist style meant reflecting what he actually saw. Around 1890, most workers' homes had just two or three rooms, including a kitchen, totalling 20 square metres (just over 200 square feet) at most: to free up space, many families had folding beds, which were often used by the children. The cramped life of the Paris apartment, speculates the historian Pierre Casselle, may explain the particular speed with which the birth rate—always falling in the nineteenth century—declined in the 1880s and 1890s, an issue that was obsessively discussed at the time by moralists, demographers, and nationalists, among many others.[59]

Zola's references to the water pump and tap speak of a time when most tenements in the city had running water only from a common fountain in the courtyard, or at best from a faucet on the landing of each floor—and the provision by landlords of such fresh running water was made compulsory by the prefect of the Seine in 1886. Until then, it was risky to draw water from neighbourhood wells, which could carry disease, not least typhoid and cholera: there was an outbreak of the latter in the mid-1880s and another in 1892.

Disposal of household waste and, before the installation of main drains, of dirty water, was a challenge. Much of it was tipped outside into the street, and its smell mingled with the odour of the shared toilets on the landings of tenement buildings. Human waste went into cesspits—and Parisians were, rightly, never happy about how thoroughly they were emptied and cleaned by the *vidangeurs*, the workers paid by landlords to do the dirty work by shovel and cart at night, carrying off the festering cargo to suburban processing plants, which converted it into fertilizers. In 1880, in fact, one of these plants, in

Nanterre to the west of the capital, was so lax about containing the odours that its licence was suspended—though not before the city was enveloped in what would be remembered as the 'Great Stink' of that year.[60] Meanwhile, the black soot Zola noticed on the windows in the Goutte d'Or would have been due not only to the way in which homes were heated—with coal-burning stoves (although many Parisians could not afford to pay for fuel, so wearing multiple layers of clothes even at home was not unusual)—but also to the fact that the strongly working-class districts of the outer arrondissements were peppered with small factories and workshops, which gave out the clanging of their industrial noise and belched smoke from their chimneys. Much as health experts extolled the benefits of fresh air, tenants of apartments more often than not kept their windows tightly shut to keep out the noise and fumes.[61]

It cannot be denied that there had been small yet important, indeed vital, improvements in public health. Medically, Louis Pasteur's vaccines against various illnesses (including anthrax), his treatment for rabies, and his discoveries on fermentation, preservation, and pasteurisation of dairy and other foods, and the filtration of water saved lives. There were also some important measures on hygiene aimed at tackling poor sanitation and the smell and disease associated with it. In 1884, the prefect of the Seine, Eugène Poubelle, had introduced rubbish bins. The rag-and-bone pickers, whose livelihoods depended upon whatever they could glean from what Parisians threw out, angrily dubbed the offending innovation *poubelles*: thus the prefect's name is, to this day, the French word for trash cans. In 1894, Poubelle's successor tried to combat the sanitation problems by introducing the *tout-à-l'égout*, a main drain that flowed directly to the sewer. Yet there followed such legal wrangling that by 1903 a mere 10 per cent of Parisian houses had been connected.[62] As late as 1939, a third of the city's households were still unconnected to the main sewer and only half had a private toilet—the rest were outside in courtyards or shared (the author remembers looking for an affordable place to rent in the early 1990s, when some studio apartments, or *chambres de bonne*,

advertised their 'W.C. sur le palier'—meaning a shared toilet on the stairway landing).[63]

City officials were well aware that many Parisians lived in the filthy, disease-ridden, rundown quarters that peppered the City of Light, bypassed or marginalised by the renovations that had been accelerated under Haussmann. They were also learning about the effects of poor housing and sanitation. Between 1886 and 1905, the city's statistician, Jacques Bertillon, number-crunched the causes of death among Parisians and found that while tuberculosis respected no class barriers, the incidence was considerably higher in the poorer districts of the capital. He demonstrated decisively that it was the poorer, outer arrondissements of the north, south, and east that suffered the most, along with the slum inner districts of the Marais, just to the east of the centre. The 18th arrondissement (which includes both the Goutte d'Or and Montmartre) was not the worst—TB was more devastating in the 13th, 19th, and 20th—but it was among those that were afflicted the most.[64] The prevailing opinion at the time was that the best defences were sunlight and sanitary living conditions.

With this in mind the municipality gave Paul Juillerat, the founder of Paris's Museum of Hygiene, the task of systematically investigating in detail the city's housing and sanitation. Juillerat and the city's *bureau de l'assainissement*—sanitation bureau—set out between 1894 and 1906 methodically to record their findings in a survey called the *casier sanitaire des maisons de Paris*.[65] They discovered that, while more than half of all of Paris's residential buildings (39,477 out of 77,149) had been affected by TB, there was a particular concentration in 820 houses that recorded more than 10 deaths due to the disease. Moreover, the findings reinforced the view that living and working in densely packed, social proximity was a factor in the spread of disease: this was because the number of deaths from tuberculosis was in direct proportion to the height of the buildings and the restricted area of open space that surrounded these residences. Juillerat argued that 'lodgings without light, where the air does not circulate, whose atmosphere is polluted by the emissions from the

toilets and gas from defective heating appliances, will exercise on its inhabitants a fatal effect and the more pronounced these conditions, the more rapid the impact.'[66] Juillerat concluded that 'tuberculosis is localised in Paris; it is concentrated at a relatively few spots and so it is not impossible to attack it in its preferred places of refuge'.[67] The result was the identification of six 'unsanitary blocks'—*îlots insalubres* (eleven more would be added in 1918, bringing the total to seventeen). These were compact and densely populated districts, almost all of them in the centre and east of the city, with two on the northernmost fringes. They were earmarked for demolition or renovation, although nothing happened until the 1930s at the earliest, owing to the intervention of the First World War and lack of money—and this despite the outbreak of bubonic plague in *îlot insalubre* No. 5, Les Épinettes (in the northernmost part of the 17th arrondissement), in 1920.[68]

At the same time, however, for all the squalor, areas like these—whether formally earmarked for renovation or, like the Goutte d'Or, not—were effervescent with the activity from which, ultimately, much of the prosperity of the city drank. Zola described the physical aspect of the Goutte d'Or in the bleakest of terms, but he also discovered a bustling, industrious neighbourhood. The 18th arrondissement to which it belonged, while the most densely populated in Paris, was not the poorest: that sad distinction was shared by the 20th arrondissement in the east (the working-class villages of Belleville and Ménilmontant) and the 13th in the south-east.[69] Along the boulevard Rochechouart, he scribbled his kaleidoscopic impressions:

Many hatless women, some with bonnets, many young girls; loose blouses, aprons, skirts hanging limply. A gaggle of feral children, some clean, many dirty. . . . Women sitting with children in their arms. . . . Clean women workers, some almost flirtatious, who go about their business; baskets, parcels, hangers. Male workers in their blouses, fatigues, and thick cardigans—some carry tools, others swinging their arms, some carry children. Women doing the shopping for dinner.

Carriages, carpet-makers, and bath tubs being emptied. The omnibuses and fiacres [carriages] come along later.[70]

Northwards off the boulevard, the rue Neuve de la Goutte d'Or (today's rue des Islettes, where Zola's characters Gervaise and Coupeau had their first rooms together) was crammed with small shops, cobblers, barrel-makers, haberdashers, grocers, and the wash-house whose soapy water streamed down the middle of the street. There was an acacia tree leaning across the roadway, a factory mak-ing seltzer water, and a barbershop. The shop fronts were plastered anarchically with the ubiquitous Belle Époque posters; towards the boulevard there was a row of single-storey buildings whose front-ages were painted green, yellow, red, blue, and white.[71] The rue de la Goutte d'Or itself boasted a substantial wine merchant; a coal seller; an umbrella shop; a greengrocers (whose shop Zola would have as the site of Gervaise's laundrette); a scissor-grinder and a bonnet-seller; a blacksmith and forge, with a whistling bellows and a glowing fire that could be heard and seen from the street; an ironmonger; and a clockmaker, who also offered repairs, and from whose small shop one could hear the cuckoos of some of the clocks. In the clock store's win-dow were displayed watches with their silver covers: 'In front of the small establishment filled with tiny tools, and delicate things beneath glass,' wrote Zola in his notes, 'there is a gentleman in a frock coat, properly dressed, who works continuously—the image of fragility in the heart of the din and bustle of the working-class street.' According to Zola, there were also plenty of cats, some of them lying imperiously in the doorways.[72]

Today's Goutte d'Or is not dissimilar. While the modernisations of the 1980s may have been, as Eric Hazan cautions, 'clumsy', involv-ing some demolition and rounding of corners, there are pockets that are still redolent of the area's old character—not least the rue Cavé, which has small houses rather like some of those that Zola described, and the space around the Church of Saint-Bernard and rue Léon.[73] And it still has its industrious bustle, thanks to the mixed population

of North and West Africans and the shops selling luscious fabrics; exotic foods, including mind-blowingly honeyed pastries; jewellery; and mobile phone accessories and prepaid long-distance calling cards—all from shops boasting signage promising 'Articles de Bazar' or 'Afro Style', or with evocative names like 'Marché de Casablanca'. Not at all far away, to the north, one can buy African specialties in the fish and vegetable market on the rue Dejean, near the Château Rouge Métro station. Move southwards, to the boulevard Rochechouart, where the Métro rumbles on its bridges above your head, and you will find that the central reservation beneath the tracks is lined with another market, where people sell all kinds of wares. The ethnicities may have changed, but one gets the feeling that perhaps the life of the quarter has evolved along with it, rather than losing its character altogether, not least because poverty accompanies the industriousness. Just as in Zola's day, the overwhelming feeling, particularly around the great, busy Barbès-Rochechouart junction and Métro station, is that a swirling tide of humanity is going about its business.

What Zola witnessed was a neighbourhood, a community that not only worked to serve its own needs, but whose myriad workers, workshops, and boutiques were also part of the wider intricate web of social and economic relations that effectively made the city live and function. If the élites consumed and looked after their wealth, it was neighbourhoods like the Goutte d'Or whose artisans and workers, men and women, provided them with the many goods and services, large and small, that made their lives comfortable and that in many ways made the pleasure and spectacle of Belle Époque modernity possible. Yet the fact that many of the denizens of such neighbourhoods also lived in such squalor and, as René Martial demonstrated in 1907, struggled to make ends meet at certain times of the year also strongly suggests that the very wealth of those who frequented the glitzier quarters of the centre, and the cafés of the boulevard des Italiens, who enjoyed the Opéra and who paraded along the Grands Boulevards in their top hats, millinery, coattails, and flowing dresses, was perversely based on the poverty of the working people of Paris.

This, at least, is what the anarchist Augustin Léger saw when he was walking close to the splendour of Garnier's opera house: 'I saw luxurious carriages, men and women covered with jewellery, dressed in their finery, carrying rare flowers,' he later wrote. 'What kind of society is this when the rich drink full glasses of champagne with women to whom they give fistfuls of money, while their brothers in the lower classes die of misery, the cold and hunger!'[74]

That was in 1895. Émile Zola had visited and observed life in the Goutte d'Or twenty years previously. There had been at best only small improvements in the conditions for the Parisian working poor in the intervening period. The sense that there were at least 'two Parises'—the gilded, monumental quarters for the rich, and the crammed, diseased ones for the vast majority of the working population—was compelling. As Léger remarked, this world of ordinary working Parisians and the legions of the urban poor who inhabited the precarious margins of society—hard-pressed workers, down-and-outs, organ-grinders, prostitutes, street-vendors, and the large families whose lives were mostly conducted in the streets because their tenements were too cramped, soot-blackened, and squalid—continued to lead lives seemingly far removed from the glamour of the boulevards.

For Victor Serge, 'our own Paris had three centres'. One was Montmartre, where (as we have seen) he met with like-minded anarchists; another (his favourite) was the Latin Quarter, where Serge soaked up the literary and philosophical milieu and fed his own ideas by spending an hour or so after work reading in the Bibliothèque Sainte-Geneviève on the place du Panthéon. But the third and most important was inhabited by most of the workers whose privations Serge shared:

> The great working class towns that began somewhere in a grim zone of canals, cemeteries, waste plots, and factories, around Charonne, Pantin, and the Flandre bridge; it climbed the heights of Belleville and Ménilmontant, and there became

a plebeian capital, lively, busy and egalitarian like an ant-heap; and then, on its frontiers with the town of railway stations and delights, became cluttered with shady districts. Small hotels for a 'short time', 'sleep-sellers' where for twenty sous one could gasp in a garret without ventilation, pubs frequented by procurers, swarms of women with coiled hair and coloured aprons soliciting on the pavements.[75]

The practical, pragmatic, and indeed well-intentioned attempts by health experts, local government, and the state to promote healthy living and good domestic and public hygiene were effectively an inadvertent but resounding 'indictment of existing social arrangements'.[76] When René Martial issued a dire warning to his audience of doctors and public health experts about the diet of the poor, his fears might also have applied to other issues that affected workers' lives, including the efforts to attack the problem of pestilential housing: 'What happens to all these healthy menus and lessons in domestic science schools? That all becomes useless. So to preach healthy living to the people is to provoke it to revolt. When one has a full stomach, it is neither moral nor good to teach cookery to those who are hungry.'[77]

Discordant though this political warning issued at a scientific gathering might sound, coming as it did in 1907 it would have rung terrifyingly true to his audience. Though Martial would later develop distinctly racist views and work with the collaborationist Vichy regime in the early 1940s, he had begun as a committed socialist with a sincere determination to build a factual basis for change. When he warned his peers that to talk to workers about healthy living was to provoke them to rebellion, the evidence was apparent to anyone who saw what was then going on in the streets of Paris. As we shall see in the next chapter, it took the shape of anarchist terror and militant, revolutionary politics.

CHAPTER 7

STRUGGLE

The monumental bronze statue that towers over the place de la République was supposed to tell a story. Marking the spot where the corners of the 3rd, 10th, and 11th arrondissements meet, the Republic—here embodied by a strong woman, Marianne—looks unflinchingly southwards towards the city centre. In one hand, she holds aloft an olive branch, symbolising peace; her other hand supports a tablet inscribed with the words 'Droits de l'Homme' (Rights of Man). Dressed in classical style, in a toga, on her head she sports the Phrygian bonnet, the cap of liberty, garlanded with a laurel wreath. Around her torso she wears a strap (or, more accurately, a baldric), from which hangs a sword. The hefty plinth beneath Marianne bears two escutcheons with the words 'Pax' (Peace) and 'Labor' (Work).

Lower down, the plinth widens to support three additional stone statues representing the Republic's core values, the heritage of the French Revolution: Liberty, Equality, and Fraternity. Liberty holds a flaming torch in one hand, a broken chain in the other, resting on

her knee. Equality bears the *tricolore* topped with the rosette 'R.F.' (for 'République Française'), a mason's plumb level across her knee, and an amulet on her neck emblazoned with '4 Août'—4 August 1789 being the date on which the French Revolution abolished all aristocratic, ecclesiastical, and local privilege. Fraternity, the hardest to define of the trinity, gazes benignly down at two small naked children who are poring over an open book, thirsty for knowledge. Behind this small family group is a sheaf of wheat and a bunch of grapes, hopeful symbols of abundance.

Beneath the feet of Liberty, Equality, and Fraternity, the base of the plinth is decorated with twelve bronze reliefs, each representing a significant event in French history between 1789 and 1880. The whole is guarded by a bronze lion poised proudly in front of an urn (the French version of a ballot box), representing universal (male) suffrage, and a shield bearing the talismanic date '1789'.[1]

The very existence of this whole fascinating ensemble was owed to the political context in which it was constructed. An indirect clue is provided by the date at the front of the plinth, which reads, 'À la gloire de la République Française—La ville de Paris—1883' (To the glory of the French Republic—The city of Paris—1883). The idea for a monument celebrating the Republic had circulated among republicans in the capital's municipal council in March 1878. Just two months before, the 'town-hall revolution' of January 1878 had swept the republicans into power in city councils across the country, with the radical republicans of the Left leading the charge.[2]

They assumed power with the vestiges of conservative rule still not quite vanquished. The crypto-monarchist regime of 'Moral Order' under President Patrice MacMahon was still clinging to power, sceptical of republicanism's democratic and egalitarian impulses. Among the oppressive strictures of the previous years was a formal ban on the red cap of liberty, the Phrygian bonnet, in official artwork, a leftover from the crackdown that followed the Paris Commune in 1871. Now the defiant republican majority on the Paris council voted that their statue to the Republic would sport precisely such a bonnet.

The radicals were responding to their working-class constituency, still traumatised by the brutal suppression of the Commune, and from whom they drew much of their electoral support.[3]

Both the minister of the interior and the prefect of the Seine stymied the plans, with the latter sharply reminding the municipality that the right to designate where a statue could be placed and 'to determine what attributes and emblems the statue of the Republic could bear' belonged to the government alone.[4] The prefect then went further and banned the 1878 Universal Exposition (another reason behind the Left's determination to instal a statue to the Republic) from displaying an earlier statue to the Republic dating to 1849, during the Second Republic.

This was, however, a cultural rear-guard action by the 'Moral Order'. In January 1879, the republicans also swept the senatorial elections, and President MacMahon resigned, giving way to Jules Grévy, the first truly republican president of France.[5] Within two months, the Paris council returned to the question of a statue to the Republic. This time, the radical republicans saw no need to be explicit about a red bonnet: it would almost certainly have one anyway. The new law, passed on 11 March 1879, simply stated that the 'statue of the Republic will be of the traditional type'. As for details, 'She will be standing and be seven metres high, excluding the plinth. The pedestal may be surrounded by allegorical or symbolic figures.'[6]

A competition was opened. Artists displayed their sketches at the École des Beaux-Arts on the Left Bank in October. In the end, the prize was carried away by Léopold Morice, whose statue still stands boldly on the place de la République today. His brother, Charles, created the plinth, including the stone allegories of Liberty, Equality, and Fraternity. Both artists' names are carved into the stone pedestal, while on the lion's plinth one can see the name of the bronze casters, the Thiébaut Brothers, whose foundry on the rue du Faubourg Saint-Denis was the most important producer of cast metal artwork in the Belle Époque.

The unveiling of the statue was supposed to mark a moment of national reconciliation around the core democratic values of the Republic. The following year, the National Assembly voted to grant amnesty to all who had taken part in the Paris Commune, except for those who had committed *délits politiques*—political crimes—such as burning down buildings or taking part in killings. So the statue was being fashioned just as former Communards, including the 'Red Virgin' Louise Michel, were returning to Paris, amidst often emotional scenes at the railway stations, where they were greeted by their families and supporters. In 1880, too, Bastille Day, 14 July, was declared a national holiday. The plaster cast of Morice's great statue was unveiled in a ceremony in which the square—called place du Château-d'Eau (after the large water house that stood here, supplying fresh water) until 1889, when it became the place de la République—was bedecked with tricolour flags and pendants.

Yet when Morice's final bronze version was inaugurated on 14 July 1883, President Grévy and the minister of education, Jules Ferry (whose brief included arts and culture), were conspicuously absent. The press quickly—and probably correctly—guessed why: the Paris municipality was now pressing for the amnesty of *all* Communards, regardless of whether or not they had committed political crimes. Grévy and Ferry, moderate republicans that they were, could not be seen to endorse either the sweeping amnesty demands of the Paris council nor the statue's symbolism, which, with its Phrygian bonnet, was too redolent of the Commune as it was. Moreover, the municipality had gone a step further, also commissioning a statue by the artist Jules Dalou, who had come in second to Morice in the contest. Dalou, himself a Communard, had lived in exile in London between 1871 and 1880, when he had returned to France thanks to the amnesty. His proposal, which shows Marianne unmistakably wearing a Phrygian bonnet, was turned into reality on the place de la Nation, where it can be seen today. Its allegorical figures represent not the mainstream republican 'Liberty, Equality, and Fraternity', but Liberty, Work, and Justice. With this choice, Dalou had adopted the concerns

of the Parisian working class, for whom the Commune and its brutal repression were still alive as both inspiration and trauma.[7] The Radical-dominated Paris council was likely thumbing its nose against the moderate republican government.

Yet, however sympathetic the city may have been to the workers, Grévy, Ferry, and other moderates almost certainly need not have worried about Morice's statue. Marianne may have been wearing the red cap of liberty, but the twelve bronze reliefs that ring her pedestal told a story not just of democracy and egalitarianism, but of national self-defense, patriotism, and moments of genuine consensus from 1789 onwards that republicans, moderate and radical alike, could agree on.

Yet consensus was no longer of interest to the republican base. Morice's statue was unveiled in 1883, just as Parisian workers were swinging away to support more left-wing movements that were more explicit in offering social welfare, social justice, and workplace reform, whether socialist or anarchist. In the 1870s, the radical republicans in Paris had drawn on working-class support because there was an expectation that they would 'do something' for the workers. In the absence of any other viable left-wing alternatives in the wake of the shellshock from the defeat of the Commune, and during the exile of much of the socialist and anarchist leadership in the 1870s, the Radicals could expect working-class votes. Yet they offered political solutions, not social policies, to address social and economic problems. Workers' pursuit of social justice would be achieved by free, universal, and compulsory education; the separation of Church and State; greater democracy; and some basic welfare and legal reform. Beyond a tax on incomes and greater access to credit for workers and tradesmen, there were few overtly socialist tinges to their programme. By the 1880s, however, socialist and anarchist alternatives began to crystallise—and while radicalism always retained some visceral appeal, thanks to its hard-core republicanism, Parisian workers began to swing, fitfully, towards the alternatives.[8] In this context, the narrative of France's democratic

progress presented by Morice's Marianne also marks the beginning of a renewed rupture.

In the Belle Époque, this divergence could degenerate into violence that shook the foundations of the Republic itself, and at such times, the statue on the place de la République became a site heavy with symbolism for both sides. On the one hand, both moderates and radicals adhered to the core values that Morice's statue expressed: Liberty, Equality, Fraternity; republican democracy and universal male suffrage; civil equality and the 'rights of man'. On the other hand, they diverged on how far these principles also implied the pursuit of social justice, the redistribution of wealth, and the assertion of workers' rights in the workplace. It was—and is—this very ambiguity that has given Morice's great statue its emotive symbolism as a rallying point both for left-wing causes and for wider, more consensus-driven mobilisations in defence of the core values of the French Republic. In the Belle Époque, however, the square would become the site of a brutal confrontation between workers and police, a moment in which the radical struggle for social justice confronted the moderate vision of the Republic. This arose on the site not just because of its republican symbolism, but also because of its proximity to the headquarters of one of the great working-class organisations of the Belle Époque: the Bourses du travail, or labour exchanges.

THE RUE DU Château d'Eau runs off the boulevard de Magenta from the north-western corner of the place de la République. At No. 3, there is a solid building designed by Joseph Bouvard and built in 1892 that, then as now, houses the central Bourse du travail for Paris. The lintels of its three front entrances are ornamented with allegorical figures representing Peace, Work, and the French Republic. Farther up, the names of statesmen, inventors, artists, and industrialists who had risen from working-class backgrounds are carved into the stone.[9] Peace, Work, and the Republic are all virtues that Morice's statue nearby also celebrated—and when city funding was provided

for the building, one suspects that the message was deliberate: the values of workers were to align with those of the democratic parliamentary Republic. Yet at this site they came to represent a more radical, indeed revolutionary, vision of the future, for the Republic as envisaged by the original founders of the Bourses du travail was not at all similar to the kind celebrated by Morice's Marianne.

The Bourses du travail were labour exchanges, as they are today, but when they were founded in the Belle Époque, they had a particular political purpose. They arose from a fusion of anarchist ideas and trade unionism in the 1890s that tapped into a longer-term tradition of French working-class radicalism based on the small-scale workshop, which remained the backbone of the French economy. Workers and craftsmen and craftswomen had long sought to associate together locally in order to defend their livelihoods against merchants, big business and finance, and, periodically, the demands or intervention of the state itself. In 1884, the Third Republic legalised trade unions—*syndicats*—giving workers a lawful means by which they could collectively bargain for better pay, shorter hours, and more tolerable conditions. Yet they were also, potentially, revolutionary.

Among the first to realise the revolutionary possibilities of trade unions was Émile Pouget, in the anarchist journal *Le Père Peinard*. But the figure who refined the idea was the journalist Fernand Pelloutier, who, along with Aristide Briand (both were from Nantes in western France) wrote, in 1892, *De la révolution par la grève générale* (On revolution through a general strike). Insurrections using barricades, fighting soldiers in the streets, the authors argued, were invariably crushed. While not necessarily peaceful in its effects, a general strike would produce the most radical of revolutions. Three years later, Pelloutier elaborated his theory in a pamphlet, *Qu'est-ce que la Grève générale?* (What is the general strike?). The piece takes the form of a discussion among a small group of workers about how to hasten the arrival of a better world. One of them explains how a general strike would develop:

It's that the General Strike must be a revolution both every-where and nowhere; the seizure of ownership of the instruments of production must operate quarter-by-quarter, street-by-street, house-by-house . . . so there would be no possibility of creating an 'insurrectionary government', a 'proletarian dictatorship'; no 'headquarters' of the riot, no 'centre' of the resistance; the free association of each group of bakers, in each bakery; of each group of locksmiths in each lock-making workshop; in a word, the freedom of production.[10]

In paralysing the economy, the general strike would provoke the collapse of capitalism, and with it, bring down the bourgeois, democratic state. This would be the moment when workers would take control over the means of production—factories, workshops, farms—and rebuild society anew into small, self-governing communes that would guarantee social equality. In the process, government as conventionally understood—indeed the state itself—would be abolished. Instead, the fundamental basis of social organisation would remain the *syndicat*—the union. Workers would form their own unions within their own trades, industries, and agricultural areas in their own towns and villages. The unions would collectively own the businesses and control production, sending freely elected delegates to councils that would handle the communes' wider affairs. The councils, in turn, would send deputies to a federal council, which would manage anything that required larger-scale co-operation. Syndicalism therefore rejected the notion, embraced by French socialists such as Jaurès, that a more just society could be achieved through parliamentary means. It also denied the Marxist route, touted by Jaurès's rival Jules Guesde, of a revolution led by a disciplined party that would impose a communist society through a dictatorship of the proletariat. The syndicalist rejection of both social democracy and communism in pursuit of an egalitarian society earned the movement the distinctive monikers of 'revolutionary syndicalism' and 'anarcho-syndicalism'. For Pelloutier,

the foyer for this revolutionary movement would be the Bourses du travail.

It is not a little ironic that these labour exchanges were first established in 1887 by Eugène Poubelle, the prefect of the Seine who did so much to try to improve sanitation for Parisians. Workers in search of jobs had for centuries gathered on the place de Grève—now the place de l'Hôtel de Ville—where they would meet potential employers (it was also where workers who had downed tools in protest traditionally converged: hence the French word for strike is *la grève*). For Poubelle, it was better for workers and public order alike that the former had a dedicated building that would serve as a labour exchange. Poubelle was supported by the left-leaning municipal council, which provided the building on the rue du Château d'Eau for the Paris Bourse du travail, where workers could be matched with jobs, take classes, and secure legal aid. Other Bourses were established across towns and cities in France: there would be 157 of them by 1907, soon managed by the workers themselves. Poubelle, supported by the former Communard and socialist Jean Allemane, saw the Bourses not just as labour exchanges, but as places where workers could learn new skills, join unions, and exchange political ideas.

In 1895, Pelloutier became the secretary of the Fédération des Bourses du travail (Federation of Labour Exchanges), which had four hundred thousand members. In his pamphlet on the general strike, one of the workers explains that 'we have propagated, we have strengthened, our unions, our Bourses du travail, and we have learned that they could become an excellent means of revolution'.[11] For Pelloutier, the labour exchanges would become the means by which unions in France would co-ordinate, so that, acting at the most localised of levels, they would come out to strike at the same time, making the stoppage general. In fact, so radical had the Bourses become that, as early as July 1893, the Ministry of the Interior shut them all down. They were not permitted to reopen until April 1896, managed jointly by an association of trade unions and the prefect of the Seine.[12]

Syndicalism's appeal to French workers came, in part, because of its emphasis on the small scale, the local, adding up to a wider revolutionary movement.[13] It made sense in an economy where, in 1906, half of all workers worked in enterprises of no more than five employees. A further 10 per cent worked in concerns of fewer than one hundred workers, while those who laboured in the large-scale industries, in factories hiring five hundred or more people, accounted for only 10 per cent.[14] The disadvantage, from the point of view of planning a revolutionary general strike, is that it was logistically challenging to unionise so many workers who were practically atomised among so many small, scattered workshops. Yet those in the traditional, artisanal trades of the city centre took pride in the insurrectionary traditions going back to the *sans-culottes* of the French Revolution. They were immersed in Pierre-Joseph Proudhon's ideas of a free society based on small producers in self-regulating communes (Proudhon himself had spoken of 'the capacity of the working class for self-government'), and their fathers and mothers had fought and died on the barricades of the Paris Commune in 1871, more often than not for Proudhon's, rather than for Marx's, social vision. The local organisation of unions based on the small-scale workshop, leading to a massive strike that finished with the workers controlling the means of production, resonated widely with both the material realities and the political traditions of French workers.

Although syndicalism rejected insurgency as the means of revolution, syndicalists regarded themselves as the heirs of the Commune and of the insurrectionary heritage dating back to the Revolution of 1789—and indeed, it had been working-class voters who had pressed the radical republicans into campaigning for the amnesty of 1880. For the syndicalists, however, the history of bourgeois republicanism was in fact a history of betrayal of the working classes who had done so much to bring revolution about in the past. This was why they rejected parliamentary politics as the means of bringing about meaningful social change.[15]

In 1895, a rival parallel organisation, the Confédération générale du travail (CGT, General Confederation of Labour), was founded (and it remains today France's largest trade union organisation). It aimed to be a great autonomous force that would unite all workers, who, as one, would spark the proletarian revolution through a general strike. In 1901, Pelloutier—who had only been born in 1867—died young: he had long suffered from tuberculosis, and his powerful intellect and political commitment belied his skinny physique enfeebled by the disease. Yet the movement that he had done so much to inspire moved onwards: in 1902, the Fédération des Bourses du travail merged with the CGT, taking on the latter's name, with its organisational capabilities and membership now vastly expanded. The moment for the great strike seemed to be at hand in the wake of the Russian Revolution of 1905 and a wave of work stoppages in Germany. The date would be May Day, 1906.

EVER SINCE 1890, French socialist and anarchist workers had chosen the first day of May to commemorate the Haymarket massacres in international solidarity with American workers. The bloody affair had occurred on 3–4 May 1886: on 3 May, six striking workers in Chicago were shot dead, and others badly bludgeoned by police. The following day, as a meeting of workers was being broken up by the forces of order, a bomb was thrown and shots were fired, leaving five police officers dead. Four men involved, including two anarchists, were hanged for the violence in 1887.

So it was on 1 May 1906 that the CGT marshalled its forces and called on all its members to down tools and take to the streets to strike for an eight-hour working day (a long-standing demand that had some wider support: in 1901, *La Fronde* had backed the women dressmakers who had struck in pursuit of this aim).[16] Photographs show the Bourse du travail on the rue du Château d'Eau emblazoned with a banner unfurled right across the building's façade: 'From 1 May 1906 we will work for only 8 hours a day.'[17]

It is hard to tell how many strikers actually meant to foment a general strike that would bring about a syndicalist revolution; some may have simply wanted an eight-hour day as a reform in its own right. For many Parisian workers, the eight-hour day was essential: for factory workers under the pressure of long hours and under the surveillance of foremen keen to improve efficiency, a shorter working day meant more time for leisure, family, and culture: the essential ingredients of basic dignity. For the skilled Parisian craftworkers of the workshops of the city centre, the eight-hour day represented a chance to improve their own effectiveness as producers, allowing them to compete through improved quality with the machine production that produced in quantity.[18] Yet for propertied Parisians and shopkeepers, as well as for the authorities—including the Radical Georges Clemenceau, then minister of the interior—it was a truly alarming moment. Metal shutters clattered as shops closed for the day, and there was wild speculation that Paris would burn, its people butchered and its stores and homes looted.

The government, however, was already on alert after the recent eruption of a wave of strikes across the country. In Paris, a strike in the spring had already brought out 200,000 workers, including 50,000 metallurgists and 30,000 road workers. From March, after a gas explosion in a mine at Courrières near Lille had horrifyingly killed 1,300 miners, a strike involving 61,000 of their colleagues had swept across the country, joined in April by other workers so that, by the end of 1906, the strike wave involved half a million workers—a record number at the time.[19]

The stoppages in the provinces left the authorities in Paris primed for action. Georges Clemenceau, who had become minister of the interior in March 1906 (and would be prime minister from October that year), put police on the streets and brought in the army, including 6,000 cavalrymen and 20,000 infantry, so that in all some 50,000 troops and police officers were on hand guarding infrastructure such as water reservoirs and gasworks as well as key strategic points around the city, including bridges and railway stations.[20] Perhaps nothing

symbolises more the divergence between mainstream republicanism and the heirs of the Commune than this moment, when a Radical brought the military into the capital to confront potentially revolutionary workers. The majestic space around the Arc de Triomphe at Étoile and the avenue des Champs-Élysées—normally the place for Proustian Paris to promenade and display itself—bore witness to the startling sight of armed ranks of soldiers and squadrons of cavalry amassing. From there they were ready to move eastwards to contain any trouble and to break the strike. On 2 May, Jaurès's newspaper, *L'Humanité*, responded acidly:

> For Paris yesterday, the sight of armed troops deployed in the streets was a tragic and entirely unexpected spectacle. . . . Public spaces transformed into camps where the soldiers guarded their stacks of arms, where the cavalrymen in field dress, their helmet straps across their chins, their carbines slung across their backs, were standing rigid and bolt upright in front of their horses. Patrols on foot and on horseback ranged along the streets: Paris had not seen this for thirty-six years. . . . The slightest incident, the most futile misunderstanding, would have been enough to redden the paving stones once more.[21]

What actually happened on and around the place de la République on 1 May is unclear: it depends upon which reports one reads. But it is possible to attempt a balanced account by weighing reports from different perspectives—in this case from Jaurès's socialist newspaper *L'Humanité* and the conservative *Figaro*. The day itself was flat, grey, and rainy: 'The shops were closed, there were very few passers-by and above all the almost complete absence of cabs accentuated the impression of an exodus from the city,' *L'Humanité* reported. 'The boulevards, deprived of the movement usually given to them by carriages, presented a mournful sight to which Parisians were not accustomed.'[22] Early in the morning, an initially small number of police officers had taken up position outside the Bourse du travail on the rue du Château

d'Eau, pacing up and down and getting anyone who lingered too long to move on: 'Circulez, messieurs, circulez', they instructed, but they could not stop the workers from arriving in small groups and entering the Bourse. Meetings were held, inspirational speeches made. According to a reporter from the *Figaro*, the latter were inflammatory: 'This gathering was numerous, tumultuous, violent. The main assembly room was full and the mass of human beings pressed all the way into the corridors. The orators, belonging to all trade unions, spoke one after the other without interruption, and all gave violent speeches: "Resist, resist", they cried. "Do not be intimidated, comrades, by a demonstration by the police that is an attack on your liberty and that oppresses your essential rights."'[23]

When several thousand workers poured out en masse into the street, aiming to muster on the nearby place de la République in defiance of a temporary ban on public processions, they were confronted with a line of mounted police along the rue du Château d'Eau, which held them back. Meanwhile, strikers—led by metallurgists, construction workers, and printers—had tried to gather on the rain-washed square, red and black flags fluttering, and were confronted by massed ranks of police, who were soon joined by a squadron of dragoons that had clattered out of the barracks lining the northern side of the place de la République.[24]

When strikers and police began to press up against each other, the tension snapped. Between 2 and 6 p.m., the police and the cavalry charged the massed ranks of the crowd, dragging off for arrest those that they could. Policemen lashed out with their truncheons and workers struck back with their fists. Meanwhile, Prefect Louis Lépine, who had been overseeing the police operation by being driven from point to point around the city in a car specially commissioned for this day, had allowed the workers from the Bourse du travail to leave and to move onto the place de la République—and they did so singing the 'Internationale', the song of social revolution, whose lyrics were written in 1871 by a Communard, Eugène Pottier.[25] Yet on the square they found themselves trapped front and

rear between ranks of police and soldiers. More scuffles ensued, and frightened, whinnying horses occasionally bolted into the crowd.

Eventually, the police and army pressed forward, and the phalanxes of workers broke apart and fled, pursued by police and cavalrymen. Today, one can follow the route of the running battles that ensued—some strikers were driven southwards down the rue de la Folie-Méricourt, others pursued eastwards along the rue de la Fontaine au Roi, where the demonstrators stopped an omnibus, unhitched the horses, and then overturned the carriage (after, one hopes, allowing the passengers to disembark).[26] The bulk of strikers, however,

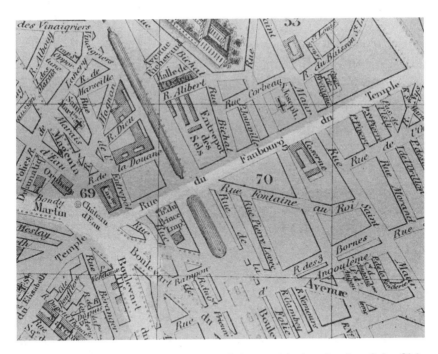

The place de la République lies to the left, here marked as the site of the Château d'Eau after the large water house, marked here, which was removed when Morice's statue to the Republic was erected in the very centre of this large open space. The rue du Château d'Eau, home to the Bourse du travail, runs off just beyond the place's north-western corner (*at far left*). Opposite, the rue de la Douane (today rue Léon Jouhaux) leads to the (unmarked) iron footbridge, the Passerelle des Douanes, across the Canal Saint-Martin.

surged northwards from the square into the rue du Faubourg du Temple and then along the banks of the Canal Saint-Martin.[27]

Today the canal is an oasis of calm and a place for a pleasant stroll along either the quai de Jemappes or its opposite, the quai de Valmy, away from the city's traffic, with its picturesque iron footbridge at the southern end (the Passerelle des Douanes, built in 1860) connecting the two quais. That day, it was guarded by ten police officers. They were bombarded with a hail of stones taken from a load of masonry or rubble stowed on a nearby barge on the canal; the officer in charge was struck on the forehead; others were hit as well—one in the face—whereupon their colleagues lashed out at the strikers with their rifle butts. They were overwhelmed by the sheer force of the hundreds of workers who were surging up from the place de la République. A police officer on a bicycle pedalled off to summon reinforcements and returned with a squadron of dragoons who pursued the protesters along the quai de Valmy, while another detachment chased down those fleeing along the rue du Faubourg du Temple.

This was not the end of the affair, for later that evening some 800 strikers re-formed on the quai de Jemappes, where, in one incident, a police officer was isolated and surrounded, with workers crying, 'Into the water! Into the water!' The agent defended himself by pulling out his revolver and firing three shots into the air. The gunshots drew the attention of a police commissioner, who led a column of dragoons down the quai, scattering the strikers and rescuing the police officer.[28]

It was not over until after 11 p.m., when the forces of order ultimately prevailed. While the Prefecture of Police reported that only 10 of its agents had been wounded in the fighting, it was also claimed that 60 protesters had been injured (the *Figaro* reported 200) and that 860 arrests had been made. Most of those arrested, however, were quickly released.[29] The strike failed to spread much beyond its Parisian epicentre, and the workers eventually returned to their benches and their machines—although there was a good deal of friction in the workplace between employers and employees for some time afterwards.[30]

Almost certainly speaking for bourgeois Parisians, the *Figaro* was in little doubt that the city had managed to avoid a full-blooded revolution and that the danger had not yet passed:

> What gives us pause is the character of the demonstrations. We are no longer witnessing traditional disturbances, but a sort of general repetition of the Revolution. The rioters had taught themselves how to build barricades, in toppling several omnibus cars. They have trained themselves in street-fighting, in positioning themselves at the windows of houses, from where they stoned the troops. It's the classic strategy of Parisian riots that have reappeared. No doubt, calm will return, and security too. But one would need to be blind not to see that all these incidents are a beginning rather than an end. From today onwards, those in charge of public order in Paris cannot sleep easily at night.[31]

And indeed, more strike waves followed for the rest of the decade, including the Paris electricians' strike of March 1907, which plunged the city into darkness, most dramatically when the lights went out at the place de l'Opéra and in Garnier's opera house itself. Many Parisians created a festive atmosphere out of the situation, the *London Times* reporting that cafés were 'lit up with innumerable Chinese lanterns, which gave them quite a picturesque appearance', while students in the Latin Quarter made their way to the bars and cafés, lighting their way by carrying potatoes plugged with candles. At home, Parisians used wine bottles as candleholders.[32] Yet Clemenceau's ruthless repression of the strikers, including his willingness to use troops (he proudly called himself 'le premier flic de France'—France's first cop), gradually wore the syndicalist movement down. In July 1909, the moderate Léon Jouhaux was elected as general-secretary of the CGT, after which the union tacked onto a more reformist course.[33]

Syndicalism failed, however, not only because of the kind of violent repression witnessed on and around the place de la République

on 1 May. Rather, by a fascinating irony, syndicalism may have been a victim of its own success. Government ministers were well aware of the revolutionary aims of the CGT, which had exuberantly publicised its anarcho-syndicalism and proselytised workers through the Bourses du travail. Yet it was precisely because of this that the authorities sought to prevent localised strikes from building into revolutionary violence or spreading across industries. In their response, therefore, they aimed not only to send in the police or the army, but to intervene quickly before matters escalated, more often than not by interceding with employers to persuade them to make concessions. Thus workers demanding better pay or improved conditions were more likely to get them if they were members of the CGT.

As a result, people joined the CGT not necessarily because they shared its revolutionary aspirations, but because it was generally successful in securing victories in local strike actions. So when the time came for the long-awaited *grève générale*, the general strike, too many workers stood aloof. Despite the 1 May 1906 movement being about the eight-hour workday, they knew that the real aim was not the prosaic, day-to-day struggles they cared most about, but a revolutionary breakdown of the social order.[34] Besides, many workers had drunk in the republican values and principles of 1789, which made them more likely, when push came to shove, to defend the Republic's core democratic principles and, in pursuit of social justice, to back more orthodox socialist parties. Ultimately, the Belle Époque weathered the revolutionary storm because it was mediated through the legal action of French social democracy.

FOR MODERATE REPUBLICANS and even some parliamentary socialists, the street violence of 1 May 1906 posed a genuine political challenge either to their principles or to their exercise of power, sometimes both. The question was how to confront the tactics of revolutionary syndicalism. One of those who reflected on this was the socialist Jean Jaurès.

For Jaurès, unions and socialist parties had to remain independent of each other, because they worked for different things, albeit on the same path. If unions could use strike action to improve the economic and working conditions of workers, the socialists could use their political power to further the aims of a more just society through legislation. For Jaurès, always a democrat, the key was for a socialist party to develop its ability to fight and to win elections. Yet this made trade unions and socialists close allies in the long campaign for, as he put it, 'the reorganisation of the property system'. He believed that there could be no better way for this to happen than for unions to do their work in the factories and workshops, while socialists did theirs in the National Assembly.[35]

Socialism had to be 'truly human', a political alliance of all social groups hard-pressed by capitalism, including the lower middle class of shopkeepers and small producers whose livelihoods were being stifled by the crushing competition of big business. It was through education, democratic elections, and peaceful reform that socialism would develop. People not only had to live, but had to live in knowledge and dignity, and needed the time and energy to exercise their rights freely and to the full. On 15 October 1890, Jaurès wrote, 'Up and down the scale the social order produces only slaves, for those men are not free who have neither the time nor the energy to live with nobility and dignity.'[36] Such dignity included cultural enrichment: when he was a deputy mayor of Toulouse in 1890, Jaurès had successfully opposed an attempt to withdraw funding from the Théâtre du Capitole. From his stance as a humanist, the theatre was an education for all, addressing some of the deeper moral and aesthetic questions that faced all people: men and women, regardless of background, needed 'to savour all the joys of life which are now reserved for the privileged'.[37] Jaurès also believed that, in order for universal male suffrage to mean anything, workers needed the space and freedom to exercise it properly.[38] The unions played an essential part in achieving all of this; however, political change would come about not through revolution but through parliamentary democracy.

Jaurès had followed a classic, middle-class republican route towards socialism. Elected to the National Assembly for the first time in 1885 as a Radical, before losing his seat four years later, in the short period of time before he returned south to Toulouse he struck up a friendship with Lucien Herr, the socialist librarian at his alma mater, the École normale supérieure. Herr was a 'Possibilist', a democratic reformist rather than a revolutionary socialist, but he and Jaurès had had long discussions of Marx's ideas, one lasting almost through the night. In February 1890, the energetic professor from Toulouse published an article in which he declared himself a socialist for the first time.

French Belle Époque socialism took broadly two forms, the parliamentary, reformist kind incarnated by Jean Jaurès, and the revolutionary, Marxist brand represented by his rival Jules Guesde—'Torquemada in glasses', as one of his comrades disillusioned by his ideological rigidity grumbled. At a socialist congress at Marseille in 1879, both wings had agreed on common 'collectivist' aims, namely, that all the strategic economic activities—railways, mines, capital—would be nationalised and placed under workers' control. Together, they founded a single party, the Parti Ouvrier (Workers' Party). But the disagreements over how to achieve such collectivist aims ran too deep, and in 1889 the reformists split off, leaving the revolutionaries under Guesde and Paul Lafargue (who was married to Karl Marx's daughter, Laura) in control of the party. To workers, the doctrinal differences between the reformists and the revolutionaries—outlined in an impressively learned fashion in an 1894 debate between Jaurès and Lafargue—probably mattered less than results. In practice, they voted for those who promised to act for change, locally and nationally, whatever their doctrinal tendencies.

In January 1893, Jaurès was elected once again to the National Assembly—and soon there would be 50 socialists of all persuasions in the Chamber of Deputies. By 1896, voters had given them control of no fewer than 157 town councils. In doing so, at the grassroots the socialist councils tended not only to 'say' but also to 'show', delivering

on amenities such as public laundries, swimming baths, parks, legal aid, school meals for children, childcare for working mothers, and strike funds for unions. Over time, Jaurès's reformist brand of socialism became more successful than the revolutionary streak embodied by Guesde. Even those grouped around the latter, in practice, embraced parliamentary politics and worked with the reformists at the local level. In April 1905, thanks in no small part to Jaurès's efforts and his open-handed, inclusive vision of socialism, the various strands in the movement were welded rather uncertainly together into a single party, the Section française de l'Internationale ouvrière (SFIO, French Section of the Workers' International).[39] Under the charismatic leadership of Jaurès and others, the socialists would flourish as an electoral force: by 1914, the SFIO would be the largest single group in the National Assembly. 'What, then, was this party?' asked the socialist Daniel Halévy. 'I will define it in a word: it was Jaurès.'[40]

Socialism did not entirely capture the working-class pursuit for social justice—far from it. The Guesdist route concentrated on the revolutionary seizure of state power, whereupon the radical transformation of society would truly begin—but workers could only wait so long for that to happen. The Jaurèsian path stressed winning elections and legislating reforms, both locally and nationally, which would see society evolve towards a more egalitarian, fairer state. Still, not everyone had the patience for this gradualist, democratic approach, and they found alternatives in anarchism.

Anarchism was not a unified movement but contained a number of strands owing much to the mid-nineteenth-century thinker and politician Pierre-Joseph Proudhon. He famously answered the question 'What is property?' with an aphoristic 'Property is theft,' arguing that ultimate, complete freedom for the individual would come when all authority—state, church, land, money—was abolished.

All anarchists agreed that the abolition of the state, and along with it the privileges of the rich and powerful, would allow people to flourish. Furthermore, since people were fundamentally good, anarchists believed, they should require no coercive or moral force to

ensure peace and harmony. It was the exploitation of capitalism, the unequal class hierarchies of society, the false preaching of religion, and the repressive authority of the police and the army that distorted the true, honest, and peaceful character of human beings. A society without such restraints would allow people to live in perfect, absolute freedom.

Anarchists also rejected parliamentary politics, with its compromises with bourgeois interests, its political parties with their hierarchies, and their piecemeal reforms that merely treated the symptoms, not the actual ills that afflicted society. Some, probably most, anarchists saw change as arising within the individual, as a state of mind. 'To be an anarchist', wrote Serge, 'is to leave the beaten paths on which for hundreds of years generations of sheep have walked without reflection, break with routines, reject commonly held beliefs, be contemptuous of public opinion.'[41] Not for nothing was one of the leading anarchist newspapers, edited in basement offices near Montmartre, called *L'Endehors*—'The Outsider'. Other anarchists sought to form and live within voluntary co-operatives, collectively pooling their productive capacities.

Yet in the early 1890s, some anarchists—a minority—embraced the tactic, already used by Russian revolutionaries, of 'propaganda by deed'. This was the idea of directing acts of violence at the rich and powerful and against institutions and agents of the state so as to send tremors through society itself and inspire the oppressed masses to embrace the revolution.

The spark came on 1 May 1891—May Day again—when some anarchists clashed with police in Clichy, a suburb on the northwestern edge of Paris. After three of the 'Clichy martyrs' were arrested and sentenced to harsh prison terms, other anarchists vowed to avenge them. Among these avengers was François-Claudius Ravachol, whose grinding poverty had driven him to theft in order to survive before he was drawn to anarchism. Along with others, Ravachol instigated a two-year spree of political terrorism that targeted those involved in the Clichy case while also striking at the townhouses

of the powerful, the offices of great capitalist companies, the institutions of republican democracy, and the restaurants where the bourgeoisie of Belle Époque Paris dined.

It began on 29 February 1892, when Ravachol exploded a bomb outside a townhouse on the plush rue Saint-Dominique. On 11 March, he planted another bomb, on the second floor of the elegant apartment on the boulevard Saint-Germain, where the judge who had sentenced the Clichy anarchists lived. On 27 March, he detonated a bomb in the apartment building of the prosecuting lawyer in the case. No one was killed in these three attacks, but they did cause serious injury. It was when Ravachol twice ate in Le Véry restaurant that he was recognised by a waiter and reported to the police. It took ten officers to overcome his desperately muscular resistance, but his detention did not end the campaign.

The bombing of the Restaurant Le Véry on 25 April was an act of revenge for Ravachol's arrest. The device, which had been planted in a suitcase, blew out the windows of the café and killed two people, including the owner, Monsieur Véry. The anarchist newspaper *Le Père Peinard*, with perverse and misplaced humour, called the attack 'Vérification'. Ravachol was convicted and sentenced to life imprisonment with hard labour before quickly being tried again on separate charges, this time in Montbrison for the earlier murder of a monk and two women. He was found guilty and guillotined on 11 July 1892, becoming a martyr for the anarchist cause.[42]

Among the other targets were the headquarters of the Carmaux Mining Company at No. 11 avenue de l'Opéra, on 8 November 1892. An anarchist named Émile Henry left a bomb wrapped in a parcel outside the main doors of the company office on the mezzanine floor. He had been inspired by the Carmaux miners' strike, during which workers were gunned down by police, and which Jaurès had brought to national attention. Finding the suspicious package, a small number of concerned employees carried it out onto the street and summoned the police. The officers bore the device to the police station at No. 22 rue des Bons Enfants near the Palais-Royal, where

it exploded, leaving a scene of horrific, bloody carnage. Five people were killed—torn apart—and others suffered severe lacerations.[43]

On 9 December 1893, a bomb tossed from the public gallery exploded in the debating chamber of the National Assembly in the Palais Bourbon on the Left Bank of the Seine. The device sent nails and tacks hurtling across the benches of the deputies, but the victims were only lightly wounded. The presiding officer, in a stylish display of *sang-froid*, rose from behind his podium, dusted himself off, and simply announced, 'The session continues.' The bomber was Auguste Vaillant, a desperate, impoverished worker who had struggled to support his wife and daughter. Although his attack killed no one—and despite political pressure from socialists and Radicals (including Clemenceau) for clemency, as well as considerable public sympathy for his plight (the royalist Duchesse d'Uzès offered to care for his little daughter, though in the end the anarchist Sébastien Faure did so)—Vaillant was guillotined outside La Roquette prison in the 11th arrondissement in the chilly dawn of 5 February 1894. On 15 March 1894, a bomb shook the pillars of the Madeleine—one of the places where Paris's upper classes worshipped; got baptised, confirmed, and married; and had their funerals. The anarchist bomber who carried the explosive device into the church was almost blown apart himself, as it went off while he was still carrying it, but as the dust and smoke billowed in the otherwise undamaged building, he was still able to shoot himself dead.[44] One of the final victims was President Sadi Carnot, stabbed to death on 24 May 1894 by an Italian anarchist at the railway station in Lyon.

Yet perhaps the most symbolic of these attacks was that committed just after 9 p.m. on 12 February 1894, when the twenty-one-year-old Émile Henry—the Carmaux Mining Company bomber, short, pale, gaunt, his dark hair closely cropped, his beard short and scraggly—hurled a homemade bomb into the Café Terminus near the Gare Saint-Lazare. The place was full of people—there were some 350 revellers enjoying dinner and a drink, and the orchestra had just struck up an aria from one of Daniel Auber's operas. It

was exceptionally lucky that no one was killed instantly, but twenty people—men and women—were seriously injured, and one of them, a draughtsman named Ernest Borde, later died of his wounds. Henry ran for it as passers-by gave chase before he was forced to an abrupt halt when he found a policeman's sword pointing at his throat. He was arrested, interrogated, tried, and finally guillotined on 21 May outside the Roquette prison. At his trial, Henry opined about the gross inequalities that everyone could see around them and his determination to sacrifice himself—and others—in the struggle for a more just society.[45]

Henry's attack was particularly shocking to the public because his target *was* the public. The other anarchists had aimed at authority figures, or people who at least had some direct connection with the arrest of anarchists. Not far from the Opéra and the *grands magasins*, and right by the Gare Saint-Lazare, the Café Terminus catered to a mixed clientele. It was a feature of Belle Époque modernity: the evolution of a consumer society that catered not just to the élites, but to a much wider, though still prosperous, cross-section of people. The terrifying novelty of Henry's attack lay in the claim that he made at his trial: as far as he was concerned, the civilians in the Café Terminus were complicit in the crimes of the bourgeois state by their very inaction. They were guilty through their complacent indifference to the plight of the working classes, or through their supine acceptance of their own lot.

By virtue of being a truly indiscriminate act of terror, the bombing of Café Terminus would eventually change the direction of anarchism in France. Until that atrocity, the anarchists had received some public sympathy, particularly among intellectuals and the denizens of the working-class eastern districts such as Belleville and Ménilmontant, and on the slopes of the Butte Montmartre. With the turn to more indiscriminate violence, such displays of sympathy began to fade out.

The wave of bombings leading up to the Café Terminus incident had already triggered a backlash. Reacting to the attempted attack

on the Carmaux Mining Company, which had ended up wreaking bloody carnage at a police station, the very miners in whose name the act was committed condemned the bombing, stating that collective action, not explosives, was the way forward for the workers. For socialists of all tendencies, the violence severely compromised the working-class movement. Jules Guesde, revolutionary though he was, declared that 'socialism will succeed only by the peacefully expressed will of the people'. Jaurès certainly sympathised with some of the anarchists as human beings—in the socialist newspaper *La Petite République*, he described Auguste Vaillant as a man driven to extremes by the abject poverty in which he had lived, which was also the lot of so many others. Jaurès was among those who appealed for clemency in vain. Yet, at the same time, he disavowed the anarchists' methods and aims: he believed they were too utopian and too individualist, and that the violence allowed their opponents to tar anarchists and socialists with the same brush of fanaticism. Jaurès emphasised social organisation, community, and democracy as well as individual freedom. The very structures of French socialism—with its parliamentary parties, its newspapers, its electoral politics, its reformism—had an orientation entirely at odds with that of the anarchists.[46]

Even worse for the socialists was that—as Jaurès had feared—the bombings served as an opening for the state to turn the screws of repression. In fact, the attacks exposed a dilemma faced by modern, democratic states when confronted with political violence. At least in theory, they were based on respect for civil liberties and individual rights. But when, if ever, was it acceptable for them to restrict the freedoms of their own citizens in the name of security and law and order? And if it was acceptable, then how far should such states be allowed to go?

The wave of attacks brought these questions into public debate. After Vaillant's bombing of the Chamber of Deputies, the moderate *Le Temps* opined that 'any society, especially a democratic one, has the right and duty, in the name of universal suffrage, to quarantine and silence those who are in constant revolt against its laws'.[47] *Le Matin*,

on 24 July 1894, went further, declaring categorically that 'the freedom of speech is far from being universal and absolute. And it is the same with writing, especially in the press.'[48] For some conservatives, the problem was the same Belle Époque ailment that seemed to infect every corner of life: modernity itself. For the *Figaro*, the anarchist bombings showed that young French people had no respect for society: They refused to find comfort in religion or to be guided by morality, and so to accept things as they were. Instead, they rebelled—and indeed, modern education was to blame for this disease.[49] The monarchist *Le Soleil* chimed in that Émile Henry was 'the natural product of our Judeo-Freemason society, of our frivolous and corrupt society, without beliefs, ideals, and faith'.[50]

From the *Soleil*'s perspective, the problem was the corruption of society more broadly. It did not use the term 'decadent' here, but it implied that morality had not kept pace with the rapid changes of modernity—and indeed had not been allowed to do so. Worse, as the editorial's antisemitic, conspiratorial vision of the state of French society and politics suggests ('Judeo-Freemason' was a right-wing epithet used to describe the republican regime), the anarchist outrages did not just elicit 'moderate' responses in defence of the social order and state security. It also provided, as Jaurès saw, an opportunity for those whose commitment to the values and freedoms that were supposed to underpin the Republic was questionable in the first place.[51]

An overwhelming majority of deputies in the National Assembly responded by passing a series of laws restricting the freedom of the press (12 December 1893) and of assembly (15 December) and targeting anarchists and their propaganda directly (26 July 1894). The first of these amended the very liberal press law of 1881, which had empowered the authorities to seize or close down only newspapers that directly exhorted their readers to engage in criminal acts. Now, not only could they act against any 'indirect provocation', but judges could order seizure and arrest pre-emptively. The second law, against 'associations of evil-doers', provided for the prosecution of any member of an organisation or meeting suspected of

criminal conspiracy, making no distinction between active members and sympathisers, but promising immunity to turncoats who gave evidence against them. The third law was aimed explicitly at specific anarchists, who were named, and banned them from publishing their ideas and propaganda. A wave of arrests ensued, along with searches of the houses of subscribers to anarchist newspapers. A police sweep on 31 July 1894 caught 657 alleged anarchists in the net within the Paris region alone: there were 4,681 across France (a number that swelled to 4,772 when France's Algerian colony was included).[52] These searches, along with the 15 December law against freedom of assembly, led to the 'Trial of the Thirty' in August 1894. Among those prosecuted were the writers Félix Fénéon and Sébastien Faure and 'illegalists' such as the anarchist burglar Léon Ortiz, who believed that law-breaking was a way of living 'outside' bourgeois society and an act of redistributive justice. In the end, all nineteen of the intellectuals were acquitted, but the eleven law-breaking 'illegalists' were given long prison sentences.[53]

For Jaurès and the socialists, it seemed clear that these three laws—which they dubbed the *lois scélérates* (shameful laws)—were aimed not only at anarchists, but also at socialists, and perhaps even at some of the more left-wing Radicals. The anarchist bombings had provided the pretext to restrain the working-class movement as a whole with police searches and harassment. 'Why have you multiplied searches and arrests among the poor on the basis of the vaguest standards, the silliest pretexts, and completely anonymous charges?' Jaurès roared at the ministerial benches in the National Assembly on 30 April 1894.[54] For him the laws were part of a wider 'new spirit', a consolidation of conservative forces on the right, whereby moderate republicans and their old monarchist opponents began to converge in defence of property against the Left—an instance where the old divisions associated with the 'Franco-French' culture war were being bridged.

The solidarity among the political and social élites, the broad abhorrence at the bombings in public opinion, and the disruption

caused by the repression unleashed by the *lois scélérates* brought an end to the wave of anarchist terror. So, too, did the very fact that there had been acquittals in the trial of the 'Thirty': The jury differentiated between the anarchist criminals, whom it convicted, and the writers and publicists, whom it freed. This gave much less of a pretext for retaliation.

Moreover, as the violence was becalmed, the authorities themselves began to soft-pedal. Calmer voices suggested that repression was counter-productive: the executions of anarchist bombers had not actually stopped further outrages but had encouraged them. None other than Maurice Barrès, soon to become the *bête noire* of liberal republicans and the Left for his antisemitic, xenophobic brand of nationalism, argued that combatting anarchism required ideas, not the guillotine blade. A contemporary historian warned that society would be helpless in its confrontation with anarchism if it resorted to repression rather than 'the power to convince'. The *lois scélérates*, in fact, remained on the statute books for many years afterwards—the law of 26 July 1894 was not repealed until 1992!—but for now the anarchist terror and the countervailing state repression were over, with one last sensational exception.[55]

Some anarchists reasoned that if property was theft, then stealing and counterfeiting money were legitimate, because they were merely taking back what was stolen from the poor by the rich, who were in turn empowered to do so by the law and the state. Thus, theft was 'a permanent revolt against the established order', an argument that was lethally deployed by the Bonnot Gang on the eve of the First World War.[56]

Jules Bonnot, son of a foundry worker, began his criminal career in the department of the Doubs in western France while still working as a mechanic. He had absorbed anarchist ideas and began to proselytise among his fellow workers. From 1907, he started stealing cars for a group of anarchists based in Romainville—a north-eastern, industrial suburb of Paris. They embraced 'illegalism', and Bonnot soon emerged as the group's leader. But in 1911, as the authorities began to

close in after a spate of thefts and burglaries, the gang decided to act in one final, spectacular orgy of violence.[57]

On the morning of 21 December, it struck at the branch of the Société Générale (still France's largest bank to this day) at 123 rue Ordener, on the corner of rue Duhesme in the 18th arrondissement, down the northern slopes of the Butte Montmartre. Bonnot drove three of his comrades, including the Belgian Raymond Caillemin (an old friend of Victor Serge's), the ideologue of the gang, in one of their stolen cars. Bonnot waited behind the steering wheel, the engine chugging, as the others strode into the bank and robbed it, bringing out money sacks. Before Caillemin got back into the car, he turned and coldly fired at two young employees, killing one of them, no doubt considering it collateral damage on the journey towards an anarchist utopia. Passers-by trying to stop the theft were scattered by more shots.

The gang kept one step ahead of the police over the next few months, emerging to rob and kill before moving on and escaping back into hiding. They hit a gunshop on the rue Lafayette just before Christmas, and they killed an old man for his money (slaughtering his servant as well) just after the New Year. They shot a policeman on the place du Havre in front of the Gare Saint-Lazare at the end of February 1912—eerily also right in front of the Café Terminus, where Émile Henry had committed the founding deed of modern terrorism eighteen years previously. They struck again in March at the Société Générale, this time in Chantilly north of Paris, after killing two people while stealing their car to commit the robbery.

The press covered their exploits with rapt attention, provoking fear and anger with their violence and through the apparent inability of the forces of order to stop them. The public was especially agog at the Bonnot Gang's use of cars in their attacks, the first 'getaway' vehicles. A police report warned that these anarchists '[would] not hesitate to employ the perfected means of locomotion to carry out their evil deeds'.[58] Politicians took note, too, and demanded action. Soon, the police themselves were equipped with fast cars, tele-

phones, and weapons to match the anarchist bandits, and a 'Brigade of Tigers'—automobile-borne, armed police nicknamed after Clemenceau's moniker—was created.

The net finally began to tighten in April, when Bonnot shot and killed the deputy chief of the Sûreté générale (a police force akin to the FBI, with responsibility for dealing with serious crimes, threats to national security, and espionage) during a search of his lodgings. Photographs of the gang members—a modern update on 'wanted' notices—were circulated among the public, and Bonnot and his accomplices were cornered in a garage at Choisy-le-Roi outside Paris on 28 April. The police—led by another deputy chief of the Sûreté—blew open one wall of the building with dynamite before surging through, mortally wounding Bonnot in a brief firefight. The rest of the gang members were either killed or arrested in the following weeks. In February 1913, three of the captured men were condemned to hard labour for life on Devil's Island off French Guiana. Three others—those involved in the rue Ordener attack—were decapitated by guillotine on the bleak, drizzly morning of 21 April on the boulevard Arago, outside of the depressing (still extant) Santé prison in the 14th arrondissement.

The Bonnot Gang's murderous embrace of 'illegalism' provoked a great deal of public revulsion. It was understandably hard for people to distinguish the group's political motives from banditry and thuggery, pure and simple. Among French anarchists, it provoked what the writer Richard Parry has called 'the theoretical autopsy of illegalism', in which the rest of the movement distanced itself from the idea of criminality as a political act.[59] Victor Serge had done just that when he was tried alongside the Bonnot Gang as one of the ideologues behind their crime spree: he was still sentenced to five years in prison, after which he was deported. Moreover, in harnessing the tools of Belle Époque modernity in its campaign of political violence, the Bonnot Gang proved in the most lethal and destabilising of ways that technology and progress were double-edged. In its politicisation of criminality, allegedly on behalf of the oppressed working

class, the group attempted to provide a direct link between the marginalised of Belle Époque Paris and the working-class struggle for social justice. It is probably safe to say that in this they failed.

Anarchist violence, syndicalism, and parliamentary socialism, in their different ways, pushed the democratic, republican moderates and the royalist, authoritarian conservatives to find common cause in defence of the social order based on the inequalities of wealth and the sanctity of property. The *Ralliement* period of French politics in the 1890s saw moderate Catholics seeking to work within the Republic's parliamentary structure to defend their beliefs and the Church while also offering to work with moderate republicans in order to face down the danger of social revolution, or what Jaurès would call the peaceful 'reorganisation of the property system'. A new political alignment appeared slowly and fitfully in which emerging questions about wealth, poverty, social justice, property, and working conditions might have energised politics along social lines, moving away from the political and cultural conflict of the 'Franco-French war'.

But it was not to be. This incipient shift was abruptly disrupted by a new legal, political, and cultural crisis that inflamed the old divisions, and in which the old identities around different ideas of what it was to be French reasserted themselves with a vengeance. This crisis was the Dreyfus Affair.

CHAPTER 8

POLEMICS

On 12 January 1898, Émile Zola, his well-tailored suit tightened around his middle-aged paunch and his features set determinedly behind his trimmed black beard and pince-nez glasses, passed through the entrance in the ornate façade of No. 142 rue Montmartre in the 2nd arrondissement. The novelist was about to drop a literary bombshell that would reverberate across France and the world, and that to this day remains one of the greatest pieces of polemic ever written.

On his way to the recently founded left-wing republican newspaper *L'Aurore*, Zola was entering a building whose very design proclaimed its identity as a hub of press activity. Standing on the opposite side of the street, the better to look at the frontage, one can see two large statues by the sculptor Ernest Hiolle flanking the main entrance: one thoughtfully bearing a quill pen, representing journalism, the other holding aloft the flame of truth amidst the tools of typography. Further underscoring the point, above the entryway's arch there are two crossed quill pens. Two outer figures, by Louis Lefèvre, are male

241

caryatids, twisting and straining to hold up the second-floor balcony that bears the name of the newspaper for which the building was designed, by Ferdinand Bal, in 1883, *La France*. Yet by the time of Zola's visit, the newspaper was in a state of decline as circulation numbers dwindled. From 1886, according to one historian of the press, it was 'no more than a phantom paper', although it clung on until 1914.[1]

La France's agonisingly slow demise was probably why it began to share its sparkling new premises with other titles, including *L'Aurore* from 1897, and another left-of-centre sheet, *Le Radical*. The *Journal du soir* also moved in from No. 123, opposite—and today you can still see its name carved into the stonework alongside that of *La France*.

Not only this building but rue Montmartre as a whole, and particularly this stretch, still carries the memories, and sometimes the visual clues, of the presence of the once bitterly partisan, brutal, but lively world of Belle Époque journalism. For the rue Montmartre was once—and remained until relatively recently—the heartland of the Parisian press. It was a world that lay at the centre of the Dreyfus Affair.

INSIDE NO. 142 on this winter's day, Zola met *L'Aurore*'s founder, the socialist Ernest Vaughan, as well as the newspaper's co-director, the Radical politician Georges Clemenceau. Struck by the arrival of their famous visitor, the staff gathered and listened as the novelist read out a long open letter addressed to the president of the Republic, Félix Faure. Zola's penetrating tenor voice built towards its climactic end, charging that Faure's government had made calamitous errors, was guilty of gross illegalities, and had engaged in a conspiracy to cover them all up. When Zola finished, his rapt audience broke into applause. Most enthusiastic of all was Clemenceau, who drew out the title of Zola's article from the climactic refrain in the closing paragraphs of the letter: 'J'Accuse . . . !'

Clemenceau and Vaughan had the text printed in a special number of the newspaper—three hundred thousand copies in all—which

would appear the following morning. They had posters printed to publicise the blistering text and employed a small army of boys and teenagers as news-criers. These vendors carried bundles of the special edition to all corners of Paris, shouting out 'J'Accuse!' to passers-by and loudly reciting Zola's more arresting phrases. The most strategic locations were, naturally enough, outside the department stores and on the Grands Boulevards. Two hundred thousand copies of the issue were sold within the first few hours of it going on sale. It would become one of the most famous moments in the history of journalism, and even in the history of France.[2]

The Dreyfus Affair was a *cause célèbre* that involved espionage in the army, a miscarriage of justice, a cover-up, fake evidence, and a battle for the truth in lockstep with a mounting political drama, raging public polemics, street violence, and, after an agonisingly long period, rehabilitation for the victim. It first broke in 1894, built towards a stormy climax in 1898–1899, and found a resolution (of sorts) in 1906 after galvanising the old, deep-rooted conflicts within French society.

At first, the affair appeared to revolve around a straightforward case of espionage from within the French army's military espionage department, euphemistically called the *section des statistiques* (statistical section), within the General Staff. Its offices were on the rue de Lille in the 7th arrondissement, which happened to be a street shared by the German embassy.

In late September 1894, the counterespionage officer Lieutenant-Colonel Hubert-Joseph Henry was routinely going through a cache of documents filched from the wastepaper basket of the German military attaché. Among these papers, he found an unsigned memorandum (*bordereau*) that proved to be clear evidence that a French officer was handing sensitive information to the Germans. The handwriting was eventually identified as that of Captain Alfred Dreyfus, a Jewish artillery captain who was on secondment in the General Staff. An arrest warrant was issued on 14 October, and the captain was charged with high treason and transported to the Cherche-Midi military prison, a former convent on the corner of the boulevard

Raspail and the rue du Cherche-Midi (a site now occupied, rather ironically, by the École des hautes études en sciences sociales [School for Advanced Studies in the Social Sciences], just around the corner from the Bon Marché department store). Despite the gossamer-thin evidence against Dreyfus—even Major Armand Mercier du Paty de Clam, who led the army's investigation, began to worry that it would not be enough to convict—the war minister, General Auguste Mercier, sought a quick resolution. The court-martial was set for December. Dreyfus's attorney, the brilliant Edgar Demange, read the report and indictment and was horrified, concluding that 'were Captain Dreyfus not Jewish, he would not be in prison'.[3]

On 22 December, the eight army officers who sat as judges unanimously found Dreyfus guilty and sentenced him to military degradation and banishment for life, to be served in solitary confinement. Dreyfus was publicly degraded on the icy morning of 5 January 1895 in the central courtyard of the École militaire (Military School, at the bottom of the Champ de Mars). His insignia were torn off his uniform and his sword snapped in two by a massive officer of the guards before he was marched around the square in front of the regimental ranks representing all the units based in and around Paris. When he came close to the grille that separated the courtyard from the place de Fontenoy outside, the baying of the crowd there—'Death to the Jew! Judas!'—drowned out his protestations of innocence. A few days after this torment, Dreyfus was shackled and taken by train to La Rochelle, and, on 22 February, he was borne across the Atlantic and, ultimately, to the barren Devil's Island off the coast of French Guiana, where he was held in an isolated hut and watched by guards who were forbidden to speak to him.

As the honourable Catholic conservative Demange saw, Dreyfus was identified as the culprit in part because of who he was: a Jew from Alsace, a French officer who had entered the army from the ranks of the bourgeoisie. In every sense, he embodied the republican values inherited from 1789. The Revolution had given full rights of citizenship to Jews and had opened careers to talent rather than

to birth, allowing, above all, the middle classes to rise to positions hitherto closed to all but those of noble birth. As an Alsatian whose family (mostly) chose to move to France rather than live under German annexation after 1871, Dreyfus amply demonstrated his patriotic credentials and loyalty to the Republic. He later said that his path to a military career began with the sight of German troops parading through his home city of Mulhouse, calling that moment 'his first sorrow'.[4]

Yet, for many of his fellow officers, almost all of this was precisely what made Dreyfus an obvious suspect. At a time of feverish Germanophobia, Dreyfus's visits to his family, who remained in German-annexed Alsace, were used to suggest that he was actually meeting with his German paymasters.[5] And all Alsatians in France struggled between their own powerful sense of French identity and the suspicion among their compatriots that, underneath, they were essentially German.

Dreyfus's pathway ran from the meritocratic and secular traditions of the French Revolution, a route that was generally favoured by the reforms that overhauled the army in the wake of the defeat of 1870–1871. The republican officers who rose in this way and who came through the science-based École militaire mingled with those who came via the military academy of Saint-Cyr, many of whose recruits were scions of the old Catholic nobility. For the latter, the army represented something deeper than whatever regime—republican, monarchist, or Bonapartist—was in power: it was an embodiment of the deeper existence of the French state. To perform military service was to serve *France*, without necessarily owing sincere allegiance to the hated Third Republic. For many of these officers, upstarts like Dreyfus threatened the 'true' traditions and loyalties of the army, which they saw, as one of the leading historians of the Dreyfus Affair, Ruth Harris, has explained, as 'their last bastion of power and patronage'.[6]

As a Jew, Dreyfus was particularly vulnerable. There were some three hundred Jewish officers in the army at the time, but there were deep undercurrents of antisemitism within the officer corps. Dreyfus

and another Jewish officer at the École supérieure de guerre (Superior School of Warfare) actually received uncharacteristically low marks from one examiner, who shrugged off the school commandant's puzzlement by stating that 'Jews were not wanted on the General Staff'.[7] For many officers, it was almost axiomatic that, as a Jew, Dreyfus could never be truly 'French'.

In truth, the liberal, inclusive values that underpinned French republican identity had always been under pressure, not least because there was a sense among some that in opening up careers in government, the army, and the professions to Jews, Protestants, and others, the Revolution had effectively denied opportunities for advancement to the 'real' French. The older forms of hatred—based on older Christian prejudices against Jews as the 'killers of Christ'—had never entirely disappeared, but something newer had begun to rear its serpentine head, all the more virulent because it fit in with the frictions of Belle Époque modernity. The writer and anarchist Bernard Lazare, exploring the history of antisemitism in 1894, distinguished between the older, traditional 'anti-Judaism', which was a religious form of intolerance and prejudice, and the emergent antisemitism, which he described as a more sophisticated, political expression of irrational hatred, a way of explaining the pressures and challenges of modern society.[8]

In the context of a drawn-out, European-wide economic downturn from the 1870s, which deepened in the later 1880s, both populist nationalist and socialist movements found in antisemitism a convenient scapegoat to blame and a means of channelling people's anger. For right-wing nationalists, Jews were 'cosmopolitan', and communist revolutionaries to boot, while for socialists, the association of some successful Jews with business and banking provided an easily identifiable class target.

In France, these prejudices were given acute focus in the wake of three important events. One was international: a series of murderous pogroms unleashed by the tsarist regime in the Russian Empire that sent waves of Jewish refugees seeking safety in central and

western Europe between 1881 and 1884. Unlike assimilated Jews, such as the Dreyfus family, the newcomers to France did not speak French, dressed differently, and were poor: in Paris, many settled in what was then the cramped Marais, around the rue des Rosiers and in the crowded, tubercular quarters just to the south of the rue Saint-Antoine. The arrival of a clearly 'foreign' element compounded older suspicions of Jews as rootless, potentially revolutionary, and certainly as not French.

The other two events were domestic. The first took place in 1882, when the Union Génerale bank collapsed. This Catholic institution had held the savings of many small investors on the promise of big returns, and the losses were blamed on Jewish financiers. The second was the Panama Affair in 1892. When the Panama Canal Company—headed by Ferdinand de Lesseps—had attempted to build a canal across the isthmus of Panama, it had run into all kinds of practical and financial difficulties. It went bankrupt in 1889, and three years later, it emerged that in 1888 Lesseps had bribed French politicians of all sides to allow the issue of new stock to raise the funds that the company had desperately needed. Among the go-betweens were the financier Baron Jacques Reinach (the uncle of Joseph Reinach, later one of the leading Dreyfusards) and the businessman Cornelius Herz, both Jews. Reinach, hounded by the revolting, antisemitic newspaper *La Libre parole* (Free Speech, edited by Edouard Drumont), committed suicide, while Herz fled the country. Although non-Jews, including Gustave Eiffel (who designed the locks for the canal, which was later completed by an American company), were convicted in 1893 of misappropriation of funds (Eiffel's conviction was later quashed on appeal), the connection between Jewish finance and parliamentary corruption was irresistible to antisemites, nationalists, and seething former Boulangists. The Panama Affair, in other words, had stoked up antisemitism just in time for the conviction of Alfred Dreyfus.[9]

The various prejudices and frictions help explain why it was that when the Dreyfus case became a *cause célèbre*, especially after

Zola's thunderous intervention in *L'Aurore*, it divided public opinion so bitterly. Although the battle lines were far from clear cut, broadly speaking the bitter polemics and, sometimes, violence that pitted the 'Dreyfusards', who called for a revision of the case against the captain, and the 'anti-Dreyfusards', who insisted that he remain shackled on Devil's Island, split opinion along the same lines as that of the deeper 'Franco-French conflict'. On one hand, there were plenty of Catholics, such as Demange, whose conscience would not allow the persecution of an innocent man; on the other hand, there were moderate republicans who wanted desperately to avoid embarrassing the army and fend off political controversy. They denied that any miscarriage of justice had taken place: in November 1897, Prime Minister Jules Méline would publicly insist, 'There is no Dreyfus Affair.'[10] But denial that there was a problem did not mean that it did not exist.

THE DREYFUS AFFAIR began quietly enough. Initially, almost everyone accepted the verdict, glad to see the matter apparently closed. In the Chamber of Deputies, when Minister of War Auguste Mercier proposed that the death penalty for treason, abolished in 1848, be restored, Jaurès seized the opportunity to make a point about class justice without so much as questioning Dreyfus's guilt.[11] He implied that the officers who had condemned Dreyfus had spared him because he was from the same bourgeois class, but that meanwhile soldiers were being 'shot without pardon or pity for a momentary lapse or act of violence'.[12] Even Bernard Lazare, who was Jewish himself, initially took little interest in the case: like Jaurès, he saw it as a middle-class problem, something the wealthy Dreyfus family could sort out by itself. It was the *Figaro* that probably captured the mood the day after Dreyfus's conviction when it stated, 'Now that it is all over, let us speak as little as possible of this sad story.'[13]

Yet the case was never entirely closed. There were plenty of influential figures who had their doubts about Dreyfus's guilt, even if initially they remained isolated and voiced their views discreetly. Thanks

to dogged detective work and courage, pressure mounted. The driving forces were Dreyfus's stalwart wife, Lucie; his brother, Mathieu; and Lieutenant-Colonel Georges Picquart, who in July 1895 became the new head of the 'statistical section'.

Evidence that there had been illegalities behind Dreyfus's conviction began to trickle out in unguarded moments from President Faure and some of the officers who had presided over the court-martial. To Demange and Mathieu, it soon became clear that Alfred's guilt had been 'proven' by documents that had remained secret and unseen by the defence on grounds of 'national security'. In mid-1895 Mathieu was introduced to Lazare, who had become deeply concerned about the groundswell of virulent antisemitism abroad in France. In November, Lazare published his pamphlet *A Judicial Error: The Truth on the Dreyfus Affair*. It was the first exposé at any length that outlined the Dreyfus case as a miscarriage of justice and claimed that it was driven by antisemitism. There were no verbal histrionics, just the facts of the case as Lazare understood them. He grouped his argument around three points: the weakness of the evidence against Dreyfus, the contradictory conclusions of the original handwriting experts, and the misleading testimony and 'secret dossier' in the court-martial itself.[14]

From within the statistical section there was Lieutenant-Colonel Georges Picquart. A Catholic from Alsace and a Saint-Cyr graduate, he was an antisemite who was nonetheless respected as a fine officer, highly cultivated (he read Tolstoy in Russian) as well as witty and debonair. In July 1895, he was appointed head of the statistical section. By this stage, some of the officers who had been involved in the original case were becoming concerned about Mathieu Dreyfus's detective work. The chief of staff, General Charles de Boisdeffre, told Picquart that the affair was 'not over': 'It is only beginning: a new offensive by the Jews is to be feared.'[15]

Told to feed more evidence into the secret dossier, Picquart initially found little surprising in this order. Meanwhile, his colleague Lieutenant-Colonel Henry continued to receive documents filched

from the German embassy. In March 1896, one of the caches included a small note on blue paper—a *petit bleu*, a small telegram-like message that was folded, addressed, stamped, and then delivered in a cylinder across the city via a subterranean network of pneumatic pipes.[16] The *petit bleu* had been torn up, but when it was pieced back together, the address was 'Monsieur le Commandant Esterhazy, 27, rue de la Bien-faisance, Paris'. Working patiently, in August 1896 Picquart laid the *bordereau* that had been used against Dreyfus side by side with a sample of some of Walsin Esterhazy's correspondence. The handwriting was identical. He had uncovered the true culprit. On 1 September, Picquart recommended that Dreyfus be exonerated and Comman-dant Walsin Esterhazy be arrested.

Esterhazy was everything that Alfred Dreyfus was not. A hard-core antisemite and the scion of an ancient aristocratic family, he had swaggered through the old networks of patronage and preferment. Although he enjoyed a social whirl funded by an unhappy but wealthy marriage and by numerous rich mistresses, he was harried by credi-tors for his debts accrued from gambling, poor investments, and the purchase of a château, and in July 1894 he had begun to sell military information to the Germans.[17]

On 18 September, Lucie Dreyfus petitioned the National Assem-bly to have her husband's case reopened, but the war ministry and the General Staff doubled down. Picquart was sidelined by being posted away, first to the provinces, in October 1896, and then to Tunisia in January. And fatefully, Lieutenant-Colonel Henry ensured that Drey-fus remained condemned, by creating new counterfeit 'evidence' that allowed the second-in-command of the General Staff, General Arthur Gonse, to reiterate his guilt in a statement read to the Cham-ber of Deputies on 18 November 1896.

Yet the pressure continued to build. In June 1897, Picquart, while on leave, confided the whole story of the affair to his friend and law-yer Louis Leblois, who was troubled enough to approach Auguste Scheurer-Kestner, the vice president of the Senate, an Alsatian who was admired for his probity. Scheurer-Kestner had long entertained

doubts about the case, and now tried in vain to convince President Faure to reopen it at the end of October. In November, he met with a stroke of luck: a stockbroker named Jacques de Castro recognised the handwriting on a facsimile of the *bordereau* published in the press as that of one of his clients: none other than Walsin Esterhazy. Armed with this independent proof, the senator at last abandoned caution, publishing a letter in *Le Temps* on 15 November accusing Esterhazy, while Mathieu Dreyfus did the same in an open letter printed in *Le Figaro*. Yet both the army high command and the government still remained obstinate—and Scheurer-Kestner's attempt to convince parliament to reopen the case was crushed by a thumping majority.

Meanwhile, Gonse, Boisdeffre, and the war minister, Jean-Baptiste Billot, urgently tried to cover the misdeeds committed in the Dreyfus case, urging Esterhazy to insist on a court-martial, in order to keep it from going to trial in a more rigorous criminal court. On 9 January 1898, Esterhazy was arrested and court-martialled, but despite the testimony against him by Picquart—and despite the damning revelation by one of his spurned mistresses that in one of his letters he had written, 'I would not harm a puppy, but I would with pleasure kill one hundred thousand Frenchmen'—on 11 January he was acquitted.[18] In clearing Esterhazy, the army had in effect reasserted the original verdict against Dreyfus, a fact appreciated by the assembled crowd who greeted the news with cries of 'Long live the army!' 'Death to the Jews!' The acquittal was the trigger that set Zola drafting the open letter that would become 'J'Accuse . . . !', published two days later, on 13 January. It would transform the Dreyfus Affair into the *cause célèbre* that tore Belle Époque public opinion apart.

Why Zola intervened at all has been a matter of some speculation ever since. The ultra-conservative writer Alphonse Daudet claimed that Zola's ego was such that he could not bear that the Dreyfus Affair, rather than his latest novel, *Paris*, had seized the public's attention.[19] Yet Zola's motivations ran deeper than a hankering for the limelight: The case of Alfred Dreyfus spoke to his own sense of social justice and

he had come to detest antisemitism.[20] In May 1896, writing in the *Figaro* against the vicious polemics of Edouard Drumont in the *Libre parole*, Zola called antisemitism 'a monstrosity . . . beyond the bounds of common sense, truth and justice' that would eventually 'bathe every country in blood'.[21] Zola also had committed himself to the Dreyfusard cause in November 1897, after meeting Scheurer-Kestner and a small group of others. On 25 November, he had closed an article in the *Figaro* with searing words: 'La vérité est en marche, et rien ne l'arrêtera' (Truth is on the march, and nothing will stop it).[22]

Yet there was already a price to pay. The editors of the *Figaro* watched with growing alarm as it haemorrhaged readers protesting Zola's assault on the army. With the *Figaro*'s doors closed to him, Zola approached Ernest Vaughan of *L'Aurore* to publish what became 'J'Accuse . . . !'

Addressing President Faure, Zola opened the piece with a reference to the acquittal of Esterhazy and then recounted the events leading to the arrest and conviction of Alfred Dreyfus. Focusing on the role of du Paty de Clam, who had led the original investigation, he described the hollowness of the case against Dreyfus ('Is it possible a man has been found guilty on the strength of it? Such iniquity is staggering.'); the shoddy conduct of his court-martial; the use of a secret document ('What makes the business all the more odious and cynical is that they are lying with impunity'); Picquart's investigation and rough handling by the army; and the fact that Picquart's findings had essentially been buried. Comparing Dreyfus's court-martial with Esterhazy's, he remarked, caustically, 'There may be room for doubt as to whether the first court martial was intelligent but there is no doubt that the second has been criminal.' He concluded by appealing to the president—'Do your duty'—and by levelling specific charges against individuals, beginning each accusation with the phrase 'J'accuse', fired like bullets from a repeater. Zola acknowledged that in making these accusations, he was liable to criminal prosecution for defamation under the press law of 29 July 1881, but said, defiantly, 'I deliberately expose myself to that law.'[23]

It was a skilful, thundering polemic, all the more powerful for being grounded in a good deal of truth. Despite its flaws, some of which, including errors of fact, are only obvious with the benefit of hindsight, 'J'Accuse . . . !' struck home against the self-serving army officers driven by authoritarianism and clericalism: 'They talk to us about the honour of the army,' Zola scoffed, but 'what we are faced with here is the sabre, the master that may be imposed on us tomorrow.' Even as members of the General Staff had 'crushed the nation under their boots, stuffing its calls for truth and justice down its throat', they had done so under 'the fallacious and sacrilegious pretext that they [were] acting for the good of the country!' They had manipulated the people by spreading falsehoods; had stoked up hatred and prejudice, especially antisemitism, claiming the mantle of patriotism; had fetishised the military; and had accused those who stood up against them of trying to tear France apart:

> It is a crime to lead public opinion astray, to manipulate it for a death-dealing purpose and pervert it to the point of delirium. It is a crime to poison the minds of the humble, ordinary people, to whip reactionary and intolerant passions into a frenzy while sheltering behind the odious bastion of anti-Semitism. France, the great and liberal cradle of the rights of man, will die of anti-Semitism if it is not cured of it. It is a crime to play on patriotism to further the aims of hatred. And it is a crime to worship the sabre as a modern god when all human science is labouring to hasten the triumph of truth and justice.[24]

Zola was warning primarily against the dangers of populist authoritarianism, militarism, and the infringements of individual liberties in the pursuit of prejudice. 'J'Accuse . . . !' was a cry against the stoking of hatreds and the sowing of falsehoods by the powerful for their own ends through the media—what would be called 'gaslighting' today: barraging people with half-truths and outright lies so that, combined with an appeal to popular fears and prejudices, it becomes

hard to distinguish veracity from falsehood, a practice that ultimately creates an alternative 'reality' completely at odds with the truth but in which a fearful, angry, disorientated public might willingly or uncritically take refuge. And the problem in the Dreyfus Affair, as today, is that while some parts of the press might be instrumental in bringing the truth to public attention, other parts play a malign role in spreading the lies and stoking hatreds. 'J'Accuse . . . !' stands as a *fin-de-siècle* warning against the manipulation of public opinion through the media.

Some hailed Zola's intervention: Séverine, Marguerite Durand's close collaborator on *La Fronde*, wrote an article declaring that 'women are happy to salute, in these times of lethargy and cowardice, an act of moral courage'.[25] Yet Zola, as we shall see in the next chapter, would pay a personal price for his intervention. For now, a fusillade of brutal polemics erupted all around him, as Dreyfusard and anti-Dreyfusard politicians, activists, and writers fought each other through the medium of print. Intellectuals could and did write books on the Dreyfus Affair, but in its fast-moving politics, it was the press that drove the debate, and the beating geographical heart of the Parisian press was the rue Montmartre.

FRENCH NEWSPAPERS HAD experienced a steady expansion during the Belle Époque. This was partly thanks to the kinds of technological advances that made the period buzz with excitement. If the telegraph had long ensured speedy communication of news reportage, the telephone slowly supplanted it, both for national and international news, from the mid-1880s, when Rouen and Paris became the first French cities to be connected by telephone wire in 1885, Brussels and Paris following in 1887, and a cable laid beneath the Channel linking Paris to London in 1891. That said, the onward march of the telephone as a journalist's tool took its time—Parisian newspapers continued to use the more ubiquitous telegram and were still receiving reports via avian airmail—pigeon carrier—right up to 1906.[26]

Printing techniques accelerated the process of producing the daily edition during these years. The linotype machine, invented in the United States in the mid-1880s, allowed the printer to set a text line by line using a keyboard rather than laboriously setting it letter by letter manually. For the printing itself, the rotary press, developed from the older cylinder press, was introduced into France in 1866 by Nicolas Serrière, the printer for, among other newspapers, *La Presse* and *Le Petit journal* at No. 123 rue Montmartre. The real breakthrough came in 1872, when the fully automated rotary press was developed, allowing paper to be fed speedily from reel to reel as it was printed, and demanding little intervention once the process had begun. This allowed a large-format, four-page newspaper to be spun off the presses at the astonishing rate of twelve thousand to fourteen thousand copies an hour. A further mechanism for folding the pages (*pliage*) into a broadsheet format was soon added. These machines, originally powered by steam, would begin to be driven by electricity in the years just before the First World War. Photography began to replace artists' sketches as illustrations from 1887, and the development of colour printing using the speedy rotary presses enabled Paris's first colour newspaper to hit the streets: it was an illustrated supplement of *Le Petit journal* in November 1890.[27] Together, all these innovations allowed newspapers to pack in more content, grab browsers' attention, and charge less while printing at greater scale so as to feed a rapidly expanding readership.

Yet the essential stimulant to the press was legal. The law of 29 July 1881 swept aside almost all restrictions. This hard-fought republican triumph over the 'Moral Order' of the 1870s asserted the freedom of the press as the touchstone of democracy. Moreover, with monarchist and Bonapartist threats receding, such freedom seemed to carry little risk. Meanwhile, the monarchists and the socialists both went along with the law, which passed through parliament with very few dissenting voices, because they saw in it a chance to strengthen and expand their own position within the public debate.

The law encouraged an explosion in newspapers and journals. In its wake, the number of titles increased by 250 per cent by 1914, including not just a range of broadsheets, of which *Le Figaro* and *Le Temps* were examples, but also a popular tabloid press, including *Le Petit journal* and *Le Petit parisien*. A colourful variety of specialist magazines also began to flourish, ranging from racy humour to sports and professional journals. The law opened up a space as well for papers of all political opinions. These included the darkest forms of prejudice: Edouard Drumont gave his antisemitic journal the title *La Libre parole* (Free Speech), which would not be the last time that a racist would hide behind free speech in order to spread hatred and attack other people's freedoms. But the range of commentary went all the way through to left-wing papers, both socialist, such as *La Petite République* and *L'Humanité* (for which Jaurès would become political editor), and anarchist, notably Émile Pouget's *Le Père Peinard*.

The law imposed few limits on what could be published, although it did ban sticking bills and posters on public buildings (one still sees 'Défense d'Afficher—Loi du 29 Juillet 1881' painted on the side of government premises everywhere). Otherwise not even attacks on the Republic and democracy themselves were out of bounds. Ambitious politicians made sure they reached their supporters and pressed their agenda by having their own newspapers, or by having an editor or journalist in their pocket, or by writing articles themselves. All journalists, mercenary or otherwise, found plenty to write about in the daily cut-and-thrust of politics: the press came to be described as the 'anti-chamber' of parliament.

Pornographic material began to flourish after 1881 and was only subject to legal sanctions as an afterthought beginning in 1882. There were further attempts to clamp down on anything that might offend 'public morality' as well. On average, there were just under seventeen press-related court cases each year, usually brought by individual politicians and officials who felt wronged, rather than by the government itself. The majority of those rebounded with the acquittal of the defendant. The prosecution of Zola and the managing

editor of *L'Aurore*, Alexandre Perrenx, for 'J'Accuse . . . !' in February 1898, would in fact be one of the rare moments when the government actually pursued a case successfully under the 1881 law. There were periods where some furious backpedalling was attempted, as we have seen when the *lois scélérates* hit out against anarchist publications, and a further wave of attempted repression in the years before the First World War would target a rising tide of antimilitarism on the left.

What press freedom meant in practice was that political journalism very quickly descended into vicious, violent partisanship and often deeply personal attacks, lies, and half-truths. The result was a media stew in which whatever restrictions there were against defamation or libel were hard to enforce and falsehoods difficult to rectify, even though the government did have the right to make statements correcting errors in reporting and individuals had the right to reply. It also meant that complex issues were often reduced to identifiable if simple positions and appeals to prejudices in order to mobilise their readership. It was easier for newspapers to capture attention through polemics, identifying and denouncing enemies and stoking outrage, rather than by presenting a careful, detailed analysis of the information or engaging in dogged investigative journalism.[28] In this way, the Third Republic saw the expansion of a particularly lively, if often bitterly partisan, press whose relationship with the truth could (to put it politely) be problematic. This was especially true of the highly charged, clamorous debate about the Dreyfus Affair that poured out of the press district on the rue Montmartre.

The street itself dated to the Middle Ages—already bearing its name in the twelfth century because it connected the city with the outlying religious community and village on the Butte.[29] In the nineteenth century, the street became the central artery of the press district, so that by the time of the Dreyfus Affair newspaper buildings dominated the street, especially the stretch between rue Réaumur and the Grands Boulevards. (The section of the rue Réaumur that intersects with the rue Montmartre, its buildings with soaring windows

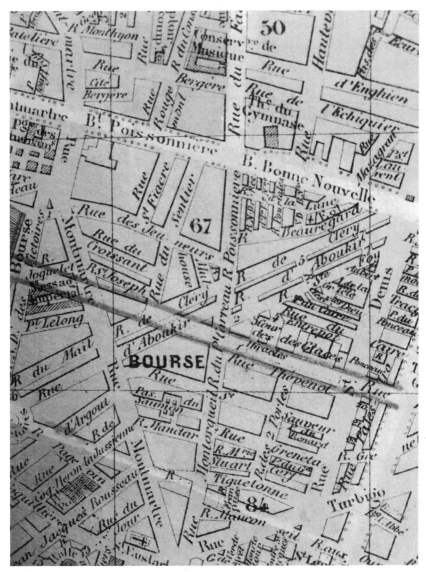

The press district lay around the rue Montmartre, which veers north-north-westwards through the centre of the city before angling northwards towards the Grands Boulevards (here the boulevards Montmartre and Poissonnière), close to the Bourse, the stock exchange (here just seen on the far left). The trajectory of the rue Réaumur (driven through in 1895) is here superimposed in bold lines. Jaurès wrote 'Les Preuves' in the *Petite République* on the south-western corner of its junction with the rue Montmartre. *L'Aurore*, which published Zola's 'J'Accuse . . . !', was a little farther north, south of the corner of the rue Montmartre and the rue du Croissant.

elegantly supported by decorative ironwork, is in itself a fascinating cornucopia of Belle Époque commercial architecture.)

During the Belle Époque the whole area throbbed with news as printworkers, office clerks, and delivery drivers went about their business and journalists raced to the office to meet their deadlines. Honoré de Balzac, writing a few decades earlier, described them as 'the light skirmishers of the press'.[30] The street resonated with the hooves and harnesses of horse-drawn carriages and, later, with the rattle of lorries, delivering the huge rolls of paper from the mills of Essonnes and Nanterre outside the city.[31]

The press took root here after publishing and printing started to diverge into more specialised industries. Until 1815, newspapers and often printers were in the same Parisian neighbourhood as book publishers, located in the Latin Quarter on the Left Bank (which still retains the headquarters of important French and global publishing houses). The movement of the newspaper press to the Right Bank marked a cultural and commercial development, with the expansion of the popular mass media in the nineteenth century producing something of a rift with the more high-brow world of book publishing.

The location around the rue Montmartre was ideal for its proximity to the central post office on the rue du Louvre, which allowed for the speedy receipt of reports sent via telegram and the swift dispatch of papers to subscribers in the provinces, as well as to the Paris Bourse, or stock exchange, on whose fluctuations some papers assiduously reported. The Havas press agency, founded in 1835, which, like Reuters, became a timely source of international news, set up shop around the corner from the rue Montmartre on rue Notre-Dame des Victoires, later moving to the nearby place de la Bourse. So it was that the rue Montmartre became a hub of the Parisian press, which—as we shall see—soon spilled across the Grands Boulevards to the north, threading along and around the rue du Faubourg Montmartre into the southern parts of the 9th arrondissement. By that point it was just a few steps westwards to the gentle incline of rue Saint Georges where Marguerite Durand set up *La Fronde* at No. 14.[32]

The rue Montmartre did not feel the crunch of Haussmann's wrecking ball. Buildings were designed—or redeveloped—to house all the key activities in the production of a newspaper: the writing and editing of journals, administration, and printing—this last activity, employing some thirty thousand people in 1896 (although not only in newspaper production), represented some 10 per cent of the industrial workers inside the capital.[33] The pressure of deadlines, layout, typesetting, and production encouraged the creation of a special type of building that, while presenting a confident, decorative face to the world outside, was actually an innovative, industrious combination directed towards the creation, management, and manufacturing of the end product.

All that remained was distribution. Within Paris this was carried out by a small army of boys acting as street-criers; street-vendors (*camelots*); news kiosks along the boulevards; bill stickers putting up posters screaming the headlines in the next explosive issue; and sandwich-board men displaying advertisements proclaiming the day's content, spreading the word across the city. At the public halls and bookshops on the ground floor of some of these buildings, people could gather to read the daily news, and, with the expansion of the illustrated press, to see for themselves the original images from the latest issue, including sketches, lithographs, and photography.[34] In one publicity stunt in September 1909, the owner of *Le Matin* bought the aeroplane from the first cross-Channel flight by Louis Blériot and had it hung from the first floor of the newspaper's premises over the boulevard Poissonnière before donating it to the Conservatoire national des arts et métiers (where the aircraft can still be seen), so that 'all Parisians [could] admire the latest manifestation of the genius of mankind'.[35]

Journalistic life shaped both the economic and the social character of the neighbourhood. The area was not just alive with writers, editors, and printers, but also with manufacturers and suppliers of ink, poster artists and draughtsmen, typeface producers, stationers, messengers, bicycle couriers, and delivery and distribution drivers.

And the pressures of deadlines meant that most journalists chose to live close to their offices, so that one historian of the modern Parisian press has calculated that around 1910 some two to three thousand of the people who flooded every day along the rue Montmartre and its surrounding streets were newspaper writers. Marguerite Durand's *Fronde* was all the more impressive because elsewhere the life of the press, including the sociability that surrounded it, was predominantly masculine, owing to the combination of, on the one hand, the late-night cycles of editing and production, and, on the other hand, the expectations of the day that women would look after the home. The theatres that studded the nearby boulevards enjoyed close relationships with the press, which reviewed their productions. Particular cafés, such as the Café Tortoni and the Café des Anglais on the boulevard des Italiens, drew the crème de la crème of the editorial staff and writers of particular newspapers, while the cheaper, bustling bistros and brasseries, such as the (still extant) Bouillon Chartier, just off the Grands Boulevards on the rue du Faubourg Montmartre, with its affordable and hearty fare, attracted office workers of all kinds, but particularly those associated with the newspaper industry, who indulged in what the French historian Patrick Eveno wittily calls a 'gastronomic sociability', driven by the relatively high earnings of workers in the printing trade compared with others.[36]

By the summer of 1898, the Dreyfusards were reeling from the successive blows of Esterhazy's acquittal, Zola's conviction for libel and flight into exile (which we will see in the next chapter), and the devastating elections of May that same year. Among those who lost their seats was Jean Jaurès, who had gone on the stump in his southern home of the Tarn, speaking to farmers, declaiming while standing atop barrels and haycarts, and mobilising the glass workers and miners of Carmaux. It availed him little. His interventions in the Dreyfus Affair allowed his opponents to paint him as someone who was in thrall to Jews and Freemasons and who wanted (as one peasant challenged him) 'to throw down the churches' ('And what, my friend, would I do with so many stones?' retorted Jaurès, who was no bigot).[37]

More widely, the scandal scarcely figured in the ballot, because, as the historian Robert Gildea has bluntly put it, 'to mention it was electoral suicide': that is, suicide for the Dreyfusards.[38] Travelling back to Paris, Jaurès had found that other Dreyfusard Socialists and Radicals had fared little better amidst electoral victories for a vocal minority of authoritarian, anti-Dreyfusard nationalists. As this group of far-right wreckers took their seats for the first time, they shouted raucously, 'Down with the Jews!' But this defeat was no landslide: in fact, the republican centre held, and the government would emerge from an uneasy alliance of Radicals and moderate ('Opportunist') republicans.

Even so, in July a parliamentary vote once again overwhelmingly endorsed the 'evidence' against Dreyfus after the unsuspecting minister of war, Godefroy Cavaignac, rested the government's case on the false evidence furnished by Lieutenant-Colonel Hubert-Joseph Henry to roars of approval from all sides of the Chamber. At least Cavaignac, if misled, had also hung Esterhazy out to dry as well, promising to ensure his punishment. A marked man, the commandant fled, first to Belgium and then to Britain, where he would die in 1923: he is buried in Saint Nicholas's churchyard in Harpenden, near Luton.

Yet just when the Dreyfusards' fortunes seemed to be at their lowest ebb, the tide began, almost imperceptibly at first, to turn. After the vote, Mathieu Dreyfus and Lucien Herr had gathered, stunned, in the socialist (and future prime minister) Léon Blum's apartment, 'with our heads in our hands . . . silent, immobile'. Just then, the doorbell began to ring incessantly. It was Jaurès, excited and smiling. Revision of the Dreyfus case, he proclaimed triumphantly, was now inevitable. Reacting to their uncomprehending looks, he took apart Cavaignac's speech: In presenting Henry's 'new' evidence, he had publicly confirmed the existence of secret documents that had been used illegally to convict Dreyfus. He had abandoned Esterhazy, which was almost as good as an admission of his guilt, and, moreover, in effect conceded that the documents upon which he had rested his claims were in fact forgeries. Jaurès was ecstatic: 'They are idiotic forgeries,

manufactured to cover others. . . . [T]he forgers have come out of their hole, and we have them by the throat.'[39]

A short distance south from where Zola had submitted his copy of 'J'Accuse . . . !' to *L'Aurore*—on the south-western corner of the junction where the rue Montmartre diagonally crosses the hurtling traffic on the rue Réaumur—were the offices of the socialist newspaper *La Petite République*. Here, the democratic socialist Alexandre Millerand offered Jaurès the chance to write the daily political editorial, giving him the means of continuing to fight the war of words that was the Dreyfus Affair.

Jaurès now watched the parliamentary debates from the gallery reserved for former deputies and spent his mornings reading in the library of the École normale before strolling across the river to his new office on the corner of rue Montmartre to take up the daunting challenge of convincing his readers. With some rare exceptions, until 1898 most socialists agreed with the vast majority of other French people that Dreyfus was purely and simply guilty as charged. *La Petite République* itself had not been above expressing the common socialist trope that rated wealthy Jews, along with all other capitalists, as exploiters of the working class.[40]

The paper had begun to shift its position in early 1898, with an editorial on 13 January—the very day that 'J'Accuse . . . !' was published—protesting 'in the name of the *Patrie* exploited by the bandits of patriotism' against 'the violation of the fundamental right of everyone to a defence when he is accused', but concluded, fatalistically, that this was just another sad episode in the annals of militarism.[41] Five days later, the paper accused leading Dreyfusards, including Scheurer-Kestner, of hypocrisy because they had voted for the 1893 *lois scélérates*: 'Because of your past, you are stripped of your right to speak in the name of humanity and justice.'[42] Socialists would make no common cause in the defence of a wealthy army officer with bourgeois politicians who upheld their class interests through repression. The following day, the socialist deputies in parliament issued a manifesto detailing their position on the affair: while admitting that

an injustice had been committed, they could not urge workers to join with the bourgeois Dreyfusards in their campaign, for to do so would be to digress from the greater battle, that between the classes in the struggle for socialism: 'Proletarians, do not enlist in any of the clans engaged in this bourgeois civil war.'[43]

Among the signatories was Jaurès, then still a deputy, even though, the day after 'J'Accuse . . . !', he had erupted in his first major parliamentary intervention on the question, seeing in the machinations of the army, the government, and the Right an assault on the Republic under the guise of patriotism. Why he signed the manifesto is unclear—it was possible that he merely sought to ensure the parliamentary unity of the socialist membership, or, as his biographer Harvey Goldberg suggests, that he saw in a reference to injustice within the manifesto tacit approval for his campaign in the Dreyfus Affair.[44]

So when Jaurès first entered the building of the *Petite République*, his task was to convince other socialists that the fight for Dreyfus was indeed part of the greater social struggle. On 9 August, Jaurès picked up his pen in his office and wrote a heading across a large sheet of paper: 'Les Preuves' (The Evidence).[45] The very next day, the same words were printed as a banner headline across the front page. The article read, 'Dreyfus himself, wrongfully and criminally condemned by the very society that we are fighting against, has, whatever his origins, become . . . a bitter protest against the social order. Thanks to the society that insists on subjecting him to violence, lies and crime, he has become an agent of Revolution.'[46] It was the start of a relentless, often forensic, demolition of the falsehoods promoted by the anti-Dreyfusards. From mid-August to early September, Jaurès's ruthless analysis poured forth from the building on the corner of rue Montmartre. He did not spare the *bordereau*, the work of the experts who confirmed the army's alleged evidence, Esterhazy, or the other dubious documents, including the *faux Henry*, presented by Lieutenant-Colonel Henry two years after the conviction.[47] Jaurès's logic was brutal, concluding that the evidence used against Dreyfus either could not be attributed to him, like the *bordereau*, or was legally

void, too absurd and convenient for Jaurès to swallow, including the *faux Henry*, which he divined was in fact a forgery.[48]

Jaurès was not the only Dreyfusard journalist to rail against the government and the army: Yves Guyot at *Le Siècle* and Clemenceau at *L'Aurore* did as well. Nor was Jaurès the only person, let alone the first, to see the forgery for what it was. Lieutenant-Colonel Georges Picquart was already paying for his own commitment to the truth: arrested on 13 July, he had been sent to La Santé prison for revealing military secrets. Meanwhile, *La Fronde* had already planted its flag early: in December 1897, Marguerite Durand had rebuffed the anti-Dreyfusard writer using the pseudonym 'Gyp' (Sybille Riquetti de Mirabeau) after she had offered to write antisemitic 'sketches' in her own 'humourous' style: this was a newspaper that, after all, carried across its banner not only the Gregorian, but also the French Revolutionary, Jewish, Orthodox, and Protestant calendars (this last the Bible reading for the day). In the brief polemical spat that followed, Durand explained that *La Fronde* 'dreams of the union of all women, regardless of religion or race'.[49] For Maria Pognon, one of the paper's writers, the denial of the rights of one French citizen was a danger to all: for this reason, the cause of Dreyfus was also the cause of all Frenchwomen. It was in this spirit that *La Fronde* took up the cause of 'the innocent who languishes on an islet'.[50] For this, the newspaper would be savaged by the anti-Dreyfusard press: *La Croix*, the paper published by the Assumptionist Order, selling itself as 'the most anti-Jewish Catholic journal in France', would soon declare that 'the first feminist newspaper in France has fallen straight into the nets of the Jews and free-thinkers'.[51] Out, too, came the old tropes about women's incapacity to reason. One anti-Dreyfusard journalist wrote bitterly, 'Unfortunately for them, our pretty colleagues have not been able to examine the facts of the case coolly; they have disdained basing their convictions on reason. It seems clear that they have only listened to their emotions, their hearts, which are so easily led by appearances, and they have all been dragooned into the regiment led by Zola.'[52]

Yet Cavaignac had begun to worry about the new Dreyfusard momentum and ordered his own investigation into the documents, which confirmed on 13 August that the letter triumphantly produced by Henry was fake.[53] The war minister had expected that his investigation would vindicate his anti-Dreyfusard position, but it was Picquart who was proven right. Jaurès had brought no new evidence to the debate, but in mustering and analysing much that was publicly available, he had shown that revision was virtually inevitable.

For Lieutenant-Colonel Henry, the results were tragic. Summoned by Cavaignac to the war ministry to explain himself on 30 August, he was interrogated in the presence of the squirming generals Gonse and Boisdeffre. After initially throwing up a wall of denial, Henry crumbled under pressure and confessed. Arrested, he was sent to Mont-Valérien, the military prison in Suresnes in the western outskirts of Paris. The next day, in the brutally stifling heat of his cell, he slashed his own throat with a razor and died as the mattress on his bed soaked up his blood.

On 1 September, before the suicide had been made public, *La Petite République* published the bulletin from the Havas agency announcing Henry's arrest. Beneath it, Jaurès forged ahead with his work of demonstrating the complicity of the General Staff in the forgery and the cover-up of the truth. The next day, 2 September, the newspaper reported Henry's death alongside the resignation of the now publicly shamed Boisdeffre.[54] Gonse's career was in tatters, and du Paty de Clam's reputation in shreds. When Henry was laid to rest in his home village, neither Gonse nor Boisdeffre—for whose cause he had effectively sacrificed himself—bothered to show up.[55] On 3 September, Cavaignac resigned as minister of war, and Lucie Dreyfus formally applied for a review of her husband's case. The government, trying to extricate itself from the political quagmire, set the proceedings for an appeal in motion, but soon fell anyway. The wheels of justice turned slowly but inevitably, and on 29 October, the court of appeals (Cour de cassation) accepted Lucie's petition to hear her husband's case.

The unfolding drama of these months sent the atmosphere of the press district around the rue Montmartre into a fever pitch, all the more so because the Dreyfusards' opponents were right next door. No. 142, home of *L'Aurore*, and No. 144, the offices of *L'Intransigeant*, are two addresses in the same block of buildings that tell such a story of bitter journalistic rivalry during the Dreyfus Affair. At the height of Zola's trial for libel, on 15 February, a police report, which appears to be based on inside knowledge of the workings of *L'Aurore*, suggested that the editor, Ernest Vaughan, had a particular hatred for the anti-Dreyfusard Henri Rochefort, editor of *L'Intransigeant*. According to this possibly exaggerated but certainly detailed account, Vaughan had said that 'he would be delighted if he could deprive [Rochefort] of several thousand readers'. One of his staff, the police agent alleges, had been sent to the Bibliothèque nationale, the national library, to read through back issues of *L'Intransigeant* in order to find Rochefort's older attacks on militarism, courts-martial, and so on—the better, presumably, to imply that his rival's ultra-nationalist support for the army was merely skin deep.[56] If there is any truth in the police report, it begs the question as to why Vaughan was so determined to go after Rochefort and *L'Intransigeant* in particular. It was not just because it was virulently nationalist, antisemitic, and anti-Dreyfusard. Indeed, there were worse examples, such as *Libre parole* just a little to the north, on the boulevard Montmartre, and *La Croix*, the Catholic newspaper produced by the hard-line Assumptionist Order, on the rue François 1er some distance away, amidst the elegance of the 8th arrondissement.

The reason was personal. Although born into an old noble family (his full name was Victor Henri, marquis de Rochefort-Luçay), Rochefort had once been a socialist and republican, as Vaughan still remained, and the two militants had once worked closely together. After abandoning his medical studies, Rochefort had embarked on a career in journalism before taking part in the Paris Commune in 1871, in the aftermath of which he was exiled to New Caledonia in the Pacific. He managed to escape after a few months, making his way first to London and then to Geneva. In 1880, when the French

government declared an amnesty for the former Communards, Rochefort returned to Paris, where he founded a new journal, *L'Intransigeant*. Meanwhile, during the Commune, Ernest Vaughan, who had embraced the socialist (or indeed anarchist) ideas of Pierre-Joseph Proudhon, had been living in Normandy, managing a factory. He was arrested in 1871 for attending an illegal meeting held in sympathy with the Parisian revolutionaries. Sentenced to prison for two years, he took refuge in Belgium, not reappearing in France until the same 1880 amnesty that saw Rochefort's return. Rochefort employed Vaughan as the managing editor of *L'Intransigeant*, but the two comrades soon diverged politically and personally.[57]

Rochefort was a razor-sharp polemicist who originally positioned himself on the radical left. In 1885, he stood for election to the National Assembly on the list of deputies aligned with the revolutionary wing of the socialist movement led by Jules Guesde. Like many former Communards who had experienced the heavy hand of repression in the early 1870s, Rochefort felt an enduring hatred for the bourgeois republic. Yet while most on the left, including Vaughan, were in the end willing to work within parliamentary politics, some, such as Rochefort, aligned themselves with the Third Republic's right-wing opponents—assorted authoritarians, monarchists, Bonapartists, former Boulangists, and nationalists who converged as anti-Dreyfusards. Their common ground was a loathing for the parliamentary system, which Rochefort derided as 'parliamentary filth' while denouncing the Chamber of Deputies as the 'rotten Assembly'.[58]

Rochefort never claimed to have abandoned socialism or republicanism, but he saw in antisemitism a means of mobilising the masses against capitalism. In nationalism and support for the army he saw the way to secure strong leadership for the rejuvenation of the French nation, both against the bourgeois values of the Third Republic and against its enemies abroad. Exiled in London after the Boulanger Affair until amnestied in February 1895, Rochefort was greeted on his return at the Gare du Nord by none other than Jaurès and another reform socialist, René Viviani. But Rochefort's poisoned embrace

of Boulangism had left a gulf too wide to be bridged. Besides their political differences, Rochefort and Vaughan were temperamentally opposites. While Vaughan was once described by Louis Bertrand, a Belgian socialist who knew him from his time in exile, as 'one of the best-natured people I have ever known', Rochefort was fearsome.[59] With a shock of snow-white hair brushed upwards, Rochefort was described by a British acquaintance as 'Rochefort the ferocious', and 'his Luridness': 'Pale, steely blue eyes that lit up cruelly, evilly at times; a face seamed, sallow, horse-like in shape; a harsh, guttural voice; large, yellowish hands with long, pointed finger nails. To ease the huskiness in his throat, Rochefort was for ever sucking lozenges. When he became agitated, he cracked them.'[60]

After a period in Lyon, where he edited a socialist newspaper, Vaughan finally, and acrimoniously, broke with Rochefort, who fired him from *L'Intransigeant* in December 1896. In October 1897 Vaughan established *L'Aurore*, socialists and Radicals among its writers: among the latter was Georges Clemenceau, one of Vaughan's close collaborators and a leading contributor (this was, of course, some time before Clemenceau became *le premier flic de France* in confronting the syndicalists, as we have seen).[61] With the deeply personal breach with Rochefort still raw, it was perhaps unsurprising that Vaughan should see in the Dreyfus Affair an opportunity to inflict damage on the bitterly anti-Dreyfusard *Intransigeant*, the very newspaper on which he had once laboured.

In the close quarters of the press district, the rival editors had a daily, visual reminder of each other's existence, and there was always the chance that they would run into each other on the pavement outside. So the police agent's report on Vaughan's particular hatred for Rochefort has a ring of truth to it, although it also underestimates the sincere commitment of *L'Aurore*'s writers to the Dreyfusard cause. If there was any *Schadenfreude* in Vaughan's words, then he may also have been referring to Rochefort's own legal travails: Just as Zola and *L'Aurore*'s managing editor were on trial, Rochefort himself was facing a charge of libel. In the pages of *L'Intransigeant* he had accused Joseph

Reinach of forging evidence against Esterhazy. Reinach sued for defamation and, on 21 February, Rochefort was sentenced to pay a fine and to five days in prison—a penalty far lighter than those meted out to Zola and to Alexandre Perrenx just two days later. Rochefort himself published the following report in his newspaper, proclaiming, 'For having denounced and foiled the Syndicate of Treason [an epithet for the Dreyfusards around Mathieu, Picquart, Scheurer-Kestner, and others]; for having defended the French *patrie* against cosmopolitan Jewry; Henri Rochefort has been condemned to five days in jail. This monstrous judgment was confirmed this very day. Henri Rochefort will go to the Sainte-Pélagie prison where he will hand himself over at 5 o'clock this evening.'[62] Rochefort also inserted a notice saying that, at 4.30 p.m., he would be on the place Monge (in the 5th arrondissement) to shake the hands of his well-wishers. In the event, a crowd of thousands carried him shoulder-high to the Sainte-Pélagie.[63]

At No. 144, *L'Intransigeant* was on the corner with the narrow rue du Croissant. Just across from No. 144, on the corner opposite, No. 146 is the Café du Croissant. The name of the street does not come from the breakfast pastry, alas, but recalls a shop sign emblazoned with a crescent that hung here when the road was first opened up in 1612.[64] In the nineteenth century it was crammed with journalists, printers, office workers, and vehicles serving newspapers occupying buildings cheek by jowl and one on top of the other, including two anti-Dreyfusard newspapers, *La Presse* and *La Patrie*, which shared premises at No. 12 at the far end to the left, just before the street narrows like the spout of a slender funnel.

This unornamented building poured forth violent, antisemitic, nationalist vitriol. Owned by Jules Jaluzot, proprietor of the Printemps department store, *La Patrie* was especially vehement. During the Dreyfus Affair, he had confided the political editorship of the newspaper to the Boulangist Lucien Millevoye, who was also returned as a Nationalist deputy in the May 1898 elections. On the news of Lieutenant-Colonel Henry's suicide, Millevoye wrote, in an editorial, 'Let us leave those cosmopolitans from Frankfurt to howl

with joy over the tomb of that modest child of French soil, whose head was not as solid as his heart; let us turn away with disgust from the spectacle of the odious triumph of the worst enemies of the army and of the French fatherland [*patrie*].'[65] For *La Patrie*, Henry's crime of forgery was honourable and disinterested, an attempt to stave off the victory of the 'revisionists' who were no better than traitors. The newspapers of the Dreyfusard 'syndicate' were doing the bidding of Germany: 'Oh dear and great country, are you truly ready to accept that supreme act of decline and agony?' With a nod to the impact of 'J'Accuse . . . !' from the newspaper just around the corner, *La Patrie* claimed that 'from the very first, the furious accusations of Zola against the leaders of our army had the sonorous resonance of an appeal to the most violent passions. And since that day, the damage has surged in like a torrent, roared like a tempest. Who has not recognised in this tactic the workings of Bismarckian politics?' It was this 'assault', as Millevoye put it, that Henry had fought against with his forgery.[66]

Other anti-Dreyfusard writers, not least Charles Maurras, painted Henry as a martyr. Maurras was no practising Catholic, but he believed that only a return to the traditions of Church and King would revivify French greatness and purge it of parliamentary corruption. Tellingly, too, he evoked the 'Sacred Heart'—the Sacré Coeur—of Jesus when he connected Henry's 'precious blood' with the suffering 'heart of the nation'.[67] The idea of a 'patriotic forgery' and of Henry's self-sacrifice would provide the basis for the anti-Dreyfusard counterattack. As the socialist journalist Francis de Pressensé wrote scathingly in *L'Aurore*, this was 'so much sophistry spread in the name of *raison d'état* and of *patrie*'.[68]

Edouard Drumont's *Libre parole* was especially active in carrying forward the baton of Henry's martyrdom by using the figure of Berthe, the colonel's widow. It had been Rochefort who, on 2 September, had secured a scoop by interviewing her and presenting her as a dignified, suffering widow. Her personal pain was unquestionably real enough, but she was too good a cause for the anti-Dreyfusards to

ignore. When Joseph Reinach published articles in Yves Guyot's *Siècle* suggesting that Henry had actively conspired with Esterhazy, and Berthe sued for slander, Drumont opened a public subscription for the widow in order to help her with her legal costs: a banner along the balcony of *Libre parole*'s offices, at No. 14 boulevard Montmartre (the building is no longer there—a modern one stands in its place), read, 'For the widow and the orphan of Colonel Henry against the Jew Reinach.'[69] Before the subscription closed, on 15 January 1899, it had attracted twenty-five thousand donors, many of whom wrote messages that were then published in the newspaper. They expressed the full range of antisemitic impulses: as a means of explaining away personal failures, as an expression of nationalism, as a condemnation of immigration and a call for expulsion, as a cry of the 'little people' against the rich and the élites and against social change and by appealing to the older religious currents in antisemitism, including appeals to God to rid France of non-Catholics and Jewish agents of the Satanic and the occult.[70] When Reinach's case was adjourned, thanks to the efforts of the barrister Fernand Labori, both Rochefort and Drumont contrasted Berthe—dignified, feminine, vulnerable—with Reinach, 'puffy, swarthy, sweaty, stomach bulging'.[71]

La Libre parole published the names of donors to Berthe Henry's fund, along with their comments, in a series of lists between 14 December 1898 and 15 January 1899.[72] A few days after the first list appeared, *L'Aurore* printed an editorial which went full-out against all the Dreyfusard targets: nationalism, antisemitism, militarism, authoritarianism, and clericalism. Looking ahead to the still distant moment of the 'definitive victory of truth over lies and liberty over oppression', the paper warned that there could be no complacency afterwards: 'If we do not want the reaction, momentarily muzzled, bloated with today's hatreds and rages, to destroy the last of our freedom, there can be no reconciliation, no embrace, until our institutions are in perfect harmony with our democracy, before clericalism and militarism have been prevented from doing harm for a very long time.'[73]

The enemy that lurked behind everything was clericalism—the insidious influence of the Catholic clergy that kept people in ignorance and prepared them for obedience to the military and for authoritarianism. The proof, for *L'Aurore*, lay in the history of the Third Republic itself:

Clericalism is not just satisfied with keeping people in terror of the supernatural and of life beyond by stories that lull you to sleep: *it aspires to domination*, it dreams of turning our republic into a theocracy of which it would be intermediary and of brashly emblazoning its motto, '*Thy Kingdom Come!*' . . . The army of Versailles prepared the ground for the consecration of France to the Sacred Viscera [a mocking reference to the Sacré Coeur] with the blood of Parisians; MacMahon's loyal sword protected the 16th of May; Boulanger carried the hopes of the Jesuits in his overnight bag; today we can see that the clericals have manifestly corrupted the minds of our top commanders; how could they not be the soul of nationalism?[74]

L'Aurore put its finger on the sinisterly modern impulses behind the new forms of antisemitism, but in doing so it also fell back on another antisemitic trope, this one found on the socialist left: the Jew as capitalist. It further explained antisemitism by the desire of the clericals to dominate banking and finance, but being prevented from doing so because 'they struck against the great [i.e., wealthy and powerful] Jews'.[75] The deployment of one antisemitic theme—the Jew-as-capitalist—in the process of combatting antisemitism in general highlights the swirling, ideological confusion of the age in general and in antisemitism in particular, a dark impulse to which the Left was itself far from being immune. Moreover, the detailed 'exposé' of the 'good apostles of clerico-nationalism' in *L'Aurore* showed that, if the anti-Dreyfusards saw the influence of the Jewish-led 'Syndicate' behind every Dreyfusard manoeuvre, so the Dreyfusards could be

equally prone to seeing a clerical conspiracy behind the actions of their adversaries.

CENTRAL THOUGH THE press was to the Dreyfus Affair, its partisan nature meant that it probably did less to *shape* opinion on either side of the debate than, on a day-by-day basis, to conduct its already convinced readership towards certain targets, to reassure them about their preconceptions, and to equip them with arguments. That the press was highly influential, but not in itself decisive, in the outcome of the affair is suggested by the contrasting circulation numbers of the anti-Dreyfusard and Dreyfusard press. According to the figures of historian Janine Ponty, the Dreyfusard titles accounted for eight out of fifty-five dailies published in France, seven of them in Paris. Since all of those except *La Petite République* had small circulations—numbering in the low tens of thousands—in 1898 their readers may have accounted for only 8 per cent of all French newspaper readers, so they were easily outnumbered by the anti-Dreyfusards. The position looked better in 1899, as other newspapers swung over as the affair developed: the Dreyfusard titles numbered eleven dailies in Paris and seventeen across France, representing, respectively, 11 per cent and 15 per cent of all readers. And these figures do not count those newspapers that, while not committed to a Dreyfusard position, were won over more moderately to revision out of a desire to uphold political stability and the integrity of France's legal institutions.[76] Formal readership figures certainly obscure the true circulation of any given newspaper, because each copy of each journal usually had more than one reader, since newspapers were shared and passed on. Even so, they show that, if the affair had been determined solely by headlines and column inches, Captain Dreyfus would have spent the rest of his days wasting away in the tropical furnace of Devil's Island.

There were certainly exceptional moments when a newspaper did have an impact on opinion: 'J'Accuse . . . !' may have been one

of those, when *L'Aurore*'s circulation momentarily mushroomed from twenty-five thousand to three hundred thousand before falling back, and then, in 1899, declining to fifteen thousand. Another was when, under the impact of Jaurès's pen in the autumn of 1898, Millerand's *Petite République* became one of the leading Dreyfusard journals, yet it was able to achieve this because it did so within the ideological framework of socialism. The conversion took place because Jaurès and others on the journal were able to argue that the struggle to revise Dreyfus's case was part of the greater socialist struggle against injustice and oppression. According to this logic, the *Petite République* did not need to challenge the core socialist assumptions or class-based sense of identity of its readers in order to nudge them into campaigning actively for Dreyfus's freedom. Moreover, in taking this position they did the newspaper no harm—quite the opposite: its circulation grew from around twenty-five thousand to one hundred thousand and, compared to *L'Aurore*'s short-lived success with Zola's bombshell, this expansion proved to be more resilient, making *La Petite République* the largest Dreyfusard newspaper by far.[77] This suggests that, by appealing to the consistency of the socialist class struggle, Jaurès's series of articles had convinced his readers, although, of course, quite *how* readers responded and why is uncertain.

One of the other rare newspapers that might have influenced its readership was, importantly, *Le Temps*, the establishment broadsheet that had its headquarters at the suitably patrician No. 5 boulevard des Italiens. Mainstream and respectable, *Le Temps* began—as almost all the media did—by accepting the verdict against Dreyfus, and it continued to do so into 1898, when its editorial line was slowly convinced by the facts as they began to emerge. By the autumn, it supported revising the judgment, and a year later, it assumed a committed Dreyfusard position. *Le Temps* may have been, as Pierre Albert, historian of the press in this period, has put it, 'serious to the point of boredom', but its influence went far beyond its modest circulation (between thirty thousand and thirty-five thousand in this period). It spoke with authority on foreign affairs, finance, and parliamentary politics—in

the 1890s, it produced a shortened evening edition to report on the day's unfolding events. It was the sort of newspaper that was read by other journalists, politicians, and financiers, and so could shape the opinions of policymakers: its command of diplomatic news gave it a reach in France, and indeed in Europe, that only its British namesake, the *London Times*, could rival.[78] Thus its migration towards the Dreyfusard position was politically important, and showed that not all the press was consumed by the partisan battle of positions in the Dreyfus Affair. What it missed in fireworks it gained in cutting critically and analytically through the sound, the fury, and what today would be called 'alternative facts' and 'fake news'.

Most newspapers, however, seemed to have tried to reflect their readers' preconceived ideas and positions, articulating them by identifying enemies, explaining away awkward turns of events (hence Henry's 'patriotic' forgery), and giving them arguments to defend their views. It is safe to assume that when the toxic *Libre parole* launched its campaign on behalf of Berthe Henry in December 1898, it was not *converting* people to antisemitism, but rather providing a channel through which antisemites across France could express their already deeply entrenched views—many of them anonymously—and see them in print. And when *Le Figaro* (which had its offices on rue Drouot, off the Grands Boulevards) saw its circulation numbers fall because of Zola's earlier interventions in the Dreyfus Affair in 1897, it stopped publishing his articles (his last one for the paper was on 17 December). This was why he had approached *L'Aurore* with 'J'Accuse . . . !' in January.[79] In the end, *Le Figaro* underwent an evolution in its position similar to that of *Le Temps*, reflecting perhaps the shift in opinion among its respectable, moderately conservative readership. In the highly competitive world of newspaper publishing, where competition for readers was brutal, papers seeking to challenge their readers' positions, rather than merely shaping or channelling their already held views, were taking a big risk: Marguerite Durand understood this when she brought *La Fronde* firmly down on the side of Dreyfus—not least because a newly published newspaper could not afford to lose

readers.[80] Belle Époque politicians and activists with particular agendas could all too easily take advantage of mass media's broad reach to arouse fears and prejudices and to evoke old grievances in order to garner support, rather than to lead opinion by challenging its preconceptions and disabusing it of misinformation. It may be all too easy to condemn the 'ignorant' who allow themselves to be misled by politicians and by 'news' that was less than honest or downright manipulative. What times such as the Dreyfus Affair show is that when so much—right up to the future shape and direction of a country—is at stake, then navigating the cascade of opinion, the arguments based on skewing the evidence, the denial of facts, the appeal to a greater, patriotic 'cause' to justify injustice or indeed 'limited' breaches of laws, makes it hard for people—unless they have the inclination and time to do their own research—to know what to believe and which sources to trust. In such circumstances, it is easier to fall back on one's own ideological position or prejudices as a means of making sense of the bewildering swirl of debate and polemic, to dismiss reliable sources of knowledge as 'just another opinion', or simply to proclaim that people have had enough of experts. In this sense, the Dreyfus Affair presaged by more than a century the challenge of news in an age of the internet and social media.

Yet while the public confusion in the fog conjured up by the lies and misinformation is understandable, the Dreyfus Affair also shows that, in an age of modern, mass politics, there are plenty of people who are comfortable with their prejudices and are *willing* to accept the lies as the truth. Within that alternative reality they are enabled to openly express their fears, hatreds, and preconceptions, which are then also confirmed and validated. In these circumstances, too, opinion becomes so divided that there is no agreement over the basic facts of the issues at stake, so there can be no scope for honest disagreement—the idea, as the Scottish Enlightenment philosopher David Hume put it, that 'truth springs from argument amongst friends'—but merely a screaming match in which the different sides shout at each other from their own entrenched positions, demonise

each other, and, ultimately, make consensus difficult if not impossible to rebuild. This can be dangerous for democracies, because the subsequent political paralysis can leave an opening for populists and authoritarians to promise seductively simple solutions to the challenges of 'healing' division and 'restoring' national unity and strength.

More deeply, then, the Dreyfus Affair offers a lesson in the importance of critical, independent thinking. This is what *L'Aurore* meant on 17 December 1898 in an editorial entitled 'La Résistance': 'It is for citizens to inform themselves, to think, to use their will; it is for them to reform their morals, to no longer let themselves be taken for fools or as things to be juggled with and to emancipate themselves, not by force, but by ideas. We need to "enlighten [our] brains, not slice them open"!'[81] Yet it is not enough to promote intellectual independence and a critical public: the individual citizen has to be equipped and *willing* to use critical judgment, which in turn presupposes a free society in which one has the space not only to think freely, to express that judgment, and to act upon it, but also—as Jaurès saw regarding the working people—the time and leisure to do so.

This is why the diversion of very real social discontent and political anxieties towards targets such as outsiders (Germans, immigrants, international institutions, global finance, and so on), or 'enemies' within (judges, Jews, 'cosmopolitans', metropolitan élites, parliamentarians), was so very dangerous in the Dreyfus Affair and remains so, in different contexts and in different ways, today. In clouding the citizens' judgment by identifying other people or groups as the cause of their woes, they are diverted from attending to the *actual*, deeper, structural problems within politics and society that underlie their anxieties and that helped to stoke their hatreds in the first place. This is the essence of populism, and of national populism in particular. The problem with misdirecting people's anger is that the solutions offered by populists, which are often xenophobic and authoritarian, would in practice do little or nothing to address the underlying social and economic challenges at hand and may even aggravate them—and so the cycle of denial and blame continues.

While much of this came to pass in France before 1914 and after, it took an enemy invasion and occupation in 1940 to bring down the parliamentary democracy. But the legacy of the Dreyfus Affair ran deep—and still sometimes effervesces to the surface of French cultural and political life. It deepened and sharpened the old divisions between those who accepted '1789' and those who did not as the source of the founding principles of French political life and identity. As we shall see, this would be most evident in the years immediately afterwards, when, on the one hand, the triumphant republicans launched a rigorous and aggressive campaign to push clerical influence out of French public life for good, culminating in the separation of Church and State in 1905, and when, on the other hand, the affair crystallised new political alignments that had already been taking shape in the Boulanger Affair, especially the emergence of a new right-wing politics that combined older appeals to authority, tradition, national strength, antisemitism, and xenophobia with the promise of social reform and national unity, a populist, authoritarian fusion that in the twentieth century would plot a course towards fascism and Vichy collaborationism. In this development lies one of the dark faces of Belle Époque modernity. Interconnected with this aspect of modernity was the role of the militant, Belle Époque crowd. This was yet another source of anxiety for contemporaries, not least because it was prone to direct manipulation by some of the same media that engaged in the polemics of the Dreyfus Affair. It is to this that we now turn in the next chapter—and the occasion was the trial of Émile Zola.

CHAPTER 9

HATE

Cross the Pont-Neuf to the Île de la Cité and where the island in the Seine narrows towards its western tip you will see the statue of the 'good king' Henri IV. From the saddle of his mount, he gazes at the entrance of the place Dauphine, designed on his orders in the early seventeenth century and named for his son, the future Louis XIII (the 'Dauphin', heir to the throne). The opening to this beautiful, triangular space, today with its canopy of trees and its benches, passes between two houses from that time, strikingly built in the combination of brick and stone that can be found in other Parisian developments commissioned by Henri IV, especially the place Royale (now the place des Vosges) in the 4th arrondissement.

The king originally intended the square to house diplomats, lawyers, and officials, and to this day it retains its connections with the law. At its far eastern side, where the rue de Harlay defines its eastern boundary, there stand, somewhat incongruously, the lawcourts. The Palais de Justice here displays the colonnaded frontage of its

forbiddingly massive west wing, with Napoleon III's imperial eagles perched high above the street at either end. Even so, the place Dauphine today is a peaceful, almost idyllic spot, a surprisingly quiet refuge in the very heart of the city, tranquil beneath its canopy of trees, with the occasional shop and café trading almost discreetly, as if not to intrude on the stillness. Yet it has a hidden, Belle Époque history. Between 7 and 23 February 1898, the place Dauphine was anything but an oasis of calm.

During those sixteen days, boisterous, aggressive crowds, which sometimes included thugs armed with leaded walking sticks, gathered in the square and in the streets around the Palais de Justice, pressing up against a cordon of police and sometimes managing to overwhelm the forces of order. The demonstrators hurled abuse and shouts of 'Death to the Jews!' 'Death to the traitors!' 'Drown the kikes!' 'Long live the army!' and 'Down with Zola!'[1]

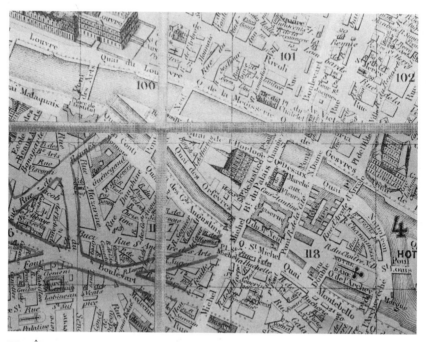

The Île de la Cité, showing the Palais de Justice, where Zola's trial was held. The triangular space of the place Dauphine, where threatening crowds gathered, lies to the north-west of the lawcourts, across the rue de Harlay.

Inside the Palais de Justice, Émile Zola was being tried for defamation—a case brought at the instigation of the War Ministry, for it was the army that the writer had allegedly maligned when he wrote 'J'Accuse . . . !' The venomous demonstrations of the crowds tell us much about the wider crisis of which Zola's trial was a part, namely the Dreyfus Affair. More broadly still, the nature of the crowd, its behaviour, and the police response expose the deeper anxieties and contradictions of Belle Époque modernity.

IN PUBLISHING 'J'ACCUSE . . . !' in *L'Aurore* on 13 January 1898, Zola intended to shift opinion in favour of reopening the case of Alfred Dreyfus. Yet he and the other Dreyfusards got more than they hoped for when antisemitic riots swept through towns across France and in France's colony of Algeria. In Paris, Jewish shops had their windows smashed. In the Latin Quarter, students went out into the streets chanting slogans against Zola, who had already earned their hatred after he had written a pamphlet reprimanding them for demonstrating against Senator Auguste Scheurer-Kestner's efforts to have the Dreyfus case revised. To the north, an effigy of Mathieu Dreyfus was burned on place Blanche—right in front of the Moulin Rouge—by a group of artists, watched by workers from the neighbourhood, so proving that politics in 'Bohemian Paris' were not necessarily progressive.[2]

On 17 January, posters were stuck up across the city calling for an 'anti-Dreyfusard' movement—and people flocked to join. That same day, a nationalist rally at the Tivoli Vaux-Hall, a huge auditorium on rue de la Douane (now rue Léon Jouhaux) in the 10th arrondissement, gathered eight thousand nationalists to hear speeches from, among others, Jules Guérin of the especially nasty Ligue antisémitique (Antisemitic League). The meeting was invaded by anarchists while police, some on horseback, tried in vain to stop the violence. After the meeting dispersed, the fighting only intensified, with battles all the way down boulevard Richard Lenoir to the Bastille. Some

groups of nationalists filtered through the narrow (and today pictur-esque) streets of the nearby Marais, stoning and smashing the win-dows of Jewish homes and shops on the rue des Rosiers in the heart of the *Pletzl*, the community of poorer, immigrant Jews from eastern Europe.[3]

The violence of the crowd, aroused by leaders who stoked their prejudices, stirred deep concerns about modernity among some of the participants in the Dreyfus Affair. For if the press response demonstrates how the competing polemics and ideological positions were articulated, the actions of the crowds clustering on the place Dauphine and jostling with the police in the nearby streets tell us much more about how the fissures and frictions within France, divi-sions and conflicts that had long and deep currents, threatened to unleash the raw violence that had so often afflicted French society over the course of the previous century.

Zola had written 'J'Accuse . . . !' explicitly in the knowledge that he would be prosecuted under the press law of 29 July 1881, which allowed the alleged target of defamation to open proceedings. While the government would rather have just let the furore die down over time, it was also under political pressure to defend the 'honour of the army' in the uproar provoked by Zola's intervention. The moderate ('Opportunist') republican prime minister Jules Méline yielded and promised to take action.

The Council of Ministers met on 18 January and agreed that the War Ministry should issue a formal complaint against Zola. The writ against the author and against Alexandre Perrenx, managing editor of *L'Aurore*, was issued on 20 January, homing in on Zola's claim that Esterhazy had been acquitted 'under pressure' from the General Staff. The aim was to narrow the focus of the trial to keep the case of Dreyfus himself out of it. That proved to be impossible in practice. In virtually inviting prosecution, Zola knew that he would have the chance to air the Dreyfus Affair in a civilian court of jus-tice for the first time. Zola's defence would provide the opportunity to bring forward evidence of Dreyfus's innocence and Esterhazy's

guilt—and to expose the behaviour of those who had sent an inno-
cent man to Devil's Island.[4]

The trial, which ran for two weeks between 7 and 23 February,
was the stuff of courtroom drama. Zola's brilliant barrister, Fernand
Labori, mounted a defense that was both ruthlessly logical and emo-
tive, while the brothers Georges and Albert Clemenceau—the former,
of course, also on the editorial staff of *L'Aurore*—strenuously wielded
their own flights of rhetoric in defense of Perrenx.

From the start, the tribunal's president, Judge Albert Dele-
gorgue, tried to confine the arguments to the precise charge of def-
amation. Labori's efforts to bring in the Dreyfus Affair itself were
consistently rebuffed with a curt response: 'The question will not
be put.'[5] Yet Zola's situation was so entwined with the Dreyfus and
Esterhazy cases that it was impossible to seal them off from each
other. Lucie Dreyfus—dignified in her widow's black—was asked
by Labori to testify to Zola's good faith, which was the first ques-
tion put out of bounds by the president. One after the other, the
officers involved—Charles de Boisdeffre, Arthur Gonse, Auguste
Mercier—testified to the certainty of Dreyfus's guilt, but resisted
questions about the secret dossier that had convicted him, frequently
retreating behind national security as the reason. Armand Mer-
cier du Paty de Clam provoked mockery in the courtroom when he
inadvertently became a parody of the robotic soldier, marching to
take the stand, clicking his heels, and stiffly saluting. After refusing
to answer most of the questions, he paraded out in the same exag-
gerated 'military' style—the stenographic report recorded 'general
hilarity'.[6]

Lieutenant-Colonel Hubert-Joseph Henry, robust, ruddy, and, he
claimed, afflicted with fever, gave mostly terse answers to questions
before he was rescued by Gonse, who successfully appealed to the
president to dismiss him owing to his illness. Picquart was accused
of trying to falsify the *petit bleu* to make it look as if it had been inter-
cepted in the post. When Picquart spoke, he did so at length, coolly
explaining his actions and how he had reached his conclusions about

Esterhazy, earning a long bout of applause from some of the more sympathetic lawyers and members of the public when he had finished. Henry, recalled to the stand, provoked uproar when he accused Picquart of lying and then confronted him directly in open court—his beefy frame blocking the jury's view of the witness—at which Picquart briefly lost his impressive composure. In a flash of anger, he nonetheless underscored his devotion to the army (from which he was about to be suspended for allegedly revealing secrets) with the words, 'I thought there was a better way of defending a cause than by imprisoning oneself within an unjustified blind faith.'[7]

Labori forensically and sarcastically took apart the testimony of Alphonse Bertillon, one of the witnesses who, though not an expert, had identified the handwriting on the *bordereau* as that of Dreyfus, until Bertillon started refusing to answer any questions related to the Dreyfus case. Labori finished by dismissing him with contemptuously devastating lines: 'I can only say one thing to the jury: there's the accusation of 1894! . . . [T]here was one charge: the *bordereau*; and there is the expert, there is the leading expert!'[8]

The decisive moment against Zola came with the cross-examination of General Georges de Pellieux, who had been in charge of the army's whitewashing of Esterhazy. He testified that Esterhazy could not have had sight of the information listed in the *bordereau*. Picquart was brought back and convincingly refuted this claim. The following day, however, Pellieux returned to the fray and with a flourish quoted directly from Henry's forged note. While this apparently decisive triumph was met with applause, it was a blunder, and Labori seized on it. Pellieux almost certainly did not know that the *faux Henry* was just that—a forgery—but Labori insisted that the note be presented to the court, thus opening it to public scrutiny for the first time. 'There is no document, of whatever kind,' he said, 'that has any value and that can be reasonably considered to be proof until it has been debated by both sides.'[9]

Boisdeffre—who knew by now that the document was fake—moved quickly to head off this line of attack, which would have

subjected the falsified evidence to close examination. Resting his testimony on his public respect and authority, he confirmed all of Pellieux's testimony, but added, 'I have nothing else to say: I do not have the right; I repeat, members of jury, I do not have the right.' Boisdeffre strongly implied that providing actual material proof would mean revealing sensitive intelligence information and endangering national security, and even possibly provoking war with Germany. The president refused Labori the right to question the general.[10]

Together, Pellieux and Boisdeffre's testimony made a deep impression—and without any chance for the defence to examine the evidence that they had cited, it would be hard for Labori and the Clemenceaus to reverse the tide of the trial. When it was Esterhazy's turn to be cross-examined, he stubbornly refused to answer the defence's questions—to applause and roars of approval from the public spectators.

On 23 February both Zola and Perrenx were found guilty by the jury, which conferred for a mere thirty-five minutes. Perrenx was sentenced to four months in prison and a fine of 3,000 francs, while Zola was given one year of imprisonment and the same fine.[11] Inside the courtroom, there were elated shouts of 'Death to Zola! Death to the Jews! Long live the army!' Zola's response—'They are cannibals!'—was recorded by the court stenographer. He had to be escorted from the Palais de Justice behind a protective wall of his friends and legal team. 'Never had a political trial so cynically shown Force prevail over Law. It was a shame and a scandal,' wrote a furious Séverine in *La Fronde*. 'Generals issued threats, rioters howled, the jurors, seized with fear or abused, rendered their extorted verdict. What has that to do with justice?'[12] The hatred of the crowd was such that Georges Clemenceau later commented that, had Zola been acquitted, 'not one of us would have come out alive'.[13]

This was no hyperbole. Fear of mob violence, in fact, led the authorities to watch not only the trial itself but also the aggressive behaviour of the gatherings outside with considerable anxiety. The level of danger ebbed and flowed with the rhythm of the trial

itself. At different points in time, police agents reporting to the Sûreté générale surveyed the crowds and offered assessments as to the possibility of violence. These messages were sent to the Sûreté two or three times a day, offering updates on the behaviour and level of threat the crowds presented. Most of them were submitted as *petits bleus*, the messages sent through the subterranean pneumatic post, at frequent intervals. Often written in a hurried hand and squeezed onto these small pieces of lightweight, folded blue telegram paper, the messages seem to show that the agents had neither the time nor the space to embellish very much. Although police reports in any historical period are notorious for their unreliability, in this case the immediacy and the rawness of the reporting give it a ring of authenticity. And a closer reading shows that the turbulence on and around the place Dauphine arose not just from the Dreyfus Affair, but also from deeper, long-running currents that threatened to tear Belle Époque France apart.

A report written at 3.40 p.m. on 12 February, the sixth day of the trial, was typical:

The crowd is beginning to invade the surroundings of the Palais [de Justice], it is very agitated (*enervée*)—groups in workers' clothes mingle with harmless groups. The foot guard has arrived—the horse guard has been summoned. The buildings [Jewish-owned businesses] that I indicated to you in my hastily written [*saccardée*—jerky] letter this morning are being guarded by the police—without <u>exaggeration</u> one has to expect some serious trouble this evening—the friends of Drumont are doing very dismal (*triste*) work. I have the honour to report to you the intelligent arrangements made by Officers of the Peace of the 1st arrondissement.[14]

The agents of the Sûreté were concerned with the measures the police had taken to ensure public order and security and with the

behaviour and composition of the crowds outside the lawcourts. They offered assessments as to the likelihood of trouble and signalled which groups might become dangerous—possibly the workers who had gathered (noticeably compared with 'harmless' people—in other words, those who were not working class), and the antisemitic protesters (the 'friends of [Edouard] Drumont', editor of the *Libre parole*), who appear to have been agitating (their 'very dismal work') among the crowd.

The reports reveal much about the rhythms of the gatherings and the nature of the protests. The place Dauphine and the nearby streets were generally quiet in the mornings and early afternoons as Zola's case was being tried. They began to fill once the day's proceedings drew to a close—and as the working day came to an end—so that the protesters could cheer, jeer at, or even attack the protagonists as they left the Palais de Justice. The reports show, for instance, that the trial started quietly enough on 7 February—though, as a precaution, most of the external gates of the Palais de Justice were shut. The few that were left half open were manned by security personnel, and police officers were stationed outside and on the place Dauphine. The people milling around before the crowds began to arrive included newspaper hawkers yelling out the titles of the journals they were selling. By the time Zola arrived at around 11.30 a.m., some 300 people were in the square. Some yelled 'Down with Zola!', but the novelist entered from the rue de Harlay with ease.[15]

As the day's proceedings drew to a close, the crowds began to swell on the place Dauphine and on the nearby quays, anticipating the exit of the witnesses and of Zola himself. The court adjourned at 5.10 p.m. after the authorities had deployed 100 police officers and 150 Republican Guards on horseback, the riders resplendent in their beplumed helmets and cuirasses, to bar the entrances of the Palais de Justice. 'The crowd surged en masse to this side and became tumultuous,' according to one *petit bleu*. 'During that time, M. Zola left the Palais via the quai des Orfèvres [the exit on the south side of

the building]. The onlookers, foiled in their attempt, retreated while grumbling.'[16] This more or less remained the pattern—quiet mornings and early afternoons becoming stormier as evening approached. Although the aggression of the crowd ebbed and flowed over the days that followed, the assessment of its dangers represented more the observations of the police agents than any clearly expressed intentions of the demonstrators themselves. The nebulous nature and the actions of the crowds on and around the place Dauphine reflected three things that were a feature not just of crowd behaviour in general, but also of the more specific features of Belle Époque culture: polarised responses to particular characters, the mixing of social classes, and the orchestration of protest.

Zola, of course, was a permanent object of hatred or a focus of support depending on the composition of the crowd in the square at any given time. The same was true of Picquart and the officers of the General Staff, as a report from 10 February makes clear:

Towards 11.45 a.m. Zola arrived at the Palais, which he entered briskly via an oblique entrance on the quai des Orfèvres, without being recognised. Later, he was followed home by furious cries yelled by a band of twelve individuals who at a jog trot followed his carriage, with three or four of them hanging onto it. Those people were finally compelled to let go on the place du Louvre. As each witness arrived at the Palais via the place Dauphine, different shouts could be heard. When the generals strode up the stairways, the public let out cries of 'Vive l'armée! Vive la France!' It was the same when other officers showed themselves. On the arrival of Commandant Esterhazy the same cries were heard, to which were added those of 'Down with the Jews!' When Lt-Colonel Picquart appeared the shouts became louder and from all sides one heard those of 'Down with the Jews! Down with the traitors! Vive la France! Down with Dreyfus!' Lt-Colonel

Picquart, all pale, turned his head twice towards the crowd, which he looked at with disdain.[17]

FOR ALL ITS bigotry, the crowd was well informed about the rhythms of the trial and had no doubts about whom they wanted to cheer or condemn. Their knowledge of the proceedings, though deployed in the service of prejudice and hatred, hints at the dark modernity of the crowd itself—one that was informed less by rumour and traditional forms of protest than by the press, by caricatures of the leading protagonists in the affair, and by some of the political organisations the Dreyfus Affair had galvanised.

The reports also indicate that demonstrators hailed from mixed social backgrounds, much like the more peaceful crowds who congregated on the boulevards and at the many sites of entertainment. Unless workers were involved in large numbers or students descended from the Latin Quarter on the Left Bank, different social groups converged in the crowds. This suggests that many of these gatherings were spontaneous, even if specific parts of the crowd had been mobilised by certain organisations.

Exactly to what extent the protests may have been organised is hard to gauge, but at least some protesters seem to have been assembled by leaders or by particular groups. In a twist that highlighted the importance of the press to Belle Époque politics as a whole, these crowds also reacted to and sometimes took their lead from specific newspapers that had taken one side or another. Particularly conspicuous were the machinations of Jules Guérin, on the editorial staff of Drumont's *Libre parole* and the leader of the Ligue antisémitique.

On the day before the trial, 6 February, Drumont's paper published an appeal 'To the French People'. It expressed faith in the jury, but warned that its members might be bought by the 'Jewish syndicate', ominously if hyperbolically declaring that the people of Paris stood ready 'to take care of its own defence'.[18] The declaration

was signed by the leadership of the league, including Guérin. On 11 February, there was one sighting of the slippery demagogue, and it was clear that he was at the head of a larger group of militants: 'At midday M. Guérin and forty individuals were seen coming along to boo the Commandant Picquart. They spread out among the wine shops on the place Dauphine.'[19] There were other groups involved in the movements on the Île de la Cité, both hostile to Zola, like the ultra-nationalist Ligue des patriotes and Guérin's shower of antisemites, and supportive of him: In the early afternoon of 9 February, for example, a Sûreté agent got wind of opposing demonstrations. At first, he tailed some members of Guérin's group:

They ate at the Commerce Restaurant on the rue Saint Denis—from the speeches I can report that all the members of the Ligue des patriotes, antisemites, and Catholic groups have agreed to gather on the place Dauphine and the boulevard du Palais. All of them had money and some individuals were seen buying rounds from 11 a.m. at the wine and liquor merchants around the Palais. Everything leads one to suspect that this evening there will be very serious trouble. I have been assured that socialists and anti-patriots will be coming to protect Zola! Many people are against Drumont and the *Libre parole*, accused of being agents provocateurs in the pay of the [Ministry of] War.[20]

What seems clear is that organisations on both the extreme right and the radical left were using the Zola trial to pursue their own agendas. Their presence also ensured that some of the crowd's actions were well-orchestrated. At 7.40 p.m. on 11 February, at the end of the day's hearings, an alarmed agent was explicit about this:

I did not exaggerate when I reported on the menacing mass of people. It was challenging to get Zola out because the antisemites, well organised and well led, guarded all the

surrounding points. Finally at 6.25 p.m. he was able to leave, but on route I am not sure what could have happened: the cries of 'Vive Zola' became louder. Two groups of friends of Zola coming from the boulevard du Palais and the other of antisemites ran into each other on the place du Châtelet at 6.35, and a full-blown battle and a real manhunt took place. It's impossible for me to know what the outcome was.[21]

The organised nature of conflicting groups in the crowd helps to explain why the reactions on the place Dauphine were so intense, at times becoming hard for the police to control. The former government minister and liberal economist Yves Guyot, editor of *Le Siècle*, one of Dreyfus's earliest supporters, took the stand on 14 February.[22] On his newspaper's front page a week before, he had published a rebuttal, titled 'Aux Francais!', to the *Libre parole*'s 'appeal' to the French people of 6 February, which had been printed up as a notice and pasted onto walls across the city. Guyot slapped down the claims that the jury might be bought and denounced the veiled threat of popular violence by stating baldly that, in free countries, citizens must refrain from any action that tries to intimidate jurors. He pointed out that the signatories of the *Libre parole*'s appeal included, predictably, the likes of Jules Guérin and Drumont, who represented 'the most hideous hatreds of religion and race, and who want to take the France of 1789 back to the Wars of Religion'. Guyot's counterblast denounced the illegalities around the Dreyfus conviction, the 'mysteries' that surrounded the Esterhazy affair, and the prosecution of Picquart. In addition, *Le Siècle* gathered the signatures of a cluster of academics in support of its position.[23]

Guyot, the same who promoted prostitution reform and was later one of the founders of the *Ligue des droits de l'homme*—the League of the Rights of Man (to which Marguerite Durand and her friend Séverine subscribed in 1898)—became a natural target for the crowds on the place Dauphine. When Guyot left the courts on 9 February, the police agent reported that 'he was marked out for a bad reception.

The place Dauphine had been depleted of police officers and it was with difficulty that he was protected, with the help of someone of goodwill. This evening a poster was put up "To the French People", signed Yves Guyot, in the 20th and 19th arrondissements. Those manifestos were protected by people who made sure that they were not torn down.'[24]

Guyot's willing bill stickers and the protectors of the posters had chosen their neighbourhood well—the 19th arrondissement was home to the hard muscle of Guérin's Ligue antisémitique, many of whose members were the slaughterhouse workers of La Villette.[25] This complex of cattle market and abattoirs dating to 1867 provided Paris with two-thirds of its meat. Over two million animals were shunted in on trains from the countryside annually, and while around half of the cattle were sold and sent back out by train to the provinces, the rest were butchered in a labyrinthine complex of individual killing-chambers and interconnecting courtyards. In the confined spaces of the complex, workers would be spattered with blood and offal, to the distaste of a public increasingly sensitive to standards of hygiene and food safety promoted by, among others, the renowned microbiologist Louis Pasteur.[26] So the 'butchers boys' of La Villette were marginal figures among the working class and, as such, stood out in the otherwise left-wing 19th arrondissement. Like the neighbouring 20th arrondissement, the 19th revelled in a tradition of revolutionary militancy that dated to at least the Paris Commune. And, like Henri Rochefort of *L'Intransigeant*, some of the slaughterhouse workers may have followed a trajectory from revolutionary socialism to hard-line, antisemitic nationalism as a protest against the liberal élites and republican politics.

That the police agent should report that Guyot's poster was pasted in these neighbourhoods reflects the assumption that the crowds around the lawcourts had to be directed in some way, be it by a leader, an organisation, or printed appeals. Guyot, a former government minister, moderate, liberal republican, hostile to socialism and editor of the high-brow *Siècle*, would not normally have endorsed

the incitement of workers in the east end of Paris. This shows that the Dreyfus Affair compelled many of its more moderate participants, who would rather have waged the struggle within parliament, the lawcourts, and the broadsheets, to abandon caution and to act in ways with which they themselves were not entirely comfortable—as Scheurer-Kestner had already done. They understood that the cause had become a battle for public opinion and that the corrosive propaganda and rabble-rousing of the likes of Guérin and Drumont had to be countered by propaganda and a popular mobilisation of their own.

The notion that Guyot's poster also had to be protected is itself a peculiar one. From whom did it need to be protected? The danger would obviously come from the anti-Dreyfusard side among the abattoir workers of La Villette and others, but as a liberal republican, Guyot was not only hostile to the authoritarian, bigoted currents at work against Zola, but also a prolific defender of free-market economics and an eloquent critic of the socialism espoused by the more left-wing supporters of Dreyfus, including Jean Jaurès and the avowed Marxist Jules Guesde. The socialists drew a good deal of support from these areas of Paris, as the legislative elections of May 1898 would soon confirm. In these 'red' districts, Guyot's posters may have needed to be defended not only against the anti-Dreyfusard 'butchers boys', but also against his working-class opponents on the left. Yet this in turn raises the question as to *who* was brave enough to stand sentry around these notices. It is equally possible that some of Guyot's socialist, working-class opponents temporarily made common cause with the liberal patrician in defence of the wider republican values to which they all subscribed. It was neither the first nor the last time that the political centre and Left in France would rally together in this way when confronted with danger from the nationalist, authoritarian Right.

The reaction to Guyot also shows that the war of words was therefore not just in print, but also physically on the streets. Mundane though this observation might at first seem, the interaction between newspapers, posters, and the authors who used them, on the one

hand, and, on the other hand, the crowds on the place Dauphine (and elsewhere in Paris), touched the most sensitive spots of Belle Époque anxieties about modernity. These anxieties were reflected in the observations of the dogged Sûreté agent on the place Dauphine.

Aside from his professional concerns for public order, his reports reflected the anxieties that contemporaries applied more broadly to Belle Époque society at large, but here, more specifically, to the impact of mass culture on the crowd. The agent may or may not have read the book himself, but his observations echo some of the arguments made in a hugely popular and influential treatise on the psychology of the crowd by the doctor, anthropologist, and psychologist Gustave Le Bon, published just three years earlier: *Psychologie des foules*— Psychology of Crowds.

For Le Bon, his era was undergoing a moral transformation, integral to which was 'the power of the crowd', which was the 'new, the final sovereign of the modern age', to the point that the new age would be known as 'THE AGE OF THE CROWD'.[27] Crowds had always arisen in the past, he said, as periodic, violent intrusions into politics by the populace, but crowds would become a permanent and essential fixture in modern life. The essential characteristic of crowds was that they had 'a sort of collective soul' that made them 'feel, think and act in a completely different way from how each person in isolation would feel, think and act'. Since the crowd was a gathering of many different individuals, its psychology could never rise above what was common to all human beings, regardless of the individual abilities and intellects of its various participants. A crowd could never accomplish anything that demanded reason and intelligence, but because of its sheer size, and because it gave the individual within it a sense of anonymity, it gave its members a sense of invincibility. So people in crowds would behave in ways that they never would as individuals, not least because behaviour in a crowd was contagious, 'to the point that the individual sacrifices his own personal interest very easily to the collective interest'. This contagion was powered by the crowd's heightened susceptibility to suggestion,

a response that Le Bon likened to hypnosis, in which the individual's own personality was (temporarily) wiped away and personal will and discernment lost: 'Thus, by the simple fact that he is part of an organised crowd, the man descends the ladder of civilisation by several rungs. He may be a cultivated individual on his own, but in a crowd he becomes a barbarian, that is to say instinctive. He has the spontaneity, the violence, the ferocity as well as the passions and the heroism of primitive beings.'[28] The crowd was therefore impulsive, unrestrained, credulous, incapable of reason, and servile in the face of a strong, charismatic figure.

Le Bon had obtained hefty medical experience at the Hôtel-Dieu hospital in the 1860s before leading a volunteer ambulance unit during the Prussian siege of Paris in 1870–1871. Politically conservative, he lived through the Paris Commune as a trauma that, combined with the military defeat, he saw as symptomatic of the decadence of French society—and in the two decades afterwards he devoted time to writing about the socially degenerative effects of alcoholism, tobacco smoke, and feminism. He also studied 'primitive peoples', arriving at viciously racist conclusions that were sharply criticised by other scholars even at the time. So when Le Bon spoke of the crowd descending into barbarism, he was partially thinking in terms of people behaving like 'lesser' races.

Le Bon's own anxieties were conditioned by the revolutionary crowds he had seen in the Commune of 1871, by the killing of the deputy director of the mining company during the Decazeville strike in the Aveyron in 1886, and by the subsequent mobilisation of protesting workers on May Day and in the trade unions.[29] Yet he was afraid enough of the crowd at least to note that Georges Boulanger's followers exhibited the same characteristics as the revolutionary, working-class crowd. Those who understood Boulangism 'could see the ease with which the religious instincts of crowds are ready to be reborn. . . . [C]rowds need a religion, since all political, divine and social beliefs need to be dressed up in religious imagery, which puts them beyond discussion.'[30]

In his earlier writings on hypnotism, moreover, Le Bon had suggested that charismatic figures 'with eloquence, personal appearance, and reputation' were able to manipulate crowds to the extent that they would 'soon become idols and engender collective hallucinations'.[31] And his analysis—which was important, because Le Bon was a populariser of science (in this case, of anthropology and psychology) and was widely read—could easily have been applied to the populist, authoritarian crowds seen on the place Dauphine. The frequent police reports on and around the square are striking in how they reflect, perhaps consciously, the elements in Le Bon's arguments. One of the longer reports submitted at the end of the day on 10 February used vocabulary and made observations that would seem to have confirmed Le Bon's analysis:

People's minds are very overexcited and the provocations in the antisemitic newspapers are bearing their fruit. Yesterday at the start of the demonstration the barriers prevented the invasion of the surroundings of the Palace, but at 6 o'clock the place Dauphine was neglected and at the exit of the officers there were some very serious incidents and especially on the exit of Monsieur Yves Guyot who only just managed to escape being torn to pieces by a band of antisemites [the same incident reported in the *petit bleu* of 9 February]. . . . One needs to be accustomed to the masses and street movements to be able to make an exact report on what is happening and on what might arise. I have the honour of reporting, in particular, the editorial staff of M. Drumont who are circulating among the groups and inciting disorders. I have the other day already warned about M. Guérin—well, yesterday he came back again and reappeared at all points, performing the job of a real agent provocateur.[32]

Here the crowd appears to have an instinctive propensity for violence—were it not for the barriers, it would have invaded the

grounds of the Palais de Justice, and once the police presence had thinned out, it tried to assault Guyot—and to do so with almost animalistic violence, as if it were in its very nature to do so. Yet, at the same time, it was also subject to the suggestions of leaders or provocateurs, not least the shady if charismatic Jules Guérin, who in this report appears almost literally to have been omnipresent in the crowd outside the lawcourts. The connection of crowd behaviour with the mass culture of the media is made implicit by the reference to the role of the editorial staff of Drumont's *Libre parole* in inciting the crowd to violence. In fact, the modernity of the crowd is further emphasised by the fact that the agent ends his letter by highlighting an important feature in the mobilisation and direction of the protesters:

> Velocepedists [i.e., cyclists] carrying notes who are stationed at the gates on the place Dauphine side are the first to give the signal for disorders. Yesterday at the exit of Colonel Picquart one of those individuals followed him yelling <u>Drown the Jews, Drown the Traitor</u>. I was obliged to threaten to have him arrested, in order to stop him from following [Picquart] on his bicycle ['machine']. . . . These street urchins [*gamins*] act as lookouts for the masses over the arrival and departure of people opposed to Rochefort, Drumont, and Company and they give the signal for hostilities.[33]

THE ROLE OF bicyclists as a means of co-ordinating the crowd and of targeting 'enemies'—identified as those hostile to the antisemitic press, such as Drumont and Rochefort—is suggestive of the ways in which the crowd's behaviour was moulded by the modernity of the Belle Époque. Moreover, the response to the exit from the Palais de Justice of clearly identifiable 'enemies' to assault, harass, and insult suggests a desire for participation in the *spectacle* of the whole affair.

It was not just the psychology and violence of the crowd that caused concern. In the self-image of those who supported Dreyfus

and Zola, the anti-Dreyfusard mob represented everything they were not. For Zola's intervention in the affair in 1898 came in a wider context that saw the launch of that now classic figure of French culture: the politically engaged 'intellectual'.

THERE WAS NOTHING new about writers and scholars sharpening their pens in *causes célèbres*. This had been a feature of French political culture dating back at least to Voltaire in the eighteenth century. What was new in 1898 was the definition of intellectuals as an autonomous political force, one whose members shared a group identity that transcended their many individual differences and who stood up for universal values against entrenched interests, prejudices, and hierarchies.[34] Up to that point the term *intellectuel* was an epithet for someone who was overly cerebral (and by implication 'effeminate' and excessively nervous) and who vainly presumed to intervene in political matters.[35] It was indeed originally an insult hurled against the Dreyfusards. The novelist Anatole France later declared that 'in calling us intellectuals, they were hurling an insult at intelligence, neither more or less than that. They were making sport of people capable of understanding. . . . It was said that they were getting mixed up in things that did not concern them.'[36]

'Intellectual' rapidly came to mean someone with influence in ideas and culture who, while remaining detached enough to protect their independence of judgment, engaged in political and social debate using their reason in the honest pursuit of truth and justice. It was Georges Clemenceau who first gave this term its positive spin in an editorial for *L'Aurore* on 23 January 1898, when he praised the academics, writers, and others who had come out publicly in support of Zola in a petition. Dubbed the 'Manifesto of the Intellectuals', it had been organised by Lucien Herr, Jaurès's friend and the librarian of the École normale. Among the earliest to sign was Marcel Proust, who would later proudly call himself 'the first Dreyfusard'. Proust had undertaken the task of gathering the signatures of other writers and

academics, and these early signers were soon joined nationwide by teachers, students, and others.

Georges Clemenceau proudly hailed the Manifesto of the Intellectuals as being underpinned by a common commitment to justice.[37] For him, the pursuit of justice could not currently be achieved through parliamentary politics. 'No party is standing up for justice, the only indestructible bond of cohesion among civilised people,' he wrote. 'Is it not a sign, all those *intellectuals* who come from all corners of the horizon to gather around an idea from which they cannot be shaken?' Furthermore, he said, 'I want to see in this the origin of a movement of opinion that is above all particular interests, and in this moment when all seems lost, it is in this peaceful revolt of the French mind that I would put my hopes for the future.'[38] 'Intellectuals' were considered to be on the left of politics, even though there were also plenty of academics, writers, and artists on the right and in the anti-Dreyfusard camp.[39] Among these was Gustave Le Bon himself, who suggested that what he called *demi-savants*—semi-scientists—had much in common with the anarchist bomber Émile Henry, who had been a failed candidate for the École polytechnique.

Caricatures in the hostile press depicted intellectuals as pale, egg-headed weaklings, bundles of nerves stricken with that infamous Belle Époque condition, neurasthenia, neglectful of women and unmanly. This stereotype was set in contrast to the image of the army officer, who was presented as virile, robust, vigorous, and gallant. The leading anti-Dreyfusard writer was undoubtedly Maurice Barrès, who rejected the overtures of the young socialist (and future prime minister) Léon Blum for his signature on Lucien Herr's petition. On 1 February, Barrès would scathingly mock the signatories as 'demi-intellectuals'. Barrès, in common with much anti-Dreyfusard propaganda, would suggest that the intellectuals were less than robust in their health, their moral fibre, and their masculinity: 'Rebellious pedants are the most sterile of men.'[40] He defined an intellectual as 'an individual who persuades himself that society ought to be founded on logic and who does not recognise

that it rests in fact on anterior necessities and is able to be foreign to individual reason'. Barrès contrasted the Dreyfusard intellectuals, who he said thought in abstractions and pursued them regardless of the practical consequences for society, with the anti-Dreyfusards, whom he lauded as '[men] of intelligence', and whose thinking, he said, was grounded in realism. These were the men, in his opinion, who understood the needs of society, but who refused to meddle in matters of which they had no knowledge, such as the workings of justice. For Barrès, it was better to be a 'man of intelligence' than to be an 'intellectual'.[41]

Yet it was precisely by appealing to such 'abstractions' as truth, justice, and reason that the Dreyfusards sought to sway public opinion, which was very different from seeking to influence a crowd. While the latter was unruly and, as Le Bon had argued, had a psychology that was irrational, violent, and all too easily aroused and seduced, 'public opinion' was a rational, collective sovereign that was the basis of republican democracy.[42] So when Zola and Guyot and other intellectuals appealed directly to the public in their writings, it was to this more abstract conception of a thinking, engaged citizenry. They believed that if only people were told the truth, and could see the facts laid out, they would mobilise behind the cause of 'truth and justice'.

The ugly realities of the Dreyfus Affair, however, showed that the challenge was in reconciling the Dreyfusards' own democratic, republican, and often socialist values with the terrifying face of the masses, such as that revealed in the riots and aggressive protests on the place Dauphine. To do this, they distinguished between the 'people'—the broader, sovereign basis of the Republic that could be enlightened and guided by the truth—and the irrational, destructive mob, which needed to be policed and controlled. It was precisely for this reason that Dreyfusard observers were dismayed by the appearance outside the lawcourts of some of the students from the Latin Quarter alongside the followers of Guérin and Drumont. These were precisely the young people, working towards a life in the

professions, whom the intellectuals expected to be independent, rational, and critical in their thinking, exercising their freedom of judgment and capable of committing to truth and justice. And indeed, some did rally to the Dreyfusard side: nationalist thugs did from time to time get confronted by students and young people in the streets, sometimes in or around the colleges on the Left Bank. Students from that bastion of republican values, the École normale, were robustly Dreyfusard. Even so, observing the presence of young scholars in the anti-Dreyfusard crowd, one disappointed journalist remarked that they were 'more servile than manual labourers': 'They are contemptible because they have willingly renounced their free will. They could have been independent but they want to be part of the crowd.'[43]

The face of the crowd was troubling to the Dreyfusards in other ways. They could agree with Le Bon that it reflected modern social ailments. The uncritical consumption of mass culture (the press, meetings, posters), the susceptibility to the spectacle of charismatic leaders, the identification and pillorying of enemies all fed into the crowd's unrestrained capacity to act on its violent impulses. Contemporaries noted the parallels between the psychology of the crowd and the impulsiveness, suggestibility, and rampant consumerism of the department store customer: the department stores (critics suggested) used advertising, lavish displays of goods, and other strategies to undermine the resistance and reason of the client and to unleash their acquisitive impulses.

It was because of their self-image of rising above these impulses that, somewhat ironically, given his own politics, Le Bon had written a book that resonated with the Dreyfusard intellectuals. Yet this very anxiety over the modern features of the crowd conflicted with the Dreyfusards' sense that they stood on the side of progress. While they would have liked to see the affair as a straightforward struggle of modernity and progress against those of tradition and atavism, the anti-Dreyfusard, antisemitic crowds in Paris showed that the affair cut across modernity, that it was actually a struggle *within* it—as

Christopher E. Forth has put it, the Dreyfus Affair 'betrayed an uneasy sense . . . that modernity also contended with its own contradictions'.[44]

REGARDLESS OF THE harm the crowds of protesters wanted to inflict on Zola, Picquart, and other Dreyfusards, the novelist himself, in the end, served no time in prison despite his conviction on 23 January. Zola's lawyer, Labori, immediately appealed the verdict, and Zola lived with his wife, Alexandrine, in suspense for a few months in their apartment at No. 21 bis, rue de Bruxelles, in the 9th arrondissement—ignoring the bawling outside from crowds who sometimes gathered in the street to hurl abuse up at their windows. On 2 April, the court of appeals (Cour de cassation) quashed the conviction, and Méline, the cautious, conservative prime minister, urged the army to let Zola's case rest.

Yet the army judges forged on, picking up on another line in 'J'Accuse . . . !', where Zola had called the acquittal of Esterhazy 'a supreme offence to all truth and justice', and filed a new lawsuit against him. The new trial—to be held in Versailles rather than in Paris—was slated for 23 May, after the parliamentary elections. 'Nothing', Zola wrote wearily to a friend, 'surprises me anymore.'[45] When the day came, Labori immediately challenged the Versailles court's competence to hear the case, and proceedings were suspended.

As Zola and his legal team drove in an automobile back home to Paris, the car was pelted with stones by the crowds milling in the Versailles streets. In the hiatus, Labori became convinced that were Zola to be imprisoned, his authorial voice would be silenced—and that was what the army and the government wanted. The best course of action, the lawyer calculated, was for Zola to leave the country for a while. The writer was reluctant: always mindful of his readership and his image, he feared that flight would diminish the heroism of 'J'Accuse . . . !' Prison, too, he calculated (somewhat hopefully, perhaps), would give him time to write. Besides, he had moral scruples. Others had already suffered in Dreyfus's cause: Colonel Picquart

had been suspended from the army on 26 February for 'grave mis-
deeds while in service'. Picquart's lawyer, Louis Leblois, was sus-
pended for six months from the Paris bar for 'betraying confidences'
to Scheurer-Kestner and dismissed by the minister of the interior as
deputy mayor of the 7th arrondissement. A professor from the École
polytechnique who testified in Zola's favour lost his post.[46]

Still, Labori prevailed. After the postponed hearing began on
18 July, Zola's friends bundled him onto the night train to London
from the Gare du Nord. Alexandrine, who did not go with him at
this time, wisely chose not to pack a suitcase for him, so as not to
attract attention: his only luggage was a nightshirt folded into a news-
paper. He crossed the Channel and arrived at London's Victoria Sta-
tion in the early hours of the following morning under the pseudonym
'Monsieur Pascal'. Ernest Vizetelly, the son of Zola's British publisher,
Henry Vizetelly, acted as his guide and helped him find his feet and
bearings. Zola remained in southern England for eleven months—
weaving around Surrey's bucolic countryside on a bicycle, and start-
ing work on his next novel, *Fécondité* (*Fruitfulness*). He was joined first
by his lover Jeanne Rozerot and their children, and then by Alexan-
drine. He would not return to France until 5 June 1899.[47]

In the meantime, the exposure of the *faux Henry* as the forg-
ery that it was and the suicide of its author did not long delay the
anti-Dreyfusard counterattack in the press, supported by militancy
on the streets: the two, as always, were interwoven. Guérin's anti-
semitic thugs and Paul Déroulède's Ligue des patriotes—a national-
ist organisation that sought to inspire patriotism and revenge against
Germany, although Déroulède himself sought (in vain, ultimately) to
steer his organisation clear of antisemitism—marched in the streets.
At the same time, Drumont published the lists of donors to the 'Mon-
ument Henry' (the appeal to support the lieutenant-colonel's widow)
along with, ominously, the addresses of the magistrates held to be
responsible for opening up the revision of the Dreyfus case.[48]

The Dreyfusard newspaper *Le Rappel* ('The Recall', edited at No.
131 rue Montmartre) reported on 29 October 1898—the day the court

of appeal ruled in favour of revision of the Dreyfus case—that baying crowds of nationalists and antisemites had invaded the Palais de Justice. A Radical-Socialist paper, its reporter claimed that Edouard Drumont was among those leading the mob: at a prearranged signal, the invaders chanted 'Down with the Jews! Death!' Along with Drumont was the editor of the anti-Dreyfusard *Patrie*, Lucien Millevoye. There is a barely concealed glee in the report, which describes how this newsman and Boulangist deputy was separated from his companions when the guards moved in to clear the buildings and the courtyard. Trapped behind a closed gate while Drumont waited comfortably in his carriage outside, Millevoye was told by the police commissioner that he had to wait for a moment before the gate could be reopened. *Rappel* mockingly attributed to the über-patriotic editor, who claimed to speak for the 'people', the pompous protest, 'If anyone has the right to give orders here, it is I, and if anyone has the right to receive them, it is you.'[49]

The laughing reportage of this 'burlesque' exchange, as *Rappel* called it, hid a genuine fear on the republican centre and left that a right-wing, authoritarian coup d'état was in the making. Déroulède's 180,000-strong league planned a mass demonstration for 26 October on the place de la Concorde, directly opposite the National Assembly, to shout out their support for the army and their opposition to revision. *Rappel* urged republican unity within the Chamber of Deputies against the threat to democracy on 25 October, as the government yet again teetered on the brink of collapse: 'It is always a fault, on the part of republicans, to seek support from the enemies of the Republic; for what worse enemies are there than the antisemites and the nationalists? Aren't they always looking for the sabre that will cut the throat of Liberty? To rely on their votes to ensure the survival of a republican government is either pure folly or supreme weakness.'[50] The editorial called instead for a union of all republicans, from the most moderate to the radical Left, to rally together. Two days previously, in fact, the *Libertaire*, edited by the anarchist Sébastien Faure, had launched just such an appeal for republican unity across the spectrum 'to defend

our common heritage: liberty': 'The decisive hour has sounded. Let us be ready. Know how to fight against the reactionary and liberticide bands in the street, the glorious street, the street of energetic protests, the street of the barricade and of revolutions.'[51]

Yet the fragility of this republican unity was unwittingly exposed by the more moderate *Rappel* when the paper warned its readers not only against the right-wing 'Caesarism' afoot in the streets, but also against being provoked by it. Déroulède's Ligue des patriotes, it warned, sought to 'invade the streets' and to intimidate 'those members of the government and those representatives of the country who have made the grave mistake of being neither antisemitic, nor Caesarist, nor dictatorial, nor even nationalists, but simply republicans and modestly patriotic'.[52] Instead of urging direct action and resistance, as the anarchist Sébastien Faure did, *Rappel* urged republicans to stay away—to let the nationalist protest take place and run its course—mockingly concluding, 'We will leave Monsieur Déroulède to find the place de la Concorde all alone tomorrow, so that all that will be left will be several lumps of manure dropped by the horses drawing General Boulanger's landau around the obelisk.'[53]

Shortly beyond where the offices of *Le Rappel* once stood, the rue Montmartre continues, correcting its north-north-western course by merging with the rue des Victoires, which cuts in from the south. If you were to turn down this street to head back towards the rue Réaumur, you would quickly emerge onto the place de la Bourse with its square, colonnaded hulk of the Palais Brongniart, the Parisian stock exchange. The square has a direct connection with the Dreyfus Affair: On the north side was—and still remains—the post office to which, in mid-November 1897, Colonel Picquart's friend and lawyer, Louis Leblois, posted a small package from Mathieu Dreyfus addressed to the minister of war, Jean-Baptiste Billot, in which he accused Esterhazy of being the real traitor. The accusation was based on the evidence gathered by both Mathieu and Picquart, and this dossier was also in the package. Leblois waited as he heard the envelope fall into the mailbox, later saying that, for the rest of his days, he would hear

that sound. Leblois's memory of that moment was a response shared by many at decisive moments in the affair: there was an awareness that once one had openly declared their position, there was no going back. In the atmosphere kept at fever pitch by the press, the revelation of a truth would inevitably have momentous and potentially violent consequences.[54]

That impact was felt personally by Leblois and his friend Picquart. Picquart, as we have seen, was imprisoned in July 1898 for allegedly revealing military secrets. Minister of War Émile Zurlinden had ordered his court-martial in the weeks after Henry's suicide with the date for the trial set for 13 December 1898. For this purpose, Picquart was to be transferred from the civilian prison of La Santé to the Cherche-Midi military jail. Meanwhile, Leblois was also pursued through the civilian courts for revealing the information on Esterhazy. Both would be given a breathing space by the intervention of Zola's barrister, Labori, who successfully urged the court of appeal to look over their cases. The judges agreed to do so on 8 December, so proceedings against both defendants were suspended.[55]

The dangers involved, however, were always more than just personal. As the polemic raged in the press, the political battle for the future of the Republic was also fought out on the streets. On 16 February 1899, President Félix Faure, an opponent of revision, died in the arms of his mistress, the salon hostess Madame Marguerite Steinheil, who was entangled with him in the private boudoir adjoining his office in the Elysée Palace. The president was struck by a seizure while they were in an amorous clinch (although that is to put it politely: one well-worn story is that Steinheil was performing oral sex on the president, which, if the story is true, was the blow-job that changed the course of French history). One of the valets, alerted by Madame Steinheil's screams, burst into the room. He later claimed to see the president virtually naked while the almost delirious young woman was similarly undressed. Faure died of a cerebral haemorrhage at 10 p.m. that night.[56] Rumours quickly abounded about the undignified passing of Félix Faure: one story had it that, as the doctor hurriedly

arrived, he had asked if the president still had *sa connaissance*— consciousness. The guard responded, 'No, doctor, she has left via the side door' (*connaissance* also meaning 'acquaintance').[57]

The Dreyfusards in parliament exploited Faure's unexpected death, successfully pressing for the election of Émile Loubet, a supporter of revision, as president on 18 February. In response, a nationalist protest, led by Déroulède and the Ligue des patriotes that evening around the golden statue of Joan of Arc on the place des Pyramides, demanded a coup then and there, with shouts of 'To the Elysée!' Déroulède demurred but went home to plan his next move. He mobilised the Ligue des patriotes, sending out no fewer than four thousand *petits bleus*, having posters pasted up and putting advertisements in the press, to summon its twenty-five-thousand-strong Parisian membership. Three days later, at the end of the state funeral of Félix Faure, he and members of the league, along with some from Guérin's Ligue antisémitique, joined by a handful of royalists, confronted the honour guard on the place de la Nation in the east of the city as the guardsmen rode back to barracks. (Most of the royalists stayed away, because Déroulède refused to support the Duke of Orléans in his pursuit of a restoration of the monarchy.) The anti-Dreyfusard writer Maurice Barrès also came, and Guérin showed up with Prince Victor Bonaparte, the claimant to the imperial throne.

Déroulède urged the commander, General Gaudérique Roget, to join them in toppling Loubet, and with it the Republic, but when Déroulède seized the bridle of Roget's horse, the general angrily rebuffed him, saying, 'Leave my horse alone and let me pass!' While Roget led his men back to barracks, Déroulède, followed by members of his league, jogged after them. He and some forty nationalists got into the barracks courtyard, but seeing his coup bungled, Déroulède now insisted on being arrested. Roget was happy to oblige. Déroulède was put on trial but acquitted on 31 May after a number of the jurors had been bribed.[58]

Despite the Déroulède farce, many anti-Dreyfusards had not given up. On 3 June, the appeals court confirmed that Dreyfus's

original conviction was quashed and that the captain should face a second court-martial. It was on hearing this news that Zola made his way back to Paris from his idyllic exile in Surrey. Picquart and Leblois finally heard that they had no charges to answer.

Yet at their moment of triumph, the Dreyfusards were immediately challenged by their opponents' response. The following day at the steeplechase at Auteuil, Loubet was confronted with a demonstration of hundreds of nationalists, one of whom managed to leap up onto the rostrum and smash in the president's top hat with his walking stick. A week later, the Dreyfusards mobilised in a counter-protest march of thousands, consisting of all shades of republican opinion and all social backgrounds. It processed from the place de la Concorde to the racetrack at Auteuil. For the Dreyfusards, the events had shown that the threat to the Republic and its values from the Right, be it monarchist or authoritarian nationalist, was all too real. The prime minister, Charles Dupuy, who had made some last-ditch attempts to block revision, fell on 12 June. His successor, the moderate republican René Waldeck-Rousseau, built a government of 'republican defence' that included the socialist Alexandre Millerand, Jaurès's editor, on the left and Gaston de Galliffet, the notorious *fusilleur*—shooter— of the Communards on the right.

In late June, Alfred Dreyfus returned to French soil, coming ashore near Quiberon in Brittany, and was then held in the military prison of Rennes, where the second court-martial was to take place, safely removed from the sound and fury of the capital. Just days after these legal proceedings opened, Waldeck-Rousseau moved against the Ligue des patriotes and the Ligue antisémitique, arresting their leading activists, including Déroulède and Guérin, so as to remove any danger of anti-Dreyfusard violence. Déroulède would be sentenced to two years in prison (changed to ten years in exile—he chose to go to Spain), while Guérin and a handful of his antisemites locked themselves up in his headquarters on rue Chabrol near the Gare du Nord. The building, dubbed 'Fort Chabrol', was besieged by police, while sympathisers handed food from neighbouring rooftops through

the upper-storey windows. Their supporters put up red, white, and blue posters in the streets, the text screaming that the legal pursuits against them showed that the Republic's vaunted values of 'equality' were a 'lie', labelling the republican *Ligue des droits de l'homme* as the *Ligue des droits du juif* (League of the Rights of the Jew), and proclaiming the anti-Dreyfusard slogans *'Vive la France!* Long live the Army! Down with the Jews! Down with the Traitors!'[59] It availed Guérin and his acolytes little: they surrendered in mid-September, whereupon Guérin was tried and sentenced to ten years in prison, a term commuted to lifetime in exile.

By then, Alfred Dreyfus had been retried from 7 August in Rennes. Marguerite Durand, who flitted between Paris and Rennes on the train, had sent two of her best writers, including Séverine, to cover the trial onsite. For her, 'the result is not in doubt: it is acquittal, because from the accusation maintained against all reason, none of the charges can stand'.[60] Yet, to the dismay of his now many supporters, Dreyfus was found guilty again on 9 September 'with extenuating circumstances' and sentenced to ten years in prison. Publicly stoic like the soldier he was, Dreyfus privately collapsed tearfully into the arms of his lawyer, the ever loyal Edgar Demange. While anti-Dreyfusards, including Barrès (who stayed in Rennes for the trial, at the sublimely apt address of rue de Bastard), crowed in triumph, the verdict immediately tore the Dreyfusards apart.

Some, such as Mathieu Dreyfus and Joseph Reinach, concerned above all for Alfred, his family, and his health, which had visibly and shockingly deteriorated in the living hell of Devil's Island, wanted to push for an immediate pardon from President Loubet. The prime minister, Waldeck-Rousseau, was sympathetic, but worried about losing the support of the more right-wing republicans, and, above all, about stirring up the army against the Republic. But the idea of a pardon enraged more hard-line Dreyfusards, such as Jaurès, Clemenceau, Guyot, and Zola's lawyer, Labori, who had survived being shot in Rennes by an assailant who was never caught. For them, the wider cause of justice, republicanism, and (in Jaurès's case) socialism was

just as important. A pardon meant abandoning all hope of a formal acquittal, and of ever holding to account the army officers responsible for the original cover-up and perversion of justice. In the end, the brutal reality of Dreyfus's frail condition and the risk carried by a third trial were decisive. Waldeck-Rousseau joined with his socialist minister Alexandre Millerand and prevailed over President Loubet. The pardon was signed on 19 September 1899.

Alfred Dreyfus was at last a free man, but he, along with Picquart, would not be exonerated and restored to his rank until July 1906. He would serve in the First World War and die peacefully in 1935. His entirely natural desire to live in peace with his wife and children and to resume his career had made Dreyfus almost too human for his more radical, ideological supporters. Dreyfus himself would later object to his role as a political symbol: 'But no, but no. I was only an artillery officer that a tragic mistake had prevented from following his own path. Dreyfus the symbol of Justice, that's not me: it is you who invented that Dreyfus.'[61]

Yet Dreyfus the symbol proved to be too compelling, not least for those ranged against him and the cause that he represented. And France in the final years of the Belle Époque proved to be no less bitterly divided than it had been in the Dreyfus Affair—as we shall now see in the final chapters.

CHAPTER 10

MEMORY

É mile Zola died suddenly on the night of 28–29 September 1902. In the previous month, he had just finished *Vérité* (*Truth*), the third novel in his new cycle of novels, *Les Quatre Évangiles* (*The Four Gospels*), which also included *Fécondité* (*Fruitfulness*), *Travail* (*Work*), and *Justice* (*Justice*). He had been taking a break, resting in the country home that he shared with Alexandrine at Médan. It was wet and cold when they returned to their apartments at 21 bis rue de Bruxelles, and they asked their servant, Jules Delahalle, to light the fire in their bedroom. Zola, who had a fear of intruders while he slept, had bolted the door on the inside, and the couple went to bed with smokeless coal warming the room. They did not know that, after some repair work that summer, the chimney flue had been accidentally—or possibly deliberately—blocked by some of the debris, and the room gradually filled with carbon monoxide.

When the couple did not appear the next morning, Delahalle at first assumed they were still resting, but finally raised the alarm at 9 a.m. The door was forced open. Alexandrine was lying on the bed,

unconscious but alive—she had awoken at 3 a.m. to be sick in the bathroom before returning to sleep, and that little bit of fresher air probably saved her life. Émile Zola was dead. Alexandrine had tried to help him but had been so overcome with the toxins herself that she had collapsed.[1]

Zola had received a fearful abundance of death threats since 'J'Accuse . . . !' and many of his admirers suspected foul play by vengeful nationalists and anti-Dreyfusards. Certainly, Jeanne Rozerot, Émile's mistress, was convinced that his death could only be murder. Denise, her daughter with Émile, recalled that Alexandrine had sent two friends to tell them the sad news, noting appreciatively that 'even in her terrible distress she had not forgotten us', but also that her shrieking mother, closing her arms protectively around Denise and her brother, Jacques, 'imagined that someone had killed Zola'.[2]

Tests on the writer's blood showed his death to be due to carbon monoxide poisoning, but when guinea pigs were left in the room in the conditions replicating those of the fateful night, they survived. Moreover, when architects took apart the flue, they found plenty of soot, but not enough to obstruct the safe exit of gasses. Still, the coroner dismissed any possibility of murder: it is said that he was concerned that a verdict of murder would bring the still simmering political conflicts of the 1890s back to the boil all over again.

Half a century later, the newspaper *Libération* received a letter reporting a dying confession made in 1927 by an anti-Dreyfusard stove-fitter. He claimed that he and his men had taken advantage of work being done on the neighbouring rooftop to block the Zolas' chimney. Then, with all the upset going on immediately below the following day, they returned unnoticed and unblocked it.[3] This hearsay testimony is far from being decisive proof, but the postmortem investigations do suggest circumstantially (but not conclusively) that there may be some veracity in the blocked chimney theory. We shall never be certain.

Zola was embalmed so that Alexandrine, in hospital until 2 October, could see him one last time before he was buried. Friends

and supporters, including Alfred Dreyfus and Georges Picquart, the architect Frantz Jourdain, and the anarchist writer Octave Mirbeau, kept vigil as his body was laid in his study surrounded by flowers.

On 5 October, Zola was buried with a military escort. When the procession passed from the rue de Bruxelles to the Montmartre cemetery, there was no anti-Dreyfusard heckling *en route*; instead the cortege—followed by rank upon rank of people, fifty thousand strong—was saluted by policemen and soldiers alike as it moved sombrely past and eventually made its ascent of the Butte. Alexandrine, heavily veiled, was there, but Jeanne Rozerot was not. There were three orations, but it was that of the Dreyfusard novelist Anatole France that most resonated. The author hailed Zola's literary genius and spoke in particular of 'J'Accuse . . . !' and its impact: 'It inspired a movement of social equity that will not halt. From it has emerged a new order of things based on sounder justice and on a deeper knowledge of everyone's rights. . . . Zola deserves well of his country for not having lost faith in its ability to rule by law.' He was, France finished, 'a moment in the history of human conscience'.[4]

As we shall see, in saluting a 'new order' based on justice and rights, Anatole France was being overly optimistic. Still, only six years later—a mere decade after he had been prosecuted, execrated, and forced to flee the country—Zola would be interred in the Panthéon, the Republic's secular temple. The political leadership of the Republic may not have transformed completely, but in the aftermath of the Dreyfus Affair, in just a few years, it had come a long way.

THE PANTHÉON, THE great domed mausoleum at the top of rue Soufflot in the 5th arrondissement, was and remains the resting place for those recognised as the great citizens of the *patrie*. The building was originally conceived as a church, first commissioned by Louis XV, after he had fallen seriously ill in 1744 in the north-eastern fortress city of Metz while his armies were campaigning in the War of Austrian Succession. A man not without his vices, the contrite

monarch appealed for the intercession of Sainte-Geneviève (patron saint of Paris, because she had saved the city from Attila the Hun through the force of prayer in 451). Sure enough, Louis made a strong recovery. Dutifully, he then undertook his pilgrimage to the abbey church dedicated to the saint in Paris, on the top of the Montagne Sainte-Geneviève, the hill whose slope gradually rises from the Seine on the Left Bank. He found the narrow confines of the medieval building in a state of decay—and the friars there appealed to the king for help. It took Louis ten years to act, but in 1754 the neoclassical architect Jacques-Germain Soufflot was appointed to design a new church on the site. Soufflot was chosen precisely because he was innovative, ambitious, and willing to experiment with church design. Moreover, Louis XV, his reputation battered by a less than successful foreign policy (which would only get worse with the disasters of the Seven Years' War in 1757–1763), needed to make a dramatic public gesture to restore some of his prestige.

Yet neither Louis XV nor his successor, Louis XVI, was to reap the benefits. Soufflot's designs had to be redrawn and redrawn again as he sought to create a building that would be as light as possible, an aim achieved by combining different kinds of load-bearing columns, pillars, arches, and vaults, including pendentives, barrel vaults, and *lunettes*—half-moon-shaped arches, some of them penetrating the vaulting of the larger arches themselves, so letting in more light.[5] Spotting and identifying these and other features is a fascinating challenge for visitors to the Panthéon today.[6]

Work finally began on the foundations in 1757, and Louis XV officially laid the first stone in 1764, but, just as with the Sacré-Coeur more than a century later, construction proceeded slowly. No less than the Butte Montmartre, the Montagne Saint-Geneviève, riddled with holes, shafts, and crevices—much of it caused by centuries of subterranean quarrying—was a geological Swiss cheese. At one point, two cracks appeared during construction. In the end, Soufflot had to drive down some sixty-nine masonry-filled mines to stabilise the terrain. He did not live to see his triumph: The Church of Sainte-Geneviève,

with its soaring dome and its massive colonnaded entrance, would not be completed until 1790, by which time the Revolution was underway. Soufflot had been dead for ten years.[7]

Yet it was the Revolution that gave the building its secular purpose. On 4 April 1791, the National Assembly decreed that, henceforth, the church would become a temple to France's 'great men'. 'Let the temple of religion become the temple of the *patrie*,' proclaimed one revolutionary. The decree spelled out the words that would be inscribed across the front of the building—and that remain there today: 'Aux Grands Hommes La Patrie Reconnaissante': 'To Great Men, a Grateful Country'. Religious symbols were stripped out and the first revolutionary leaders were interred there, as well as the Enlightenment philosophers Voltaire and Rousseau, the ideological forebears of the Revolution itself. Nguyễn Trọng Hiệp was impressed enough to write that 'this monument is vast, tall and imposing'.[8]

So the Panthéon is the mausoleum where those recognised for the greatness of their contributions to French life are interred, and, as such, it is intended as a commemoration of France's past, a store of historical memories around which, it was hoped, the country could unite.[9] This aim certainly did not have the intended impact on France's overseas empire, for even as cultivated an observer as Nguyễn Trọng Hiệp admitted that his knowledge of French history was too limited to understand all the intended messages—perhaps wilfully so.[10] Within France itself, almost all choices for interment in the Panthéon cause controversy—there has been absolutely no consensus on who is worthy of the honour because there has been no agreement over the meaning of France's past.[11] This was, unsurprisingly, especially true within the highly contentious politics of the Belle Époque: the different sides of the culture war had very different conceptions of French history, so very different ideas as to who was worthy of commemoration and who was not. As the historian Mona Ozouf has put it, 'The Panthéon, conceived as a quasi-religious staging of national unity, is in itself a place of rupture among the French.'[12] It does not in practice combine memories that unify; rather, it presents to French

people *a particular set* of political memories. In the wake of the Dreyfus Affair, interring Zola in the Panthéon in 1908 was like pouring lighter fluid on a smouldering fire.

This was all the more so because the use of the church as a Pantheon has not suited every regime since 1789.[13] Napoleon, pragmatic as always, allowed it to be restored as a church in 1806, although the crypt below was still used to bury 'great men'—those who served him in politics, finance, and, above all, the army—since he was determined to ensure political stability by making peace with Catholicism. In 1816, the restored Bourbon monarchy was less compromising and returned the building wholly to its original function as a Catholic church. When the Bourbons were overthrown in 1830, the more liberal July Monarchy of 1830–1848, keen to legitimise itself by connecting with France's revolutionary, secular past, reconverted the building into the Panthéon. The Second Republic in 1848 named it a 'Temple of Humanity', and then Napoleon III, mindful of needing the support of Catholic voters when he became emperor in 1852, turned it back into a church. It was only in 1881 that the Third Republic restored the building to its use as a secular temple. Four years later, Victor Hugo became the first to be interred there since 1830. Under the Third Republic, the building was used to emphasise the values of the regime, which the republicans saw not only as universal but also as secular: in the absence of the traditional Christian promise of an afterlife in republican ideology, the promise of eternal memory was a way of immortalising the Republic's 'grands hommes'.[14]

In France, the different sides had told themselves very different stories about the past and about who they were, so it was virtually impossible, particularly in the febrile politics of the Belle Époque, for any government to pantheonise a figure without causing bitter and indeed angry debate. The French could unite around a few notable historical figures who were universally admired, but most of these had already been commemorated in some other way. Joan of Arc, for example, could appeal to both Left and Right—to the former

because she was a peasant girl (from the now lost province of Lorraine) who liberated the country from foreign conquerors and was betrayed by the élites (and in particular, by the Church); to the latter because not only had she liberated the nation, but she had done so as a Catholic who was loyal to her king. As Charles Péguy, a poet, a socialist, a Catholic, and a Dreyfusard who understood both sides of the 'Franco-French' divide, wrote in 1913 of the memory of Joan, 'France is not just the first daughter of the Church. . . . She is undeniably a sort of patron and witness (and often a martyr) of liberty in the world.'[15] And although Joan did transcend the divisions among the French to some extent, even she could not quite unite the two sides, because they drew different meanings from her and, as the historian Frederick Brown writes, she was confiscated by the political Right as the Third Republic was finding its feet.[16] It is no accident that the golden equestrian statue of Jeanne d'Arc on the place des Pyramides (1st arrondissement), created by Emmanuel Frémiet in 1874—that is, during the period of 'Moral Order'—stands on a pedestal designed by none other than Paul Abadie, the architect behind the Sacré-Coeur. During the Dreyfus Affair, a police report noted that a Catholic youth organisation was going to celebrate Jeanne's feast day (30 May) by gathering at the statue and singing a specially written song, whose refrain begged the saint to intercede and to save the country from the 'invasion' of the 'sans patrie'—a thinly veiled reference to Jews, in particular.[17] Unsurprisingly, the statue has become a symbol for the extreme Right, most recently the Front National (rebranded as the Rassemblement National), which holds an annual rally there on May Day.[18]

In the context of France's fraught cultural and political divisions, the honouring of Zola in 1908—just two years after Dreyfus's conviction had finally been quashed—was bound to be a partisan affair, provoking powerful and indeed violent reactions from those who hated him, hated Dreyfus, and hated the Republic itself. The decision jabbed French cultural and political life at its most sensitive, wounded spot. And the context of the early 1900s was particularly

tense, since the Dreyfus Affair had further cystallised and deepened these divisions.

The moderates, beleaguered in the polarisation of the Dreyfus Affair, had split apart. Dreyfusards had joined the prime minister, René Waldeck-Rousseau, to the left of centre, while the anti-Dreyfusards, led by Jules Méline, formed their own party that allied with what remained of the shattered Catholic *ralliement*. On the left, the Dreyfusards consolidated their political position, with the Radicals at last forming their own formal political party in 1901, and Jean Jaurès leading the fractious socialists into a united party, the Section française de l'Internationale ouvrière (SFIO, French Section of the Workers' International), in 1905.

Crucially, the Dreyfus Affair had put paid once and for all to the Boulangist moment, in which the extreme Left and the authoritarian, nationalist Right could converge in their common hatred of the bourgeois, parliamentary Republic. The anti-Dreyfusard writer Maurice Barrès had envisaged a similar alliance at the start of the Dreyfus Affair, but now the revolutionary Left either eschewed such marriages of convenience, and pursued its own path, or else fused with the revolutionary, authoritarian Right in what the historian Zeev Sternhell has called a 'synthesis of social radicalism with national radicalism'.[19] The term 'national socialism' was not coined in Germany in the 1920s, but in Belle Époque France: Maurice Barrès stood for election as a 'National Socialist', which included opposition to those whom he and his ilk claimed were corroding the nation from within, including liberals, intellectuals, socialists, Jews, and foreigners.[20] For socialists who stayed the course, however, particularly after the defeat of syndicalism in 1906–1907, even revolutionaries like Jules Guesde thought it was better to work within the democratic system for change rather than to undermine it and so create an opening for the nationalist Right to exploit. In 1912, both the Confédération générale du travail (CGT, General Confederation of Labor) and the SFIO would unanimously and without requiring any debate condemn antisemitism.[21] The days in which a socialist could attack capitalism by associating it

with Jews were gone: it became almost axiomatic (if not entirely true) that antisemitism was the exclusive reserve of the nationalist Right. The Left, as we will see, had also found a new cause in antimilitarism. And right up to the First World War, the Left of Radicals and Socialists was politically resurgent, with the Right steadily losing seats to them, down from 246 in 1902 to 121 in 1914.[22]

Among the extreme Right, the Dreyfus Affair sharpened the reordering of the counter-revolutionary forces, reinforcing its darkly modern combination, present since the Boulanger Affair, of xenophobic nationalism, militarism, racism (including antisemitism), authoritarianism, social reformism, and, in some cases, Catholicism. In the immediate wake of the retrial of Dreyfus at Rennes, the prime minister, René Waldeck-Rousseau, had moved to crush the leagues (including the Ligue des patriotes and the Ligue antisémitique) that had provided the shock troops for the anti-Dreyfusard cause, but the mantle was taken up above all by Charles Maurras and by Maurice Barrès. The Provençal Maurras, whose deafness did not hold him back from becoming a literary critic and anti-Dreyfusard polemicist, had cultivated a distinctly romantic view of France's monarchist and Catholic past and founded the royalist movement Action française in 1899. Barrès, the suave, slender novelist, politician, critic, and anti-Dreyfusard writer, was from Lorraine, carrying with him the childhood memory of German troops occupying his hometown of Charmes-sur-Moselle. As an erstwhile Boulangist elected to parliament in 1889, he may once have seen himself as a potential ally of the socialist critics of bourgeois, republican society, but in the Dreyfus Affair he chose nationalism, antisemitism, and anti-Dreyfusism. Barrès's view of nationhood was that it was rooted in 'the earth and the dead', with which few on the left could now compromise. The emergent brand of extreme right-wing politics was active both in the streets and in the press and was especially strong in Paris, where it fed off the economic distress of shopkeepers, office workers, the self-employed, and some workers who felt threatened by both big business, on the one hand, and socialism, on the other,

along with idealistic students drawn to the apparent romanticism of ultra-patriotism, populist authoritarianism, and royalism. Then, as now, they were defined unambiguously as nationalists—and not in the old liberal, progressive sense.

After the Rennes trial, Waldeck-Rousseau, Dreyfusard though he was, sought to stabilise the country after years of bitter division—and not least because he wanted the Universal Exposition of 1900 to pass without controversy. That year, he pushed through parliament a general amnesty for all those involved in the Dreyfus Affair, quoting Léon Gambetta's argument in favour of amnestying the Communards: 'When disagreements have divided and torn apart a country, all men of political wisdom understand that the time comes when these need to be forgotten.'[23] Since this primarily benefitted the anti-Dreyfusards, who had perpetrated the many illegalities, the Dreyfusards, and Dreyfus himself, were dismayed.[24] Yet the amnesty merely applied paper to the deep political and cultural fissures, a fact that was soon evident in the policies pursued by the government against the Catholic Church. Despite the prime minister's desire for stability, Radicals and Socialists, now strongly embedded in parliament and triumphant from the Dreyfus Affair, embarked aggressively on a campaign of far-reaching reforms that, predictably, embittered the divisions within Belle Époque society, divisions that would find a point of rupture in the 'pantheonisation' of Émile Zola.

Waldeck-Rousseau merely wanted to curb the political influence of the clergy, not destroy the Church altogether, and the law on associations of 1901 was actually intended as a liberal measure to legalise the many organisations, including religious ones, that had not formally been authorised by the government. Waldeck-Rousseau's measure formally recognised all such associations except religious ones, which still needed to seek permission to exist, under some strict conditions. The prime minister quietly let it be known, however, that most religious orders would receive the authorisation they needed. This changed with the elections of 1902, which further tilted the political balance to the Left—formed together in an alliance, the Bloc des

Gauches, which won a majority of over eighty seats. The Radicals, in particular, saw clericalism as *the* enemy, a conviction merely reinforced by the Dreyfus Affair—which seemed to illustrate the insidious influence of the Jesuits on the army, among other things—and, in particular, by the toxic, antisemitic propaganda of the Assumptionist Order.

The new government, under the diminutive, goateed provincial doctor Émile Combes—a Radical whose anti-clericalism was sculpted in seminary school, where his struggle with his faith led him to reject a career in the priesthood—turned the law into a weapon against the Church. The government forced the closure of any religious house and school that did not secure approval within three months; applications were rejected wholesale, and the courts backed the newer, more rigorous interpretation of the law. This was followed by another wave of closures in 1904, when members of the clergy were prohibited from teaching, leading to thousands of Catholic schools and seminaries shutting down. Diplomatic relations with the Vatican were ruptured and the next, most radical step was taken in September 1905, when Napoleon's Concordat of 1802 was torn up. This was an agreement in which the pope had recognised some of the changes brought by the Revolution to the relationship between Catholicism and the French state, but in return the government had promised to recognise the faith as the religion of the majority of citizens and to pay the salaries of the clergy. Once this compromise was swept aside, starting in December, Church and State were officially separated.

The Church would survive the onslaught, not least because it found, ironically, that it was now freer to act. Moreover, the republican government itself soft-pedalled some issues—for example, allowing (in a law that had the support of Jaurès) ordinary Catholics to form cultural associations, which could use church buildings free of rent. Yet the impact on the Catholic Church in France was far-reaching, and it has never recovered the position that it enjoyed prior to 1905.

To reflect on this episode in French history, it is worth taking a stroll through the Musée Rodin and its beautiful gardens on the rue de Varenne in the 7th arrondissement. One might legitimately ask what a museum devoted to the work of the great French sculptor has to do with the separation of Church and State. The answer is that the Musée Rodin exists because of the anticlerical laws of 1901–1905. The museum was founded in 1919, but before then it was known as the Hôtel Biron. Built in the early eighteenth century, the mansion had fallen into government hands during the Revolution (when its occupant, the duc de Lauzun, was guillotined in 1793); five years after the Restoration of the monarchy in 1815, it was given to the women's branch of the Sacred Heart order, the Dames du Sacré-Coeur, who converted the palatial townhouse into a boarding school for the daughters of wealthy Catholics. The fine wooden wainscoting, the tall eighteenth-century mirrors, and the chandeliers were stripped out to make the atmosphere more austere. A chapel was built. And so it remained for the rest of the nineteenth century, until the republican assault on the Church after the Dreyfus Affair.

With the 1905 law separating Church and State, church property was taken over by the government, which sent its agents fanning across the country to take inventory. This process began in January 1906, but in Paris it was not without violence: the archbishop of Paris called on all the devout to occupy their churches and to resist—passively—the inspections. In practice, there were fist-fights between the parishioners and the police in some of Paris's most famous churches, such as Saint-Roch on the rue Saint-Honoré and Saint-Étienne-du-Mont next to the Panthéon. In Saint-Pierre-du-Gros-Caillou, not too far from the Hôtel Biron on the rue Saint-Dominique, some of the leading lights of the anti-Dreyfusard movement, including the author Léon Daudet and the antisemitic journalist Edouard Drumont, shut themselves into the church, prompting the prefect of police, Louis Lépine, to try to flush them out—literally—by ordering the fire brigade to spray their hoses into the church. When the police finally

broke through the doors, they found the interior flooded with ten centimetres of water.[25]

The expulsion of the teaching sisters from the Hôtel Biron, which, as a religious school, was closed down, took place without violence, but prints from the time suggest that it was an emotionally devastating moment for the nuns and their charges alike. Once it was in possession of the building, the government initially subdivided it into apartments, which were let out. Among those who took lodgings here was the sculptor Auguste Rodin, who also rented some downstairs rooms in which to store his work. These bright and airy rooms quickly became his studio: here he would shape his striking sculptures, and stroll with his friends and admirers through the increasingly tangled, overgrown gardens. Rodin was by now a celebrity and, in 1909, he offered his works and papers to the nation. The French government accepted them, and, when the artist died in 1917, preparations were made to convert the Hôtel Biron into a museum devoted to his work (and also to his former lover, the talented sculptor Camille Claudel, the troubled sister of the great Catholic poet and diplomat Paul Claudel). The Musée Rodin formally opened in 1919. Its very existence makes it a *lieu de mémoire*—a site in which the legacy of the Dreyfus Affair and the 'Franco-French' conflict between Catholicism and republicanism is heavily inscribed.[26] The republican assault on the Church could not but exacerbate the old cultural and political divisions in France, but for the Radicals and for the Socialists, including Jaurès, it was part of a much wider policy of democratising French society, of which secularisation—*laïcisation*—was an essential part—although Jaurès, like Péguy, could see the possibility of common ground: he noted that some progressive priests were seeking to 'reconcile the Gospel and the rights of man . . . priests democratic in heart and spirit'.[27] In practice, however, there was a concerted attempt to squeeze Catholic influence out of the army and administration.

In 1903, laws on *laïcité* insisted that all officials be politically neutral, and these laws were used to ban army officers from joining Catholic organisations. Combes's minister of war, General Louis André,

effectively spied on army officers by asking Masonic Lodges to report the religious and political views of those who attended Mass. These were to be submitted on special forms, or *fiches*. André's trawl for information produced a staggering list of 'suspect' officers—consisting of some twenty-five thousand names—who were then blacklisted for promotion. When *Le Figaro* broke the story in October 1904, the Right was outraged: Gabriel Syveton, a founder of the anti-Dreyfusard Ligue de la patrie française, slapped André in the face during contentious arguments about the matter in the Chamber of Deputies. Combes would eventually be compelled to resign in the New Year. For the anti-Dreyfusards, the *affaire des fiches* was crystal-clear evidence of their opponents' hypocrisy, for they had indulged in the kind of illegality that they themselves had so roundly criticised.[28]

It was in this bitterly partisan environment that, on 13 July 1906, the day after the reinstatement of both Dreyfus and Picquart into the army, the Chamber of Deputies voted to have Zola's remains transferred from Montmartre to the Panthéon. There was no debate then, but, while the bill passed easily, with 344 to 210 voting in favour, there was clearly a significant proportion of deputies who balked at the idea.[29] The decree passed through the Senate on 11 December and was signed into law four days later. The Nationalists hit back, however, on 19 March 1908, when it came to voting on the 35,000 francs needed for Zola's pantheonisation.

The session was a turbulent one. The Nationalist Maurice Barrès spoke first and critiqued his fellow writer's entire body of work as having misrepresented France and its people: 'In Monsieur Zola's books, the truth was ill-served and his depictions often mendacious and slanderous for our nation. . . . [T]here was a low and pornographic obsession in Zola.' For Barrès, Zola used science and republican ideals merely as a shield to defend himself against public opinion, which rebuffed his work. The only reason that Zola was now being canonised by republicans was 'J'Accuse . . . !'—and for that one article Zola was to be interred along with the likes of Victor Hugo, Napoleon's marshals, and the great chemist and onetime foreign minister Marcellin

Berthelot (who had been buried in the Panthéon the previous year). Barrès finished by presenting Zola's work as unpatriotic and giving comfort to France's enemies, particularly in *Le Débâcle*, Zola's novel of France's defeat in the Franco-Prussian War.[30] For other Nationalists, this was Zola's real crime: he had dishonoured France, patriotism, and, above all, France's army and soldiers.[31]

Jaurès, although frequently heckled by the Right, made the case in support of Zola, and in so doing he touched on the deeper conflicts that had frequently torn apart French society since 1789—and that, indeed, separated him so widely from Barrès, and Barrès from Zola. While Barrès had sought to detach Zola-the-novelist from Zola-the-activist, so allowing him to focus on his literature rather than his politics, for the socialist the two were inseparable: 'As a worker of letters, as a citizen, he was an energetic fighter for truth, and in that passionate love of truth lies the profound unity of his life and work,' declared Jaurès. For Zola, he added, merely to portray reality would be mere dilettantism: the truth that he put into his work he also had to put into his life:

> That, *messieurs*, that, Monsieur Barrès, is what the moving grandeur of his intervention [i.e., 'J'Accuse . . . !'] did for us, for the people of France [*exclamations on the right, applause on the extreme left and the left*]. And don't say that in doing so he did not serve the interests of the *patrie*; don't say that he belittled it in the eyes of the world and in its own eyes. The worst thing to have happened to France would have been to have tolerated without protest the prolongation of an injustice, leaving the corpse of justice to rot.[32]

Zola's realism as a novelist and his willingness to engage as a citizen put him alongside Voltaire and Rousseau, whose remains already lay in the Panthéon, and connected him with the age of Enlightenment. According to Jaurès, Zola was the heir of the Enlightenment: 'What humanity can keep [from Zola] are the striking efforts of truth

and science. Well! In Zola's work there are not only admirable and powerful depictions of life, but a sort of robust optimism, an invincible faith in the power of work, science, and life itself [*applause on the left and the extreme left*].' Before closing, Jaurès referred to Barrès's own vision of what French identity and nationhood meant: '[Zola] shows that, if it is good, as Monsieur Maurice Barrès demands, for great peoples not to forget their deep past, to honour the land and the dead, it is important not to mutilate the traditions of the country and [to recognise that] the bright genius of the *Encyclopédie* [one of the most important works of the Enlightenment] and of the Revolution is part of that tradition [*applause on the left and the extreme left*].'[33] After an intervention by the minister of education and arts, Gaston Doumergue, who also took aim at Barrès, the Chamber of Deputies voted the funds through.

Zola's defenders had won, but the arguments showed how both Zola and the Dreyfus Affair still bitterly divided French politics and cultural debate. The protagonists themselves traced these divisions deeper into the French past, and they expressed the profound, long-running conflict over identity and over what it meant to be French. For the republicans and the Left, Zola represented the inheritance of the Enlightenment, the French Revolution, and the pursuit of justice, truth, and liberty, universal values that were held to underpin the Republic itself. For the nationalist Right, Zola, the son of an Italian immigrant, was a foreigner and no better than a pornographer, a man whose activism merely corroded the moral virtues and religious values that came from the 'true', ancestral France that had existed before 1789.

It was the solidly moderate *Le Temps* that expressed the battle-weariness of many in the country over the debate. On the one hand, it suggested that Zola's pantheonisation was due less to his literary merits and more to his role in the Dreyfus Affair: It was 'the—fatal—consecration of the victory of a party most of whose members felt that they were defending the Republic as much as the idea of justice'. *Le Temps* pointed out that, should political fortunes be reversed, there would be nothing to stop their Nationalist opponents

from glorifying their own heroes in a similar fashion. In any case, it would have been best, the newspaper concluded, for Barrès not to have unleashed the debate, 'if only to avoid disturbing the peace of the country, which has barely begun to breathe again after so much agitation'.[34]

Yet such agitation persisted, in part because of the continuing aggression of the Nationalists, an aggression that made itself felt at the Panthéon on 4 June 1908. Among the emerging new leaders was Charles Maurras, the young literary critic whose career had been aided by Anatole France, but whose own philosophical journey, and his work with Maurice Barrès on the newspaper *La Cocarde* (The Cockade) in 1894–1895, had taken him into royalism. Maurras's view of French history was that the country's greatness had shone brightly in the sixteenth and seventeenth centuries, when France was a strong monarchy, Catholic and ordered. Already, however, the seeds of decline had been introduced in the shape of Protestantism, and then, in the eighteenth century, with the rationalism of the Enlightenment. The Enlightenment, with its universalist ideas of 'planetary fraternity', had nurtured rebelliousness among French citizens, with catastrophic consequences for France in the form of the Revolution. The corruption continued with the nineteenth-century Romantic movement, and with Maurras's 'intellectual' contemporaries, who, he argued, did nothing to defend the traditional values and national interests of France. He felt that the parliamentary republic was weak and corrupt and believed it was controlled by four 'Estates'—foreigners, Jews, Protestants, and Freemasons—who exposed the country to the control and influence of foreign forces. The state and the political élites bore no relationship to the 'real' country at large.[35]

The intellectuals who had joined with Maurras to form Action française in 1899, in response to the then impending retrial of Alfred Dreyfus, would almost certainly have preferred to be called 'men of intelligence'. They included Henri Vaugeois and the writer Léon Daudet. Action française was an extreme Nationalist organisation as well as royalist; it had a journal, *Revue d'Action française* (often called

'The little grey review' because of its grey cover), and, from 1908, a newspaper, *L'Action française*, edited by Daudet and funded by the anti-Dreyfusard salon hostess Madame de Loynes. In the first number of the newspaper on 31 March 1908, Maurras, Daudet, and the other founders outlined their idea of 'integral nationalism'. They identified the ills that they believed had beset France: the 'cosmopolitan anarchy' that left government in the hands of 'foreigners by birth or at heart'; 'academic anarchy' that allowed Jews and Protestants to spread their anti-French views among the young at universities; 'domestic anarchy' that undermined the authority of fathers and ruptured marriages; and 'religious anarchy' that was 'determined to dissolve the organisation of Catholicism'. The solution they offered through 'integral nationalism' was a restored Bourbon monarchy, with no parliament, that would embody the nation in the person of the king, who would control a strong central government but also allow 'entirely free Towns, Provinces, and Corporations' that would uphold people's freedoms but offer mutual support to the monarchy.[36] What these 'freedoms' were, and who would enjoy them (presumably not foreigners, Protestants, Jews, and Freemasons), remained unclear.

Action française's reactionary position—Vaugeois's aphorism was 'reaction first'—was bolstered by a cascade of antisemitic and xenophobic propaganda and street violence in the years immediately after 1899.[37] Maurras never let up on Dreyfus, 'the rehabilitated traitor', repeatedly calling for him to be shot. The rank-and-file members of the organisation, workers and students of the youth wing of Action française, were called *les Camelots du Roi*, a name that came from the term for newspaper vendors, *camelots*, because they also sold the organisation's newspaper, except that, unlike the regular news vendors who trod the streets, they also carried heavy walking sticks. It is probably safe to say that these implements were not, in most cases, required to aid mobility. The students amongst the *camelots* were particularly active in the Latin Quarter around the Panthéon and the Sorbonne (not so long ago, in the 1990s, the present author was somewhat stunned to see Action française graffiti on the back wall of the

Sorbonne). The controversy over Zola's pantheonisation was an ideal opportunity for them to make their presence felt. At a public meeting held on 30 March 1908, the orators, including Daudet and Vaugeois, spoke out violently against the late Zola. In May, Action française protesters disrupted the lectures of a professor who had dared to organise a study trip to Germany. The concerned police commissioner reporting on this insanity noted that 'the momentum brought by Action française to the demonstrations in the Latin Quarter . . . will certainly not relent before 4 June, the date fixed for Zola's pantheonization'.[38] If what happened at the ceremony that day was not the direct responsibility of Charles Maurras and Action française, they certainly helped to build the toxic atmosphere that made it more likely.

ON THE EVENING of 3 June 1908, Zola's body was exhumed from the cemetery in Montmartre, placed in a new coffin, and then put into a hearse for the journey across the city to the Panthéon. When the carriage—followed by others bearing his wife, Alexandrine; his two children by his mistress, Jeanne Rozerot; and some of his supporters, including Georges Clemenceau—entered the rue Blanche, a group of *fiacres*, small, four-wheeled coaches for hire, appeared in pursuit. They were foiled, however, by the authorities, who had anticipated trouble and blocked the road to all other traffic.

The procession got as far as the Latin Quarter without any further incident, but there, the crowds awaited, packed into the rue Soufflot. Some of them were chanting 'Down with the Jews! Down with Zola!', while on the opposite side, others yelled 'Vive Zola!' Reinforced by the *Camelots du Roi*, the nationalist protesters attacked the cortege—Alexandrine's carriage was nearly taken by force, its decorative crowns torn off and the flowers strewn about. The surge of police officers on foot, on bicycles, and on horseback swept the assailants away, but in the fracas, journalists accompanying the procession were mistaken for supporters of Zola, and, as the writer for *Le Temps*

later reported, one of them received a blow on the head with a tell-tale walking stick.

Escaping the violence, the carriages swung down towards the rue Cujas, from where they gained entry to the place du Panthéon. The front of the mausoleum was draped with tricolour flags and billowing black mourning drapes, and lit by torches slowly burning with a green glow. Although out of harm's way, the cortege was still within earshot of the raging crowd, which surged back up the rue Soufflot. The pallbearers carrying Zola's coffin raced to carry it up the steps and into the former church, while porters ran to close and lock the iron grilles that enclosed the ground immediately around the Panthéon. Teeming outside the fence, the crowd screamed, 'Drown the Jews! Down with Zola!', reducing Alexandrine to tears.

Inside, the *Temps* reporter wrote, 'The monument was only feebly lit at this time of evening and beneath the high vaults the silence was impressive.' The seats were covered in red velvet, the floor with a red carpet. Zola's coffin was placed on the catafalque beneath the soaring dome and draped with gold and purple. Standing before it were Alexandrine and the children, carrying flowers, and 'all around the catafalque, there was an expanse of flowers that were blooming and perfuming the air'. At the apse, there was a massive tricolour flag hanging, along with a large green palm leaf veiled in violet and black crepe. Fixed to the pillars were flags and the author's intertwined initials.

Aware of the danger from outside, the friends who were admitted to this quieter, more intimate ceremony were determined to stand vigil over the coffin through the night. Among them was Alfred Dreyfus. As darkness thickened, lanterns were lit along the floor: the feeble light, the silence, the shadows, and the scent of the flowers contrasted starkly with the now distant sound of the crowd from beyond the rue Saint-Jacques and on the boulevard Saint-Michel, close to the Luxembourg Gardens. Their voices, baying against Zola and Jews, were only a distant murmur occasionally floating up whenever the mourners went out into the peristyle outside for a breath of fresh air. There,

the sabres of the police officers lined up to guard the building were seen to glint in the moonlight. It was midnight before the crowd dispersed and all was calm. Ominously, one demonstrator was arrested carrying a gun.[39]

The following morning, the official guests, including the president, Armand Fallières, and Georges Clemenceau, now minister of the interior, began to arrive from 9 a.m.—running the angry, braying gauntlet that had reassembled outside. At one point, the police defences came close to being overrun when the officers were diverted to help some of the traffic through the press of the crowds. A counter-protest of republican students—many, as during the Dreyfus Affair, from the École normale—clashed violently with the Nationalists, and the police moved in, arresting no fewer than a hundred people.

During the ceremony, the crowds were kept back by barriers, but more arrests were made—*Le Temps* noted that they were mostly young people between eighteen and twenty-two, so of college age. Judging by the reports of them fighting back to resist arrest, most of them were *Camelots du Roi*. Inside, the ceremony itself passed off without incident. It included the playing of the 'Marseillaise'; some Beethoven (including the soaring final movement of the Ninth Symphony, which includes Schiller's 'Ode to Joy'—it's almost a pity that Maurras and Barrès were not at the ceremony: they would have had a conniption at such an airing of Germanic culture); and the revolutionary 'Chant du Départ' (Song of Departure). In between, Gaston Doumergue gave a speech.

It was at the end of the ceremony, as the president was about to exit the building to take the salute from the military parade outside, that there was an attempt to murder Alfred Dreyfus: 'There was the explosion of a revolver being fired a few steps from the catafalque. Since people were leaving the Panthéon, in the hubbub of conversation and the scraping of seats, this detonation did not provoke much of a reaction, but only a few seconds later, a second shot was heard and straight away we saw a stampede around where the Zola family had been sitting. One person had fired at point blank range at

Commandant Dreyfus.[40] Dreyfus was only lightly wounded in the arm, which he had raised to defend himself.[41] The would-be assassin, Anselme-Louis Grégori, was quickly bundled away, arrested, and then questioned. A veteran of the Franco-Prussian War and a writer for a specialist military journal, Grégori claimed to be motivated by anger over the insult against the army, which was being compelled to undergo the ceremony honouring Zola. He also claimed not to have wanted to kill Dreyfus, but only to make a protest—against, as he clarified later, the Dreyfusards.[42]

The republican press roundly condemned the outrage. *L'Aurore* wondered whether or not those who fomented such discord—alluding particularly to writers such as Maurras, to *L'Action française*, and to Drumont's *Libre parole*—would now reflect on the consequences, but was not optimistic: 'Who knows! Maybe they are still proud! And the blood which could have flowed in even greater abundance has not weakened their hatred or slaked their thirst for vengeance.'[43]

L'Aurore's doubts about the possibility of any healing or consensus were shared by the Nationalists on the other side. While not directly endorsing Grégori's actions, the right-wing press nonetheless justified the motives behind them: Arthur Meyer, the monarchist editor of the anti-Dreyfusard *Le Gaulois*, which had published some of Grégori's articles, argued that the paper was 'too respectful of the teachings of the Church to approve of a murderous act—even if it seems to be justified'. Reporting the attack, it judged Grégori merely to be 'an exasperated patriot', so his motivations were honourable no matter how misguided his actions were: deeper responsibility lay with the republicans, 'the radico-socialist council', which had proceeded with Zola's 'secular canonisation'.[44] For Meyer, attempted murder was, clearly, an entirely understandable response. *L'Action française* went further, publishing a short biography of the assailant highlighting his earlier academic brilliance, his military career, and his patriotism: he was 'the author of the act of vengeance'.[45] At the same time, however, Charles Maurras inserted an editorial in which he reported that he and Léon Daudet had talked an outraged army officer out of trying just such an

act, on the grounds that 'what we have demanded, demand and will always demand for the author of the treasonous *bordereau* . . . is the twelve bullets of a firing squad'. This, Maurras added, was how they would have advised Grégori if he had come to them.[46]

When Grégori was brought to trial, he declared that he wanted his case to be 'the revision of the revision' of the Dreyfus Affair. Sure enough, he would be acquitted—which would be astonishing were it not for the fact that the jury appears to have agreed with the Nationalist press that he was an exasperated patriot, as the defence counsel argued: 'In acquitting him, you would both be doing justice to the generous sentiment that made him act . . . and saying that to restore peace requires concessions from both sides, but that there are concessions that should not be made—those that affect the country and the flag.'[47] In the end, what prevailed was Maurice Barrès's notion that 'abstract' ideas like truth and justice for the individual mattered less than the 'honour' and alleged sovereignty and security of the nation.

ACTION FRANÇAISE WOULD always remain on the fringes of French politics, although Maurras would later (unsurprisingly) enjoy a flourish during the Nazi Occupation and Vichy regime in 1940–1944. His extreme views did not entirely capture the mainstream of French public opinion any more than Action française's radical opponents on the left did. But that it was able to spearhead such violent protests against the pantheonisation speaks to the sway it had over some of the young people and students, the denizens of the Latin Quarter. Moreover, it fed into the wider political context, particularly after 1910, when a 'nationalist revival' would be led by moderate republicans who had been anxiously watching events unfold in Europe, and who were concerned about the mounting possibility of war. In so doing, they embraced a more energetic brand of patriotism, emphasising French military glory and greatness, and issued appeals for national unity.[48]

Even so, this 'nationalist revival'—which went right to the top, since it was embraced by the conservative republican Raymond

335

Poincaré, who was president from 1913—could only paper over the very real challenges of building a consensus in French politics. Moderate republicans and the Left—although they had their seething differences—generally held together right up to the fall of the Third Republic in 1940, bolstered by the reflex among socialists, and later communists, to rally with the centre in defence of the Republic whenever the nationalist Right presented a serious threat.[49] Such mobilisation was needed in times of crisis, as the danger from anti-republican, anti-democratic forces on the Right was never quelled. Yet at the same time, as we have seen, this period also saw revolutionary threats from the extreme Left, in the shape of syndicalism and the strike wave that continued to course through France in the years that followed May Day 1906. And the 'nationalist revival' was also exploited by moderate republicans eager to garner support from the Right as they tried to face down the challenge from the Left: in some respects, Poincaré—'cold, aloof, unemotional', in the historian Jim McMillan's assessment—used nationalism to mobilise the moderates and the Right against Socialists and left-wing Radicals.[50]

But the ceremony for Zola in June 1908 had brought out the challenge from the extreme Right: Although it made a lot of noise and was violent, it could not hope to overthrow the regime, however much Maurras, Daudet, and Barrès wanted it to. All they could do was to register a vehement and indeed violent protest against the values of the Republic and its attempt to shape French identity in a republican image. The demonstrations around the Panthéon in June 1908 therefore subverted the Republic's attempt to align its 'official' memory with the 'collective' memory of the nation at large: the latter did not exist in any unified sense. A vocal and potentially large section of the population accepted neither Zola as a figure worth commemorating nor the values that he and the Republic claimed to represent.[51]

The pantheonisation of Zola and the demonstrations against it exposed once again the 'two Frances' in opposition to each other, as the French historian Jean-François Condette has argued. The ceremony was not, as the republicans wanted, a unifying moment, but

rather (as *Le Temps* noted at the time) an overtly political act—one that evoked a triumphant radical Republic exulting in the heritage of the French Revolution and the Enlightenment as against a more conservative France that accepted neither the inheritance of 1789 nor the parliamentary Republic.[52] Perhaps, however, it is better to say that, given the survival of the Republic until it collapsed under the shock of Nazi Blitzkrieg in 1940, the event revealed the dangers to democracy, and to the essential values of the Republic, should the broad consensus among republicans and socialists to rally together in 'republican defence' ever fail in the face of a resurgent extreme Right. That is surely a lesson for today—and not just for democracy in France. The demonstrations were not representative of the balance of French political forces as it was at the time, but a nightmarish evocation of what they could be: a brutal polarisation between the 'two Frances' that risked civil war, whether in print or with bullets. The violence surrounding Zola's pantheonisation became, in retrospect, a warning from the past.

That the Panthéon is in the Latin Quarter was unfortunate for the celebrants of Zola's memory. Paris's academic heartland, with its youthful population, was a fertile recruiting ground for radical causes of both Left and Right, as we have seen in the case of Action française. Yet the challenges arising here were not just political, but also intellectual and cultural. It was not only a place where bourgeois morality could still be challenged, and where feminists struck at established ideas of what women could and could not do. It was also where long-held assumptions and cherished ideas underpinning faith in progress and science might be whittled down. It was where, in an intellectual sense, the assumptions of Belle Époque modernity came to die.

CHAPTER 11

CRISIS

D own the hill from the Panthéon, the place de la Sorbonne sits snugly between the boulevard Saint-Michel and the Sorbonne itself, at the very heart of Parisian intellectual life. The university's domed Baroque chapel, commissioned in the 1640s by Cardinal Richelieu, dominates the western vista of the square, giving it an elegance and beauty that is enhanced by its trees and its fountain. With its rows of cafés, their seating extending outside, the square, somewhat removed from the traffic on the nearby boulevard, is a very pleasant place to stop and have a drink and to savour the hubbub of conversation. However sociable this corner of Paris, its location within the heartland of Parisian academia also placed it close to the geographic centre of the final intellectual crisis of the Belle Époque, a crisis which unravelled the certainties underlying so much of the era's triumphant modernity.

Towards the northern side of the square (to the left as one admires the dome of the Sorbonne chapel) is a statue of Auguste Comte. Comte was a philosopher who, in the first half of the nineteenth

century (mostly—he died in 1857), posed the theory of 'positivism'.[1] To grapple with the meaning of the French Revolution, Comte sought to view it in the context of a wider phenomenon—the development of human society. For him, the pace of change in modern times had outstripped the older worldviews that were based on religious and metaphysical beliefs. The human mind needed a new philosophy, a new way of understanding the world: what was needed was a scientific, empirical doctrine rooted in the close examination of society, which could be analysed through an understanding of the past, a detailed assessment of the present, and a projection of future developments. Essential to this study was a grasp of what Comte called 'social statics'—the conditions in which society existed—and 'social dynamics', the laws of change.

Comte believed that social development and social phenomena could be scientifically observed and ultimately predicted. The human mind, universally, passed through three stages of development. First came a theological stage, in which belief in a divinity explained the natural world, which for Comte preceded the age of Enlightenment. The second stage was metaphysical, positing abstract laws—namely, concepts such as rights, which were inherent in human beings—and questioning religious dogma and divinely ordained authority, and it was to this transitional stage that the struggles of the French Revolution belonged. The third and final stage was the 'scientific or positive state', whereby the human mind found its answers in investigation, connecting anything that could be observed and analysed to wider, scientific laws.

In the 'positive state', the human mind sought 'the discovery, through reason and observation combined, of the actual laws that govern the succession and similarity of phenomena'. Comte spoke of his approach as 'social physics': he was laying the foundations of the social sciences, and particularly sociology and political science. He ranked the different scientific disciplines according to their movement through the three stages: maths (to the chagrin of those of us who, like the present author, despite enthusiasm for the subject, are

not much good at it) comes out on top. Comte sought to understand the interconnectedness of the different parts of society and to formulate 'the positive theory of order' and of social progress. This emphasis on scientific investigation and knowledge also led him to stress the importance of education as the instrument by which people would come to understand that their personal interests were actually subordinate to the greater, common good of society. This would be a 'positive morality' that would make people accept that their own happiness was connected to the wider well-being of everyone else.

Comte died during the Second Empire, but his impact on the Third Republic was profound. His emphasis on science, knowledge, and education—the analysis of observable, verifiable facts—gave republicans a philosophy to support their scientific, secular worldview. Among the consequences of the Dreyfus Affair was a push to infuse France's universities with the republican values that sponsored the 'critical idealism' embraced by Comte's disciples. Comte's stress on the scientific analysis of society permeated much of French republican culture, from Gustave Eiffel's towering celebration of engineering genius to the gritty, 'naturalist' novels of Émile Zola, who sought to depict society as it was, not as he thought it ought to be. In *Paris*, one of his last novels, Zola's main character, the priest Pierre Froment, ultimately embraces the possibilities of science and progress. As the narrator puts it, reflecting Froment's point of view, 'A religion of science is the clear, certain, inevitable end of the long march of humanity towards knowledge.'[2] During the debates on funding Zola's pantheonisation, Jaurès had lauded the novelist for his 'robust optimism, an invincible faith in the power of work, science and life itself'.[3] It was also this scientific, empirical approach to knowledge that Nguyễn Trọng Hiệp was lauding when he wrote of 'the particular way' in which France taught its young people—going on, in particular, to discuss sciences and chemistry.[4]

The centrality of human reason and knowledge was elevated into an informal, secular religion bolstering the Republic. As the linguist, historian, and philosopher Ernest Renan exulted in 1891, 'Science is a

religion, science alone will henceforth make the creeds, science alone can solve for men the eternal problems.'[5] It is no surprise to learn that, when the statue to Auguste Comte was unveiled on the place de la Sorbonne in 1902, it was Émile Combes's minister of war, General Louis André, a hard-line republican and an admirer of Émile Littré, positivist and onetime friend of Comte, who officiated.[6]

Yet the empirical certainties that underpinned the celebrations of science, human progress, and republican democracy were thrown into question from a popular, influential, and earnest source: Henri Bergson. Bergson was Jewish, the son of a Polish musician who had left his country—then in the iron grip of tsarist rule—married an Englishwoman (thanks to whom Henri would be fluent in English), and worked as an organist in Paris. Henri took a scholarship at the Lycée Condorcet, then another at the élite teacher training college École normale supérieure. There, one of his classmates was none other than Jean Jaurès, and the two competed with each other. When their history professor, Ernest Desjardins, pitted them against each other in a debate on Roman history, although it was felt that Jaurès's rhetoric was superb, ultimately Bergson's logic won out. When both Bergson and Jaurès graduated in 1881, Bergson came in second in the class, Jaurès third. In the year below them was Émile Durkheim, who would become one of the world's most influential sociologists, refining Comte's positivist ideas. Jaurès struck up a lifelong friendship with Durkheim, but Bergson's ideas would soon contradict Durkheim's.[7] Bergson spent the 1880s teaching at various lycées before defending his doctoral thesis in 1889. The thesis would become his first great work, *Essai sur les données immédiates de la conscience* (Essay on the Immediate Data of Consciousness), soon translated into English as *Time and Free Will*. In 1896, the year in which he published his second important book, *Matière et mémoire* (*Matter and Memory*), he was appointed to the Collège de France, where, in 1904, he secured the modern philosophy chair.[8]

The Collège de France sits somewhat austerely behind the Sorbonne, the two prestigious institutions divided from each other not

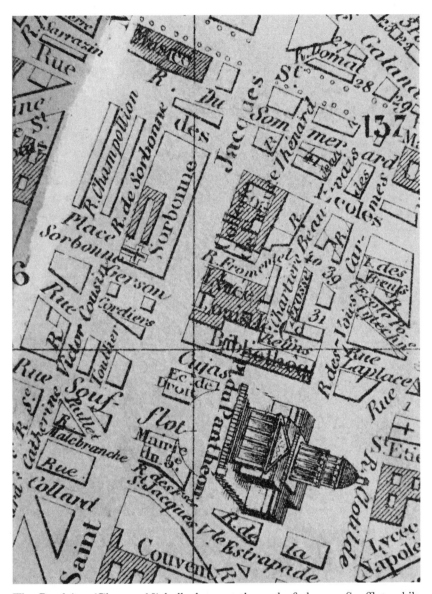

The Panthéon (Chapter 10) bulks large at the end of the rue Soufflot, while to the north, down the rue Saint-Jacques, lie the Sorbonne and the Collège de France (Chapter 11). The place Sorbonne sits outside the western entrance of the former.

just by the relatively narrow rue Saint-Jacques but, as the Russian poet and philosopher Raïssa Maritain put it, 'by a mountain of

prejudice and distrust'.[9] The Collège was founded in the sixteenth century as a Renaissance alternative to the Sorbonne, whose theologians and faculties claimed a monopoly not only of teaching, but also of all beneficial knowledge. The Renaissance opened up new avenues for learning and inquiry, and by the sixteenth century it seemed clear that the privileges of the University of Paris were so deeply entrenched that there was little hope of compelling the Sorbonne to change with the times. In 1530, the Collège royal (as it was originally called) was founded to engage with the new knowledge and to teach languages in addition to Latin, such as Hebrew and ancient Greek (at one point, it was called 'The College of Three Languages'). Now one of France's most prestigious institutions of higher learning, it sought to present a curriculum wider than that shaped by the Sorbonne's theologically driven scholastic traditions.

The Collège royal had no 'corporations', so no formal student body, and it did not offer degrees or diplomas. This is still true today, and its classes are still open to everyone—each professor has to deliver a new course of public lectures each year. The Collège therefore has always stood at the very touching-point between academia and the general, interested public.[10] The oldest of the buildings standing today were constructed in the seventeenth century during the reign of King Louis XIII. In the eighteenth century the forecourt, the 'Cour d'Honneur', which opens up towards the rue des Écoles, was added, and in the mid-nineteenth century buildings were extended eastwards towards the rue Saint-Jacques. In 1870, with the advent of the Third Republic, the 'Collège impérial', as it had been called under Napoleon III, took the name that it has today, the Collège de France.[11] If one descends from the Panthéon on the Montagne Saint-Geneviève today, down the rue Saint-Jacques, with the towering, almost monolithic wall of the Sorbonne to the left, one eventually passes the old gate of the Collège royal, with its two figureheads representing science and literature: for the latter, one could read the humanities.

In keeping with the humanist traditions upon which it was founded, lectures and classes in the Collège were and are freely open to the public—today, indeed, they are accessible online as podcasts on the institution's website. Between 1900 and 1914, Henri Bergson lectured almost without fail twice weekly in Room 8 on Fridays at 5 p.m. and on Saturdays at 4 p.m. The first three of Bergson's great works—his doctoral thesis, *Time and Free Will* (1889), *Matter and Memory* (1896), and *L'Évolution créatrice* (*Creative Evolution*, 1907), which became a bestseller—made him not only a well-known philosopher in academic circles, but also something of a celebrity among the interested public. These three books had been translated into English by 1910: after dining with him in 1911, when Bergson lectured in London and Oxford, Bertrand Russell remarked that 'all England has gone mad about him for some reason. It was an amusing dinner.' Bergson also became popular in the United States: in *Tropic of Capricorn*, Henry Miller boards the elevated line at Brooklyn Bridge with, as he puts it, '*Creative Evolution* under my arm. . . . My language, my world . . . under my arm.'[12]

Bergson's popularity flowed not only from his own considerable depth as a philosopher and skill as a speaker, but also from the fact that his ideas addressed that old anxiety that had been stirring in the Belle Époque, but which became more urgent after the dawn of the new century. People were beginning to seek a deeper understanding of the world around them, in which the speed of material, technological, and scientific change seemed to be accelerating at a head-spinning rate, but behind which lagged morality, spirituality, and meaning. What was the purpose of all this 'progress'? In what direction was it heading, and to what end? What room was there for God or the soul, if they existed at all, in these developments? For all the advances in scientific knowledge and the application of technology, what deeper value could be found in the world?

Confronted with the swirl of confusion and doubt thrown up by the very pace of change, people were coming to find the positivist, scientific emphasis on observable, verifiable facts and reason to be

rather desiccated. Science simply did not have the answers to these moral questions. Bergson, by contrast, sought to bridge the gap between science and metaphysics—the search for answers to the fundamental questions about existence, knowledge, time, and space. And he tested the ideas for his works with his public lectures at the Collège de France.

Writing in *Time and Free Will*, Bergson argued that there were two kinds of human consciousness, or self: the relative and the absolute.[13] The 'relative' consciousness assumed that we perceived things from the outside and so depended upon our perspective and the language (symbols) that we used to define those things. This process, which was the basis of scientific thinking, focussed on the outside world and ignored our inner states, which we tended to explain merely with reference to outside influences. 'Absolute' consciousness, on the other hand, understood objects from the inside. This understanding was not dependent upon either one's own perspective or the symbols to express it, but was instead *intuited*. As Bergson explained it, we understood our absolute selves 'by deep introspection', which enabled us 'to grasp our inner states as living things . . . as states not amenable to measure [and] which permeate[d] one another'. Relative consciousness reduced things to their already-known elements, and analysed their constituent parts, before 'translating' them into symbols (such as language or numbers) defining them in relation to other, similar objects. This missed their true meaning, which lay not in how they measured up to other things, but within their true essence. With the relative self, he wrote, 'we live outside ourselves, hardly perceiving anything of ourselves but our own ghost. . . . [W]e live for the external world rather than for ourselves.' With absolute consciousness, we grasped the essence of things, because we in some way entered into ourselves and took hold of our own, autonomous nature—and this required 'intuition', which (as it turns out) was a somewhat slippery concept, but involved what Bergson called 'multiplicity', that is, beginning one's observations afresh: it was a 'true empiricism' that did not seek to assess

consciousness through symbols (language), but rather conceptualised its responses in the light of ever-changing experiences, each and every time. 'To act freely', he wrote, 'is to recover possession of oneself.'[14]

Crucially, Bergson argued, conventional, relative ways of thinking missed the actual reality of our experiences. This misunderstanding came from the fact that, while objects and phenomena, including space and time, could be measured, we tended to transfer that habit of measurement of external objects to our feelings, to our inner states. In doing so, we misunderstood the experience: our experience of, for example, a particular sound was connected less to what could be measured (the sound in decibels) than to the intensity of our experience of it in that particular moment. It could not be measured or objectified (that is, treated as a physical object). This was the mistake of the conventional scientific method, but it was also the error of seeking to understand inner feelings as though they were explicable solely through the impact of external factors, and understandable through reason: in fact, they could only be fully and truly grasped as a whole through intuition.

This notion had implications for our understanding of space and time. Space and time as measured in relative consciousness were 'spatialised'—units separated from each other and counted. They gave experience a fixed form, not least because they were expressed in symbols (words and numbers) that measured them in relation to other fixed forms. We also tended to see time as linear or cyclical, which imposed an order—a spatial dimension—on time that actually restricted how we thought about it. This sense of time and space as *quantity* missed the *quality* of experiencing them, which came from the different sensations that arose in the moment of the experience, feelings that flowed and ebbed from one moment to the next, that came together and were experienced as an encompassing, unique sensation in that moment. The 'spatialisation' of time and space, as if they were physical objects, was the basis of the conventional way of thinking about time as fixed and measurable. But *real* time

for Bergson was actually rooted in the multiplicity of ways in which we *experienced* time from one moment to the next. Bergson called this conception of real time *durée* (duration). He accepted that conventional, relative understanding—by being expressed in symbols such as language—gave people a common way to grasp the world around them and communicate with each other about it. It shaped the 'social self', but it missed the true 'fundamental self', not least by confusing the *representation* of the self through words and symbols with the actual essence of the real self, our true inner states, which could only be grasped through intuition in real time. So for Bergson, the intellect alone could not fully understand the complexity and fluidity of existence. To begin to do so, we needed to abandon the limitations imposed by language and embrace through intuition the myriad twists and turns that made up human experience.

For Bergson, the contemporary debate between determinists, who argued that human behaviour was so shaped by environment and antecedents that any given situation ultimately led to only one possible response, and proponents of free will, who suggested that there could be a wide range of actions arising from the same set of circumstances, was wide of the mark. This was because both sides expressed themselves in the language of conventional thought, which put fixed, measurable values on human experience. These, in turn, obscured the understanding that human consciousness was not, in fact, constrained by the physical laws of the external world.

Bergson argued that the free expression of true consciousness was restrained by the social self and by the very mode of thinking and the symbols used to communicate it to the external world. So genuinely free acts were rare: people most frequently only saw the expression of their true consciousness in their dreams. In *Matter and Memory*, Bergson explored the role of memory and the unconscious, which he regarded as the foundation of human spirituality, because the accumulation (often subconsciously) of memory from experience, understood through real time, *durée*, was unique to each individual, and therefore could not be subject to scientific laws.

For Bergson, the essence of our humanity was its potential for freedom, a freedom that was only truly expressed when we were willing to think in ways that engaged with the whole experience around us without the distortions of our reflective consciousness and our social selves. What this meant was that thinking was not some quiet, contemplative act, but rather the prelude to action, to true interaction with the world around us whereby we sought to shape its direction. We could be truly free, but we usually chose not to be so, partly because we were unwilling to cast aside ways of thinking that confused language and other symbols with the things they were seeking to represent.

True, living reality, for Bergson, came from grasping our inner states and understanding how those inner states were shaped by the succession of experiences through real time, *durée*. And since those experiences, and therefore living reality, were constantly in flux, our manner of thinking needed to change with them. In *Creative Evolution*, the book that turned him into an international celebrity, Bergson suggested that such change was existence itself: 'For a conscious being, to exist is to change, to change is to mature, to mature is to go on creating oneself endlessly. . . . [L]ife, like conscious activity, is invention, is unceasing activity.'[15] If only we were able and willing to grasp our inner selves, we could use this movement to participate in and shape creation itself. It was this energy unleashed by our ever-changing selves, rather than scientific laws, such as Darwin's theory of natural selection, that was the force behind evolution: Bergson called it the *élan vital*, the vital energy of life.

BERGSON'S TWICE-WEEKLY LECTURES were social and cultural events. Charles Péguy, the Dreyfusard poet who had attracted a circle of other young writers and intellectuals, attended Bergson's lectures assiduously. In 1902, he wrote, 'I saw men, elderly men, ladies, young girls, young men, many young men, Frenchmen, Russians, foreigners, mathematicians, naturalists, I saw humanities students, science

students, medical students, I saw engineers, economists, lawyers, laymen and priests. . . . I saw poets, artists . . . haute bourgeoisie, socialists, anarchists.'[16] Bergson's audiences consisted mostly of a mixture of university students, avant-garde intellectuals, and the educated middle class, men as well as women. The crush in lecture theatre number 8—which had a maximum capacity of 375—was such that people arrived hours early to make sure they got a seat, thereby inadvertently swelling the audiences of the lecturers speaking beforehand. The economist Pierre Leroy-Beaulieu's lectures were once heckled by those who were waiting, because they were eager to speed things up and get to the main attraction (Bergson after this incident rounded on his shamefaced listeners and gave them a telling off).

The entrance to the hall was often a scene of uncollegial carnage, with people pushing, elbowing, and shoving to get ahead in the race for seats—Alvan F. Sandborn, an American journalist, laconically observed that it was rather like rush hour at the City Hall–Brooklyn Bridge subway station in New York.[17] People sat in the aisles, while those who could not gain access tried to listen at the windows and from the hallway. Breaking the rules that did not permit the reservation of seats, wealthier bourgeois ladies would send their servants ahead to keep a place for them until they arrived. The carriages of the richer attendees would be parked outside the Collège all the way down the rue des Écoles.

Pressure to find a solution to the problem mounted, particularly from the students, who felt that they should have a section reserved for them. In 1910, Bergson, while sympathetic, rejected the request, on the grounds that it was contrary to the 'spirit of this institution, whose teaching is free, and where no course is closed'. When, in January 1914, the Collège finally relented and introduced a new seating policy, asking audience members to surrender some of their seats to students, there were immediate protests. As one smirking journalist describing the 'beautiful uproar' remarked, the people who refused to budge 'proved superabundantly, by their wild objections, that they totally lack[ed] the philosophic spirit'.[18] There was a suspicion that much of

the audience was less inspired by a search for understanding than by the desire to take part in a fashionable cultural phenomenon: they were 'neophytes eager to hear a witticism', in the opinion of the director of the Collège, Maurice Croiset (who was speaking in particular of the fashionable women in attendance, although Bergson himself held that women were the intellectual equals of men).[19]

In this sense, the controversy was strangely part of the broader frictions of Belle Époque modernity, both materially and morally. Materially, Room 8, housed in buildings constructed before the rise of mass culture, could not accommodate the new, expansive public. Moreover, critics who suggested that much of Bergson's audience was merely vogueish were inadvertently expressing one of the concerns about mass culture—that it lacked depth and would lead to mediocrity, driven by the public quest for entertainment rather than knowledge.

Bergson's public reach came, of course, thanks to the public-facing culture of the Collège de France itself (at least, for those who managed to battle their way into his lectures). But his popularity also came because he was able to enrapture his audiences for hours. Slender, dressed in black, and, when he entered in a swirling dark frock-coat, with his piercing, alert blue eyes and a long, slim nose beneath his tall forehead and balding hair, always composed, he looked every part the philosopher. He lived quietly in a house in Auteuil with his wife and daughter (who was deaf and would grow up to become a distinguished sculptor), and travelled to and from work on the tram. In 1914, the humourist René Benjamin lampooned his appearance: there was no better way for Bergson to advertise his calling than to 'be dressed completely in black, from head to foot, with his sinister frock-coat hugging his thin figure and making his elbows stick out, giving him the appearance of a mummy wrapped in its funeral bandages'.[20] Bergson's student Étienne Gilson fondly remembered his style as he 'concentrated upon the inward vision that his words sought to communicate': 'Standing, always speaking without notes,' Gilson wrote, Bergson 'held us under the same spell

that Socrates' listeners knew in olden days and that only the music of pure intellect can create.'[21]

Yet the heft of Bergson's impact came from what he said. Positivism was beginning to feel to many people like an arid, intellectual scepticism, devoid of spirituality and unable to promise answers to the deeper questions about life and its meaning. As Gilson wrote, he had felt like he was 'wandering the desert of scientism' and looking for a way out.[22] At the same time, science and social science themselves were opening up new ways of understanding the physical and the human world: studies of neurology by, among others, Jean-Martin Charcot, who influenced both Bergson and Sigmund Freud (who attended his lectures for three months in 1885), and developing ideas about psychiatry opened up new vistas on the mind, some of which defied earlier, rationalist explanations. Some of this work suggested that the human mind did not just respond to the external world, but the influence could go in the other direction: someone's mental state could also affect their physical health. Scientific discoveries, such as X-rays by Wilhelm Röntgen in 1895 and of the transmission of radio waves by Guglielmo Marconi that same year, and even the demonstration by the Lumière brothers of the cinematograph (Bergson was himself an enthusiast, likening a single frame to a single idea, the whole film to the process of thought), all seemed to suggest that matter itself was more elusive, indeed more flexible, than was once imagined.[23]

Different elements of Bergson's philosophy appealed to different segments of his public. Among the university students, who were being channelled into an increasingly complex array of academic specialisms, Bergson offered an overarching understanding of knowledge, one that also bridged the gap between scientific and metaphysical questions. 'Bergsonianism' seemed to provide an answer to the fragmentation of knowledge that had been identified as a symptom of modernity and, for the young, an understanding of the world that was broader and less doctrinaire than that offered by their positivist professors at the Sorbonne. As one of those professors, Georges

Fonsegrive, later admitted, members of the younger generation of 1914 felt that they had 'carried scientific dogmatism, positivism and mechanism too far', and that these approaches amounted to a materialism that was arrogant and based on 'formulas that were so absolute and tyrannical of claim that the critique of intellectualism professed by Monsieur Bergson was, for many young spirits, a kind of liberation'. One of these students, Raïssa Maritain, put it even more harshly: the understanding that their professors had given them 'for life's journey' had turned out to be nothing but 'death and dust'.[24] The desire for knowledge beyond the empirical also echoed more widely through Belle Époque culture: Maurice Barrès spoke to many young readers when his popular trilogy *Le Culte du moi* (*The Cult of the Self*) offered a more spiritual alternative to positivism's scientific determinism. In his book on Barrès, Henri Massis wrote in 1909 that 'while our professors spoke to us only of universal reason . . . [Barrès] spoke to us about our soul'.[25]

The possibility of a soul was also part of Bergson's appeal. It was a tantalising notion for progressive, reformist Catholics who were seeking a modern, philosophical basis for their beliefs. Confronting the 'integralists' who, with the backing of the pope, reasserted the traditional values of the Church, these 'modernists' sought to reconcile science, history, and philosophy to modify the Church's traditional doctrine. Among them was the mathematician and philosopher Edouard Le Roy, who published a book on Bergson in 1912. Le Roy deployed Bergson's ideas to ensure that Catholic beliefs could stand up to the scrutiny of modern science—and so, in the process, reform Catholic dogma itself.[26] Charles Péguy, seeking spiritual answers and already slowly finding his way towards Catholicism without ever abandoning his Dreyfusard views, found a decisive influence in Bergson's ideas—and a group of the philosopher's admirers would gather in the offices of Péguy's literary and philosophical journal, *Cahiers de la Quinzaine* (*Fortnightly Notebooks*), before heading over to the Collège de France. Among them was Raïssa Maritain and her husband, Jacques Maritain, also a poet. They all eventually found Catholicism, their

path eased by Bergson's marriage of the scientific with the metaphysical. In a lecture to the Catholic Institute in 1913, Maritain would claim that Bergsonian ideas had restored to philosophy 'the existence of God . . . the existence of a soul distinct from the body and perhaps its immortality, the freedom of man, and even maybe man's distinction from animals deprived of reason'.[27]

Politically, Nationalists and *revanchist* patriots drew some comfort from Bergson's ideas, although that was almost certainly not his intention. Bergson had sought to remain studiously above politics and had swerved away from the engagement expected of 'intellectuals' in the Dreyfus Affair. Yet his ideas, not least that the subconscious accumulation of memory was the essence of the human spirit, appealed to patriots who transferred this consciousness from the level of the individual to that of a whole nation. They could argue that such accumulated experiences, layer upon layer, bound together a people with a shared past that, even if forgotten, was never lost: it remained in the people's subconscious and so still shaped a people's sense of itself as a distinct nation. This chimed with Maurice Barrès's conception of nationhood, which saw in the human subconscious the repository of memories that bound the people together and stirred them to action—action that, through racial unity, would rejuvenate France. For Barrès, the ties of soil, custom, family, and tradition, all rooted in local, provincial cultures, were the source of France's internal diversity, the multiple wellsprings from which flowed its vitality. That energy would be guided by the memory of ancestors, whose 'voice of blood and the instinct of the soil' could be heard from the grave. This emphasis on intuitive, ancestral memory promoted the love of family, community, region, ancestry, soil, and tradition over reason and universal principles as the sources of political identity. It also, by definition, excluded those, such as foreigners and Jews, who did not share the same ties to the soil and the familial antecedents.[28]

It was darkly ironic, then, that while Bergson's ideas should chime with Nationalists, some of the Catholics among them should, in June 1914, have approved of the pope's decision to list the philosopher's

writings on the Index Librorum Prohibitorum—list of banned works. While the Vatican acted against Bergson's ideas, which were a fillip to French Nationalists, some of the Nationalists themselves perversely welcomed the move simply because Bergson was Jewish.[29] Among those who rejected Bergsonism was Charles Maurras—curiously, because the rest of the leadership of Action française, and certainly its young, student membership, had embraced it. For Maurras, the positivism of Auguste Comte, whose ideas he had long admired, was essential to order. In various writings, Maurras admitted that in his own, non-practising Catholicism, he felt 'the rigorous need of the absence of God', but that at the same time he believed it was necessary for an 'organising empiricism' to meet the 'intellectual, moral and political needs that are natural to all civilised men'. Comte's scientific ordering of the world met this need, except that Maurras rejected his universalism, his vision of a new international order organised for peace. Instead, Maurras argued that attachment to one's country, based (as it was for Barrès) on the unity of past, present, and future generations, would 'represent humankind for any given group of men'.[30]

Bergson's ideas were reaching the zenith of their popularity just as the 'nationalist revival' was gathering pace from 1910. The implications of Bergson's ideas, chiming as they inadvertently did with the 'integral nationalism' of *L'Action française* and the works of Barrès, both boasting a youthful readership, ensured in turn that the young could find intellectual foundations for their disenchantment with both positivism and parliamentary republicanism. Republicans and many on the political left feared that this amounted to a rejection of the liberal and rationalist worldview that underpinned republicanism and led them towards a more emotive form of nationalism, to the spirituality of Catholicism, and towards seeing action rather than reason as the primary political virtue. The stress on vitality (which seemed to be confirmed by Bergson's argument about actively engaging with immediate experience) appealed to the students of Action française and other Nationalist youth, who saw action, not scientific rationalism, as the essential virtue in politics. And in Bergson's ideas

of intuition and the individuality of human experience—an individuality that defied classification through any scientific laws—they found a justification for being led by their own sense of what was true, rather than being bound by any rational laws, universal principles, or indeed logic itself, and for elevating their exclusive sense of French identity over the more abstract, cosmopolitan conception of humanity sharing the same fundamental and natural rights.[31] Surveys among students of the Parisian *lycées* and the *grandes écoles*, published in July 1910 under the name 'Agathon' by Henri Massis and Alfred de Tarde, suggested that the young men of the day were abandoning the anti-clericalism and rationalism of older, republican generations and were indeed more willing to embrace religion and tradition as their compass.[32] Among 'Agathon's' criticisms of the positivist teaching in the Sorbonne was that it was delivered by 'a few masters dazzled by Germanic science'.[33] And this on the eve of the First World War.

One of the fundamental overarching concerns among the positivist establishment was that Bergsonianism was anti-intellectual. The Sorbonne mathematician Émile Borel accused Bergson of substituting instinct for intellect. Simplifying Bergson's emphasis on intuition does indeed appear to open the way to subjectivism, whereby one's feelings about an idea or an action prevail over any overarching ideas of right and wrong: I *feel* it's right so it must be true. Bergson, in fact, strenuously rejected the charge, replying that an 'anti-intellectual' was actually someone who refused to see the limits of the intellect in reaching true understanding. Bergson rooted his ideas in scientific works and argued that intellect and intuition, philosophy and science, actually worked together in a finely tuned balance.[34]

Yet there is no doubt that Bergson was acutely aware of the political impact that his ideas were having. 'I believe we are now experiencing a moral renaissance in France,' he said. 'It is the love of energy, the quest for a full and active life.'[35] This was in an interview with the right-wing *Gaulois littéraire* on 15 June 1912. Bergson would have been well aware that his teaching stirred the action-driven, mystical, right-wing nationalism of his admirers. This was certainly what

Alphonse Aulard, one of the great historians of the French Revolution, a professor at the Sorbonne and a staunch republican, feared when he wrote about the mounting criticisms of his institution: 'The real grief against the Sorbonne . . . is not, in fact . . . either literary or pedagogical. It is political. It is religious. She has against her conservatives and clericals of every shade,' he wrote. 'She is an alarming centre for those who want to subject youth to the old political and religious dogmas.'[36] This amounted to an intellectual crisis, one that saw the long-standing positivist worldview challenged and refashioned in a complex way, even if it did not collapse altogether. It also helped to reinforce new cultural movements that, while it emerged in the last years of the Belle Époque, would flourish in the interwar years, in the abstractions of modernism and symbolism.

Accompanying this cultural evolution was a geographical one, for the avant-garde, having moved from the Latin Quarter to Montmartre in the late nineteenth century, now returned to the Left Bank in the early twentieth and found a home in Montparnasse—with its cheap studio space and exuberant watering-holes, such as La Rotonde, Le Dôme, and the Closerie des Lilas. Yet while Bergson's ideas would be a fillip for new waves of creativity, they also appealed to some on the political left seeking new ways to energise the struggle for socialism. Among these was the writer and critic Georges Sorel, who in 1908 published his most notorious book, *Réflexions sur la violence* (*Reflections on Violence*). In it, Sorel rejected the 'scientific' reasoning of socialist parliamentarians and reformers like Jean Jaurès. Sorel claimed that their arguments for socialism reduced action one-dimensionally to material, economic interests that denied or even deprived the struggle of its moral, emotive impulses. Revolutionary socialism came not from rational analysis but from inner conviction, which resided in the deeper recesses of the human mind and responded not to the onward march of history but to the accumulated experience of social relations and the emotive mythology of the final, emancipating class conflict. This conviction could only be grasped by intuition, not by reason. Without it, there would be no urge to act, and without that impulse,

the working class would be reduced to bargaining for minor concessions from bourgeois politicians in parliament.[37]

Although Sorel attended Bergson's lectures, he had been working on these ideas beforehand, leading one critic at the time to remark that he was 'Bergsonian before ever having met Bergson'. Sorel was not uncritical of Bergson, but both thinkers accepted their similarities, Sorel suggesting that Bergson's great insight was its capacity to inspire a spiritual revival, its rejection of rationality and empiricism, and its stress on intuition.[38] Sorel's own rejection of rationalism, as well as of universalist principles such as human rights, and his emphasis instead on the mobilising power of myths, including the energising 'myth' of the general strike, helped him to break from the materialist, class-based, 'scientific' socialism of Marxism. As Zeev Sternhell has suggested, in stressing the concept of 'vitalism'—energy, action, heroism, morality, virtue, intuition, and the elevation of violence as opposed to reason, science, and social class—Sorel became 'the intellectual father' of twentieth-century fascism. These ideas could appeal not just to the proletariat, but also to the middle classes, inspiring both to action.[39] Sorel's rejection of the universalist values of the Enlightenment, of ideas of natural rights, progress, and democracy, was abhorrent to many on the political left who clearly saw the danger in the emphasis on intuition, action, and 'vitality' rather than science and reason. They feared the threat that this worldview—and the upsurge of nationalism more broadly—posed to the political underpinnings of the Republic, and therefore to the social-democratic society that they wanted to create. Among these was Jean Jaurès, who worried that his former classmate was fanning the flames of international conflict—the putative enemy being, of course, Germany.

ON 22 JANUARY 1914, a worried Jaurès called on French youth not to abandon the older rational and scientific system of understanding the world, a system of thought that claimed its inheritance from the Renaissance, the eighteenth-century Enlightenment, and the French

Revolution, and that now provided the intellectual basis of socialism. The venue was the salle Serpente at the Société savante (Learned Society) on the rue Danton in the 6th arrondissement, not far from the Sorbonne and the University of Paris Medical School. It was a good place from which to launch the appeal to the students who were so enthralled by Bergson's ideas of intuition and vitality and with the nationalist Right's calls to ultra-patriotic action. The event was a commemoration of the life of Francis de Pressensé, a fellow socialist and Dreyfusard who in many ways embodied the 'scientific' socialism embraced by Jaurès and whose funeral had just taken place in the cemetery at Montparnasse. For Jaurès, Pressensé's deep knowledge, drawn from his readings in his study, was the basis of action for the pursuit of (that old Dreyfusard watchword) 'truth and justice': 'He wanted to maintain the loftiness of his knowledge and mind . . . in order to project far and wide all the enlightenment that would help the proletariat on their path and in their struggle.' In an appeal both to peace and to reason, Jaurès issued a warning to France's young people:

Today they repeatedly tell you: go into action. But what is action without thought? It is the brutality that comes from inertia. You are told: cast aside the side of peace that weakens your courage. But we say that today to stand up for peace is the greatest of struggles, a struggle to repress within others and within ourselves the brutal aspirations and the crude blandishments of a hateful pride; a struggle to brave the ignominy of the inferior forces of barbarism that with an incredible insolence claim to be the guardians of French civilisation! . . . Beware of those who warn you against what they call 'systems' and who advise you to abdicate your intelligence in the name of a philosophy of instinct or intuition.[40]

FEW AMONGST THE wider public were listening. But one group that held true to the humanist heritage to which Jaurès was referring was

the feminist movement. And these feminists, too, found the Left Bank good terrain on which to wage their campaigns for equal rights.

As we have seen at different points, Frenchwomen were second-tier citizens in just about every sense, the inequalities based on assumptions about gender differences. It was not just that women of all classes were confronted with disparities in the workplace, in the family, and socially: it was also that some of these were actually enshrined in both the Napoleonic (Civil) Code that was still the basis of French civil law and in the political institutions of the Third Republic, which denied women the right to vote and to hold public office. The French feminist movement that challenged this state of affairs was smaller and, with a few exceptions, less militant than others in Europe and the rest of the world at the time—and indeed, French feminists looked somewhat aghast at the tactics adopted by their suffragette colleagues across the Channel—although there were exceptions, such as Hubertine Auclert, who, in 1908, famously overturned the ballot box in the *mairie* (town hall) of the 4th arrondissement in protest against women's exclusion from the vote.

Feminists of the Belle Époque campaigned over a rich range of issues that affected women, including the suffrage and the reform of the Civil Code, women's control over their own finances and property, reproductive rights and childcare, rights within marriage and the home, prostitution, welfare provision, children's health, women's education, workplace rights, and access to the professions.[41] 'Doctoresse' Madeleine Pelletier, who cut her hair short and wore a suit because she believed that women's dress (especially *décolletage*) showed that women were valued to the extent that they were sexually attractive to men, would become the first Frenchwoman to qualify as a psychiatrist, after a campaign supported by *La Fronde*.[42] Feminists were also divided over their politics: there were republican, socialist, and Catholic organisations. This partly reflected differences in the priorities among women of different social backgrounds. Many republican feminists came from the same bourgeois circles as republican politicians, and that, along with a desire to avoid any militancy that might

shake the Republic's not-always-secure foundations, made them hold back from a full-frontal assault for equal rights. They followed *la politique des brèches*—gradually securing one reform after another, making small 'breaches' in the wall of resistance towards greater gender equality, although this often led working-class women to invest their hopes instead in the more radical, socialist organisations.[43]

Moderate though the republican feminist approach was, the very diversity and activities of feminism—including organisations, newspapers, pamphlets, books, congresses, and marches—suggest, as the historian Máire Cross has argued, that, if it did not secure the vote, it did embed feminist issues within the wider political culture of Belle Époque modernity.[44] And some progress had in fact been made: on 1 September 1903, when *La Fronde* switched from being a daily to a monthly publication wholly devoted to women's causes, Marguerite Durand proudly listed some of the reforms achieved since 1880, in no small part thanks to pressure from feminists, including (since 1896) recognition at last of their capacity to act as witnesses to civil acts (such as registering births, marriages, and deaths and the signing of contracts and wills). Mundane though this sounds, it gave women a stronger legal status. But there were still many barriers yet to be breached. Of these, two of the most challenging were securing the right to vote, as we shall see, and reform of the Civil Code.

The Napoleonic Code, or the *Code civil*, entrenched women's subordination within the family and, as such, became a target of feminist campaigns. According to its provisions, women were subject to the authority first of their fathers, then of their husbands. They could not take up a job, act as legal witnesses to civil acts, sit on juries, or even, when they did work, control their own earnings. While men were only legally liable for adultery if they committed the heinous act in their own home, women who erred could be divorced and even criminally prosecuted if they did so, regardless of where the furtive deed was done.

In 1904, the centenary of the Civil Code was commemorated in the amphitheatre of the Sorbonne on 29 October. The

prestigious auditorium was filled with moustached, bearded, and mutton-chopped politicians, university professors, jurists, and others, a sea of black suits and sparkling decorations, when one of Marguerite Durand's associates, Caroline Kauffmann, managed to burst inside. Just as the *garde des sceaux*, the Republic's chief lawyer, was about to finish his speech on the Code, Kauffmann released dozens of balloons onto the heads of the great and the good, shouting 'Down with the Napoleonic Code that crushes women and is a shame on the Republic!' Before anyone could react, she was gone, reappearing outside the National Assembly (opposite the place de la Concorde) with a small group of other feminists to symbolically set fire to a copy of the Code.

Later that evening, Durand saluted Kauffmann's intervention at a public meeting of some eight hundred people who had gathered in the Société savante on the rue Danton—the same venue where, ten years later, Jaurès would make his appeal to France's younger generations to hold true to the rational, universalist commitment to truth and to justice—to protest against the restrictions of the Civil Code. At the opening of the gathering, Durand made the position clear:

> If there are men who complain about the Code, there is not a woman who should not loathe it, because there is no woman, rich or poor, great lady or worker, who, in her misery or enjoying her wealth, as an individual or with her children, in her work or in her leisure, has not had to suffer, thanks to the Code. . . . The task for women is not easy. They do not hold in their hands the ballot paper, the weapon with which men can secure all their liberties—and according to the apt saying of René Viviani [a socialist politician and feminist], legislators only make laws for those who make the legislators.[45]

For Durand, reform of the Code was desirable in itself—but only the right to vote would ensure that progress towards equal rights could be achieved and then maintained. The meeting approved a resolution to demand that 'those articles of the Code that enshrine the

inferiority and incapacity of women be abolished and that all French citizens, without distinction of sex, be declared equal before the law'. For Durand, as for many of her fellow campaigners, the basis of this demand was not any special consideration for women as women, but civil equality based on the founding deeds of 1789: 'We do not want a law for women any more than we want a law for men. We want a single law, as defined by Article 6 of the Declaration of the Rights of Man and the Citizen: it is the same for all, whether it protects or punishes.'[46] This appeal to the principles of 1789 also provided the basis of the demand for the right to vote.

The same demands were made on 5 July 1914, just a few months after Jaurès's oration for Pressensé, at another feminist rally involving a range of organisations marching under the slogan 'Je veux voter' (I want to vote), sponsored by Gustave Téry's *Le Journal*, which was now in a publishing partnership with *La Fronde*. The place was on the Left Bank not far from either the scene of Kauffmann's protest or the Société savante: the statue of Condorcet on the quai de Conti along the River Seine, occupying a space between the Académie française and the mint—the Hôtel de la Monnaie. Marie-Jean-Antoine-Nicolas de Caritat, the marquis de Condorcet, had been one of the few French revolutionaries to propose that women should get the right to vote in 1789. He was also a philosopher, a mathematician, and a republican. His end was tragic—hunted down during the Terror, he committed suicide in 1794 rather than face trial and execution. Condorcet therefore embodied not just the feminist demand for the suffrage, but also the very intellectual heritage that Jaurès defended against the emotive currents of 'vitalism' and 'action' that threatened to overwhelm it. The bronze statue itself was commissioned for the centenary celebration of 1889, but not completed until 1894, when it was unveiled on Bastille Day by the prefect of the Seine, Eugène Poubelle. Significantly, those invited to the ceremony included the positivist writer Émile Corra, as well as Eliska Vincent, a socialist and a veteran feminist, having been one of the founders of the Société pour la revendication du droit des femmes (Society for Reclaiming the Rights of Women) back in 1866.

Just as appropriately, the original statue was melted down by the collaborationist Vichy authorities in 1942 and then restored (based on a plaster cast of the original) for the bicentenary in 1989.[47]

Depending upon whom one believes—the Prefecture of Police or the feminist reports—two thousand to six thousand supporters mustered first of all at the Orangerie at the western end of the Tuileries Garden.[48] After speeches, including one in which Maria Vérone, president of the Ligue française pour le droit des femmes (French League for Women's Rights), explicitly connected the early feminism of Condorcet with contemporary women's struggles for rights, the thousands of marchers set off—men as well as women, carrying olive branches, fans, and flowers, all wearing a pin with the motto 'One for all, and all for one.'[49] If one then follows their route to the Condorcet statue, one is treated to a stroll along the Seine: alongside the river as far as the Pont de Solférino, across the bridge to the Left Bank, and then along the quays to the French Academy and a few steps more to Condorcet's bronze monument.[50] Durand was the first to lay her bouquet of flowers at the foot of the pedestal, watched by the fixed, austere gaze of the philosopher.[51]

In connecting the feminist demand for political rights with the French Revolution, Durand and others were claiming that the inheritance of 1789 on which the Third Republic claimed to be founded belonged to women as much as it did to men. The speakers at the rally recognised that the Revolution had not, in fact, lived up to its own principles: in her speech in the Tuileries, Vérone reminded her audience that it was in this very park that Théroigne de Méricourt had been assaulted, humiliated, and flogged for her political activism by a hostile crowd during the Revolution. Channelling the French revolutionary feminist Olympe de Gouges, Vérone bluntly stated that 'the equality that was applied most frequently during the revolutionary period was the equality of the scaffold'.[52] Yet this did not mean that the feminists rejected the Revolution's egalitarian promise itself: Instead, they appealed to its historical memory—a particular narrative of France's past, one that stressed the rational values of

the Enlightenment and the rights proclaimed by the French Revolution as the foundation of an inclusive conception of what it was to be French. It was a reminder to the recalcitrant politicians of the Third Republic that they, unlike their revolutionary forebears, might still fulfil the promise of universal rights proclaimed in 1789.[53]

The hopes, shared by Durand, Jaurès, and others, that the universal values of reason and rights might prevail over humanity's darker, more atavistic impulses were about to be overwhelmed by a human tragedy on a continental, indeed global, scale. Just weeks after the hopeful, dignified feminist march from the Tuileries, Europe would be plunged into the carnage of the First World War. And Jaurès would be dead.

CONCLUSION

The Café du Croissant on the corner of rue Montmartre and the rue du Croissant was a favourite with the journalists whose newspaper offices studded the area. It was late, a balmy summer evening. A large group of writers from *L'Humanité* and some of their wives were having an animated discussion, sitting together at dinner along a series of tables pushed together by the obliging waiters. The windows were open and the net curtains were wafting in the gentle breeze.

Jean Jaurès, his curly hair now silvering with age, had his back to one of the open windows. Voracious as always, he was tucking into his dessert—a strawberry tart—when a shadowy, hatted figure stopped in the street immediately outside. Before anyone in the gathering could understand what was happening, the barrel of a pistol slid through the open window, the muzzle not twenty centimetres from the back of Jaurès's head. A quick shot of flame, an explosive 'pan!', followed quickly by another report, and Jaurès, the slice of tart still on his lips, fell leftwards onto a colleague. As the smoke and the smell of cordite swirled over the stunned gathering, one of the journalists' wives, who was the first to recover from the initial shock, screamed, 'They have killed Jaurès! They have killed Jaurès!' It was 9.40 p.m. on Friday, 31 July 1914.[1]

For days Jaurès and his colleagues had been absorbed by a frenetic, desperate whirl of activity as Europe seemed to slide

inexorably into catastrophe. Jaurès himself had contacted his socialist associates in other European capitals to try to agree on international co-operation over ways to stop the breakneck race towards war. He had just returned from Brussels, where he had met colleagues from across the continent, including his counterparts from the German Social Democrats. As the leader of the largest single party in the National Assembly, he had used his authority to meet with French government ministers to urge restraint and to do whatever they could to encourage other European cabinets to engage with the British government's wise offer of mediation. And he had written article after article urging politicians and diplomats to work harder for arbitration and peace, while also counselling workers to be ready to join with others across the continent in a strike to make war impossible.

By 31 July, Jaurès was beginning to feel that it was almost too late. In Brussels, he had found many of his colleagues swinging loyally behind their national governments rather than rallying towards international solidarity. Austria-Hungary and Serbia were already at war; Russia—in a military alliance with France since 1893—had mobilised its forces in its western districts; and Germany had issued an ultimatum to the tsar's government. The Kaiser declared that war was imminent, the prelude to the mobilisation of German armed forces. Late that evening, Jaurès was pronounced dead by a doctor who had rushed to the scene on the rue Montmartre. His death, as the historian John Keiger has suggested, symbolised the failure of the opposition to war.[2] As word spread across the country, people said the same thing: 'Jaurès est assassiné: maintenant on aura la guerre' (Jaurès has been assassinated: now there will be war).[3]

And Jaurès died precisely because he had worked hard to stop the war. His assassin, as it turned out, was a mentally unbalanced twenty-eight-year-old, aptly named Raoul Villain. Recently enrolled in the École du Louvre after a series of other academic failures, he had rejected his parents' moderate republicanism and, after a trip to Alsace, embraced nationalism, joining the Ligue des jeunes amis de l'Alsace-Lorraine (League of Young Friends of Alsace-Lorraine),

among whose other members were Maurice Barrès and Paul Déroulède. In March 1913, this group had joined Action française's young thugs, the *Camelots du Roi*, in disrupting a socialist meeting, crying 'Down with Jaurès! To Berlin! We want Alsace-Lorraine!'[4] In his trial, witnesses recalled that he was seen with Charles Maurras's newspaper under his arm. Villain himself testified that he went to the rue Montmartre to 'vent his anger' on Jaurès. On 10 August, now under arrest, he wrote to his brother that he had killed 'the great traitor . . . the big mouth that drowned out all the cries from Alsace-Lorraine, I punished him and it was a symbol of a new era for the French and for foreigners'.[5]

Jaurès's belief in reason, rights, and universal human values, as well as his socialism, had led him to be repelled by *revanchisme*—the desire for a war of revenge in which the lost provinces of Alsace and Lorraine would be reconquered. In this, he was far from alone. Marguerite Durand also rejected *revanche*. On 1 January 1899, in fact, she had penned an editorial in *La Fronde* outlining a vision for a system of international arbitration that would make war unthinkable: 'At the dawn of the twentieth century, let us proclaim the rule of Law and of Justice, let us demand tribunals of arbitration among nations and let us suppress the rule of the gun.'[6] In making this appeal, Durand, in fact, was aligning herself not only with antimilitarists on the left, such as Jaurès, but also with an important, more mainstream strand of thinking within the French political establishment. Like some French diplomatic officials, she had begun to conceive of international politics in Europe in a new way that broke from traditional ideas emphasising military solutions. The traditional view was that war was inevitable and that military alliances and the exercise of power, if necessary by force, were thus part and parcel of the workings of the balance of power in the region. This older view was embraced especially by the military officer corps—regardless of politics and cultural background. Durand was among those who saw the expanding interconnectedness of European economies and the growing number of organisations and agreements managing

international trade and dealing with medical challenges, social problems, and technological changes as the basis of a rules-based international order. As Peter Jackson has shown, an awareness of growing interdependence and of international co-operation was what had led some French policymakers to think in new ways about international relations: it was not just that war might become unthinkable because of the disruption it would cause to all sides, but also that it could be avoided by international arbitration that regulated relations among states through law and agreement rather than through force.[7]

Alongside this vision, there was also French antimilitarism—given a shot of adrenaline by the Dreyfus Affair—which was focused more specifically on the place of the army in French politics and society. It had become an essential focus of the Left, including for Jaurès, which sought a reduction of the power of and abuses within the armed forces, even their abolition altogether. For Jaurès, this did not mean that there should be no army, but that the army of professional officers and conscripted peasants and workers should be replaced by a truly national militia made up of 'all valid citizens' when the country was threatened with attack.[8]

Yet by 1914, all this was almost to no avail. The swell of international tensions, combined with the surge of nationalism in France itself and the mounting anticipation of war, had culminated in 1913 with the government proposing to raise military service from two to three years. The prime minister, Aristide Briand, argued that the 'Three-Year Law' was essential if France were to withstand a German attack, not least because Germany's army stood at 870,000 men as against France's 540,000.

Socialists and syndicalists alike believed strongly that such a measure would merely inflame tensions with Germany and make war more likely and, once it was underway, all the more destructive.[9] Jaurès denounced the proposal as 'a crime against the Republic' (not least because one of the Dreyfusard political victories in the aftermath of the Dreyfus Affair had been to *reduce* the term of military service).

He also argued that the law would not in practice increase France's defensive capabilities: an unwieldy army of conscripts would have neither the *élan*—the impetus and enthusiasm—nor the agility and skill for a war against Germany. The solution, he argued in a series of public meetings held just outside eastern Paris, on the open ground of Le Pré Saint-Gervais, was a true citizen army, with universal military service for an initial period followed by transfer into the reserves. This force could then be mobilised if and when invasion came—the nation-in-arms. Led by Jaurès, the Section française de l'Internationale ouvrière (SFIO, French Section of the Workers' International) that year voted to campaign relentlessly '*against* the Three-Year Law and *for* Franco-German collaboration, international arbitration, and a national militia'.[10]

Yet the antimilitarists and supporters of a new kind of international relations were up against the nationalist revival: the historian Alphonse Aulard complained that one could not argue against the Three-Year Law with reason and logic because one was immediately assailed as a traitor and 'a citizen of nowhere' (*sans-patrie*).[11] The law passed in July 1913.

Jaurès was no pacifist: he did not reject wars of legitimate defence, and his internationalism, even in the fraught days of the July crisis in 1914, had its limits. He did not advocate a general strike in France alone if the German people supported a war, for that would be to strip the country of the means of defending itself. He had made this abundantly clear in his speeches and writings, but no amount of nuance or reason could stand up against the bitter Nationalist caricaturing of Jaurès as a traitor and a German stooge.

Villain, who was arrested almost immediately after the incident, had not, it turned out, read any of Jaurès's substantive work, but he had been exposed, relentlessly, to the polemics against him. In the end, Villain was held in prison for the duration of the war and not tried until March 1919, for fear of inflaming or demoralising public opinion during the conflict. In the febrile postwar atmosphere, Villain was acquitted. He would find refuge in the Balearics, where, in September

1936, after the eruption of the Spanish Civil War, he would be shot by Republicans.[12]

The day after Jaurès's death, 1 August 1914, Germany declared war on Russia and mobilised its forces. France reacted by ordering a general mobilisation that same day. Germany declared war on France on 3 August and invaded Belgium in order to strike from the north. On 4 August, Britain entered the war in response to this breach of Belgian neutrality.

French politics-as-usual was suspended: in what was called the *union sacrée*, old opponents came together in defence of the *patrie*, but for all the enthusiasm on the surface, there was a good deal of anxiety and resignation. Marguerite Durand wrote in her diary, on 1 August, 'General mobilisation declared. Lamentable spectacle! Women and men are crying. There are drunks all over the streets. The stations are packed with people.'[13] Durand, like just about everyone else, quickly supported the war, but the *union sacrée* proved to be a sticking plaster over the deep divisions that roiled French politics and culture. When the domestic conflict reemerged, it did so in circumstances very different to those prior to 1914, not least because it now arose among a people traumatised and decimated by four years of 'total war'. The Belle Époque would expire along with the 1.7 million French people who would be slaughtered in the trenches or who would die as civilians caught up in industrialised butchery. What followed was nostalgia.

IN THE WAKE of the carnage, writers looked back with mixed feelings to a period that would eventually come to be known as the 'Belle Époque'. In 1930, the writer André Warnod produced a lavishly illustrated volume on *The Faces of Paris* in which he recalled his youthful ambling around the city. For Warnod, the city had changed since the halcyon days before the First World War: 'One of our most cherished and intimate and profound joys was to have known the period before the war, and at an age when we were able to taste all its delights.' Warnod, who was fifteen years old in 1900, added that perhaps he

and others of his generation had 'found this time so beautiful because we were at that age ourselves'.[14]

Yet it was not just Bohemian types who looked back through the dark glass of the war to the Belle Époque. A song composed in 1917 by two *poilus*—soldiers—who had experienced the full horrors of trench combat firsthand, 'Tu reverras Paname' (You will see Paname again), became popular in the years after the conflict for its evocation of Paris before the war ('Paname' being an affectionate nickname for the city coined by the troops, a reference to the panama hats Parisians wore). The song's lyrics name-checked some of the glories of the Belle Époque: 'The Tour Eiffel, the place Blanche [where the Moulin Rouge is], Notre-Dame. . . . The boulevards and the pretty women. . . . The bar counter and the bistro, where you took your apéritif after work'.[15] But much of the nostalgia was for the changing face of the city in the 1920s, 1930s, and beyond, a longing for the *quartier*, or neighbourhood, whose old character was being altered by urban renewal, migration, and further integration within the wider city—a process that, of course, had in fact begun long beforehand. Especially cherished here was Montmartre, with the winding streets of the Butte, the *maquis*, and its cheap dance halls and wine bars.[16]

Yet this was not necessarily a memory of a Belle Époque frozen in time. Warnod managed to accommodate the striking modernity and changes in the period within the nostalgia for the old: 'A golden age? Oh no! But it was a singular and prodigious age, still attached to tradition by a thousand ties, but also possessing formidable new forces. Paris before the war? A city where the past remained living, but which welcomed new times harmoniously and so it could evolve gently.'[17] This is, to put it mildly, an optimistic view of how the Belle Époque negotiated the pace of social, economic, technological, and cultural change.

Firstly, as we have seen, among those who thought and wrote about it at the time these were years riven with anxiety and controversy about modernity and its ills. It was a period when social conflict, and indeed revolutionary violence, roiled the grace and poise of

Parisian life. These conflicts, moreover, were brought on by the gross disparities of poverty and wealth of the era and by the attempts some workers made to escape the grinding struggle for survival. Secondly, it was a period in which long-standing political and cultural divisions amongst the French deepened—in darkly spectacular fashion in the Dreyfus Affair. These conflicts crystallised into new political alignments, including those that sinisterly presaged the murderous totalitarianism of the mid-twentieth century.

The allure of Belle Époque Paris is certainly founded in aspects of life that were real enough, as we have seen. Yet, as we have also seen, it had its dark side, too, and, for this very duality—its pleasures and its torments—it had a particular resonance to writers and thinkers in the 1930s. On the one hand, that decade saw a cultural flourishing that included Art Deco and the last Universal Exposition hosted by Paris (in 1937); on the other hand, it experienced the booted dictatorships of totalitarianism and the ominous stirrings of a new war abroad, as well as, at home, the Great Depression, political scandal, and instability. For some, this was a good reason to immerse oneself within Belle Époque nostalgia as a means of escape: in 1933, none other than Jane Avril, recounting her glory days as one of the star attractions at the Moulin Rouge, remarked that 'people are starting to recognise the charm of our era. . . . Since then I have never found anywhere that sensation of collective yet respectable gaiety.'[18] It was perhaps no mistake that it was in the later 1930s that, as the French historian Dominique Kalifa has shown, 'Belle Époque' came into wide currency as a general term to mean 'good times' of charm, elegance, and gallant manners. Yet it was rapidly coming to be associated more precisely (and, it turns out, irreversibly) with the decades before the First World War. Kalifa suggested, referring to the year the Second World War broke out in Europe, that in people's minds the era had become 'the tragic prewar period that spoke to the men and women of 1939'.[19]

For many of those across the ideological spectrum who actually remembered the Belle Époque, the 1930s seemed to be reliving the

turbulence and anxieties of their youth. In both the 1930s and around 1900, writers (sometimes the same authors) fretted about a moral or spiritual as well as an economic and political crisis. With the danger of war looming ever larger as the 1930s drew towards a close, the novelist Roger Martin du Gard was awarded the 1937 Nobel Prize for Literature, primarily for his cycle of novels *Les Thibault*, a family saga set in the early 1900s that culminates in the outbreak of the First World War.[20] Sympathetic to the humane form of socialism and internationalism embodied by Jaurès (in the penultimate volume, *L'Été 1914* [*Summer 1914*], he depicts the frantic but vain efforts of socialists to stop the escalation, and two of the main characters witness Jaurès's assassination), Martin du Gard used his acceptance speech to the Swedish Academy to highlight the parallels between the present and the past: 'At this exceptionally grave moment through which humanity is passing, I wish, without vanity, but with a gnawing disquietude in my heart, that my books about *Summer 1914* may be read and discussed, and that they may remind all—the old who have forgotten as well as the young who either do not know or do not care—of the sad lesson of the past.'[21] In identifying the years up to 1914 with their own era, the members of the 'generation of 1939' understood that this was to 'recount a history that was both very distant and very close by'.[22] Martin du Gard wanted his own version of the story to sound as a warning to which others would take heed—although it would turn out to be in vain.

And today, almost a century after the novelist was honoured with the Nobel Prize in Stockholm, so the Belle Époque both retains its glamourous pull of attraction and provides parallels and lessons from the past. It is perhaps this dichotomy that lies at the heart of its nostalgic appeal: it was, as Eugen Weber has written, an experience that is both familiar and different to our own.[23] The Belle Époque's attractions and glories were real enough, and among them, as we have seen, were the soaring frame of the Eiffel Tower; the glistening white Sacré-Coeur; the sleek, organic lines of Art Nouveau; the gentle, electric whine of the Paris Métro (to which one might

add the bicycle and, later, the motorcar); the spectacle of the boulevards, with the fashionable on parade; the shameless opulence of the department stores; and the concentration of Bohemian creativity alongside the exuberant promise of 'naughty' eroticism in Montmartre.

Yet, if we wish to take Martin du Gard's advice today, what parallels and lessons might be drawn from this era? This book has suggested some, both for good and for ill. Belle Époque concerns about 'degeneration', 'neurasthenia', and moral decline, brought on by the pace and direction of technological and social change, might provide some perspective on our worries about how new, rapidly evolving technology—especially artificial intelligence—appears to be outpacing our capacity to absorb it responsibly, and about whether the internet and its tools might atomise communities by reducing personal contact. Belle Époque concerns about public health in the squalor of Parisian slums might be extrapolated to a broader canvas, becoming distant echoes of our own deep concerns about the environmental damage that our economic development has wrought, and how we, as the city authorities did all those years ago, might seek remedies. The protests and strikes of workers and the violence committed by those who (wrongly) claimed to speak for them present us with a warning about the destabilising effect that extremes of wealth and poverty can have on society and political institutions. Women's pursuit of equal political and legal rights, pay, opportunities, and respect during the Belle Époque, personified in the tireless campaigning of Marguerite Durand and the staff of *La Fronde*, will surely speak directly to today's campaigns for the same, well over a century later. Belle Époque anger about an almost unfettered media and its capacity to spread lies and disinformation speak directly to our own frustration with 'fake news', 'alternative facts', and 'gaslighting'.

And it is perhaps this that resonates most clearly as a warning to our own era, a time in which populists and authoritarians can use their platforms—be it the floor of the legislature, the media, or

cyberspace—to spread lies, hatred, xenophobia, and racism, stirring up old hatreds, assailing the rights of large groups of people who are somehow identified as 'different' or 'other', undermining legality and democratic values, and eroding the rights of citizens and of particular groups in the pursuit of power. This same alarm was sounded within the politics of the Belle Époque: Martin du Gard saw the same dangers in the 1930s, and people listened, but it was not enough to stop the continuing slide into another era of darkness, slaughter, and genocide. If the Belle Époque teaches us anything, it is that no matter how polarised our politics might become, and even if it is almost certainly too naïve to hope for reason to prevail, it is vital that the differences be peacefully fought out not only within a broadly accepted democratic and legal framework, but also on an understanding that political debate must be based on an honest appraisal of facts. In such an appraisal, though it is fine to interpret facts through one's own ideological lens, it is unacceptable—and in fact undemocratic—to lie, to pose 'alternative' facts, and to create such a web of disinformation that citizens struggle to make informed judgments, and in the end rely on preconceptions, falling prey to prejudice and division. Cutting through all this puts a great but necessary burden of responsibility on citizens in any democracy: critical thinking—a determination not only to examine the 'facts' for their veracity, but also to scrutinise sources for their reliability—requires time, energy, and inclination. Jaurès saw this when he argued that working people should have the time and leisure to access culture and education, not only in order to enhance their quality of life, but in order to engage fully as citizens of the Republic: 'Le courage, c'est de chercher la vérité et de la dire' (Courage is to seek out the truth and to say it).[24] Although this is perhaps easier said than done, it is worth remembering that Jaurès gave this advice only five years after he had sought to do just that in the Dreyfus Affair, and after Zola had published his thunderous—and personally costly—intervention in the shape of 'J'Accuse . . . !' In this respect, among others, such as the indefatigable

activism of Marguerite Durand, feminist and Dreyfusard, the Belle Époque might be a source of inspiration.

THIS BOOK HAS explored these Belle Époque frictions and conflicts through some of the buildings and spaces that can still be visited today and that carry (sometimes hidden) stories from these years. In so doing, it has been informed by what historians call the 'spatial turn'—that is, a focus on the ways in which people have conceived of and used space in symbolic and material ways and how that has shaped the past.[25] This is not the place to delve too deeply into these ideas. For now, it is, I hope, enough to say that in writing this book I have followed the advice of the historian David Blackbourn that 'every historian should possess a pair of stout walking shoes'. With Blackbourn, I believe that one should get a personal sense of the real physical spaces where the events unfolded, because they were more than just a backdrop, but in different ways interacted with those events.[26] It almost goes without saying that to undertake historical research by donning a good pair of shoes and walking around Paris is, as they say, 'nice work if you can get it'. This entirely enjoyable process has helped me to shape a proposed answer to a puzzle related to the 'spatial turn' that has been central to this book: what buildings (and spaces) *mean*—whether their meaning is in the intentions and plans of their designers and constructors, or in the ways in which people perceived, used, and responded to them in practice.[27]

The places explored in this book and the Belle Époque stories behind them suggest that the solution lies neither solely in the designer's intentions nor only in the public's interpretation and use of a building, but rather in the tension between them—a friction that, moreover, is acted upon by a third force, the historical context, which evolves along with society, culture, and politics. So the meaning of a building or space changes as, over time, people attribute new symbolism, memories, and uses to them in response to the needs of the moment: yet they are not working on a blank canvas, but within the

constraints of a material building, monument, or space whose design and symbolism were often devised with a particular purpose in mind. So the only stable point in the architectural triangle—architect, public, context—is the original intention of the first. This flux explains why the historical memories associated with places as *lieux de mémoire*, realms of memory, are constantly overlaid with new associations over time, their older meanings often forgotten as others emerge into the foreground to serve new cultural or social needs or political purposes. Sometimes, as we have seen, this is a matter of political choice, and it is a process that can be seen at work in Belle Époque Paris, which was no stranger to battles over what was worthy of commemoration. What this tells us about any city was best expressed by a remarkable Belle Époque figure, the Scottish pioneer of (among other things) urban planning, civic education, and environmentalism, Patrick Geddes.[28] Geddes knew Paris well, had many friends among the Dreyfusards, and was heavily involved in the Universal Exposition of 1900, and as he put it, 'A city is more than a place in space, it is a drama in time.'[29]

ACKNOWLEDGEMENTS

AN AUTHOR'S NAME runs across the cover of a book, but it only tells a small part of the story. A book also exists thanks to the expertise, skill, and support of many people: publishers, colleagues, friends, and family. If the current book is any good, it is because of this.

The publishers at Basic Books and Bridge Street Books at Little, Brown have been superb: Lara Heimert and Brandon Proia at Basic and Sameer Rahim at LB are brilliant—as were Tim Whiting, my original editor at LB, and his immediate successor, Holly Harley. They have all been remarkable in their attention to detail, their acute advice, their kindness, and the occasional 'nudge' when I dallied for too long. I could not have hoped for a better, more alert copy editor than Katherine Streckfus, who saved me from myself on multiple occasions. And I appreciate the efficiency of Shena Redmond and Kristen Kim at Basic.

Among my colleagues at the University of Glasgow, I thank Callum Brown and Alex Shepard, who first encouraged me to write this book—the subject of which is not my primary area of research but which I love to teach—during one of our regular 'research conversations'. Among my other colleagues who enthusiastically gave their time, advice, and support, I thank in particular Stuart Airlie, Thomas Munck, Karin Bowie, Steven Reid, the late, much-loved David Code, Samantha Dobbie, Sarah Dunstan, and Peter Jackson. Peter, moreover, has allowed me to join as an affiliated researcher

his dynamic team of scholars working on 'The Weight of the Past in Franco-British Relations', a project exploring the role of representations of the past in policy debates since 1815. The wide-ranging discussions of the team have illuminated for me the wider diplomatic and political context of the Belle Époque. The History Research Support fund and the Centre for Scottish and Celtic Studies enabled me to undertake some of the visits to archives and to enjoy the legwork that went into this book. Thanks, too, to the members of the admin staff in the School of Humanities who do so much of the heavy lifting and who make No. 1 University Gardens such a convivial place to work, particularly those with whom I work directly: Christelle Le Riguer, Leigh-Ann Dragsnes, Sara Murdoch (whose regular roastings of me in the office banter have become part of my work schedule), Ashley Brown, Heather Shannon, Kirsti-Ann Mullen, and Kathleen, who has offered her calm wisdom and friendship. The University of Glasgow Library is a rich source of materials and its staff members have been helpful as always, particularly Elaine Anderson of the Maps and Official Publications Department and Sam Dyer of the Photographic Unit. My students, who over the years have suffered through my teaching of France between 1789 and 1914, are inspirational in their embrace of the subject, in their discussions, and in their analysis of the sources: the seminar on the Dreyfus Affair always sees the sparks flying.

Overlapping with Glasgow University, I thank the Scottish Network of Nineteenth-Century European Cultures (SNNEC), whose series of workshops funded by the Royal Society of Edinburgh in 2018 allowed me to begin to shape some of my ideas for this book—special thanks here go to Katherine Mitchell of Strathclyde University and to Manon Mathias, Henriette Partzsch, and Barbara Burns, all of Glasgow. Outside my university, thanks to Agnès Coric and Sophie Caranta at the splendid Alliance française de Glasgow for asking me to give a public talk on the Eiffel Tower and Sacré-Coeur—and to Peter Jackson (again) for presenting an earlier lecture on my behalf when I was unable to do so myself. Bernhard Struck, Konrad Lawson,

and Riccardo Bavaj of the University of Saint Andrews Institute for Transnational and Spatial History invited me to participate in a workshop for doctoral students on space and place, and the discussions that followed have informed some of my thinking for this book. In Paris, the archives of the Musée d'Orsay and the Archives nationales at Pierrefitte-sur-Seine are a joy in which to work.

I have had the support of many good friends—too many to list in full here—but I'd like to thank in particular Terry and Yvonne Wisdom for looking after our glorious former guide dog, Yulie, and to Jen and Gordon Dougall for keeping an eye on things at home when we were away on our Paris trips. Barry and Eilidh Smith and Vicky Myers have been firm friends and have provided support at various junctures during the writing. I enjoyed Ross and Nina Bryson's wonderful company when I was last able to travel to London to visit Little, Brown: they, along with Colin and Jacqui Mitchell, have been strong, lifelong friends. There are many others—you know who you are . . .

My family has put up with a lot while this book was being written. My little daughter Rachel has sometimes sat on my lap, or kept me company close to my desk, while I tried to do 'just one more edit'.

And then there is my eldest daughter, Lily, whose mission appears to have been to keep me grounded in reality: a stern, intelligent, and wonderfully humorous critic of whom I am immensely proud.

My Francophone sister-in-law Elizabeth has been a good, supportive friend to this book and a wonderful travelling companion.

My mother, Anita Radford, and my father, George Rapport, both passed away during the writing of this book. They are still dearly held by my beloved step-parents—Mike Radford and Jane Rapport, respectively—and by my siblings, Allan, Sarah, John, and Nicholas. This book is dedicated to the memory of our parents with love.

It is also dedicated, as ever, to my wife, Helen, with love. Paris has proven to be a *leitmotif* (or rather *un fil rouge*) that has run through our life together from the very first year that we dated. We have built so many memories of the city over the years that—cliché though it is—Rick's words to Ilsa ring very true: 'We'll always have Paris.'

NOTES

Introduction

1. Émile Zola, *Les Trois Villes: Paris* (Paris: Bibliothèque Charpentier, 1898), 1–2.

2. On the evolving conceptions of the 'Belle Époque', see Dominique Kalifa, *The Belle Époque: A Cultural History, Paris and Beyond*, trans. Susan Emanuel (New York: Columbia University Press, 2021). For nostalgia for the Paris of the Belle Époque in the decades from 1914, see Charles Rearick, *Paris Dreams, Paris Memories: The City and Its Mystique* (Stanford, CA: Stanford University Press, 2011), esp. 44–81.

3. See, for example, Nina Epton, *Love and the French* (London: Cassell, 1959), 321.

4. For a useful annotated list of examples, see Brian Silverstein, 'Modernity', Oxford Bibliographies, www.oxfordbibliographies.com/display /document/obo-9780199766567/obo-9780199766567-0167.xml, last modified 30 March 2017.

5. Peter Wagner, *Modernity: Understanding the Present* (Cambridge: Polity Press, 2012), 3–10. See also Charles Taylor, 'Two Theories of Modernity', *Public Culture* 11 (1999): 153–174.

6. Eugen Weber, *France: Fin de Siècle* (Cambridge, MA: Belknap Press of Harvard University Press, 1986), 6.

7. Patrice Higonnet, *Paris: Capital of the World*, trans. Arthur Goldhammer (Cambridge, MA: Belknap Press of Harvard University Press, 2000), 186.

8. For Haussmann and his Parisian renovations, it is worth looking at the photographs of Charles Marville, who was commissioned to document old Paris before it disappeared, but who also captured some of the work during and afterwards—as well as the damage wrought during the Commune in 1871. See,

for instance, 'Charles Marville: Photographer of Paris', National Gallery of Art, Washington DC, www.nga.gov/features/marville.html, accessed 5 October 2023. And see, among others, David H. Pinkney, *Napoleon III and the Rebuilding of Paris* (Princeton, NJ: Princeton University Press, 1958); Joan Chapman and Brian Chapman, *The Life and Times of Baron Haussmann: Paris in the Second Empire* (London: Weidenfeld and Nicolson, 1957); Stéphane Kirkland, *Paris Reborn: Napoléon III, Baron Haussmann, and the Quest to Build a Modern City* (New York: St. Martin's Press, 2013); David P. Jordan, 'The City: Baron Haussmann and Modern Paris', *American Scholar* 61 (1992): 99–106.

9. David Lepoutre, 'Histoire d'un immeuble haussmannien Catégories d'habitants et rapports d'habitation en milieu bourgeois', *Revue française de sociologie* 51 (2010): 324; Higonnet, *Paris*, 186.

10. Higonnet, *Paris*, 182–185.

11. *Figaro*, 14 February 1894; *L'Intransigeant*, 11 February 1898.

12. Pierre Casselle, *Paris républicain, 1871–1914* (Paris: Hachette, 2003), 353.

13. See, for example, Charles Rearick, *Pleasures of the Belle Époque: Entertainment and Festivity in Turn-of-the-Century France* (New Haven, CT: Yale University Press, 1985).

14. One of the best recent books on the questions around women's nature and status in France in this era is Karen Offen, *Debating the Woman Question in the French Third Republic, 1870–1920* (Cambridge: Cambridge University Press, 2018).

15. On the *guerre franco-française* as an historical concept, see the entire issue of *Vingtième siècle* 5 (1985), particularly the short introductory article by Jean-Pierre Azéma, Jean-Pierre Rioux, and Henry Rousso, 'Les Guerres franco-françaises', 3–6, and the concluding essay by Jean-Pierre Azéma, 'Une guerre de deux-cents ans?', 147–154.

16. Quoted in Élizabeth Coquart, *La Frondeuse: Marguerite Durand, patronne de presse et féministe* (Paris: Payot, 2010), 25.

17. Marguerite Durand, 'Confession à M. Émile Faguet de l'Académie française', *La Fronde*, 1 October 1903.

18. Nguyễn Trọng Hiệp, *Paris, capitale de la France: Recueil de vers* (Hanoi: F.-H. Schneider, 1897).

19. Quoted in Harvey Goldberg, *The Life of Jean Jaurès* (Madison: University of Wisconsin Press, 1962), 14, 15.

Chapter 1: Conflict

1. Nguyễn Trọng Hiệp, *Paris: capitale de la France: Recueil de vers* (Hanoi: F.-H. Schneider, 1897), verse 23; Charles Rice-Davis and Mia Nakayama,

'Electric Light and Clouds of Dust: A Reading and Translation of Nguyễn Trọng Hiệp's *Paris, capitale de la France*', *Litera* 30 (2020): 648.

2. Colin Jones, *Paris: Biography of a City* (London: Penguin, 2006), 328.

3. Quoted in Robert Gildea, *Children of the Revolution: The French, 1799–1914* (London: Penguin, 2008), 244.

4. Quoted in Frederick Brown, *Zola: A Life* (London: Macmillan, 1995), 221.

5. Quoted in Brown, *Zola*, 215.

6. Quoted in Gildea, *Children of the Revolution*, 244.

7. Élizabeth Coquart, *La Frondeuse: Marguerite Durand, patronne de presse et féministe* (Paris: Payot, 2010), 16–17.

8. Quoted in Émile Jonquet, *Montmartre: Autrefois et aujourd'hui* (Paris: Dumoulin, 1890), 143.

9. R. A. Jonas, *France and the Cult of the Sacred Heart: An Epic Tale for Modern Times* (Berkeley: University of California Press, 2000), 153–157, 176, 179.

10. 'Voeu national au Sacré-Coeur de Jésus pour obtenir la délivrance du souverain pontife et le salut de la France', *Bulletin de l'Oeuvre du Voeu National au Sacré-Coeur de Jésus*, no. 1 (December 1873).

11. Joseph-Hippolyte Guibert, 'A MM. les membres du Comité de l'Oeuvre du Voeu national au Sacré Coeur de Jésus', appendix to Jacques-Marie-Louis Monsabré, *Discours prononcé dans l'église métropolitaine de Notre-Dame de Paris, le 14 avril 1872* (Paris: Joseph Albanel, 1872), 41–42 (emphasis in original).

12. Guibert, 'A MM. les membres du Comité de l'Oeuvre', 43.

13. Quoted in David Harvey, *Paris: Capital of Modernity* (London: Routledge, 2003), 333.

14. Jonas, *France and the Cult of the Sacred Heart*, 186, 190, 192 ('foreign and pagan').

15. Jones, *Paris*, 375–377.

16. Harvey, *Paris*, 334–335.

17. Jonas, *France and the Cult of the Sacred Heart*, 182, 183 ('monument to extravagance').

18. *Bulletin de l'Oeuvre du Voeu National*, no. 1 (December 1873): 22–23.

19. Guibert, 'A MM. les membres du Comité de l'Oeuvre', 44; Jonas, *France and the Cult of the Sacred Heart*, 183–184.

20. Jonas, *France and the Cult of the Sacred Heart*, 207–215.

21. Jonas, *France and the Cult of the Sacred Heart*, 200–201.

22. Jonas, *France and the Cult of the Sacred Heart*, 219–221.

23. Quoted in Harvey, *Paris*, 333–334.

24. Jonas, *France and the Cult of the Sacred Heart*, 235, 240–241.

25. Harvey, *Paris*, 327–328.

26. Archives Nationales, Paris, F/7/12387, dossier: Église du Sacré-Coeur de Montmartre, Procès-verbal du Conseil Municipal de Paris, 8 June 1891.

27. See the interesting juxtaposition of chapters in Pierre Nora's edited volumes on *lieux de mémoire* (realms of memory) in modern France: François Loyer, 'Le Sacré-Coeur de Montmartre', and Henri Loyrette, 'La Tour Eiffel', in *Les Lieux de mémoire*, vol. 3, *Les France: De l'archive à l'emblème*, ed. Pierre Nora (Paris: Gallimard, 1992), 451–473, 475–503.

28. Quoted in Gildea, *Children of the Revolution*, 253.

29. Quoted in Brown, *Zola*, 448.

30. 'La rue Montorgueil, à Paris: Fête du 30 juin 1878. Claude Monet (1840–1926)', Musée d'Orsay, accessed 16 November 2022, www.musee-orsay .fr/en/artworks/la-rue-montorgueil-paris-fete-du-30-juin-1878-10896.

31. Quoted in Patrice Higonnet, *Paris: Capital of the World*, trans. Arthur Goldhammer (Cambridge, MA: Belknap Press of Harvard University Press, 2002), 356.

32. Quoted in Coquart, *La Frondeuse*, 13.

33. Quoted in Gildea, *Children of the Revolution*, 255.

34. Jean-Marie Mayeur, *Les Débuts de la Troisième République, 1871–1898* (Paris: Seuil, 1973), 168.

35. Quoted in Robert Tombs, *France, 1814–1914* (London: Longman, 1996), 448.

36. Mary Louise Roberts, *Disruptive Acts: The New Woman in Fin-de-Siècle France* (Chicago: University of Chicago Press, 2002), 58; Coquart, *La Frondeuse*, 52–53, 63.

37. Mayeur, *Les Débuts*, 176.

38. Coquart, *La Frondeuse*, 63–65.

39. Quoted in Tombs, *France*, 452.

40. Quoted in Harvey Goldberg, *The Life of Jean Jaurès* (Madison: University of Wisconsin Press, 1962), 52.

41. Quoted in Roberts, *Disruptive Acts*, 58.

42. Quoted in Brown, *Zola*, 591.

43. Quoted in Goldberg, *Life of Jaurès*, 49, 51.

44. Quoted in Caroline Mathieu, 'Introduction', *1889: La Tour Eiffel et l'Exposition universelle*, ed. Françoise Cachin and Caroline Mathieu (Paris: Éditions de la Réunion des Musées nationaux, 1989), 15.

45. 'Règlement du concours de l'Exposition universelle de 1889', *Journal officiel*, 3 May 1886, in Mathieu, 'Introduction', 16.

46. David I. Harvie, *Eiffel: The Genius Who Reinvented Himself* (Stroud: Sutton Publishing, 2004), 80.

47. Mathieu, 'Introduction', 17.

48. G. Eiffel, *La Tour de trois cents mètres*, 2 vols. (Paris: Société des Imprimeries Lemercier, 1900), 1:6; Michel Lyonnet de Moutier, 'Financing the

Eiffel Tower: Project Financing and Agency Theory', *Journal of Applied Finance* 20 (2010): 133; Harvie, *Eiffel*, 93–94.

49. Eiffel, *Tour de trois cents mètres*, 1:100.

50. Eiffel, *Tour de trois cents mètres*, 1:13.

51. Harvie, *Eiffel*, 108–109.

52. G. Eiffel, 'Proposal for an Iron Tower: 300 Metres in Height Destined for the 1889 Exposition', *Architectural Research Quarterly* 8 (2004): 12, 14–17; Harvie, *Eiffel*, 109–110.

53. Eiffel, *Tour de trois cents mètres*, 1:100–101.

54. Eiffel's assembly technique actually inspired the creation of Meccano, a construction toy invented in Britain in 1904 (the Erector set in America is similar) (Harvie, *Eiffel*, 114).

55. Émile Goudeau, 'Ascension à la tour', quoted in Harvie, *Eiffel*, 119.

56. Eiffel, *Tour de trois cent mètres*, 1:118.

57. Eiffel, *Tour de trois cents mètres*, 1:119–120. In contrast, fifty-seven workers died during the construction of the Forth Bridge in Scotland, which was being built at the same time. The Forth Bridge formally opened in March 1890. Harvie, *Eiffel*, 116–117.

58. 'Les Artistes contre la tour Eiffel', *Le Temps*, 14 February 1887.

59. Quoted in Brown, *Zola*, 574.

60. Quoted in Harvie, *Eiffel*, 99.

61. Quoted in Jones, *Paris*, 342 (emphasis in original).

62. Quoted in Mathieu, 'Introduction', 18.

63. *Le Temps*, 14 February 1887.

64. Harvie, *Eiffel*. See also Henri Loyrette, *Gustave Eiffel* (New York: Rizzoli, 1985), and the Eiffel Tower's official website, which contains much useful background detail, www.toureiffel.paris/en/the-monument/gustave -eiffel, accessed 17 November 2022.

65. Eiffel, *Tour de trois cents mètres*, 1:11.

66. Eiffel, 'Proposal', 24.

67. Quoted in Debora Silverman, *Art Nouveau in Fin-de-Siècle France: Politics, Psychology, and Style* (Berkeley: University of California Press, 1989), 7.

68. Quoted in Silverman, *Art Nouveau*, 4–5.

69. Coquart, *La Frondeuse*, 73–74.

70. Tyler Stovall, *Transnational France: The Modern History of a Universal Nation* (Boulder, CO: Westview Press, 2015), 206.

71. Michel Wieviorka, 'La République, la colonisation. Et après . . .', in *La Fracture coloniale: La Société française au prisme de l'héritage colonial*, ed. Pascal Blanchard, Nicolas Bancel, and Sandrine Lemaire (Paris: La Découverte, 2006), 117–118.

72. Stovall, *Transnational France*, 212.

73. Quoted in Stovall, *Transnational France*, 212.

74. Wieviorka, 'La République, la colonialisation', 118.

75. Lynn E. Palermo, 'Identity Under Construction: Representing the Colonies at the Paris *Exposition Universelle* of 1889', in *The Color of Liberty: Histories of Race in France*, ed. Sue Peabody and Tyler Stovall (Durham, NC: Duke University Press, 2003), 286–287.

76. Nicolas Bancel, Pascal Blanchard, and Sandrine Lemaire, 'Ces zoos humains de la République coloniale', *Le Monde diplomatique*, August 2000, 16–17; Palermo, 'Identity Under Construction', 291.

77. Quoted in Palermo, 'Identity Under Construction', 285.

78. Quoted in Palermo, 'Identity Under Construction', 291.

79. Harvey Mitchell, 'Jean Jaurès: Socialist Doctrine and Colonial Problems', *Canadian Journal of History / Annales Canadiennes d'histoire* 1 (1966): 33–34.

80. Nguyễn Trọng Hiệp, *Paris*, verse 36.

81. See J. P. Daughton, *An Empire Divided: Religion, Republicanism, and the Making of French Colonialism, 1880–1914* (Oxford: Oxford University Press, 2006).

82. Stovall, *Transnational France*, 228.

83. E. M. de Vogüé, *Remarques sur L'Exposition du Centenaire* (Paris: Plon, 1889), 24–25.

84. Quoted in Higonnet, *Paris*, 358.

85. Quoted in Jones, *Paris*, 341.

86. Jonquet, *Montmartre*, 161–162.

87. *Guide official du pèlerin dans le Sacré-Cœur de Montmartre* (Paris: Bureaux de la Basilique, 1896), 90.

Chapter 2: Modernity

1. *La Fronde*, 20 July 1900.

2. *La Fronde*, 20 July 1900.

3. *Le Figaro*, 20 July 1900.

4. Georges Baumier, 'Le Métropolitain: Les Revendications du public', *La Presse*, 27 July 1900.

5. Siân Reynolds, '*Vélo-Métro-Auto*: Women's Mobility in Belle Epoque Paris', in *A Belle Epoque? Women in French Society and Culture, 1890–1914*, ed. Diana Holmes and Carrie Tarr (New York: Berghahn Books, 2006), 90.

6. Max Nordau, *Degeneration* (London: William Heinemann, 1898), 2.

7. Caroline Grubbs, 'Terminus 1900: The Métro and the Universal Expositions in Fin-de-Siècle Paris', *Dix-Neuf: Journal of the Society of Dix-Neuvièmistes* 29 (2020): 204.

8. Grubbs, 'Terminus 1900', 203; Alain Cottereau, 'Les Batailles pour la création du Métro: Un choix de mode de vie, un succès pour la démocratie locale', *Revue d'histoire du XIXe siècle* 29 (2004): 2.

9. Carlos López Galviz, *Cities, Railways, Modernities: London, Paris, and the Nineteenth Century* (New York: Routledge, 2019), 2.

10. Grubbs, 'Terminus 1900', 210.

11. Pierre Giffard, 'Le Métropolitain', *Le Figaro*, 16 March 1886.

12. Paul Brousse and Albert Bassède, *Les Transports*, 2 vols. (Paris: Dunod et Pinat, 1907), ii, 85.

13. Galviz, *Cities, Railways, Modernities*, 152.

14. Giffard, 'Le Métropolitain'.

15. F. Bienvenüe, 'Preface', in Jules Hervieu, *Le Chemin de fer métropolitain municipal de Paris*, vol. 1 (Paris: C. Béranger, 1903), v–vi.

16. Cottereau, 'Les Batailles', 18–20.

17. 'Les Embarras de Paris au mois de septembre 1906', clipping from *L'Illustration*, 29 September 1906, Archives de la Musée d'Orsay, Architecture, Topographie Paris, Paris [Métro].

18. Clipping from *La Revue illustrée*, 1899, Archives de la Musée d'Orsay, Architecture, Topographie Paris, Paris [Métro].

19. Clipping from *L'Illustration*, 16 December 1899, Archives de la Musée d'Orsay, Architecture, Topographie Paris, Paris [Métro].

20. Cottereau, 'Les Batailles', 25–26.

21. Baumier, 'Le Métropolitain'.

22. For press reporting, see *Le Temps*, 12 August 1903 (with a diagram of the station) and *La Presse*, 12 August 1903.

23. Walter Benjamin, *The Arcades Project* (Cambridge, MA: Belknap Press of Harvard University Press, 1999 [1982]), 84, 519.

24. Anthony Sutcliffe, *Paris: An Architectural History* (New Haven, CT: Yale University Press, 1993), 117–118.

25. B. Champigneulle, *L'Art Nouveau* (Paris: Somogy, 1972), 15–21, 89.

26. It was a spectacular small cinema from 1931 until 2015 (with a garden café that was especially beautiful at night). Although closed for several years, the property was taken over by a New York–based developer in 2020, and its future as a reopened cinema may at the time of writing be secure. On *Japonisme*, see, among others, Lionel Lambourne, *Japonisme: Cultural Crossings Between Japan and the West* (London: Phaidon Press, 2007), and Gabriel P. Weisberg, *Japonisme: Japanese Influence on French Art, 1854–1910* (London: Robert G. Sawyers, 1975), a catalogue of an exhibition held at the Cleveland Museum of Art in 1975.

27. Debora Silverman, *Art Nouveau in Fin-de-Siècle France: Politics, Psychology, and Style* (Berkeley: University of California Press, 1989), 8–9.

28. Champigneulle, *L'Art Nouveau*, 11–12, 27–28.

29. Silverman, *Art Nouveau*, 1–7 (Vogüé quoted on 6).

30. Silverman, *Art Nouveau*, 10, 106.

31. Isabelle Gournay, 'Revisiting Guimard's Auteuils', in *Hector Guimard: Art Nouveau to Modernism*, ed. David A. Hanks (New Haven, CT: Yale University Press, 2021), 42.

32. Alisa Chiles, 'Commercial Architecture', in Hanks, *Hector Guimard*, 122.

33. Champigneulle, *L'Art Nouveau*, 211–216.

34. Champigneulle, *L'Art Nouveau*, 217.

35. Sutcliffe, *Paris*, 117–118.

36. See 'Did You Know About Guimard Station Entrances?', Régie autonome des transport parisiens (RATP), 13 August 2021, ratp.fr/en /discover/coulisses/daily-life/did-you-know-about-guimard-station-entrances.

37. For an analysis of the interlocking anxieties around 'degeneration' and 'decadence', see Eugen Weber, *France: Fin de Siècle* (Cambridge, MA: Belknap Press of Harvard University Press, 1986).

38. For the Paris flood of 1910, see Jeffrey H. Jackson, *Paris Under Water: How the City of Light Survived the Great Flood of 1910* (New York: Palgrave Macmillan, 2010).

39. Quoted in Weber, *France: Fin de Siècle*, 21.

40. Quoted in Silverman, *Art Nouveau*, 80.

41. Eugen Weber suggests that concern for 'decadence' was a worry of the literate few, not the broader mass of people, although accepts that the problems were real enough (*France*, 13–14). Debora Silverman, on the other hand, suggests that these anxieties were circulated widely in the media (*Art Nouveau*, 81). I'm inclined to agree with Silverman, although it can never be clear how seriously the *readership* of this material took the discussion.

42. Quoted in Weber, *France*, 10.

43. Octave Uzanne, *La Femme à Paris: Nos contemporaines. Notes successives sur les Parisiennes de nos temps dans leurs divers milieux, états et conditions* (Paris: Libraries-Imprimeries Réunis, 1894), ii.

44. Nordau, *Degeneration*, 5–6.

45. Nordau, *Degeneration*, 17.

46. Nordau, *Degeneration*, 18–19.

47. Nordau, *Degeneration*, 34, 35.

48. Nordau, *Degeneration*, 39.

49. Nordau, *Degeneration*, 42.

50. Quoted in Silverman, *Art Nouveau*, 81.

51. Patrice Higonnet, *Paris: Capital of the World*, trans. Arthur Goldhammer (Cambridge, MA: Belknap Press of Harvard University Press, 2002), 95.

52. Sutcliffe, *Paris*, 129–130.

53. Quoted in Philippe Jullian, *The Triumph of Art Nouveau: Paris Exhibition 1900*, trans. Stephen Hardman (London: Phaidon Press, 1974), 43.

54. Jullian, *Triumph of Art Nouveau*, 38.

55. Higonnet, *Paris*, 359–362; Colin Jones, *Paris: The Biography of a City* (London: Penguin, 2006), 349–355.

56. Uzanne, *La Femme à Paris*, ii.

Chapter 3: Spectacle

1. Francis Carco, *Nostalgie de Paris* (Paris: Ferenczi et fils, 1945), 144.

2. Colin Jones, *Paris: The Biography of a City* (London: Penguin, 2006) (see chapter 10, 'The Anxious Spectacle', on the 1889–1918 period).

3. Eric Hazan, *The Invention of Paris: A History in Footsteps*, trans. David Fernbach (London: Verso, 2010), 51.

4. Hazan, *Invention of Paris*, 14; Jones, *Paris*, 161.

5. Hazan, *Invention of Paris*, 73.

6. Paule Delys, *Guide des plaisirs à Paris: Paris le jour, Paris la nuit* (Paris: Guides Conty, 1908), 201.

7. Delys, *Guide des plaisirs à Paris*, 201.

8. Edmond Deschaumes, *Pour bien voir Paris: Guide parisien pittoresque et pratique* (Paris: Maurice Dreyfous, 1889), 6–7.

9. Deschaumes, *Pour bien voir Paris*, 12–13.

10. Nguyễn Trọng Hiệp, *Paris, capitale de la France: Recueil de vers* (Hanoi: F.-H. Schneider, 1897), verse 20.

11. Deschaumes, *Pour bien voir Paris*, 15.

12. Deschaumes, *Pour bien voir Paris*, 30.

13. This boulevard is named after the Théâtre des Italiens that performed there in the eighteenth century.

14. Deschaumes, *Pour bien voir Paris*, 33.

15. A.-P. de Lannoy [Auguste Pawlowski], *Plaisirs de la vie de Paris: Guide du flâneur* (Paris: Borel, 1900), 22–23, 23–24, 26. Auguste Pawlowski was a respected authority on labour organisations.

16. Marcel Proust, *À la recherche du temps perdu: Du côté de chez Swann* (Paris: Bernard Grasset, 1914), 284.

17. Deschaumes, *Pour bien voir Paris*, 33–38.

18. Elizabeth Ezra, *Georges Méliès* (Manchester: Manchester University Press, 2000).

19. Pierre Casselle, *Paris républicain, 1871–1914* (Paris: Hachette, 2003), 414–417; Raymond Rudorff, *Belle Époque: Paris in the Nineties* (London: Hamilton, 1972), 302–303.

20. Roger Shattuck, *The Banquet Years: The Arts in France, 1885–1918* (London: Faber, 1959), 10–11.

21. Richard Abel, *The Ciné Goes to Town: French Cinema, 1896–1914* (Berkeley: University of California Press, 1994), 10–11.

22. Quoted in Abel, *Ciné Goes to Town*, 6.

23. Quoted in Abel, *Ciné Goes to Town*, 7.

24. Casselle, *Paris républicain*, 407.

25. Eugen Weber, *France: Fin de Siècle* (Cambridge, MA: Belknap Press of Harvard University Press, 1986), 159.

26. Quoted in Weber, *France*, 162.

27. On popular theatre, see Jessica Wardhaugh, *Popular Theatre and Political Utopia in France, 1870–1940: Active Citizens* (London: Palgrave Macmillan, 2017).

28. Carco, *Nostalgie de Paris*, 155.

29. See Brigitte Brunet, *Le Théâtre de Boulevard* (Paris: Nathan, 2004).

30. Émile Zola, *Nana*, trans. George Holden (Harmondsworth: Penguin, 1972), 44–45.

31. Lenard R. Berlanstein, *Daughters of Eve: A Cultural History of French Theater Women from the Old Regime to the Fin de Siècle* (Cambridge, MA: Harvard University Press, 2001), 158, 159.

32. Berlanstein, *Daughters of Eve*, 160–162, 166, 181.

33. Casselle, *Paris républicain*, 412–413.

34. Mary Louise Roberts, *Disruptive Acts: The New Woman in Fin-de-Siècle France* (Chicago: University of Chicago Press, 2002), 167–168.

35. Robert Gottlieb, *Sarah: The Life of Sarah Bernhardt* (New Haven, CT: Yale University Press, 2010), 1.

36. Sarah Bernhardt, *My Double Life: Memoirs of Sarah Bernhardt* (Luton, UK: Andrews, 2012), 62.

37. Rudorff, *Belle Époque*, 312–313.

38. Quoted in Gottlieb, *Sarah*, 81.

39. Gottlieb, *Sarah*, 120; Vincent Cronin, *Paris on the Eve, 1900–1914* (London: Collins, 1989), 320.

40. Patricia A. Tilburg, *Colette's Republic: Work, Gender, and Popular Culture in France, 1870–1914* (New York: Berghahn, 2009), 102–103.

41. Quoted in Weber, *France*, 161.

42. Charles Rearick, *Pleasures of the Belle Époque: Entertainment and Festivity in Turn-of-the-Century France* (New Haven, CT: Yale University Press, 1985), 177.

43. Charles Baudelaire, *The Painter of Modern Life and Other Essays*, trans. Jonathan Mayne (London: Phaidon Press, 1964), 9, 11.

44. Quoted in Patrice Higonnet, *Paris: Capital of the World*, trans. Arthur Goldhammer (Cambridge, MA: Belknap Press of Harvard University Press, 2002), 211.

45. Quoted in Tom McDonough, 'City of Strangers', in *The Invisible Flâneuse? Gender, Public Space, and Visual Culture in Nineteenth-Century Paris*, ed. Aruna D'Souza and Tom McDonough (Manchester: Manchester University Press, 2006), 149.

46. Quoted in Geoffrey Kurtz, 'An Apprenticeship for Life in Common: Jean Jaurès on Social Democracy and the Modern Republic', *New Political Science* 35 (2013): 74, 74n.

47. Quoted in Higonnet, *Paris*, 225.

48. Griselda Pollock, *Vision and Difference: Feminism, Femininity and the Histories of Art* (London: Routledge 2003), 94–95. See also more general treatments on attitudes towards, debates on, and condition of Frenchwomen, such as those by Susan K. Foley, *Women in France Since 1789: The Meanings of Difference* (Basingstoke: Palgrave, 2004); Karen Offen, *Debating the Woman Question in the French Third Republic, 1870–1920* (New York: Cambridge University Press, 2018); and James F. McMillan, *France and Women: Gender, Society and Politics, 1789–1914* (London: Routledge, 2000).

49. Elizabeth Wilson, 'The Invisible Flaneur', *New Left Review* 1, no. 191 (January/February 1992): 98.

50. Pollock, *Vision and Difference*, 78.

51. Quoted in Pollock, *Vision and Difference*, 98.

52. Baudelaire, *The Painter of Modern Life*, 30–31.

53. Wilson, 'Invisible Flaneur', 104.

54. Patricia Tilburg, *Working Girls: Sex, Taste, and Reform in the Parisian Garment Trades, 1880–1919* (Oxford: Oxford University Press, 2019), 25.

55. The Square Jules Ferry, the wide, green central reservation on the boulevard Jules Ferry, was formed when the Canal Saint-Martin was covered over at this stretch of the waterway. Here there is none of the exuberant sexuality often associated with the *grisette*. Descomps's *grisette* is demure, earnest, and hardworking: she is carrying the merchandise of her trade, in this case a basket of flowers.

56. Quoted in Tilburg, *Working Girls*, 37.

57. Quotation and detail from Tilburg, *Working Girls*, 37.

58. The *première* usually referred to their immediate supervisor, such as the shopfloor chief or steward. Quoted in Tilburg, *Working Girls*, 47.

59. Quoted in Tilburg, *Working Girls*, 47–48.

60. Janet Wolff, 'The Invisible *Flâneuse*: Women and the Literature of Modernity', *Theory, Culture and Society* 2 (1985): 37–46. This point has since been debated in detail: see D'Souza and McDonough, *Invisible* Flâneuse? especially D'Souza and McDonough, 'Introduction', 1–17.

61. Wilson, 'Invisible Flaneur', 95.

Chapter 4: Luxury

1. Quoted in Frederick Brown, *Zola: A Life* (London: Macmillan, 1995), 491.

2. Michael B. Miller, *The Bon Marché: Bourgeois Culture and the Department Store, 1869–1920* (Princeton, NJ: Princeton University Press, 1981), 21–38.

3. For a survey of the emergence of the early department store in its international dimension, see Rudi Laermans, 'Learning to Consume: Early Department Stores and the Shaping of the Modern Consumer Culture (1860–1914)', *Theory, Culture and Society* 10 (1993): 79–102.

4. Quoted in Brian Nelson, 'Introduction', in Émile Zola, *The Ladies' Paradise*, trans. Brian Nelson (Oxford: Oxford University Press, 2008 [1883]), ix.

5. Zola's novel, set as it was during the Second Empire, uses the street name from that period, which celebrated the landslide victory of Louis-Napoleon Bonaparte, later Napoleon III, in the presidential elections of 1848. With a certain mischief, the current name recalls the date in 1870 on which that same regime was overthrown and the Third Republic proclaimed.

6. Quoted in Brown, *Zola*, 491–492.

7. Émile Zola, *Au Bonheur des Dames* (Paris: Charpentier, 1883), 282.

8. Zola's notes are held by the Bibliothèque nationale de France [BnF]: Manuscrits, nouvelles acquisitions françaises, 10278 (Émile Zola, Oeuvres: Manuscrits et dossiers préparatoires, les Rougon-Macquart. Au Bonheur des Dames: dossier préparatoire, deuxième volume, 1881) ('Zola's notes, 10278', hereafter). They have been digitised and can be read via the BnF's online library, Gallica. The architect's description is on folios 264–269.

9. Zola's notes, 10278, f. 264r.

10. Zola's notes, 10278, fs. 268v, 269r.

11. Zola, *Au Bonheur des Dames*, 4.

12. Zola's notes, 10278, fs. 268v, 269r.

13. Zola's notes, 10278, f. 268r.

14. Zola's notes, 10278, f. 266v.

15. Nguyễn Trọng Hiệp, *Paris, capitale de la France: Recueil de vers* (Hanoi: F.-H. Schneider, 1897), verse 9.

16. Zola's notes, 10278, fs. 265v, 266r, 266v.

17. Anthony Sutcliffe, *Paris: An Architectural History* (New Haven, CT: Yale University Press, 1993), 132.

18. Zola's notes, 10278, fs. 266v–267r.

19. Zola's notes, 10278, f. 268r.

20. Zola's notes, 10278, f. 269r.

21. Quoted in Olivier Vayron, 'Dômes et signes spectaculaires dans les couronnements des grands magasins parisiens: Dufayel, Grand-Bazar de la rue de Rennes, Printemps, Samaritaine', *Livraisons de l'histoire de l'architecture* 29 (2015): 15.

22. Meredith L. Clausen, 'The Department Store: Development of the Type', *Journal of Architectural Education* 39 (1985): 26.

23. Zola's notes, 10278, f. 264v.

24. La Samaritaine takes its name from its location on the site of the early seventeenth-century water pump that had been demolished by Napoleon and where, under an arch of the Pont-Neuf, Cognacq had once run a stall selling fabrics before leasing premises of his own close by. Information on the Cognacq-Jaÿs drawn from the website of the museum of the same name: www .museecognacqjay.paris.fr/en/cognacq-jay-family#paragraphe0. The museum, in the Marais, houses their remarkable collection of eighteenth-century artwork, donated to the city in the 1920s. It is well worth a visit.

25. Vayron, 'Dômes et signes spectaculaires', 14.

26. Sutcliffe, *Paris*, 119.

27. Vayron, 'Dômes et signes spectaculaires', 14.

28. Quotations all in Vayron, 'Dômes et signes spectaculaires', 13, 14.

29. The strange name Arbre-Sec—'dry tree'—refers to the gibbet that stood at the top of the street in the Middle Ages.

30. Musée d'Orsay archives: Paris, Grands Magasins, dossier Galeries Lafayette.

31. Musée d'Orsay archives: Paris, Grands Magasins, dossier Galeries Lafayette.

32. Musée d'Orsay archives: Paris, Grands Magasins, dossier Au Printemps.

33. Vayron, 'Dômes et signes spectaculaires', 15–16.

34. Quoted in Robert Proctor, 'Constructing the Retail Monument: The Parisian Department Store and Its Property, 1855–1914', *Urban History* 33 (2006): 395.

35. The boulevard links the avenues leading into the city from the west with (via the relentlessly upwards and north-eastwards march of the rue Lafayette) the railways at the Gares du Nord and de l'Est, and the canal port at the Bassin de la Villette.

36. Clausen, 'Department Store', 26.

37. Patrice Higonnet, *Paris: Capital of the World*, trans. Arthur Goldhammer (Cambridge, MA: Harvard University Press, 2002), 200.

38. Lenard R. Berlanstein, *The Working People of Paris, 1871–1914* (Baltimore: Johns Hopkins University Press, 1984), 49.

39. *L'Humanité*, 19 December 1904.

40. Zola, *Au Bonheur des Dames*, 91.

41. Laermans, 'Learning to Consume', 85–86.

42. Nguyễn Trọng Hiệp, *Paris*, verse 9; Charles Rice-Davis and Mia Nakayama, 'Electric Light and Clouds of Dust: A Reading and Translation of Nguyễn Trọng Hiệp's *Paris, capitale de la France*', *Litera* 30 (2020): 656n.

43. Dana S. Hale, 'French Images of Race on Product Trademarks During the Third Republic', in *The Color of Liberty: Histories of Race in France*, ed.

Sue Peabody and Tyler Stovall (Durham, NC: Duke University Press, 2003), 133; Tyler Stovall, *Transnational France: The Modern History of a Universal Nation* (Boulder, CO: Westview Press, 2015), 223–224, 238.

44. Miller, *Bon Marché*, 59.

45. Musée d'Orsay archives: Paris, Grands Magasins, dossier Au Bon Marché.

46. Georges Avenel, *Le mécanisme de la vie moderne* (Paris: Armand Colin, 1896), 45.

47. Musée d'Orsay archives: Paris, Grands Magasins, dossier Au Bon Marché.

48. Brian Wemp, 'Social Space, Technology, and Consumer Culture at the Grands Magasins Dufayel', *Historical Reflections / Réflexions historiques* 27 (2011): 6.

49. Zola's notes, 10278, f. 267v.

50. Wemp, 'Social Space, Technology, and Consumer Culture', 5, 10.

51. Zola, *Au Bonheur des Dames*, 91–92.

52. Marguerite Durand, 'Confession à M. Émile Faguet de l'Académie française', *La Fronde*, 1 October 1903.

53. Quoted in Mary Louise Roberts, 'Acting Up: The Feminist Theatrics of Marguerite Durand', *French Historical Studies* 19 (1996): 1105.

54. Quoted in Roberts, 'Acting Up', 1105.

55. Roberts, 'Acting Up', 1107–1108.

56. On the 'New Woman', including Marguerite Durand, see Mary Louise Roberts, *Disruptive Acts: The New Woman in Fin-de-Siècle France* (Chicago: University of Chicago Press, 2002).

57. Roberts, 'Acting Up', 1108 (Séverine), 1109.

58. Durand, 'Confession à M. Émile Faguet', *La Fronde*, 1 October 1903. See also Roberts, *Disruptive Acts*, 61.

59. Naomi Wolf, *The Beauty Myth: How Images of Female Beauty Are Used Against Women* (New York: Willam Morrow, 1991).

60. Mary Lynn Stewart, *For Health and Beauty: Physical Culture for French-women, 1880s–1930s* (Baltimore: Johns Hopkins University Press, 2001), 13.

61. Ruth E. Iskin, 'Popularising New Women in Belle Epoque Advertising Posters', in *A Belle Epoque? Women in French Society and Culture, 1890–1914*, ed. Diana Holmes and Carrie Tarr (New York: Berghahn Books, 2006), 97.

62. Elizabeth Carlson, 'Dazzling and Deceiving: Reflections on the Nineteenth-Century Department Store', *Visual Resources* 28 (2012): 117–137.

63. Zola's notes, 10278, f. 88.

64. Rachel Mesch, *Having It All in the Belle Époque: How French Women's Magazines Invented the Modern Woman* (Stanford, CA: Stanford University Press, 2013), 4, 13, 190–194.

65. Lisa Tiersten, *Marianne in the Market: Envisioning Consumer Society in Fin-de-Siècle France* (Berkeley: University of California Press, 2001), 17.

66. Tiersten, *Marianne in the Market*, 2–3.

67. Quoted in Tiersten, *Marianne in the Market*, 25.

68. Tiersten, *Marianne in the Market*, 48–49.

69. Claudie Lesselier, 'Employées de grands magasins à Paris (avant 1914)', *Le Mouvement social*, no. 105 (October–December 1978): 109–110.

70. Quoted in Lesselier, 'Employées de grands magasins', 114.

71. Theresa M. McBride, 'A Woman's World: Department Stores and the Evolution of Women's Employment, 1870–1920', *French Historical Studies* 10 (1978): 665–668, 675.

72. McBride, 'Woman's World', 672; Lesselier, 'Employées de grands magasins', 112, 120.

73. Quoted in Lesselier, 'Employées de grands magasins', 112–113.

74. McBride, 'Woman's World', 678; Lesselier, 'Employées de grands magasins', 113.

75. Blanche Baur, 'La Femme dans les grands magasins', *La Fronde*, 20 December 1897.

76. Lesselier, 'Employées de grands magasins', 116–119, 122–133.

77. McBride, 'Woman's World', 676.

78. Lesselier, 'Employées de grands magasins', 124–125.

79. Zola's notes, 10278, fs. 213–214; McBride, 'Woman's World', 680–681.

80. Zola, *Au Bonheur des Dames*, 90.

81. F. W. J. Hemmings, *Émile Zola* (Oxford: Clarendon Press, 1953), 181.

82. Jean Jaurès, 'Le Capitalisme et la classe moyenne', *La Dépêche: Journal de la Démocratie du Midi* (10 March 1889).

83. Philip G. Nord, *Parisian Shopkeepers and the Politics of Resentment* (Princeton, NJ: Princeton University Press, 1986), 75, 429.

84. Quoted in Nord, *Parisian Shopkeepers*, 415.

85. Nord, *Parisian Shopkeepers*, 420.

86. Miller, *Bon Marché*, 3–5.

87. David Chaney, 'The Department Store as a Cultural Form', *Theory, Culture and Society* 1 (1983): 24, 25.

Chapter 5: Bohemia

1. 'Marianne reçoit . . .', *La Fronde*, 24 April 1900. The author of this article was Andrée Téry.

2. 'Spectacles à ne pas offrir aux étrangers', *Revue des revues*, 1 April 1900, 142.

3. 'Spectacles à ne pas offrir', 144–145, 148.

4. 'Marianne reçoit . . .', *La Fronde*, 24 April 1900.

5. Jerrold Seigel, *Bohemian Paris: Culture, Politics, and the Boundaries of Bourgeois Life, 1830–1930* (New York: Viking Penguin, 1986), 5.

6. Seigel, *Bohemian Paris*, 10–11, 14–15.

7. For a lively example of the kind of literature spawned by this 'tourism' in 'Bohemia', see the misadventures of two English-speaking visitors in Montmartre's Moulin de la Galette, in W. C. Morrow and Edouard Cucuel, *Bohemian Paris of To-Day* (Philadelphia: Lippincott, 1900), 226–248.

8. Eric Hazan, *The Invention of Paris: A History in Footsteps*, trans. David Fernbach (London: Verso, 2010), 198.

9. Seigel, *Bohemian Paris*, 5, 342–345.

10. Roland Dorgelès, *Promenades montmartroises* (Paris: Se Trouve Chez Trinckvel, 1960), 7.

11. Charles Rearick, *Pleasures of the Belle Époque: Entertainment and Festivity in Turn-of-the-Century France* (New Haven, CT: Yale University Press, 1985), 91.

12. The painting is in the Musée d'Orsay.

13. The painting is in the Guggenheim Museum, New York.

14. The painting is in the Musée d'art moderne, Troyes.

15. The painting is in the Museum of Modern Art, New York.

16. Vincent Cronin, *Paris on the Eve, 1900–1914* (London: Collins, 1989), 169–170, 174–177, 180; Pierre Casselle, *Paris républicain, 1871–1914* (Paris: Hachette, 2003), 391.

17. Casselle, *Paris républicain*, 387n.

18. Victor Serge, *Memoirs of a Revolutionary, 1901–1941* (London: Oxford University Press, 1978), 22.

19. John Merriman, *The Ballad of the Anarchist Bandits: The Crime Spree That Gripped Belle Époque Paris* (New York: Nation Books, 2017), 50–53.

20. Serge, *Memoirs*, 18.

21. Serge, *Memoirs*, 22.

22. John Merriman, *The Dynamite Club: How a Bombing in Fin-de-Siècle Paris Ignited the Age of Modern Terror* (New Haven, CT: Yale University Press, 2009), 61–62, 88–89, 208–209 (Kees van Dongen quoted on 62).

23. Merriman, *Dynamite Club*, 88.

24. John Storm, *The Valadon Drama: The Life of Suzanne Valadon* (New York: Dutton, 1959), 51–52.

25. Catherine Hewitt, *Renoir's Dancer: The Secret Life of Suzanne Valadon* (London: Icon Books, 2017), 107.

26. Quoted in Hewitt, *Renoir's Dancer*, 56.

27. Hewitt, *Renoir's Dancer*, 84.

28. Hewitt, *Renoir's Dancer*, 136; Storm, *Valadon Drama*, 106.

29. Storm, *Valadon Drama*, 151–160, 183.

30. Seigel, *Bohemian Paris*, 339–340.

31. Seigel, *Bohemian Paris*, 342, 344–345; Cronin, *Paris on the Eve*, 168.

32. Morrow and Cucuel, *Bohemian Paris of To-Day*, 224.

33. Dominique Kalifa, *The Belle Époque: A Cultural History, Paris and Beyond*, trans. Susan Emanuel (New York: Columbia University Press, 2021), 124.

34. George Moore, *Confessions of a Young Man* (London: 1904), n.p. (chapter 8).

35. F. W. J. Hemmings, *Émile Zola* (Oxford: Clarendon Press, 1953), 113–114.

36. Seigel, *Bohemian Paris*, 308–309, 296–297.

37. Émile Goudeau, *Dix ans de Bohème* (Paris: Librairie Illustré, 1888), 255–256.

38. Goudeau, *Dix ans*, 95.

39. Seigel, *Bohemian Paris*, 228.

40. Goudeau, *Dix ans*, 131.

41. *Le Chat Noir*, no. 1 (14 January 1882).

42. À Kempis, 'Voyage de Découvertes', *Le Chat Noir*, Supplement (15 January 1882), and nos. 2, 4, and 6 (21 January and 4 and 18 February 1882).

43. *Le Chat Noir*, no. 12 (1 April 1882).

44. Michael L. J. Wilson, 'Portrait of the Artist as a Louis XIII Chair', in *Montmartre and the Making of Mass Culture*, ed. Gabriel P. Weisberg (New Brunswick, NJ: Rutgers University Press, 2001), 185.

45. Raymond Rudorff, *Belle Époque: Paris in the Nineties* (London: Hamilton, 1972), 74–76.

46. Morrow and Cucuel, *Bohemian Paris of To-Day*, 292.

47. Seigel, *Bohemian Paris*, 237–239.

48. Quoted in Rudorff, *Belle Époque*, 48.

49. Colin Jones, *Paris: The Biography of a City* (London: Penguin, 2006), 373.

50. Rudorff, *Belle Époque*, 50–52.

51. Rearick, *Pleasures of the Belle Époque*, 77 (elephant), 102 (Pétomane).

52. Quoted in Jones, *Paris*, 373–374.

53. For 'Sarah Brown', see the entry by Marie Lathers in Jill Berk Jiminez and Joanna Banham, eds., *Dictionary of Artists' Models* (London: Fitzroy Dearborn, 2001), 86–88. For the invention of the striptease, see Rudorff, *Belle Époque*, 58–59.

54. On this point, see Dominique Kalifa's discussion of the responses to the reopening of the Moulin Rouge after the Second World War in Kalifa, *Belle Époque*, 95–98.

55. See Elena Cueto-Asin, 'The Chat Noir's Théâtre d'Ombres: Shadow Plays and the Recuperation of Public Space', in Weisberg, *Montmartre and the Making of Mass Culture*, 224–226.

Chapter 6: Survival

1. Eric Hazan, *The Invention of Paris: A History in Footsteps*, trans. David Fernbach (London: Verso, 2010), 200.

2. Frederick Brown, *Zola: A Life* (London: Macmillan, 1995), 297.

3. Brown, *Zola*, 363.

4. Nguyễn Trọng Hiệp, *Paris, capitale de la France: Recueil de vers* (Hanoi: F.-H. Schneider, 1897), verse 25.

5. Hazan, *Invention of Paris*, 201. The square is now home to a community garden, with planters and floral bushes arranged elegantly across the small, paved space. The wash-house actually existed; it was not demolished until this quarter was renovated (up to a point) in the 1980s.

6. Émile Zola, *L'Assommoir*, trans. and with an introduction by Leonard Tancock (Harmondsworth: Penguin, 1970), 305.

7. Leonard Tancock, 'Introduction', in Zola, *L'Assommoir*, 7.

8. Zola, *L'Assommoir*, 21.

9. Quoted in Brown, *Zola*, 364.

10. Quoted in Brown, *Zola*, 365.

11. Quoted in Brown, *Zola*, 365.

12. Quoted in Brown, *Zola*, 367.

13. Zola, *L'Assommoir*, 21.

14. Charles Sowerwine, *France Since 1870: Culture, Politics and Society* (London: Palgrave, 2018), 69. Sowerwine is here citing the French economist Thomas Piketty.

15. Pierre Casselle, *Paris républicain, 1871–1914* (Paris: Hachette, 2003), 153–155.

16. Lenard R. Berlanstein, *The Working People of Paris, 1871–1914* (Baltimore: Johns Hopkins University Press, 1984), 3.

17. Jean Lhomme, 'Le Pouvoir d'achat de l'ouvrier français au cours d'un siècle: 1840–1940', *Le Mouvement social*, no. 63 (April–June 1968): 45.

18. Berlanstein, *Working People of Paris*, 43.

19. Berlanstein, *Working People of Paris*, 40–41.

20. René Martial, 'L'Alimentation des travailleurs', *Revue d'hygiène et de police sanitaire* 29 (1907): 517.

21. Lhomme, 'Le Pouvoir d'achat', 49; Michel Winock, *La Belle Époque* (Paris: Perrin, 2003), 138–139.

22. Berlanstein, *Working People of Paris*, 50–51.

23. Winock, *Belle Époque*, 140; Eugen Weber, *France: Fin de Siècle* (Cambridge, MA: Belknap Press of Harvard University Press, 1986), 64.

24. Berlanstein, *Working People of Paris*, 46–49, 55.

25. Martin Breugel, 'Workers' Lunch Away from Home in the Paris of the Belle Époque: The French Model of Meals as Norm and Practice', *French Historical Studies* 38 (2015): 269.

26. Breugel, 'Workers' Lunch', 265, 269, 276 (quotation on p. 277).

27. Martial, 'L'Alimentation des travailleurs', 522.

28. Quoted in Breugel, 'Workers' Lunch', 276.

29. Martial, 'L'Alimentation des travailleurs', 518–520.

30. Berlanstein, *Working People of Paris*, 137.

31. Ernest Laut, 'Variété: Comment débarrasser Paris des Apaches?', *Le Petit journal: Supplément illustré*, 23 January 1910.

32. Régis Pierret, 'Les Apaches, 1900–1914: Premier acte de violence des jeunes en milieu urbain', *Débats jeunesses* 13 (2003): 215–227.

33. Yves Guyot, *La Prostitution* (Paris: Charpentier, 1902), 95; Armand Villette, *Du Trottoir à Saint-Lazare: Étude sociale de la fille à Paris* (Paris: Librairie Universelle, 1907), 2.

34. Jill Harsin, *Policing Prostitution in Nineteenth-Century Paris* (Princeton, NJ: Princeton University Press, 1985), 103 (quotation on p. 123).

35. 'Dr. Caufeynon' (Jean Fauconney), *La Prostitution: La Débauche, corruption, son histoire, législation* (Paris: Nouvelle Librairie Médicale, 1902), 79. On Fauconney, see Alison Moore, 'Frigidity, Gender and Power in French Cultural History: From Jean Fauconney to Marie Bonaparte', *French Cultural Studies* 20 (2009): 331–349.

36. Quoted in Alain Corbin, *Les Filles de noce: Misère sexuelle et prostitution au XIXe siècle* (Paris: Flammarion, 1982), 15–16.

37. Laure Adler, *Les Maisons closes, 1830–1940* (Paris: Fayard/Pluriel, 2010), 13.

38. Corbin, *Filles de noce*, 55–56.

39. Villette, *Du Trottoir à Saint-Lazare*, 1.

40. Corbin, *Filles de noce*, 60–61.

41. Henri de Toulouse-Lautrec, *Medical Inspection, rue des Moulins*, 1894. On this painting and its context, see Mike McKiernan, 'Henri de Toulouse-Lautrec Medical Examination, rue des Moulins (1894): North Wall Fresco, Lower Panel 5.398 m × 13.716 m. Detroit Institute of Arts, Detroit, USA', *Occupational Medicine* 59 (2009): 366–368.

42. Corbin, *Filles de noce*, 88–91.

43. Harsin, *Policing Prostitution*, 311.

44. Villette, *Du Trottoir à Saint-Lazare*, 222–224.

45. Villette, *Du Trottoir à Saint-Lazare*, 5.

46. Émile Zola, *Nana*, trans. George Holden (Harmondsworth: Penguin, 1972), 272.

47. Villette, *Du Trottoir à Saint-Lazare*, 5.

48. Zola, *Nana*, 275.

49. Guyot, *La Prostitution*, 307–322.

50. Guyot, *La Prostitution*, 217–218.

51. Quoted in Harsin, *Policing Prostitution*, 302–303.

52. Harsin, *Policing Prostitution*, 3–5.

53. Berlanstein, *Working People of Paris*, 127–131.

54. Michael R. Marrus, 'Social Drinking in the Belle Époque', *Journal of Social History* 7 (1974): 122, 124–125.

55. Winock, *Belle Époque*, 141.

56. Casselle, *Paris républicain*, 314.

57. Bibliothèque nationale de France [BnF]: Manuscrits, nouvelles acquisitions françaises, 10271 (Émile Zola, Oeuvres: Manuscrits et dossiers préparatoires, les Rougon-Macquart. L'Assommoir) ('Zola's notes, 10271', hereafter), 106–107.

58. Zola, *L'Assommoir*, 67.

59. Casselle, *Paris républicain*, 312–314. On natalism, see, among others, Fabrice Cahen, 'Medicine, Statistics, and the Encounter of Abortion and "Depopulation" in France (1870–1920)', *History of the Family* 14 (2009): 19–35; Karen Offen, 'Depopulation, Nationalism, and Feminism in Fin-de-Siècle France', *American Historical Review* 89 (1984): 648–676.

60. David S. Barnes, *The Great Stink of Paris and the Nineteenth-Century Struggle Against Filth and Germs* (Baltimore: Johns Hopkins University Press, 2006), 16, 24–27.

61. Casselle, *Paris républicain*, 312.

62. Weber, *France*, 64, 58.

63. Colin Jones, *Paris: The Biography of a City* (London: Penguin, 2006), 396.

64. Casselle, *Paris républicain*, 145.

65. See, for example, the report from 1906: Paul Juillerat, *Rapport à M. le préfet sur les enquêtes effectuées en 1906 dans les maisons signalées comme foyers de tuberculose* (Paris: Imprimerie Chaix, 1907). For the *casier sanitaire*, see Yankel Fijalkow, 'L'Enquête sanitaire urbaine à Paris en 1900: Le Casier sanitaire des maisons', *Revue mil neuf-cent*, no. 22 (2004): 95–106.

66. Paul Juillerat, *L'Hygiène de logement* (Paris: Librairie Charles Delagrave, 1909), 4. For different contemporary ideas about overcrowding and sanitation, see Yankel Fijalkow, 'Surpopulation ou insalubrité: Deux statistiques pour décrire l'habitat populaire (1880–1914)', *Mouvement social*, no. 198 (1998): 79–96.

67. Quoted in Casselle, *Paris républicain*, 146.

68. Jones, *Paris*, 362.

69. Casselle, *Paris républicain*, 223, 226.

70. Zola's notes, 10271, 113.

71. Zola's notes, 10271, 105.

72. Zola's notes, 10271, 106–108.

73. Hazan, *Invention of Paris*, 201.

74. Quoted in John Merriman, *The Dynamite Club: How a Bombing in Fin-de-Siècle Paris Ignited the Age of Modern Terror* (New Haven, CT: Yale University Press, 2016), 16.

75. Victor Serge, *Memoirs of a Revolutionary, 1901–1941*, trans. Peter Sedgwick (Oxford: Oxford University Press, 1978), 21–23 (quotation on p. 21).

76. Berlanstein, *Working People of Paris*, 60.

77. Martial, 'L'Alimentation des travailleurs', 521.

Chapter 7: Struggle

1. The best way to see this is, of course, to visit the square itself—especially since it has been pedestrianised—but some good photographs revealing much of the detail can be found at 'Statue de la République—place de la République—Paris (70511)', E-Monumen, https://e-monumen.net/patrimoine -monumental/statue-de-la-republique-place-de-la-republique-paris, accessed 4 April 2023.

2. Pierre Casselle, *Paris républicain, 1871–1914* (Paris: Hachette, 2003), 29; Robert Gildea, *Children of the Revolution: The French, 1799–1914* (London: Penguin, 2008), 253.

3. Lenard R. Berlanstein, *The Working People of Paris, 1871–1914* (Baltimore: Johns Hopkins University Press, 1984), 158.

4. Quoted in Janice Best, 'Une statue monumentale de la République', *Nineteenth-Century French Studies* 34 (2006): 308.

5. Gildea, *Children of the Revolution*, 254.

6. Conseil municipal de Paris, *Rapport . . . au nom de la Commission spéciale des Beaux-Arts sur le programme du concours pour l'érection d'une statue de la République sur la place du Château-d'Eau* (Paris, 1879), 3.

7. Best, 'Une statue monumentale', 309–310, 312–313.

8. Berlanstein, *Working People of Paris*, 158.

9. Casselle, *Paris républicain*, 198.

10. Henri Girard and Fernand Pelloutier, *Qu'est-ce que la Grève générale?* (Paris: Imprimerie Jean Allemane, 1895), 9–10.

11. Girard and Pelloutier, *Qu'est-ce que la Grève générale?*, 12.

12. Casselle, *Paris républicain*, 198.

13. Roger Magraw, *A History of the French Working Class*, vol. 1, *Workers and the Bourgeois Republic* (Oxford: Blackwell, 1992), 103.

14. Michel Winock, *La Belle Époque* (Paris: Perrin, 2003), 137.

15. Casselle, *Paris républicain*, 198; Magraw, *History of the French Working Class*, 103.

16. *La Fronde*, 14 February 1901.

17. Casselle, *Paris républicain*, 200.

18. Berlanstein, *Working People of Paris*, 186.

19. Charles Sowerwine, *France Since 1870: Culture, Politics and Society* (London: Palgrave, 2018), 79.

20. Casselle, *Paris républicain*, 199.

21. 'La Police maîtresse de Paris', *L'Humanité*, 2 May 1906.

22. 'La Police maîtresse de Paris', *L'Humanité*, 2 May 1906.

23. Anonymous ('XXX'), 'Le 1er Mai', *Figaro*, 2 May 1906.

24. Magraw, *History of the French Working Class*, 110.

25. Anonymous ('XXX'), 'Le 1er Mai'.

26. Anonymous ('XXX'), 'Le 1er Mai'.

27. 'La Police maîtresse de Paris', *L'Humanité*, 2 May 1906.

28. Anonymous ('XXX'), 'Le 1er Mai'.

29. 'La Police maîtresse de Paris', *L'Humanité*, 2 May 1906; Anonymous ('XXX'), 'Le 1er Mai'.

30. Berlanstein, *Working People of Paris*, 186–187.

31. Anonymous ('XXX'), 'Le 1er Mai'.

32. Elizabeth K. Collumb, 'A Dimming of Perspective: The Paris Electricians' Strike of 1907', *UCLA Historical Journal* 9 (1989): 32–51 (quotation on p. 32).

33. Magraw, *History of the French Working Class*, 117.

34. Gerald C. Friedman, 'Revolutionary Unions and French Labor: The Rebels Behind the Cause; or, Why Did Revolutionary Syndicalism Fail?', *French Historical Studies* 20 (1997): 155–181.

35. Harvey Goldberg, *The Life of Jean Jaurès* (Madison: University of Wisconsin Press, 1962), 392.

36. Quoted in Goldberg, *Life of Jaurès*, 84–85, 100.

37. Quoted in Goldberg, *Life of Jaurès*, 65.

38. Goldberg, *Life of Jaurès*, 103.

39. Sowerwine, *France Since 1870*, 71; Robert Tombs, *France 1814–1914* (London: Longman, 1996), 458.

40. Quoted in Goldberg, *Life of Jaurès*, 341.

41. Serge quoted in John Merriman, *The Ballad of the Anarchist Bandits: The Crime Spree That Gripped Belle Époque Paris* (New York: Nation Books, 2017), 57, 58.

42. John Merriman, *The Dynamite Club: How a Bombing in Fin-de-Siècle Paris Ignited the Age of Modern Terror* (New Haven, CT: Yale University Press, 2016), 81, 78–82.

43. Merriman, *Dynamite Club*, 102–105.

44. Merriman, *Dynamite Club*, 138, 145, 177.

45. For the best secondary account, see Merriman, *Dynamite Club*, passim.

46. *La Petite République*, 14 January and 6 February 1894; Goldberg, *Life of Jaurès*, 120–121.

47. *Le Temps*, 12 December 1893.

48. Quoted in Goldberg, *Life of Jaurès*, 123.

49. *Le Figaro*, 27 March 1894, quoted in Merriman, *Dynamite Club*, 172.

50. Quoted in Merriman, *Dynamite Club*, 237n171.

51. Goldberg, *Life of Jaurès*, 121.

52. Archives Nationales, F/7/12506 ('État numérique des anarchistes', 31 July 1894).

53. Merriman, *Dynamite Club*, 208–209.

54. Quoted in Goldberg, *Life of Jaurès*, 122.

55. Merriman, *Dynamite Club*, 209, 240n209.

56. Merriman, *Ballad of the Anarchist Bandits*, 69.

57. The detail for the rest of this chapter is drawn from Richard Parry, *The Bonnot Gang: The Story of the French Illegalists* (London: Rebel Press, 1987), and Merriman, *Ballad of the Anarchist Bandits*.

58. Quoted in Merriman, *Ballad of the Anarchist Bandits*, 145.

59. Parry, *Bonnot Gang*, 166.

Chapter 8: Polemics

1. Pierre Albert, 'La Presse française', in Claude Bellanger, Jacques Godechot, Pierre Guiral, and Fernand Terrou, *Histoire générale de la presse française*, vol. 3, *De 1871 à 1940* (Paris: Presses Universitaires de France, 1972), 358.

2. Jean-Denis Bredin, *The Affair: The Case of Alfred Dreyfus*, trans. Jeffrey Mehlman (New York: George Braziller, 1986), 247; Ruth Harris, *The Man on Devil's Island: Alfred Dreyfus and the Affair That Divided France* (London: Penguin, 2011), 116; Frederick Brown, *Zola: A Life* (London: Macmillan, 1995), 233–234, 613 (appearance and voice).

3. Quoted in Piers Paul Read, *The Dreyfus Affair: The Story of the Most Infamous Miscarriage of Justice in French History* (London: Bloomsbury, 2012), 104.

4. For Dreyfus's family background, see, especially, Michael Burns, *Dreyfus: A Family Affair, 1789–1945* (London: Chatto and Windus, 1993) ('first sorrow' from p. 51).

5. On the role of Germanophobia, see Allan Mitchell, 'The Xenophobic Style: French Counterespionage and the Emergence of the Dreyfus Affair', *Journal of Modern History* 52 (1980): 414–425.

6. Harris, *Man on Devil's Island*, 300.

7. Quoted in Harris, *Man on Devil's Island*, 63.

8. Bredin, *The Affair*, 25. For a useful exposé of the converging roots of antisemitism in the Dreyfus Affair, see Martin P. Johnson, *The Dreyfus Affair: Honour and Politics in the Belle Époque* (Basingstoke: Macmillan, 1999), 5–8, and Harris, *Man on Devil's Island*, 64–66.

9. Harris, *Man on Devil's Island*, 64–65; Bredin, *The Affair*, 25.

10. Quoted in Harris, *Man on Devil's Island*, 101.

11. Harvey Goldberg, *The Life of Jean Jaurès* (Madison: University of Wisconsin Press, 1962), 131–132.

12. Quoted in Bredin, *The Affair*, 98.

13. Quoted in Read, *Dreyfus Affair*, 111.

14. Bernard Lazare, *La Vérité sur l'affaire Dreyfus*, 2nd ed. (Paris: Stock, 1897), xiv.

15. Quoted in Read, *Dreyfus Affair*, 162.

16. These pipes flowed along the same tunnels as the Paris sewers. The messaging system was created in 1866 and remained in use until 1984.

17. On Picquart's discovery and on Esterhazy, see Harris, *Man on Devil's Island*, 76–78.

18. Quoted in Harris, *Man on Devil's Island*, 101.

19. F. W. J. Hemmings, *Émile Zola* (Oxford: Clarendon Press, 1953), 273. Details on the publication of *Paris* in Brown, *Zola*, 707.

20. Brown, *Zola*, 726; Hemmings, *Émile Zola*, 266–268.

21. Émile Zola, 'A Plea for the Jews', in Émile Zola, *The Dreyfus Affair: 'J'Accuse' and Other Writings*, ed. Alain Pagès, trans. Eleanor Levieux (New Haven, CT: Yale University Press, 1996), 2.

22. Zola, *Dreyfus Affair*, 14.

23. Émile Zola, 'Letter to M. Félix Faure, President of the Republic' ('J'Accuse'), in Zola, *Dreyfus Affair*, 43–53.

24. Zola, *Dreyfus Affair*, 51.

25. Quoted in Élizabeth Coquart, *La Frondeuse: Marguerite Durand, patronne de presse et féministe* (Paris: Payot, 2010), 126.

26. Louis Charlet and Robert Ranc, 'L'évolution des techniques de 1865 à 1914', in Claude Bellanger, Jacques Godechot, Pierre Guiral, and Fernand Terrou, eds., *Histoire générale de la presse française*, 5 vols. (Paris: Presses Universitaires de France, 1969–1976), 3:98–99.

27. Charlet and Ranc, 'L'évolution des techniques', 3:66–72, 80–94, 95, 97.

28. Bellanger et al., *Histoire générale*, 3:343.

29. Jacques Hillairet, *Connaissance du vieux Paris: Rive Droite* (Paris: Gonthier, 1954), 114–115; Colin Jones, *Paris: The Biography of a City* (London: Penguin, 2006), 47.

30. Quoted in Eric Hazan, *The Invention of Paris: A History in Footsteps*, trans. David Fernbach (London: Verso, 2010), 48.

31. Charlet and Ranc, 'L'évolution des techniques', 3:129.

32. Patrick Eveno, 'La Presse parisienne du second empire aux années 1970: Un quartier, des métiers et des sociabilités', in *Être parisien*, ed. Charles Gauvard and Jean-Louis Robert (Paris: Èditions de la Sorbonne, 2004). I used the online version available at Open Edition Books, https://books.openedition.org /psorbonne/1415#ftn21, but the page numbers in the print version are 125–134.

33. Eveno, 'La Presse parisienne', n15.

34. Eveno, 'La Presse parisienne'.

35. *Le Matin*, 4 September 1909.

36. Eveno, 'La Presse parisienne'.

37. Goldberg, *Life of Jaurès*, 228–231 ('throw down the churches', p. 228).

38. Robert Gildea, *Children of the Revolution: The French, 1799–1914* (London: Allen Lane, 2008), 275.

39. Quoted in Goldberg, *Life of Jaurès*, 239.

40. Janine Ponty, 'La Presse quotidienne et l'affaire Dreyfus en 1898–1899: Essai de typologie', *Revue d'histoire moderne et contemporaine* 21 (1974): 205.

41. *La Petite République*, 13 January 1898.

42. *La Petite République*, 18 January 1898.

43. *La Petite République*, 20 January 1898.

44. Goldberg, *Life of Jaurès*, 223–224.

45. Goldberg, *Life of Jaurès*, 240.

46. *La Petite République*, 10 August 1898.

47. *Le Petite République*, 13, 14, 18, 19, and 20 August 1898; Jean Jaurès, *Les Preuves: L'Affaire Dreyfus* (Paris: La Petite République, 1898), 54–72, 73–96, 97–168.

48. *La Petite République*, 25 and 28 August 1898; Jaurès, *Les Preuves*, 169–219.

49. *La Fronde*, 13 December 1897.

50. Quoted in Coquart, *La Frondeuse*, 124 (Pognon cited on p. 131).

51. Quoted in Coquart, *La Frondeuse*, 123.

52. Quoted in Coquart, *La Frondeuse*, 129.

53. Harris, *Man on Devil's Island*, 164–165, 236.

54. *La Petite République*, 1 and 2 September 1898.

55. Read, *Dreyfus Affair*, 257.

56. Archives Nationales, F/7/12474 (Procès Zola), police reports of 15 and 17 February 1898.

57. 'Vaughan Ernest, Joseph, Richard', Le Maitron: Dictionnaire biographique, mouvement ouvrier, mouvement social, 2010, modified 13 January 2021, https://maitron.fr/spip.php?article136035.

58. Quoted in Jean Garrigues, 'Henri Rochefort', in Michel Drouin, *L'Affaire Dreyfus de A à Z* (Paris: Flammarion, 1994), 267.

59. Quoted in Harris, *Man on Devil's Island*, 101.

60. John F. Macdonald, 'Henri Rochefort', *Contemporary Review*, no. 104 (1 July 1913): 192.

61. On the founding of *L'Aurore*, see Albert, 'La Presse française', 368.

62. *L'Intransigeant*, 21 February 1898.

63. Garrigues, 'Henri Rochefort', 268.

64. Hillairet, *Connaissance du vieux Paris*, 252.

65. 'Frankfurt' is a reference to the Treaty of Frankfurt that ended the Franco-Prussian War in 1871. The treaty ceded Alsace and Lorraine to Germany. The reference is probably to those Alsatians who had opted to move to France, including the Dreyfus family, as well as Scheurer-Kestner and Picquart, who were at the core of the Dreyfusard cause. The term 'cosmopolitan' has antisemitic connotations in this context.

66. *La Patrie*, 2 September 1898.

67. Harris, *Man on Devil's Island*, 239.

68. *L'Aurore*, 2 September 1898.

69. Stephen Wilson, *Ideology and Experience: Antisemitism in France at the Time of the Dreyfus Affair* (Madison, NJ: Fairleigh Dickinson University Press, 1982), 125.

70. For a full analysis of the Henry subscription, see Wilson, *Ideology and Experience*, 125–165.

71. Harris, *Man on Devil's Island*, 242–243.

72. These lists were collated and analysed by the anarchist and Dreyfusard Pierre Quillard, publishing the work as *Le Monument Henry: Liste des souscripteurs classés méthodiquement et selon l'ordre alphabétique* (Paris: Stock, 1899).

73. *L'Aurore*, 17 December 1898.

74. *L'Aurore*, 17 December 1898 (emphasis in original).

75. *L'Aurore*, 17 December 1898.

76. Ponty, 'La Presse quotidienne', 214, 220.

77. Figures from Albert, 'La Presse française', 373; Ponty, 'La Presse quotidienne', 214.

78. For *Le Temps*, see Albert, 'La Presse française'; Bellanger et al., *Histoire générale*, 352–356 ('boredom' quotation on p. 352).

79. Ponty, 'La Presse quotidienne', 208.

80. Coquart, *La Frondeuse*, 130.

81. *L'Aurore*, 17 December 1898.

Chapter 9: Hate

1. Frederick Brown, *Zola: A Life* (London: Macmillan, 1995), 742.

2. Ruth Harris, *The Man on Devil's Island: Alfred Dreyfus and the Affair That Divided France* (London: Penguin, 2011), 118.

3. Harris, *Man on Devil's Island*, 119.

4. Jean-Denis Bredin, *The Affair: The Case of Alfred Dreyfus*, trans. Jeffrey Mehlman (New York: George Braziller, 1986), 258–259; Piers Paul Read, *The Dreyfus Affair: The Story of the Most Infamous Miscarriage of Justice in French History* (London: Bloomsbury, 2012), 222.

5. *L'Affaire Dreyfus: Le Procès Zola devant la cour d'assises de la Seine (7 février–23 février 1898). Comte rendu sténographique 'in extenso' et documents annexes* (Paris: Stock, 1998), 94–97, 131 ('La question ne sera pas posée').

6. *L'Affaire Dreyfus*, 231, 233.

7. *L'Affaire Dreyfus*, 251–252, 304–305, 324, 391, 392 ('faith').

8. *L'Affaire Dreyfus*, 469.

9. *L'Affaire Dreyfus*, 714–715.

10. *L'Affaire Dreyfus*, 724.

11. *L'Affaire Dreyfus*, 1006.

12. Quoted in Élizabeth Coquart, *La Frondeuse: Marguerite Durand, patronne de presse et féministe* (Paris: Payot, 2010), 126.

13. Quoted in Bredin, *The Affair*, 270.

14. Archives Nationales, Paris (AN hereafter), F/7/12474 (Procès Zola), dossier: 1er procès—Rapports, coupures de presse (janvier–mars 1898), *petit bleu*, 12 February, 3.40 p.m.

15. AN, F/7/12474 (Procès Zola), dossier: 1er procès—Rapports, coupures de presse (janvier–mars 1898), letter, 7 February.

16. AN, F/7/12474 (Procès Zola), dossier: 1er procès—Rapports, coupures de presse (janvier–mars 1898), *petit bleu*, 7 February, 6 p.m.

17. AN, F/7/12474 (Procès Zola), dossier: 1er procès—Rapports, coupures de presse (janvier–mars 1898), letter, 10 February.

18. 'Aux Français', *La Libre parole*, 6 February 1898.

19. AN, F/7/12474 (Procès Zola), dossier: 1er procès—Rapports, coupures de presse (janvier–mars 1898), *petit bleu*, 11 February, 1 p.m.

20. AN, F/7/12474 (Procès Zola), dossier: 1er procès—Rapports, coupures de presse (janvier–mars 1898), *petit bleu*, 9 February, 1.50 p.m.

21. AN, F/7/12474 (Procès Zola), dossier: 1er procès—Rapports, coupures de presse (janvier–mars 1898), *petit bleu*, 11 February, 7.40 p.m.

22. Coquart, *La Frondeuse*, 128; *L'Affaire Dreyfus*, 473–476. For Yves Guyot, see Jean-Claude Wartelle, 'Yves Guyot ou le libéralisme de combat', *Revue française d'histoire des idées politiques*, no. 7 (1er semestre 1998): 73–109.

23. 'Aux Français!', *Le Siècle*, 7 February 1898.

24. AN, F/7/12474 (Procès Zola), dossier: 1er procès—Rapports, coupures de presse (janvier–mars 1898), *petit bleu*, 9 February, 9 p.m.

25. Robert Gildea, *Children of the Revolution: The French, 1799–1914* (London: Allen Lane/Penguin, 2008), 275.

26. On the abattoir at La Villette, see Kyri W. Claflin, 'Abattoirs-Usines, the Modernizing Project for the French Meat Trade, and World War I', *Historical Reflections/Refléxions historiques* 44 (2018): 116–137. The First World War, when feeding the army became paramount, forced change, and large-scale 'Abattoirs-Usines', used and cleaned on an industrial scale, were developed. See also Kyri W. Claflin, 'La Villette: City of Blood, 1867–1914', in *Meat, Modernity and the Rise of the Slaughterhouse*, ed. Paula Lee (Durham: University of New Hampshire Press, 2008), 27–45.

27. Gustave Le Bon, *Psychologie des foules* (Paris: Félix Alcan, 1895), 2.

28. Le Bon, *Psychologie des foules*, 15–20.

29. Susanna Barrows, *Distorting Mirrors: Visions of the Crowd in Late Nineteenth-Century France* (New Haven, CT: Yale University Press, 1981), 162–166.

30. Le Bon, *Psychologie des foules*, 63–64.

31. Quoted in Barrows, *Distorting Mirrors*, 166.

32. AN, F/7/12474 (Procès Zola), dossier: 1ᵉʳ procès—Rapports, coupures de presse (janvier–mars 1898), letter, 10 February.

33. AN, F/7/12474 (Procès Zola), dossier: 1ᵉʳ procès—Rapports, coupures de presse (janvier–mars 1898), letter, 10 February.

34. Christophe Charle, *Birth of the Intellectuals, 1880–1900*, trans. David Fernbach and G. M. Goshgarian (Cambridge: Polity, 2015).

35. Christopher E. Forth, 'Intellectuals, Crowds and the Body Politics of the Dreyfus Affair', *Historical Reflections/Réflexions historiques* 24 (1998): 64.

36. Quoted in Bredin, *The Affair*, 276.

37. Harris, *Man on Devil's Island*, 135–137.

38. *L'Aurore*, 23 January 1898.

39. Sarah Shurts, 'Redefining the *Engagé*: Intellectual Identity in Fin de Siècle France', *Historical Reflections/Réflexions historiques* 38 (2012): 24.

40. Christopher E. Forth, *The Dreyfus Affair and the Crisis of French Manhood* (Baltimore: Johns Hopkins University Press, 2004), 80–81 (Barrès quoted on p. 80).

41. Shurts, 'Redefining the *Engagé*', 28–29 (quotation on p. 29); Frederick Brown, *For the Soul of France: Culture Wars in the Age of Dreyfus* (New York: Anchor Books, 2010), 208–209.

42. Forth, 'Intellectuals, Crowds and the Body Politics', 71.

43. Quoted in Forth, *The Dreyfus Affair and the Crisis of French Manhood*, 103.

44. Forth, 'Intellectuals, Crowds and the Body Politics', 72.

45. Quoted in Brown, *Zola*, 745.

46. Brown, *Zola*, 745–746; Bredin, *The Affair*, 271.

47. On Zola's time in England, see Michael Rosen, *The Disappearance of Émile Zola: Love, Literature and the Dreyfus Case* (London: Faber and Faber, 2017); see also Brown, *Zola*, 749–767.

48. Michel Drouin, *L'Affaire Dreyfus de A à Z* (Paris: Flammarion, 1994), 91.

49. *Le Rappel*, 29 October 1898.

50. *Le Rappel*, 25 October 1898.

51. Quoted in Drouin, *L'Affaire Dreyfus*, 90.

52. *Le Rappel*, 25 October 1898.

53. *Le Rappel*, 25 October 1898.

54. Douglas Johnson, *France and the Dreyfus Affair* (London: Blandford Press, 1966), 2.

55. Drouin, *L'Affaire Dreyfus*, 88; Harris, *Man on Devil's Island*, 238.

56. Eric Cahm, *L'Affaire Dreyfus: Histoire, politique et société* (Paris: Livre de Poche, 1994), 176.

57. Quoted in Robert Tombs, *France, 1814–1914* (London: Longman, 1996), 464. On the affair between Faure and Steinheil, see Armand Lanoux, *Madame Steinheil, ou la connaissance du président* (Paris: Grasset, 1983). The title is a play on the story of the policeman's response to the doctor.

58. Cahm, *L'Affaire Dreyfus*, 178–182; Harris, *Man on Devil's Island*, 301–303.

59. AN, F/7/12459 (Antisémitisme), dossier: imprimés, tractes, affiches, 1898–1902.

60. *La Fronde*, 9 September 1899.

61. Quoted in Patrice Boussel, *L'Affaire Dreyfus et la presse* (Paris: Armand Colin, 1960), 227.

Chapter 10: Memory

1. Frederick Brown, *Zola: A Life* (London: Macmillan, 1995), 791–792; F. W. J. Hemmings, *Émile Zola* (Oxford: Clarendon Press, 1953), 289.

2. Quoted in Brown, *Zola*, 792.

3. Brown, *Zola*, 793.

4. Quoted in Brown, *Zola*, 795–796.

5. The pendentives are triangular structures that arch from the corners of a square or rectangular space to support a dome or cupola above. Their downward, tapering points are each supported by a load-bearing column; at the top they join together to form the dome's or cupola's base.

6. A useful, concise architectural guide can be found in the official booklet by Alexia Lebeurre, *Le Panthéon: Temple de la Nation* (Paris: Éditions du Patrimoine, Centre des Monuments Nationaux, 2000), 12–13.

7. Lebeurre, *Le Panthéon*, 8–11.

8. Nguyễn Trọng Hiệp, *Paris, capitale de la France: Recueil de vers* (Hanoi: F.-H. Schneider, 1897), verse 17.

9. There are now still only six women interred in the Panthéon—most recently, in 2021, the singer, dancer, and French Resistance member Josephine

Baker became the first black woman to be so honoured. The former health minister Simone Veil, who campaigned for women's rights and for European integration, was interred there in 2018. Among the others is the Nobel Prize–winning scientist Marie Curie (Anne Chemin, 'La panthéonisation de Simone Veil est, à tous points de vue, une exception', *Le Monde*, 1 July 2018).

 10. Nguyễn Trọng Hiệp, *Paris*, verse 17.

 11. The complexities of historical memory and its conflicting uses by different groups are analysed in fascinating detail by Robert Gildea in *The Past in French History* (New Haven, CT: Yale University Press, 1994).

 12. Mona Ozouf, 'Le Panthéon, l'école normale des morts', in *Les Lieux de mémoire*, vol. 1, *La République*, ed. Pierre Nora (Paris: Gallimard, 1984), 162.

 13. Michel Poisson, *The Monuments of Paris: An Illustrated Guide* (London: I. B. Tauris, 1999), 172–173; Ozouf, 'Le Panthéon', 139–196; Caisse nationale des monuments historiques et des sites (CNMHS), *Le Panthéon, symbole des révolutions: De l'Église de la nation au temple des grands hommes* (Paris: CNMHS/Picard, 1989). See also the nuanced assessment by Suzanne Vromen, 'The French Panthéon: A Study in Divisiveness', *Journal of Arts Management, Law and Society* 25 (1995): 27–37.

 14. Avner Ben-Amos, 'The Other World of Memory: State Funerals of the French Third Republic as Rites of Commemoration', *History and Memory* 1, no. 1 (1989): 93–94.

 15. Quoted in Michel Winock, 'Jeanne d'Arc', in *Les Lieux de mémoire*, vol. 3, *Les France: De l'Archive à l'emblème*, ed. Pierre Nora (Paris: Gallimard, 1992), 729.

 16. Frederick Brown, *For the Soul of France: Culture Wars in the Age of Dreyfus* (New York: Anchor Books, 2010), 81.

 17. Archives Nationales, Paris, F/7/12480, dossier: Jeunesse de l'union nationale.

 18. For Jeanne d'Arc as a symbol, see Winock, 'Jeanne d'Arc', 675–733; Gildea, *The Past in French History*, 154–165; Brown, *For the Soul of France*, 81–84; Frederick Brown, *The Embrace of Unreason: France 1914–1940* (New York: Anchor Books, 2014), 76–91.

 19. Zeev Sternhell, *Ni Gauche, ni Droite: L'Idéologie fasciste en France* (Paris: Seuil, 1983), 30.

 20. Zeev Sternhell, 'National Socialism and Antisemitism: The Case of Maurice Barrès', *Journal of Contemporary History* 8 (1973): 47.

 21. Jean-Marie Mayeur and Madeleine Rebérioux, *The Third Republic from Its Origins to the Great War, 1871–1914*, trans. J. F. Foster (Cambridge: Cambridge University Press / Éditions de la Maison des Sciences de l'Homme, 1984), 207.

 22. Robert Gildea, *Children of the Revolution: The French, 1799–1914* (London: Allen Lane / Penguin, 2008), 280–281.

 23. Quoted in Gildea, *Children of the Revolution*, 279.

24. Ruth Harris, *The Man on Devil's Island: Alfred Dreyfus and the Affair That Divided France* (London: Penguin, 2011), 342–343.

25. Pierre Casselle, *Paris républicain, 1871–1914* (Paris: Hachette, 2003), 430.

26. For the rather tortuous background to the Musée Rodin, which the artist himself envisaged, see Sonya Stephens, 'Auguste Rodin, or the Institutionalization of the Self as Artist', in *Institutions and Power in Nineteenth-Century French Literature and Culture*, ed. David Evans and Kate Griffiths (Amsterdam: Rodopi, 1994), 279–295.

27. Quoted in Harvey Goldberg, *The Life of Jean Jaurès* (Madison: University of Wisconsin Press, 1962), 336.

28. Harris, *Man on Devil's Island*, 365–366.

29. *Journal official de la République française* 38, no. 188 (13 July 1906): 2368.

30. *Journal official de la République française* 40, no. 78 (19 March 1908): 658–660.

31. See, for example, the intervention by Georges de Grandmaison in *Journal official de la République française* 40, no. 78 (19 March 1908): 661.

32. *Journal official de la République française* 40, no. 78 (19 March 1908): 662.

33. *Journal official de la République française* 40, no. 78 (19 March 1908): 662.

34. *Le Temps*, 21 March 1908.

35. Jeremy Jennings, *Revolution and the Republic: A History of Political Thought in France Since the Eighteenth Century* (Oxford: Oxford University Press, 2011), 367–370.

36. 'Le Nationalisme intégral', *L'Action française*, no. 1 (21 March 1908).

37. Eric Cahm, *L'Affaire Dreyfus: Histoire, politique et société* (Paris: Livre de Poche, 1994), 198.

38. Quoted in Jean-François Condette, 'La Translation des cendres d'Émile Zola au Panthéon. La Difficile et posthume revanche de l'intellectuel dreyfusard, juillet 1906–juin 1908', *Revue historique* 302 (2000): 680.

39. *Le Temps*, 5 June 1908; Condette, 'La Translation', 675–676.

40. *Le Temps*, 5 June 1908.

41. *L'Aurore*, 5 June 1908.

42. *Le Temps*, 5 June 1908.

43. *L'Aurore*, 5 June 1908.

44. *Le Gaulois*, 5 June 1908.

45. *L'Action française*, 5 June 1908.

46. *L'Action française*, 5 June 1908.

47. Quoted in Michel Drouin, *L'Affaire Dreyfus de A à Z* (Paris: Flammarion, 1994), 111.

48. On the 'nationalist revival', see Eugen Weber, *The Nationalist Revival in France, 1905–1914* (Berkeley: University of California Press, 1968).

49. Gildea, *Children of the Revolution*, 279.

50. James F. McMillan, *Twentieth Century France: Politics and Society, 1898–1991* (London: Arnold, 1992), 37.

51. Ben-Amos, 'The Other World of Memory', 96.

52. Condette, 'La Translation', 682.

Chapter 11: Crisis

1. The following paragraphs are based on Jeremy Jennings, *Revolution and the Republic: A History of Political Thought in France Since the Eighteenth Century* (Oxford: Oxford University Press, 2011), 354–357, and Stephen Gaukroger and Knox Peden, *French Philosophy: A Very Short Introduction* (Oxford: Oxford University Press, 2020), 45–48.

2. Émile Zola, *Les Trois Villes: Paris* (Paris: Bibliothèque Charpentier, 1898), 597.

3. *Journal official de la République française* 40, no. 78 (19 March 1908): 661.

4. Nguyễn Trọng Hiệp, *Paris, capitale de la France: Recueil de vers* (Hanoi: F.-H. Schneider, 1897), verse 27.

5. Quoted in Kevin Duong, 'The Left and Henri Bergson', *French Politics* 18 (2020): 361.

6. Jennings, *Revolution and the Republic*, 370.

7. Harvey Goldberg, *The Life of Jean Jaurès* (Madison: University of Wisconsin Press, 1962), 16, 22.

8. Eric Fourcassier, *Bergson* (Brussels: Lemaitre, 2013), 3–6.

9. Robert C. Grogin, 'Henri Bergson and the University Community, 1900–1914', *Historical Reflections/Réflexions historiques* 2, no. 2 (1975): 209–222.

10. Marguerite Bistis, 'Managing Bergson's Crowd: Professionalism and the *Mondain* at the Collège de France', *Historical Reflections/Réflexions historiques* 22 (1996): 390.

11. The Collège de France website has a history of the college, its buildings, and its archaeology. See www.college-de-france.fr/site/histoire-et -archeologie/histoire.htm.

12. Russell quoted in Paul Ardoin, S. E. Gontarski, and Laci Mattison, 'Introduction. "About the Year 1910": Bergson and Literary Modernism', in *Understanding Bergson, Understanding Modernism*, ed. Paul Ardoin, S. E. Gontarski, and Laci Mattison (London: Bloomsbury, 2013), 5; Miller quoted in Suzanne Guerlac, 'Foreword', in Ardoin et al., *Understanding Bergson, Understanding Modernism*, vii.

13. The following paragraphs are based on Ardoin et al., *Understanding Bergson, Understanding Modernism*, especially the essay by Mary Ann Gillies, '(Re)Reading *Time and Free Will*: (Re)Discovering Bergson for the Twenty-First

Century', 11–23; and Suzanne Guerlac, *Thinking in Time: An Introduction to Henri Bergson* (Ithaca, NY: Cornell University Press, 2006).

14. Henri Bergson, *Time and Free Will: An Essay on the Immediate Data of Consciousness* (London: Swan Sonnenschein, 1910), 231–232.

15. Henri Bergson, *Creative Evolution* (New York: Henry Holt, 1911), 7, 23; quoted in Paul Douglass, 'Bergson on *Élan Vital*', in Ardoin et al., *Understanding Bergson, Understanding Modernism*, 303.

16. Quoted in Bistis, 'Managing Bergson's Crowd', 392.

17. Quoted in Bistis, 'Managing Bergson's Crowd', 395.

18. Quoted in Bistis, 'Managing Bergson's Crowd', 401.

19. Quoted in Bistis, 'Managing Bergson's Crowd', 402 (translation adapted).

20. Quoted in Bistis, 'Managing Bergson's Crowd', 399.

21. Quoted in Grogin, 'Henri Bergson and the University Community', 216.

22. Quoted in Bistis, 'Managing Bergson's Crowd', 393.

23. Vincent Cronin, *Paris on the Eve, 1900–1914* (London: Collins, 1989), 46.

24. Fonsegrive and Maritain quoted in Grogin, 'Henri Bergson and the University Community', 212, 213, respectively.

25. Quoted in Phyllis H. Stock, 'Students Versus the University in Pre–World War Paris', *French Historical Studies* 7, no. 1 (1971): 95.

26. Paul Michael Cohen, 'Reason and Faith: The Bergsonian Catholic Youth of Pre-War France', *Historical Reflections/Réflexions historiques* 13 (1986): 478–479.

27. Quoted in Duong, 'The Left and Henri Bergson', 360.

28. Ruth Harris, *The Man on Devil's Island: Alfred Dreyfus and the Affair That Divided France* (London: Penguin, 2011), 206–209 ('voice of blood', p. 208).

29. Stephen Wilson, *Ideology and Experience: Antisemitism in France at the Time of the Dreyfus Affair* (Madison, NJ: Fairleigh Dickinson University Press, 1982), 522.

30. Maurras quoted in Jennings, *Revolution and the Republic*, 368.

31. Gilbert D. Chaitin, 'Education and Political Identity: The Universalist Controversy', *Yale French Studies*, no. 113 (2008): 76.

32. Cohen, 'Reason and Faith', 474–475.

33. Quoted in Eugen Weber, *The Nationalist Revival in France, 1905–1914* (Berkeley: University of California Press, 1968), 81.

34. Grogin, 'Henri Bergson and the University Community', 220.

35. Quoted in Goldberg, *Life of Jaurès*, 443.

36. Quoted in Weber, *Nationalist Revival*, 81.

37. Duong, 'The Left and Henri Bergson', 366.

38. For Sorel and Bergson, see J. R. Jennings, *Georges Sorel: The Character*

and Development of His Thought (Basingstoke: Macmillan, 1985), 139–142 (critic's quotation on p. 142).

39. Zeev Sternhell, *Ni Gauche, ni Droite: L'Idéologie fasciste en France* (Paris: Seuil, 1983), 23, 93–96.

40. *L'Humanité*, 23 January 1914.

41. On the wide-ranging and diverse campaigning for women's rights, see the richly detailed work by Karen Offen, *Debating the Woman Question in the French Third Republic, 1870–1920* (Cambridge: Cambridge University Press, 2018).

42. Felicia Gordon, *The Integral Feminist: Madeleine Pelletier, 1874–1939: Feminism, Socialism and Medicine* (Minneapolis: University of Minnesota Press, 1990), 17–19, 54–57, 81. On women in the professions, see Julian Fette, 'Pride and Prejudice in the Professions: Women Doctors and Lawyers in Third Republic France', *Journal of Women's History* 19 (2007): 60–86.

43. Susan K. Foley, *Women in France Since 1789* (Basingstoke: Palgrave, 2004), 144; Steven C. Hause and Anne R. Kenney, *Women's Suffrage and Social Politics in the French Third Republic* (Princeton, NJ: Princeton University Press, 1984), 40–45.

44. Máire Cross, '1890–1914: A "Belle Époque" for Feminism?', in *A 'Belle Époque'? Women in French Society and Culture, 1890–1914*, ed. Diana Holmes and Carrie Tarr (New York: Berghahn Books, 2006), 23–35.

45. *La Fronde*, 1 November 1904.

46. *La Fronde*, 1 November 1904.

47. For the history of the statue, see 'Monument à de Condorcet—Paris (75006)', E-monumen, https://e-monumen.net/patrimoine-monumental /monument-a-de-condorcet-paris-6e-arr, accessed 28 April 2023.

48. *L'Humanité*, 6 July 1914.

49. *Le Journal*, 6 July 1914; *L'Humanité*, 6 July 1914.

50. *Le Journal*, 6 July 1914.

51. Élizabeth Coquart, *La Frondeuse: Marguerite Durand, patronne de presse et féministe* (Paris: Payot, 2010), 251–252.

52. *L'Humanité*, 6 July 1914.

53. On resistance to women's suffrage, see the work of Helen Chenut, 'L'Esprit antiféministe et la campagne pour le suffrage en France, 1880–1914', *Recherches féministes* 25 (2012): 37–53; and Helen Chenut, 'Attitudes Towards French Women's Suffrage on the Eve of World War I', *French Historical Studies* 41 (2018): 711–740.

Conclusion

1. Jean Rabaut, *Jaurès et son assassin* (Paris: Éditions du Centurion, 1967), 65–69.

2. John F. V. Keiger, *France and the Origins of the First World War* (London: Macmillan, 1983), 163.

3. I thank my student Louis Marciniak for sharing this memory, passed down from his grandparents. Other sources say much the same thing: in Paris, people were heard to say, 'Ils ont tué Jaurès, c'est la guerre!' (They have killed Jaurès, it's war!). Rabaut, *Jaurès et son assassin*, 70.

4. Rabaut, *Jaurès et son assassin*, 119.

5. Rabaut, *Jaurès et son assassin*, 123, 130.

6. Quoted in Élizabeth Coquart, *La Frondeuse: Marguerite Durand, patronne de presse et féministe* (Paris: Payot, 2010), 199.

7. Peter Jackson, *Beyond the Balance of Power: France and the Politics of National Security in the Era of the First World War* (Cambridge: Cambridge University Press, 2013), 47–78. My thanks go to Professor Jackson for a copy of his compelling book.

8. Paul B. Miller, *From Revolutionaries to Citizens: Antimilitarism in France, 1870–1914* (Durham, NC: Duke University Press, 2002), 3.

9. Miller, *From Revolutionaries to Citizens*, 194.

10. Quoted in Harvey Goldberg, *The Life of Jean Jaurès* (Madison: University of Wisconsin Press, 1962), 441.

11. Eugen Weber, *The Nationalist Revival in France, 1905–1914* (Berkeley: University of California Press, 1968), 124.

12. Rabaut, *Jaurès et son assassin*, 204–211.

13. Quoted in Coquart, *La Frondeuse*, 259.

14. Quoted in Dominique Kalifa, *The Belle Époque: A Cultural History, Paris and Beyond* (New York: Columbia University Press, 2017), 47.

15. 'Martin et Martine', 'A Paris, le huit octobre 1932', *Martin et Martine: Bulletin du Groupe de Lille de l'Association des anciens combattants du 1ᵉʳ régiment d'infanterie* (1 September 1932), 2.

16. Charles Rearick, 'The Charms of Paris . . . Yesterday', *Historical Reflections / Réflexions historiques* 39 (2013): 13–14.

17. Quoted in Kalifa, *Belle Époque*, 47.

18. Quoted in Kalifa, *Belle Époque*, 54.

19. Kalifa, *Belle Époque*, 65.

20. On Roger Martin du Gard, see David L. Schalk, *Roger Martin du Gard: The Novelist and History* (Ithaca, NY: Cornell University Press, 1967), and Denis Boak, *Roger Martin du Gard* (Oxford: Clarendon Press, 1963).

21. Quoted in Kalifa, *Belle Époque*, 64. For the full speech, see the Nobel Prize website: 'Roger Martin du Gard Banquet Speech', Nobel Prize, 10 December 1937, www.nobelprize.org/prizes/literature/1937/gard/speech.

22. Kalifa, *Belle Époque*, 64.

23. Eugen Weber, *France: Fin de Siècle* (Cambridge, MA: Belknap Press of Harvard University Press, 1986), 6.

24. Jean Jaurès, *Discours à la jeunesse* (1903) (voice recording by Suzanne Desprès, published 1927), Bibliothèque nationale de France (BnF), https://gallica.bnf.fr/ark:/12148/bpt6k129177h?rk=793995;2#. The line is at about 2 minutes 40 seconds.

25. To explore the 'spatial turn' further, see, among others, the useful discussion by Leif Jerram, 'Space: A Useless Category for Historical Analysis?', *History and Theory* 52 (2013): 400–419, and the richly documented guide to spatial methods and research by Konrad Lawson, Riccardo Bavaj, and Bernhard Struck, 'A Guide to Spatial History: Areas, Aspects, and Avenues of Research', University of Saint Andrews Institute for Transnational and Spatial History, June 2021, https://spatialhistory.net/guide. The philosopher whose ideas have weighed most heavily on this approach is Henri Lefebvre, *The Production of Space*, trans. Donald Nicolson-Smith (Oxford: Blackwell, 1991).

26. David Blackbourn, *A Sense of Place: New Directions in German History. The 1998 Annual Lecture, German Historical Institute London* (London: German Historical Institute, 1999), 17, 23. I thank Professor Riccardo Bavaj of the Institute for Transnational and Spatial History at the University of Saint Andrews, Scotland, for the reference to this thought-provoking and often witty discussion.

27. William Whyte, 'How Do Buildings Mean? Some Issues of Interpretation in the History of Architecture', *History and Theory* 45 (2006): 153–177, has a very thorough exposé of the different viewpoints in this long-running debate.

28. On Patrick Geddes in Paris, see Siân Reynolds, *Paris-Edinburgh: Cultural Connections in the Belle Époque* (Aldershot: Ashgate, 2007), esp. 115–142.

29. 'Patrick Geddes, 'Civics: as Applied Sociology', *Sociological Papers* 1 (1904, published in 1905): 107.

INDEX

Index

Index

Index

Index

Index

Index

Index

Index

Pont Alexandre III, 90–91
Ponty, Janine, 274
populism, 44, 45, 253, 278, 376–377
positivism and 'positive state', 8,
 340–342, 345–346, 352, 356, 357
Poubelle, Eugène, 202, 217, 363
poubelles, 202
Pouget, Émile, 215
poverty and poor of Paris
 children in, 189–191
 economic inequality, 184–185
 escape from, 198–199
 and Haussmann's changes, 7
 housing, 199–202, 203–204
 lessons from Belle Époque, 376
 in Montmartre, 156–157
 public health, 202–203, 208
 research by Zola, 179, 182, 199–202,
 204–205, 207
 and tuberculosis, 203–204
 and wealthy, 206–207
 See also Goutte d'Or district
president of Republic, 38
press. *See* newspapers
press law (1881), 235, 252, 255–257, 284
La Presse, 42, 64–65
Pressensé, Francis de, 271, 359
printing, 9
prostitution (sex work/trade)
 filles soumises (registered workers),
 194–195, 196, 197–198
 gangs in, 191–192
 insoumises, 194, 196–197
 maisons d'abattage, 195–196
 official views and research, 192–194
 recognised brothels *(maisons de tolérance)*,
 194, 195
 as symbol of consumerism, 112
Proudhon, Pierre-Joseph, 218, 229
Proust, Marcel, 100–101, 300–301
psychology
 and Art Nouveau, 76–77
 and change, 84–85, 87, 88
 of crowds, 296–300, 302, 303–304
 public health and sanitation,
 202–204, 208

race and racism, views on, 56
radicals and Radicals
 anti-clericalism, 323
 description, 14
 in government, 28, 41, 144, 210
 and place de la République statue, 211,
 213, 214
 and working-class, 213
railway (national, *grandes lignes*), 68
Ralliement period of politics, 240
Le Rappel (newspaper), 305–307
Ravachol, François-Claudius, 230–231
reality (living reality), 349
reason. *See* science and reason
Reinach, Jacques, 247
Reinach, Joseph, 270, 272, 311
Renan, Ernest, 341–342
Renaudin, 176
Renoir, Pierre-Auguste, 152, 154,
 160–161
repression, use by state, 234–235,
 236–237
Republic
 crises in early decades, 37–40
 monument as celebration, 210–211
 rupture in 1880s, 213–214
 values, 209–210, 212, 214, 215
 See also Third Republic
Republic (statue). *See* place de la
 République statue
republicanism and republicans
 coming to power in Paris, 39,
 210–211
 conflict with monarchists, 37–39
 in Dreyfus Affair, 306–307, 310, 311
 electoral wins, 38–39, 211
 and feminism, 360–361
 and Franco-Prussian War, 27–28
 and imperialism of France, 55–56
 moderates in, 40–41
 and outcome of Revolution, 12
 and place de la République statue,
 210–211, 212–213
 secular worldview, 8
 in two crisis of Third Republic, 37–40
La République des lettres (journal), 183

433

Index

Helen Rapport

Mike Rapport is a professor of history at the University of Glasgow in Scotland and a Fellow of the Royal Historical Society. The author of *1848: Year of Revolution*, *The Napoleonic Wars*, and *The Unruly City: Paris, London, and New York in the Age of Revolution*, Rapport lives in Stirling, Scotland.